Urban Spaces

No. 3

The Design of Public Places

Edited by
John Morris Dixon, FAIA

Designed by
Harish K. Patel

Visual Reference Publications, New York

Urban Land Institute, Washington, DC

Copyright © 2004 by Visual Reference Publications, Inc.

Visual Reference Publications, Inc.
302 Fifth Avenue
New York, NY 10001

Distributors to the trade in the United States and Canada
Watson-Guptill
770 Broadway
New York, NY 10003

Distributors outside the United States and Canada
HarperCollins International
10 East 53 Street
New York, NY 10022-5299

Book Design: Harish Patel Design Associates, New York
Book Production: John Hogan

Library of Congress Cataloging in Publication Data:
Urban Spaces No.3
Printed in China
ISBN: 1-58471-027-6

Contents

Contents by Project Type

Note: *Most projects in this book include, by their nature, more than one function. A few guidelines to categories below:*

Mixed-Use Developments: *reserved for those with substantial mix of uses within buildings (beyond accessory parking or retail included in buildings listed as office, residential, etc.).*

Communities: *wide mix of uses, typically on cleared land, with new buildings and infrastructure.*

Urban Redevelopment: *large in scope, including existing construction and infrastructure.*

Remodeling/Re-use: *including specifics on re-use of individual buildings.*

Other project types: *largely devoted to listed type (not listing, for instance, inclusion of recreation in residential projects, plazas with office buildings, or street improvements in urban redevelopment).*

Introduction

The design of public places has successfully overcome some 20th-Century setbacks.

Although some marvelous architecture was created in the 20th Century, we are still playing catch-up in the area of public spaces. Earlier eras seemed to understand the need for places where people would enjoy gathering and circulating. And they developed some great precedents for us among the countless parks, plazas, boulevards, public gardens, arcades, palm courts, and railroad stations that still give pleasure to people all over the world.

But urban spaces were among the initial casualties of the Modernist revolution. When Modern architecture dismissed previous experience, public spaces were viewed for a while as nothing more than the gaps between buildings – carved up by roadways and garnished with a few trees. Meanwhile, architects who didn't take Modernism too seriously were bucking the trend by designing truly world-class public spaces, such as those at New York's Rockefeller Center.

By mid-century, Modern planners and landscape architects were developing some new, positive concepts for public space – still avoiding established Renaissance and Baroque principles, but influenced by more intuitive, vernacular examples from all over the world. And there was some sheer invention, as well, reflecting behavioral studies of how people used shared space. Design leaders such as Lawrence Halprin, Isamu Noguchi, Hideo Sasaki, Paul Friedberg, Roberto Burle Marx, and Dan Kiley showed us some new possibilities. Still, the process of experimenting, while ignoring history, produced many unsuccessful efforts, in the form of forbidding plazas, deserted pedestrian streets, and mind-numbing executive parks.

Then, too, the 20th Century brought negative trends beyond the control of designers. There was the proliferation of the automobile, taking up vast areas in our communities and reducing pedestrian activity while obstructing what remained. There was also a tendency to funnel resources into private amenities, rather than the public realm, but that was offset by the tendency of private developers – or public-private partnerships – to provide places where the public congregates.

In the area of indoor public spaces, the 20th Century opened up some great opportunities in new facilities such as airport terminals, shopping malls, convention centers, hotel atriums, and arts centers. While a few early examples of these were delightful, it took decades before many architects and clients understood how to make them appealing to the public.

At any rate, we are now playing catch-up with apparent success. We are now open to learning from the examples of history, worldwide – including the once-rejected Western Classical precedents. The city planning traditions of the 19th and early 20th Centuries have been revived as the New Urbanism. And we are eager for the lessons of current efforts such as those documented in this book.

Among the factors motivating our efforts are the changes in demographics discussed in Richard Rosan's Preface on the following pages: families with kids accounts for a shrinking percentage of today's population, and even they don't feel homebound. While admittedly some people spend long hours at their private computer or TV screens, the demand for satisfying public places is rising steadily – as is the wisdom to create them.

John Morris Dixon, FAIA

Preface

Richard M. Rosan, FAIA
President, Urban Land Institute

Lifestyle centers. Urban villages. Walkability. Livability. Place making. Transit-oriented development. Anyone involved in development or design these days is inundated with articles and discussions about these latest development trends. They're all part of a search for a more humane lifestyle, for human-scale environments. Quality of life issues have become inextricably linked to real estate development fashions. But there's another thread that connects all these trends: choice. We are looking for more choices in how and where we live, work, and play. We want the choice of walking to the store, of taking public transit, of purchasing a home that's something other than a traditional suburban dwelling.

The dynamics of community in the United States are changing. In 2000, the Census Bureau counted more than 281.4 million Americans, an increase of over 13 percent compared to a decade earlier. The nation gained 13.6 million households, creating demand for new housing, retail space, and entertainment venues. And these new households are not homogeneous. Traditional "married couple with children" families have declined sharply—from 40 percent of all households in 1970 to 23 percent in 2000. Only 36 percent of all households include any children under age 18. These demographic changes bring new needs and wants.

And how we work has been evolving as well. The dot-com bubble brought to the forefront the desire for alternative workspaces and friendlier, amenity-filled work environments. We want the option of working at home—and having a home that can comfortably accommodate a complete office setup.

In every type of real estate, the development community is realizing the need to provide more choices and respond to the significant niche of people who are looking for something different in their living and working arrangements.

The need for choice is further illustrated by a fundamental change in the shape of urban America. Our cities have evolved into urban regions with multiple centers of economic and social activity. Now, there is seldom a dominant center acting as the economic engine for the entire area. Instead, there are numerous business districts or nodes throughout urban areas. And what was once the downtown for an entire metropolitan region is quickly turning into a "central social district" or an entertainment district, a leisure-time destination for a region with multiple nodes serving as downtowns for suburban districts.

These new suburban downtowns, often called town centers, are providing some important lessons for the design of public spaces. They exemplify the growing awareness of how well-designed places can put a project "on the map" and bring people to it simply because of how it looks and feels and because of the strong identity good design can bring. And this isn't just an American phenomenon. Around the world we see a stronger emphasis on the design of urban and public spaces, of providing more choices for changing populations.

ULI has nearly 19,000 members in some 70 countries who are working to create better places. Since 1936, ULI has attracted the most significant thinkers, practitioners, and experts in land use and real estate development, first, just within the United States, and now expanding abroad very rapidly.

With each edition, Urban Spaces showcases global innovation and efforts to meet the demand for choice. ULI is pleased to cosponsor this effort once again. The firms and their projects represented in this book offer examples of best practices worldwide. They are truly the urban space trendsetters and all are worth watching.

annex|5

An Epstein Design Group

600 West Fulton

Chicago

Illinois 60661

312.454.9100

312.559.1217 (Fax)

www.annex5.net

ametter@annex5.net

Los Angeles

New York

Tel Aviv

Warsaw

China

Beijing Dazhalan Area Renewal Master Plan
Beijing, China

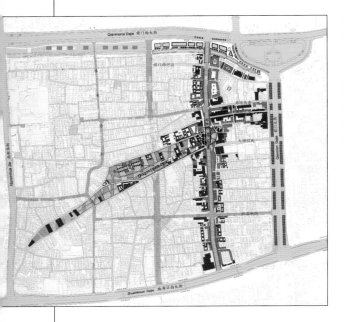

As extensive urban improvements proceed for the 2008 Olympics, the Dazhalan area has a key role. The 110-hectare (272-acre) area, adjoining Tiananmen Square and the city's ceremonial core, already has powerful characteristics and key features, though many of them altered or lost in previous planning efforts. A crucial new element is a new cultural park slashing diagonally through the area's center, yet complementing historic street patterns and "hutong" residential configurations. This "Dragon's Spine" incorporates key cultural relics, contemporary gardens, and gathering places, providing recreational amenities for both residents and tourists. A node at one end of the Dragon's Spine is the site of a cultural center, including an urban history museum, cinema, amphitheater, and market stalls. Qianmen Street, part of the city's main north-south axis, is widened and developed as a grand pedestrian-vehicular boulevard. An ancient canal, hidden underground, is uncovered and lined with landscaped promenades. New residential development is planned along the new boulevard and the restored river.

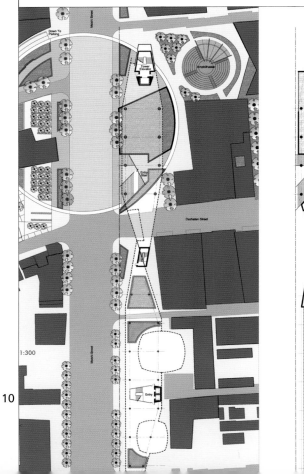

1:300

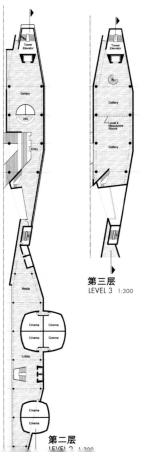

第三层
LEVEL 3 1:300

第二层
LEVEL 2 1:300

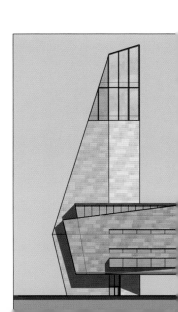

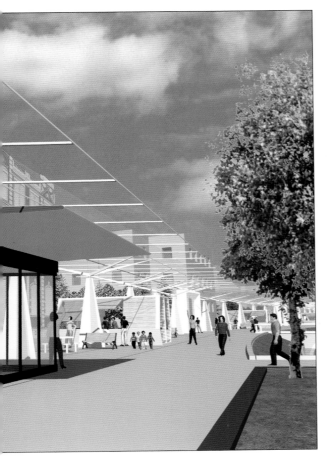

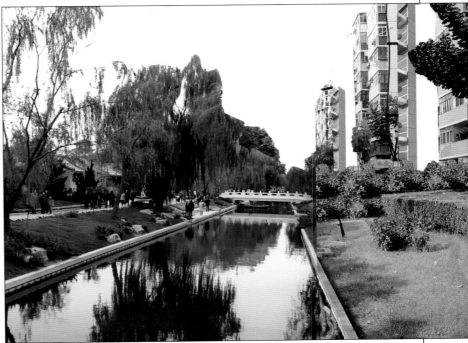

Left: Mixed development along restored canal.
Above: New towers on the bank of canal.
Below: Elevation of museum-mediateque, showing observation tower.

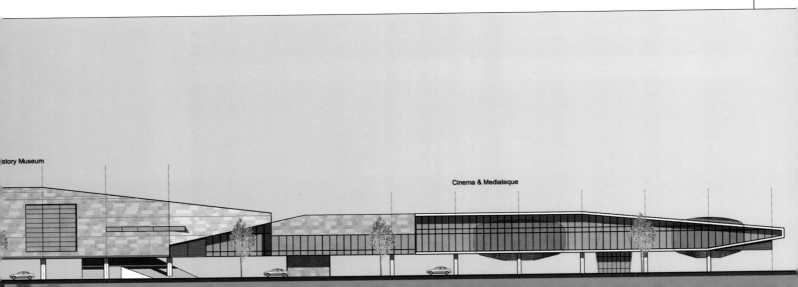

istory Museum

Cinema & Mediateque

Mangrove Bay
Shenzhen, China

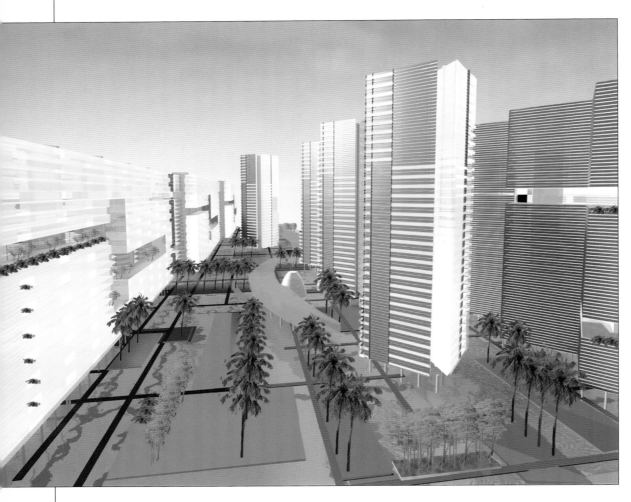

Left: Central pool and garden area, with point towers set on the diagonal.

Below left: Elevation of flanking structures, with through openings at various levels.

Bottom left: Axonometric illustrating concept of flanking walls and central towers.

Below: Site plan showing low curved structures for common facilities.

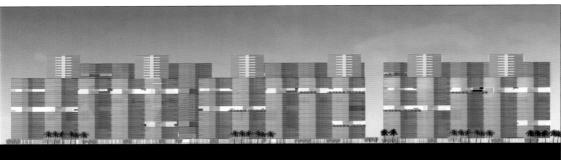

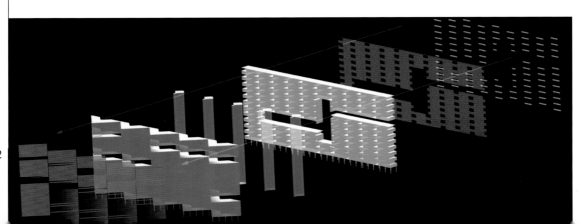

Located where the city meets the sea, the design seeks to weave them together with a landscape of pools and floating gardens. Open space in the center of the site is maximized to meet the city planning department's desire for an open north-south visual corridor. Most of the 4,104 housing units are along the east and west sides of the site, with only six point towers occupying the middle. The building forms recognize the rich history of Chinese culture, the point towers appearing like floating lanterns and the slab buildings recalling folding screens. Acknowledging the semi-tropical climate, the buildings are set diagonally on the site, so that none faces directly west, and the maximum number of units receive south light. All exterior walls are of glass, with outer skins of operable louvers, made of wood on the northwest and southwest facades for shading, and of glass on the other sides. The slab buildings are punctured at various levels for light and ventilation, and the tower buildings have open central light and ventilation shafts. Parking is on one level below the garden, with some garden areas sunken to this level for light, air, and orientation. Common facilities such as kindergartens and meeting rooms are housed in low curvilinear structures linked to an elevated walkway system.

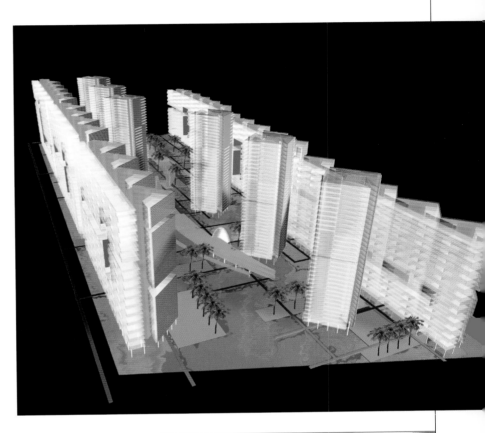

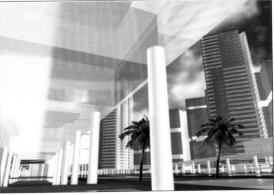

Top: Aerial view of complex.
Above: Garden-level view from open base of long flanking building.

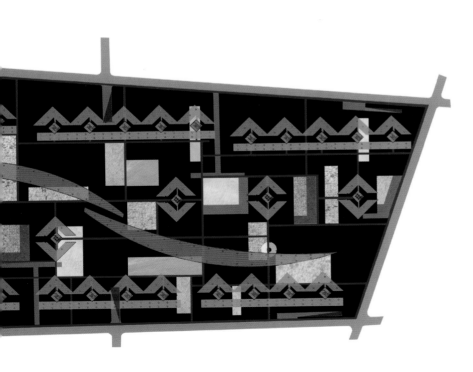

annex|5
An Epstein Design Group

NTTA Prototype Toll Plaza
Dallas, Texas

Due to the advent of express lanes, and the requirement that the traditional toll plaza canopy also function as a worker access bridge, this toll plaza features a steel tubular truss spanning 320 feet. Two supporting pylons, each holding a trio of cables, allow the tube to be lightweight and of modest dimensions. The need for a programmed 6,000-square-foot support structure is almost eliminated by placing facilities such as lunchroom, locker room, and shop in prefabricated boxes – variously transparent, translucent, and opaque – inside the tube. Aside from the pylons, the only elements touching the ground are an underground vault and a stair tower, which also houses the supervisor's office. Sustainable features include individual heating and cooling of the facilities in the boxes, with the glazed tube as an insulating volume. The tube is shaded by photovoltaic cells, louvers, tension fabric, and fritted glass. Continuous LED signage is incorporated in the underside of the tube. Retaining walls and acoustic barriers, adapting the prototype to specific sites, would display contextual murals by local artists.

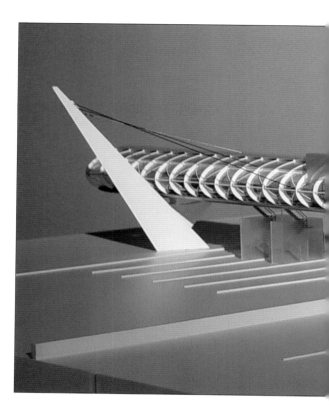

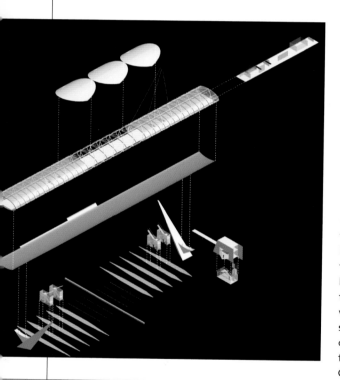

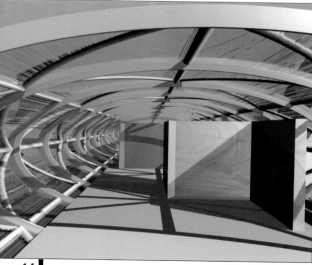

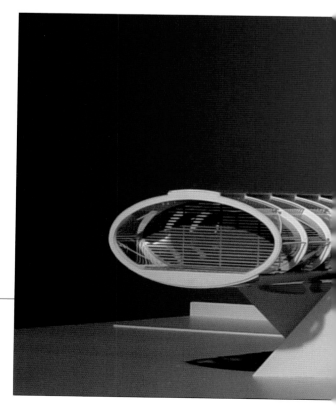

Above left:
Axonometric of components.
Left: *Tube interior.*
Right: *Two model views of toll plaza.*

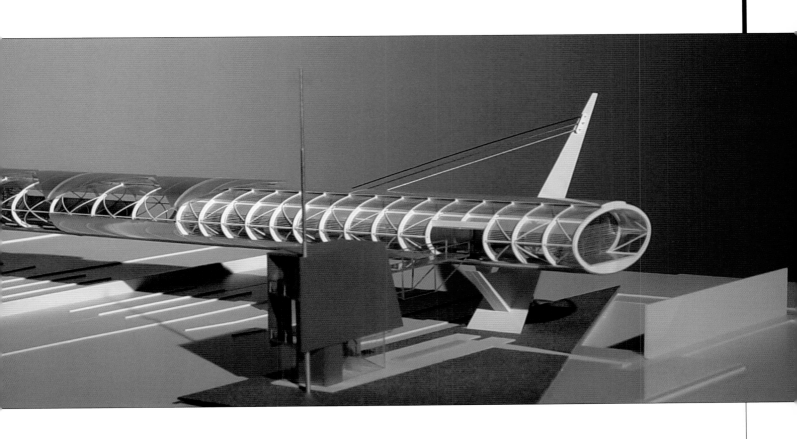

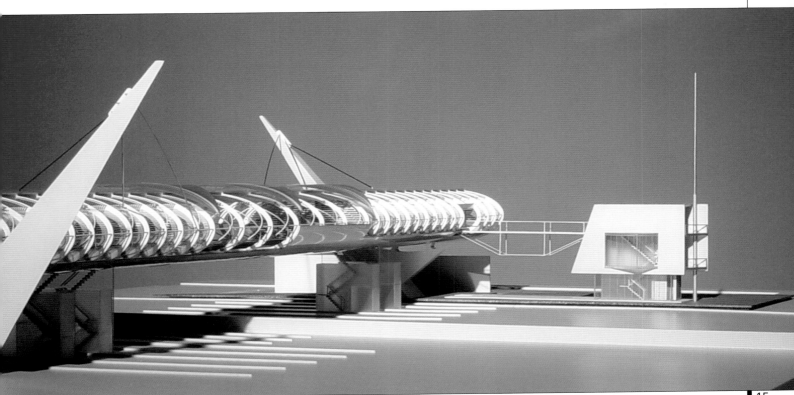

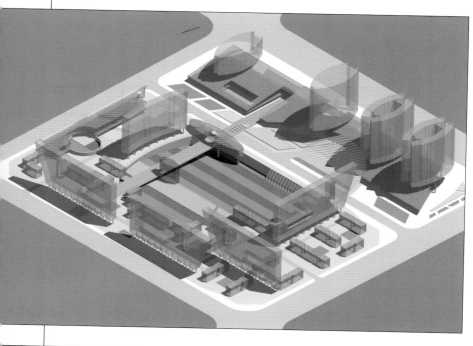

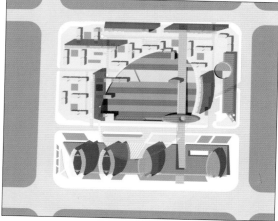

Top: *View of complex from northwest.*
Above: *View from southeast.*
Top right: *Street-level plan.*
Above right: *Site plan.*

The oval shape of the project's central garden unifies the two city blocks comprising the site. The series of landscapes and water gardens in the oval slope gently toward the south, maximizing sun exposure and providing lower-level access to the retail-commercial buildings. At the south edge of the oval a linear community building accommodates public functions and serves as a buffer between residential and commercial functions.

Housing and commercial structures have been arrayed around the oval to maintain and enhance the street edges. Housing units are primarily four-to-six-floor walk-ups, with some taller slabs, all with single-loaded plans and no habitable rooms facing north. Office structures rise from a continuous base containing shops and cinemas.

Ayers/Saint/Gross, Inc.

800 Eye Street NW

Suite 600

Washington, DC 20001

202.628.1033

202.628.1034 (Fax)

www.asg-architects.com

Ayers/Saint/Gross, Inc.

Lexington College Town Study
University of Kentucky at Lexington

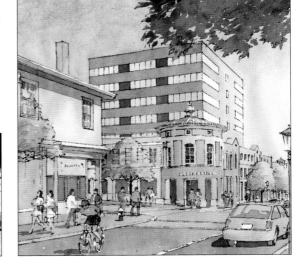

The master plan aims to restore older and historic buildings in the college town area and guide new developments in their response to surrounding architectural character. The plan also attempts to improve pedestrian safety, promote transit, cultivate owner-occupied residences, and sets a high standard for the public realm within the district. The College Town design team combined Ayers/Saint/Gross with three distinguished consultants, supporting the effort with traffic, residential, and retail analyses. Traffic engineers Martin/Alexiou/Bryson concurrently worked on a University of Kentucky master plan and conducted traffic and parking surveys of the collage town area. They addressed micro and macro issues such as changing one-way streets to two-way and the completion of ongoing transportation infrastructure improvements. Zimmerman/Volk Associates examined the residential market and helped to determine price points for new housing that the district can support. ZHA analyzed retail development and made recommendations on the type and scale of retail likely to succeed in the College Town. The regional context was researched, successful commercial centers in Lexington were examined, and local residents and officials were interviewed, enabling the team to understand how the district functions within the larger Lexington area.

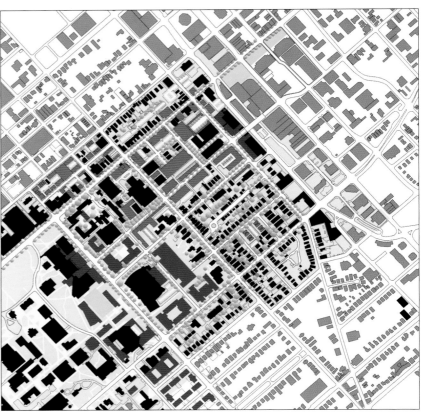

Above: *Master plan at full build-out; study area tinted green, existing buildings in black, new buildings in red. Drawing frame represents one square mile surrounding the study area.*

Right and below: *Vacant corner developed as a meeting place at the edge of campus.*
Below left: *Other potential street scenes.*

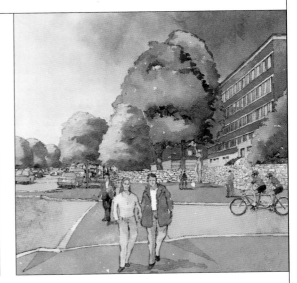

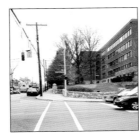

Right: *Air rights above an existing transit center are developed for a university professional development center, creating a gateway to the campus.*

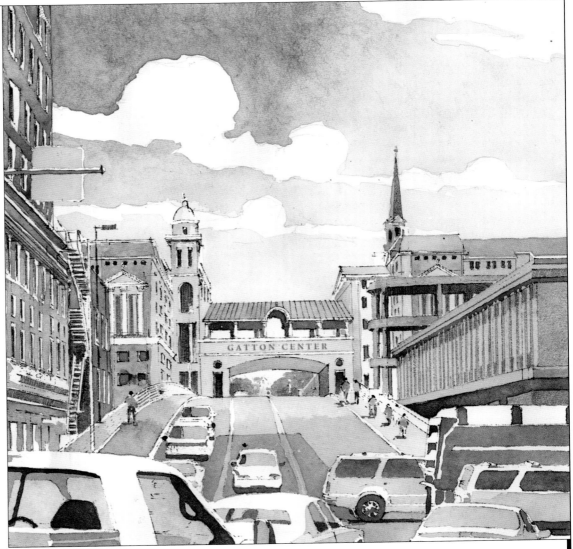

GATTON CENTER

Ayers/Saint/Gross, Inc.

J.J. Pickle Research Campus
University of Texas at Austin

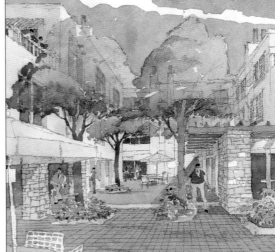

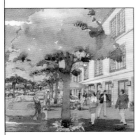 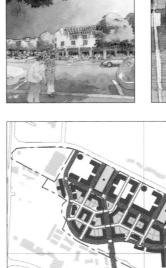

This research campus of the University of Texas comprises 382 acres of prime real estate in northwest Austin. In planning for development, priority has been given to open spaces. The Conceptual Framework Plan organizes streets and blocks to generate a hierarchy of spaces. Quads and streets have sizes and geometries that identify them as special places. Buildings gain identity by their locations on public open spaces and in turn helps to define those spaces. From natural stream valleys to formal quadrangles, spaces are designed to foster public interaction and private activity.

Residential blocks include intimate courtyards linked by pedestrian corridors. Thoroughfares are given an identity through landscaping and street trees. Open spaces, including playing fields, are directly accessible from workplaces and dwellings. The redevelopment will have the two essential features of successful pedestrian environments: an integrated mix of uses and a well-defined urban structure. The plan was developed in collaboration with Carter & Burgess.

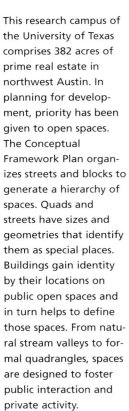

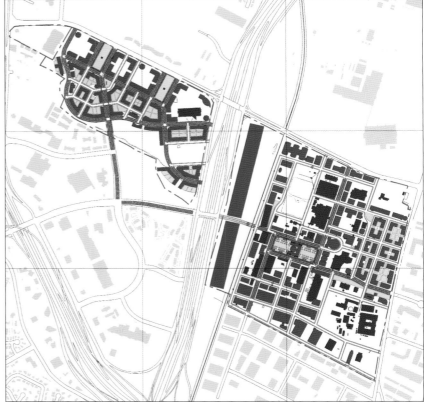

Above: *Master plan at full build-out; site boundary tinted tan, existing buildings in black, new buildings in red. The drawing frame represent one and a half square mile surrounding the study area.*

Right: A commercial
square along a major
arterial gives businesses
a desirable address
and creates destinations
associated with identifi-
able open spaces.

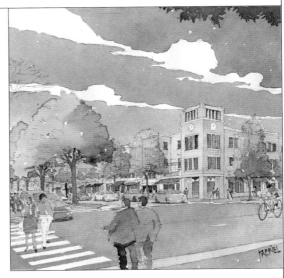

Above: Variety of vehic-
ular and pedestrian
routes.
Right: A figural vertical
element marks the
center of an open space.

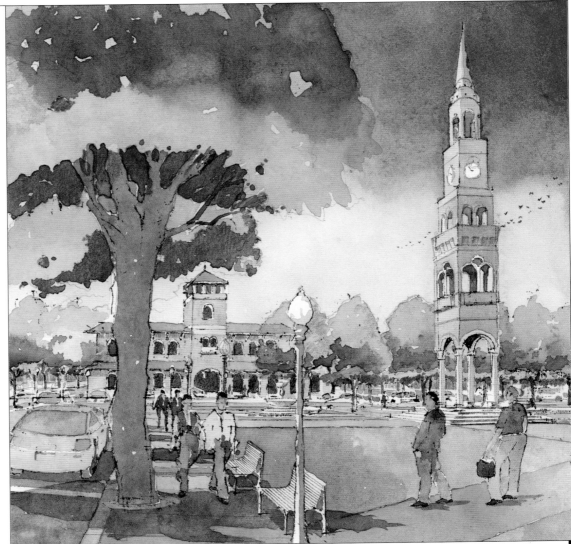

Ayers/Saint/Gross, Inc.

Beall's Hill
Master Plan, Architectural & Urban Design Guidelines
Macon, Georgia

 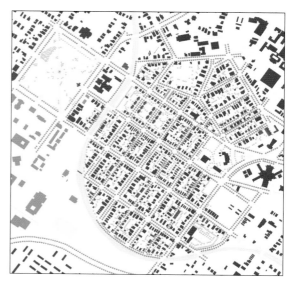

Beall's Hill is poised for re-birth, a renaissance awaits this neglected urban neighborhood. Its intrinsic beauty lies in the fact that it is approximately 100 acres and comfortably fits within a five-minute walking radius. The guidelines embody and strive to emulate the best urban design, architectural, `and landscape traditions evident in the city of Macon, the State of Georgia, and the country.

Right and below:
Before and after view of proposed development along a major street in the neighborhood.

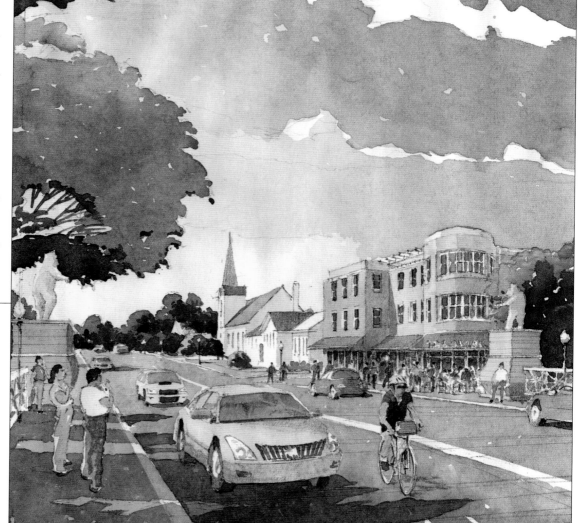

Ayers/Saint/Gross, Inc.

Notre Dame Avenue
Residential Guidelines
South Bend, Indiana

Architectural Guidelines for houses along Notre Dame Avenue are intended to aid in the design of new houses and fulfill the original vision of the avenue as a processional approach to the university. The guidelines deal with the appearance of each house and also suggest ways to improve the public realm along this corridor.

Right and below:
Suggested transformation of a dysfunctional intersection into a public amenity.

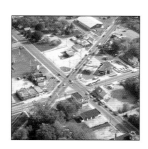

Ayers/Saint/Gross, Inc.

University of Maryland
College Park, Maryland

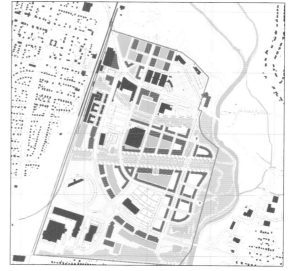

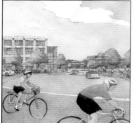

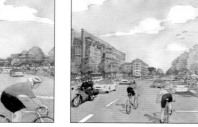

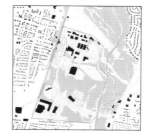

The University of Maryland presently controls a large portion of land in close proximity to the College Park Metrorail Station. The master plan complies with the Transit Development Overlay Zone guidelines, and proposes a development of balanced mix of uses in a vibrant, pedestrian-friendly setting focused around a safe and efficient multi-modal transportation system.

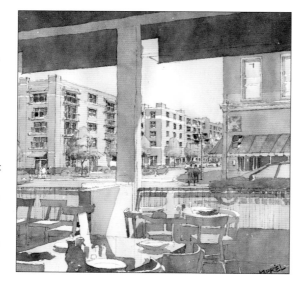

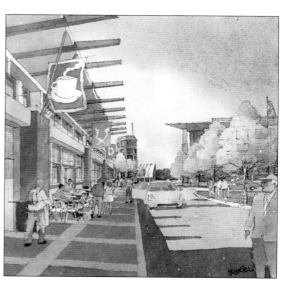

Images: *Process sketches to aid with the visualization of the Master Plan.*

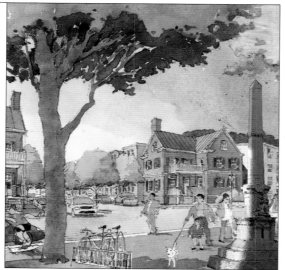

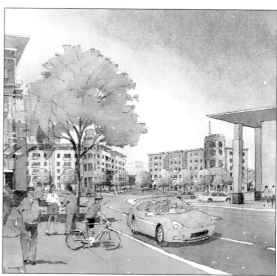

BAR Architects

1660 Bush Street
San Francisco
California 94109
415.441.4771
415.536.2323 (Fax)
www.bararch.com
info@bararch.com

BAR Architects

Santana Row
San Jose, California

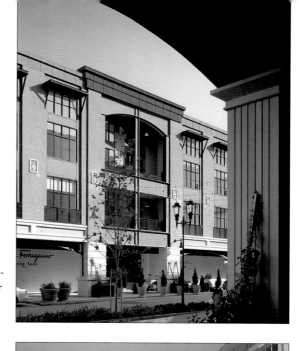

This unique mixed-use development is among the largest in the country and provides a new standard for urban living and shopping. The development replaces a rundown suburban shopping center with an urban neighborhood in the center of Silicon Valley that combines living, shopping, dining and working environments. Phase One, which opened in November 2002, is organized around Santana Row, a four-block long main street, and includes 258 residential units, 500,000 sf of retail, 30,000 sf of offices, and above and below-grade parking. Future plans include a 213 room hotel, 150,000 sf of additional retail, a cinema complex and 942 residential units.

BAR Architects designed four buildings in Phase One. Two arcaded loft and retail buildings, The DeForest and The Margo, face each other on Santana Row and are modeled on turn-of-the-century industrial structures. Their block-long facades are broken to create an urban pedestrian scale. The arcaded ground floors of both structures recall historic shopping venues. Above are 200 loft units, most with 20-foot ceilings and large windows facing Santana Row or with views of the mountains. A third building, The Villa Cornet, symmetrically addresses the street with corner tower elements. Above two levels of retail are 21 luxury townhouses that range in

size from 2,300 to 3,200 square feet. The fourth building, The Park Valencia, accommodates restaurants and retail on the ground level with offices and retail as anticipated uses for the upper floors. It also houses the central mechanical plant for the entire Santana Row development.

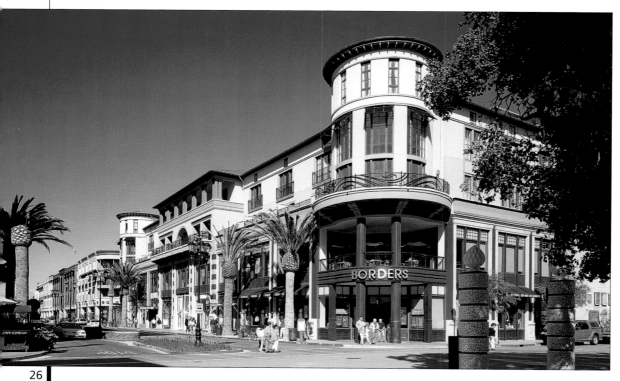

Above right: *Margo building seen from DeForest arcade.*
Right: *The DeForest block seen from Santana Row.*

Left: *Villa Cornet block.*
Facing page: *Central entrance of The DeForest façade, which is reminiscent of 19th century offices & factories. Entry façade icon is a tribute to radio pioneer Lee DeForest.*
Photography: *Doug Dun, BAR Architects.*

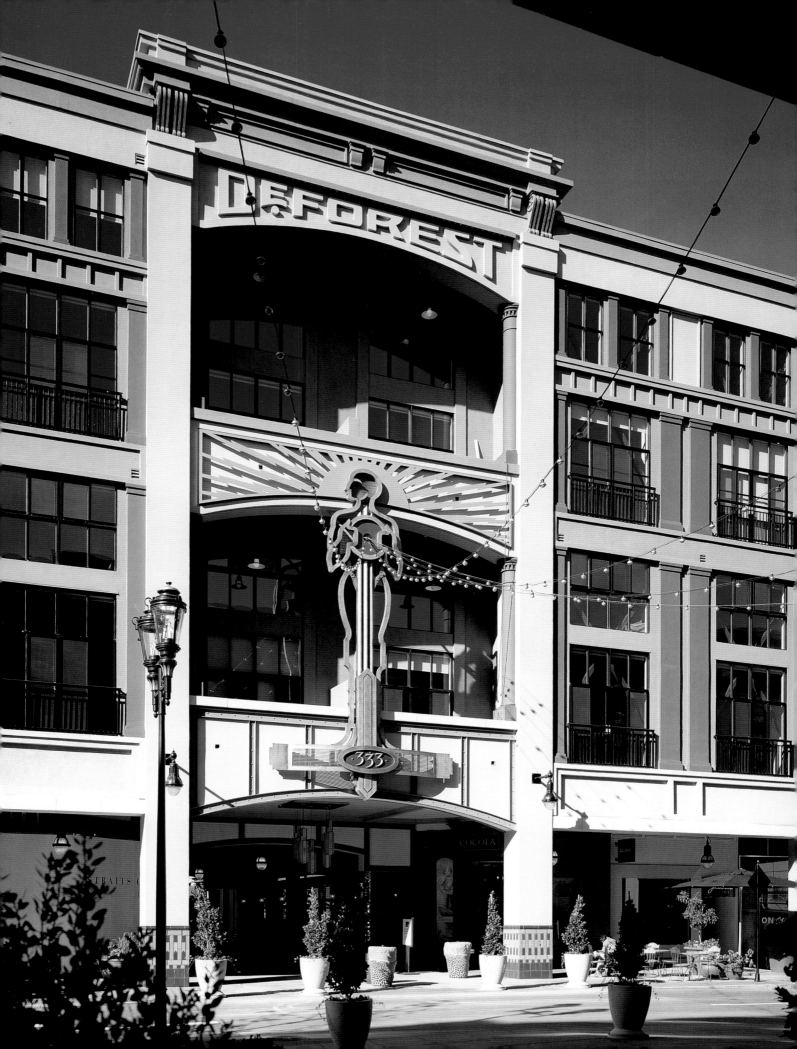

BAR Architects

Avalon Towers on the Peninsula
Mountain View, California

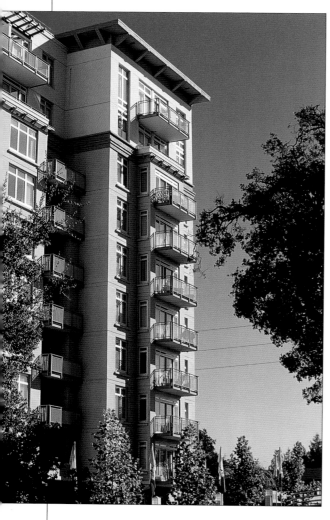

Avalon Towers on the Peninsula, with 211 luxury units in two 11-story towers, represents a successful example of high-density housing that is both complementary to the adjacent commercial office buildings and to the surrounding suburban neighborhoods. The first high-rise apartment community to be built south of San Francisco in nearly forty years, the twin apartment towers are key parts of a four-building mixed-use development. The transit-oriented complex takes advantage of proximity to regional train and bus transit as well as shared parking. Conceived as an "urban resort", the towers' curved roofs, terraces, and decks create a residential complex which establishes itself as a clearly identifiable community that is complementary yet distinctive from the nearby commercial towers. The contemporary design reflects the modern and progressive nature of the Silicon Valley in a timeless and elegant style. Sited to take maximum advantage of the views to the surrounding hills and bay, the twin towers house 211 one and two-bedroom luxury apartments and provide a density of 105.5 units per acre. The floor plate has an efficiency of over 87%. Each tower is entered through a two-story lobby accessed from a central landscaped plaza. The plaza also provides all community amenities, including a swimming pool, spa, health club and management offices for the entire development.

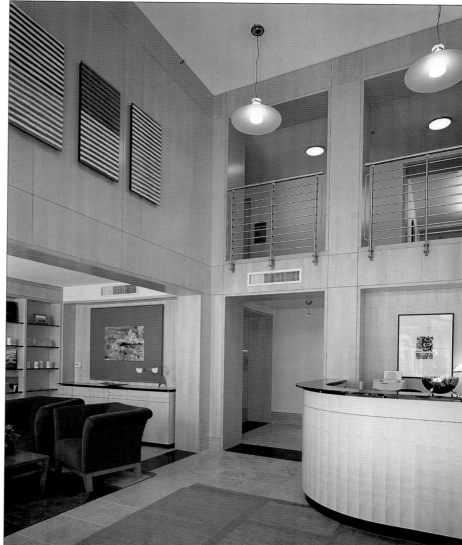

Facing page, left: Tall windows and balconies take advantage of views to hills and bay.
Below left: Two-story apartment lobby and concierge.
Right: Partial view of towers.
Photography: Doug Dun, BAR Architects.

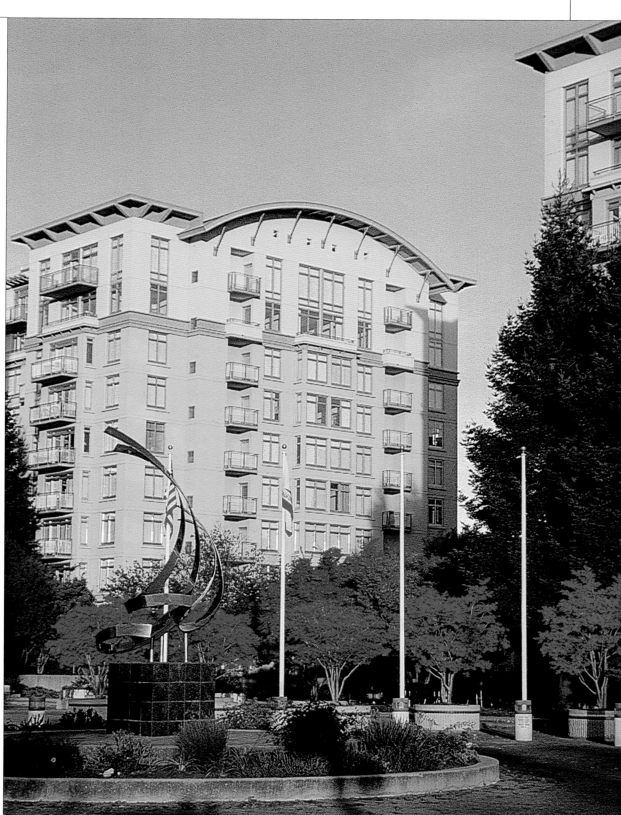

BAR Architects

Paseo Plaza
San Jose, California

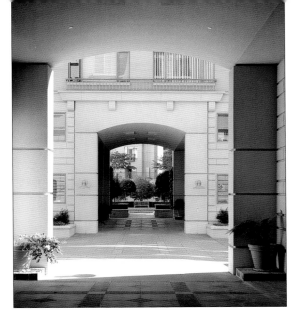

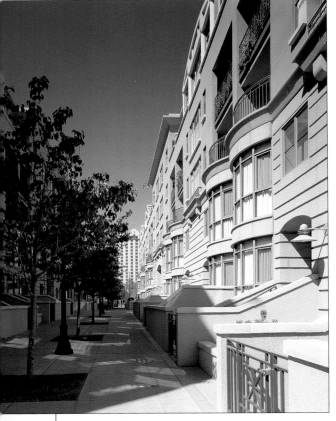

Left: Facades along pedestrian paseo.
Below: Retail under flats and townhouses, which are entered from landscaped terrace on opposite side.
Above right: Passage between internal courtyards.
Facing page:
Townhouse stoops along major street.
Photography: Doug Dun, BAR Architects.

This urban infill housing complex exemplifies the San Jose Redevelopment Agency's goal to create high-density, pedestrian-friendly housing downtown. Located adjacent to light-rail and regional bus transit lines, the five building complex provides 209 condominium flats and townhouses and 10,000 sf of retail. Building heights vary from five to six stories and include a mix of three and four levels of flats above ground level, two-story townhouses. The townhouses are designed with private entrance stoops, planting areas and private terraces. These first two floors are articulated with a deeply rusticated "base," while the middle and top of the building utilize contrasting color and materials. The two-story townhouse facades, street-side stoops and unit entries provide direct access from the street and help create a highly activated street. Secure access is also provided from the subterranean parking garage directly to the units. The two pedestrian connections through the site

creates a link from San Jose State University to the east and downtown to the west. The southern paseo has flats and townhouses above retail and the northern paseo is a semi-public area of townhouses with front stoops. The buildings' configuration forms two private courtyards. The larger (southern) court comprises three distinct areas: a pool and amenities, a lawn terrace and a formal garden. A smaller courtyard to the north is landscaped as an intimate garden. The two interior courtyards are linked by a vaulted galleria through the north and south buildings providing a visual and pedestrian connection between these open spaces. Parking, mailboxes and tenant storage lockers are located a half level underground.

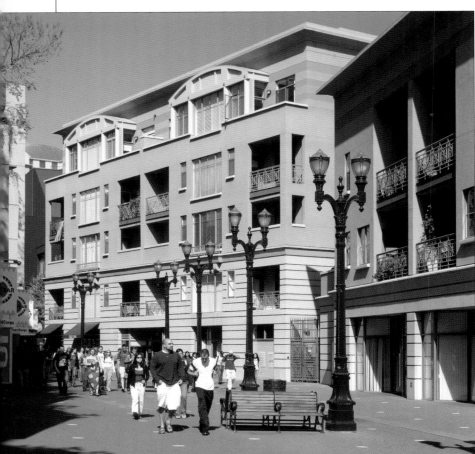

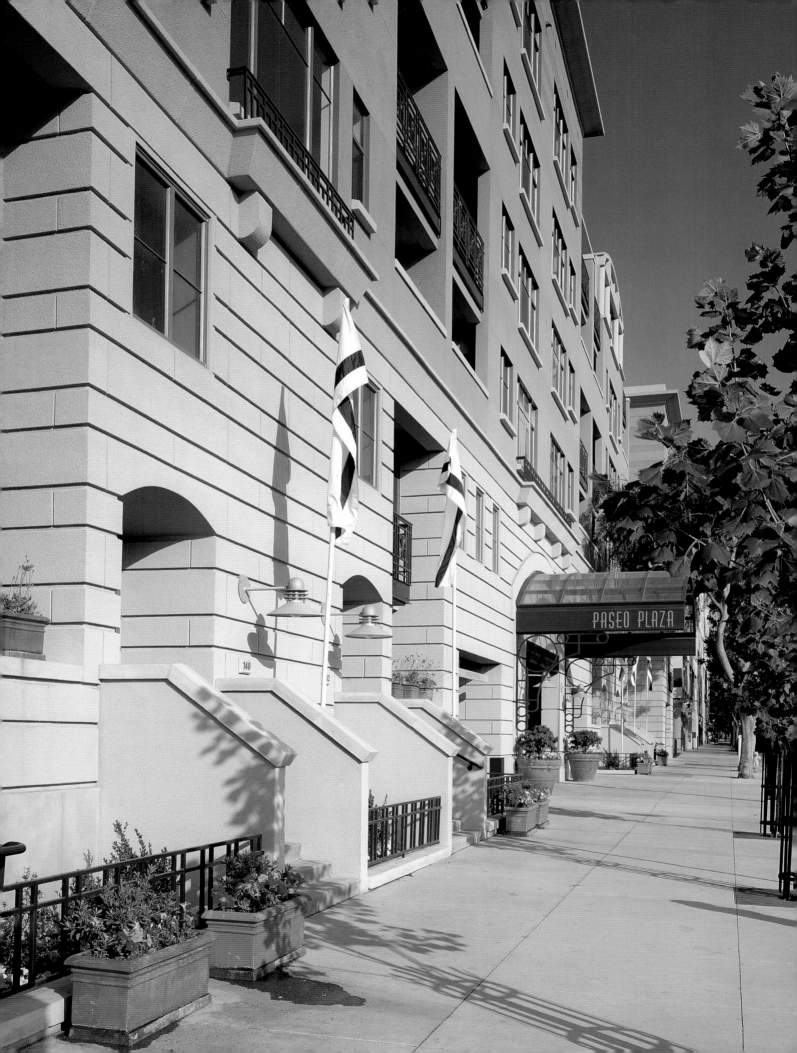

BAR Architects

Sun City Tower, Kobe Senior Living Complex
Tokyo, Japan

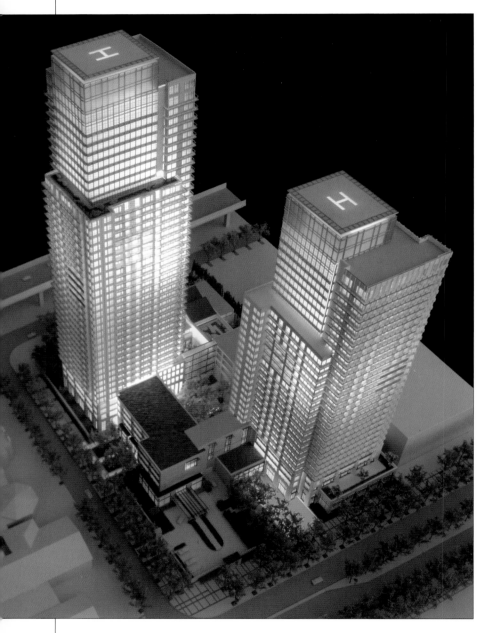

The Sun City Tower, Kobe, recently designed by BAR Architects, is estimated to be the largest urban senior housing project in the world. The 850,000 sf complex consists of 730 independent living units in 42-story and 32-story towers, with an additional 200 skilled nursing units. Units range in size from 425 sf to 925 sf. The two towers are located at opposite corners of the site to provide unobstructed views. Although identical in plan, the towers are rotated 90 degrees relative to each other to present unique facades on all four sides of the project and to provide a variety of views for every unit. To further differentiate unit types, the larger "penthouse units" have been placed at the upper third of each tower. Another of the distinguishing features of the project is the intensity and arrangement of 12 gardens on four levels which offers residents an intimate garden experience despite being in a major international city. Additional amenities include a large porte cochere with valet car service, reception, lobby lounge, library, a performing arts hall and two restaurants. Two ofuros (communal hot tubs) and spas, fitness and aquatic facilities complete the complex. Parking is located below grade.

Above: *Aerial view of model looking down into garden courtyards.*
Right: *Photomontage model/site looking from principal intersection toward Kobe Mountains.*
Photography: *Doug Dun, BAR Architects.*

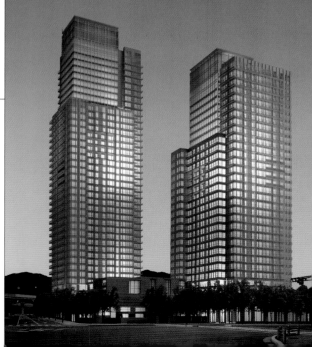

Beeler Guest Owens Architects, L.P.

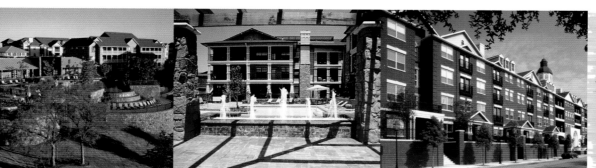 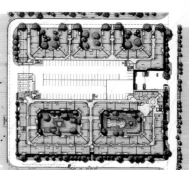

4245 North Central Expressway

Suite 300

Dallas

Texas 75205

214.520.8878

214.520.8879 (Fax)

www.bgoarchitects.com

bgoarch@bgoarchitects.com

Beeler Guest Owens
Architects

Austin Ranch
The Colony, Texas

The most distinctive feature of Austin Ranch is its exemplary Texas terrain, comprising 1900 acres with several natural lakes and hundreds of old oaks preserved through environmentally sensitive planning. The Ranch will comprise residential, retail, and commercial properties. The initial residential portion occupies 24.4 acres and includes 548 dwelling units. To make traditional neighborhood planning of the project possible, the municipality amended its requirements for setbacks, street widths, and landscape design. The Lodge, at the heart of the development, rises at the edge of Lake Connell with its 3.5-acre park and commands a long view across a nature preserve. Smaller parks are located within the residential area. The 4,000-square-foot Ranch House Conference Center accommodates retreats, seminars, and community social events. The development's buildings incorporate materials indigenous to Texas, such as limestone, red granite, and traditional brick.

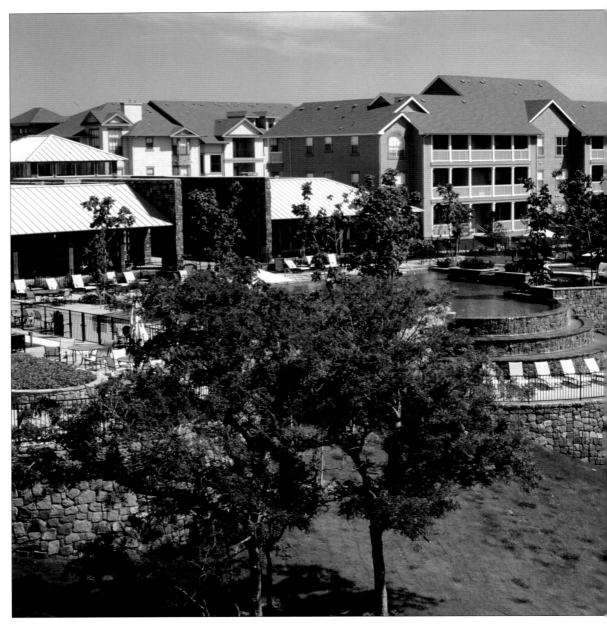

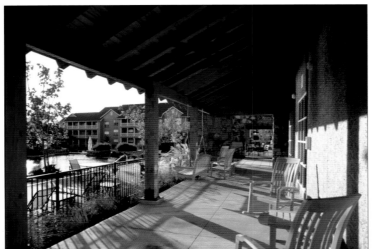

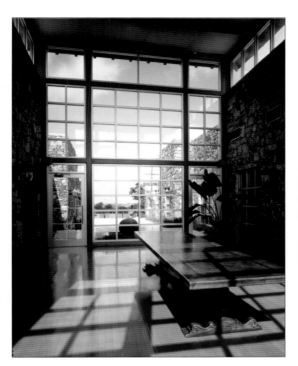

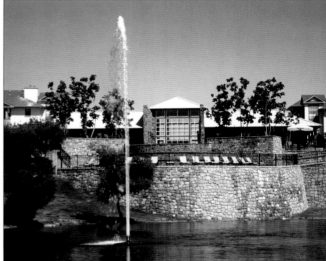

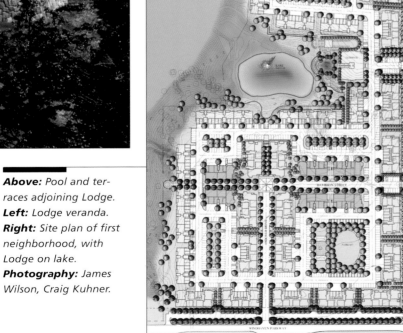

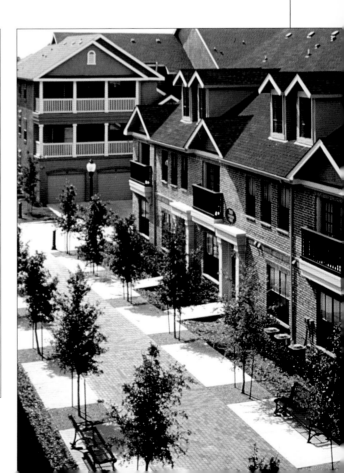

Beeler Guest Owens Architects

Eastbridge
Dallas, Texas

The development is tucked into an existing area of bungalow homes, with local shopping, dining, and nightlife. The design concept fits into this neighborhood as an integral part, not an afterthought, notably by aligning the plan with existing streets and reinterpreting the Arts and Crafts aesthetic seen throughout the area. Exteriors combine stucco, brick, stone veneer, and shingle panels, with the bracketed eaves, unusual mullion patterns, and prominent chimneys which are characteristic of Craftsman design. Since adequate parking was essential, parallel parking niches were incorporated into the brick-paved streets and a bi-level garage included to accommodate residents and visitors. The development has succeeded in appealing to a young, high-income target group that appreciates the historical atmosphere of the area and the cosmopolitan shopping and dining opportunities nearby. Eastbridge was entirely leased before receiving its final certificate of occupancy, at about 10 percent above budgeted rents.

Left: Building entrance with Arts and Crafts characteristics.
Right: Tiered balconies overlooking pool court.
Below right: Another variety of residential entrance.
Below, far right: Detail view of pool-court trellis.
Photography: James Wilson.

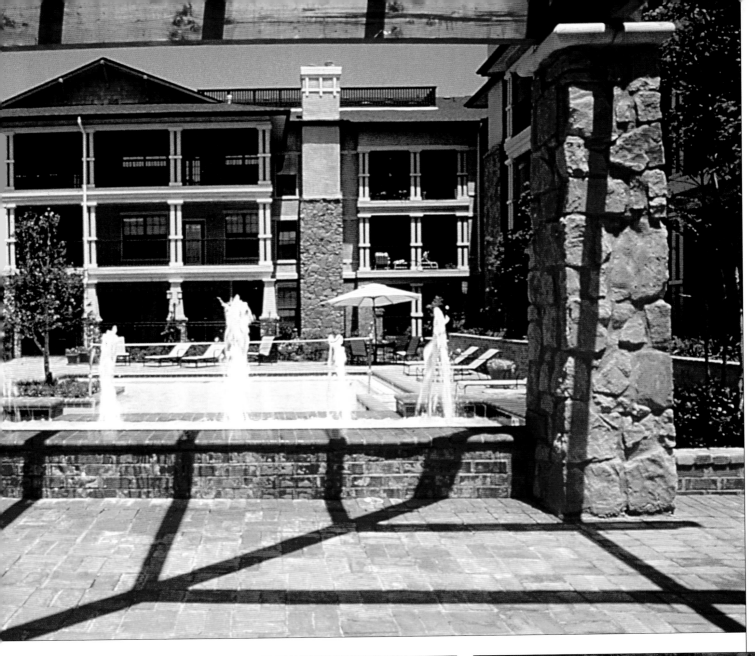

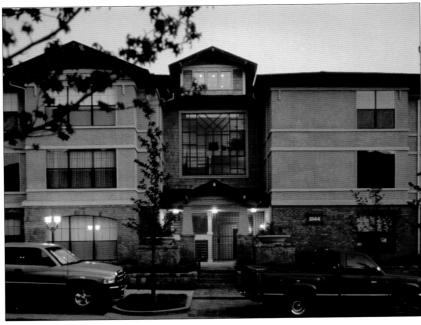

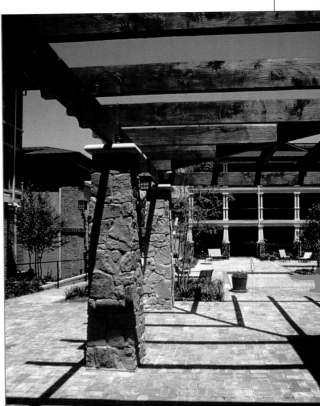

Beeler Guest Owens
Architects

2400 McCue
Houston, Texas

This 200-unit single-building residence is less than one block from Houston's Galleria complex, which offers ample retail and entertainment opportunities within walking distance. The target market includes high-income professionals working in the area, which has an employment base exceeding 100,000 within a short drive. Because of high land costs, maximum density and wood-frame construction were required. A 60-foot height restriction dictated four residential floors above a parking garage situated a half level below grade. The symmetrical structure surrounds a two-part courtyard, with ornamental pools and lush landscaping at one end and a swimming pool at the other. Brick is used on the exterior, with stucco tinted to match the brick color facing the courtyard. Cast stone accents appear throughout. The density is 73 units per acre.

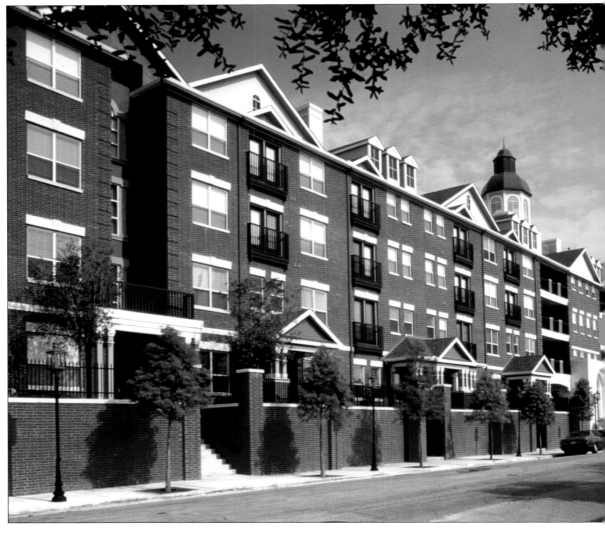

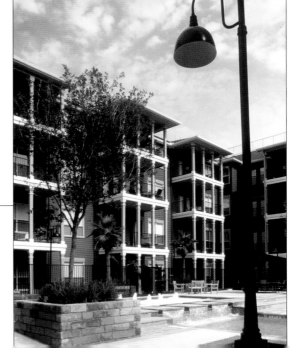

Above: Garden end of central court.
Right: Swimming pool end of court.

38

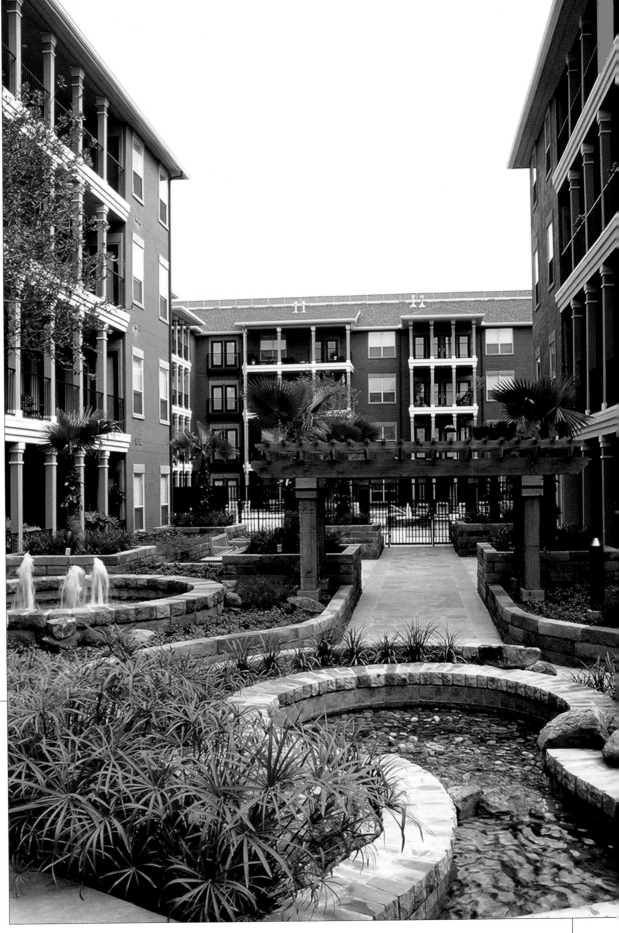

Above: Street front, with arch and cupola marking entrance on central axis.
Right: Ornamental pool and planting in central court, looking toward swimming pool court at far end.
Photography: Mark Scheyer, Inc.

Beeler Guest Owens Architects

The Highlands of Lombard
Lombard, Illinois

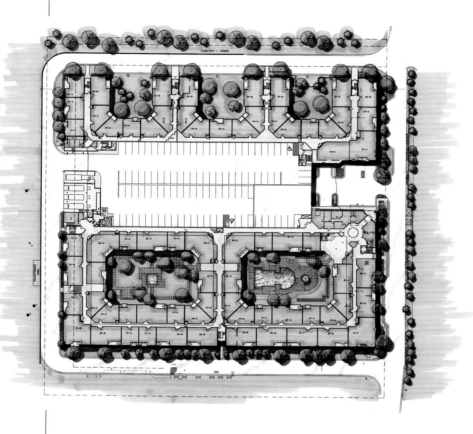

Left: Site plan, with top deck of parking structure in center.
Below: Façade suggesting a series of smaller linked buildings.

An urban infill site in the Chicago suburbs is the setting for this dense development, with 403 units on 5 acres. Since the terrain slopes 50 feet diagonally across the site, a unique combination of entries, stairs, and elevators was required to access all levels of the building. To minimize the impact of the large-scale project on the neighborhood, its outer facades are divided to resemble a series of separate buildings, varied in materials, fenestration, and roof configuration. Berms and plantings along the street fronts also respond to neighborhood concerns. A 7-level precast parking structure is located in the center of the complex, which is otherwise framed in light-gauge structural metal studs. The density is 81 units per acre.

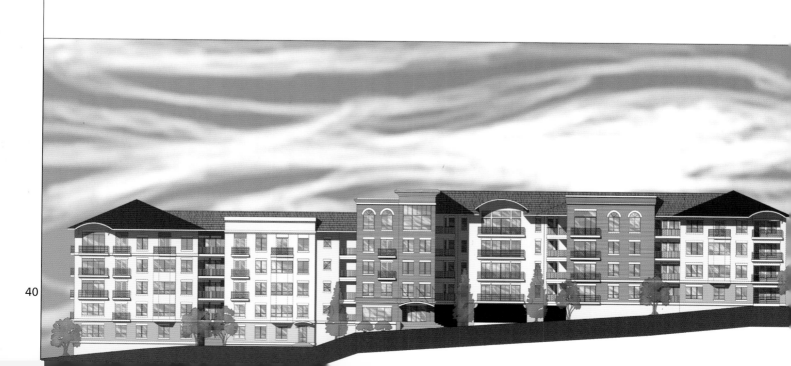

Brookwood Group

1819 Peachtree Road, NE

Suite 201

Atlanta

Georgia 30309

404.350.9988

404.351.6153 (Fax)

www.brookwoodgroup.com

Brookwood Group

Georgia Tech's Satellite Campus
Savannah, Georgia

A new academic and research campus will eventually occupy 47 acres of a 150-acre business center development of the Savannah Economic Development Authority. Financed by The University Financing Foundation ("TUFF") the new campus will allow southeast Georgia students to earn Georgia Tech degrees without leaving the area. The business center, located along I-95 near the Savannah Airport, is laid out in a circle around small lakes in the central area, with the academic campus overlooking the lakes. The campus is designed to present a distinctive public image along the circular access roadway, with a more naturalistic, pedestrian-oriented treatment toward the interior of the circle. Brookwood carried out development management services as well as the planning and design, employing the Bridging method of contracting for the construction. Expected to join Georgia Tech in the complex are the Georgia Tech Economic Development Institute and the Savannah Advanced Technology Development Center.

Above: Campus sides of initial campus buildings.
Left and right: Other campus views.
Below right: Entire business center.

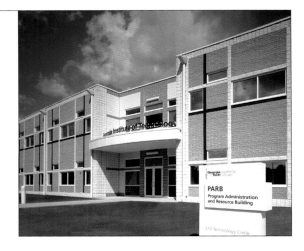

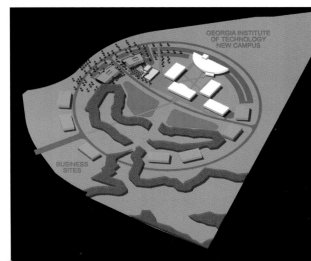

Brookwood Group

The Wakefield
Atlanta, Georgia

Above: Details in brick and cast stone.
Right: Tower rising amid mature trees.

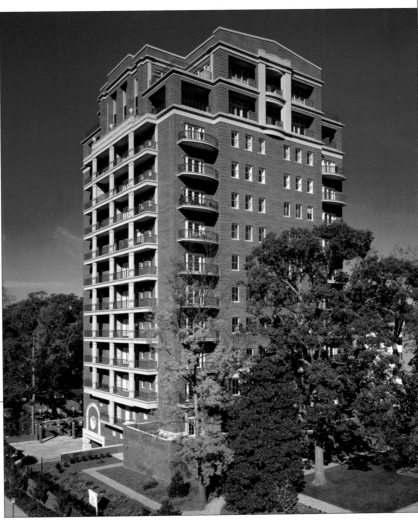

This luxury cooperative tower was developed without variance from the pre-existing zoning requirements for this high quality residential area. The building was designed to harmonize with the 1920 brick architecture prevailing in the Buckhead district, including the distinguished houses designed by the 20th century architects Neel Reid and Phillip Schutze. The brick and cast stone exterior recalls Georgian Revival precedents in its massing and details. The site was developed to preserve existing trees, and an Italian-French garden was developed at the front of the site. Brookwood provided development management services as well as design services, employing the Bridging method of contracting for the construction. The Wakefield Development company, a sister company to Brookwood Group, pre-sold 60 percent of the units prior to construction loan closing, at an average price of $1.4 million in shell form.

Brookwood Group

Morehouse College Master Plan
Atlanta, Georgia

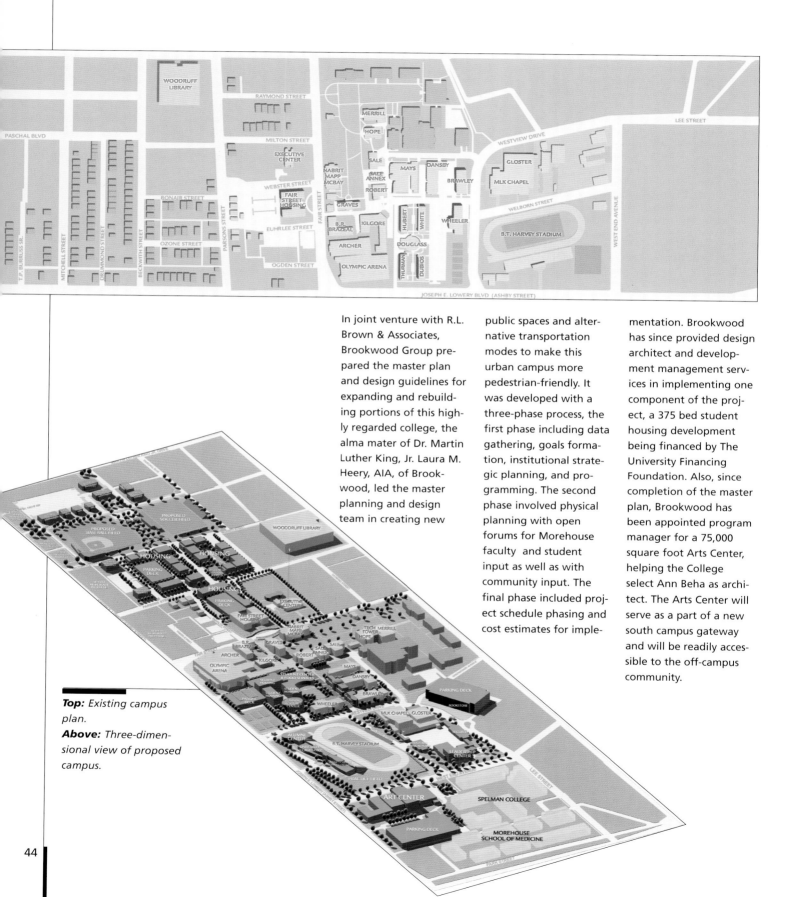

In joint venture with R.L. Brown & Associates, Brookwood Group prepared the master plan and design guidelines for expanding and rebuilding portions of this highly regarded college, the alma mater of Dr. Martin Luther King, Jr. Laura M. Heery, AIA, of Brookwood, led the master planning and design team in creating new public spaces and alternative transportation modes to make this urban campus more pedestrian-friendly. It was developed with a three-phase process, the first phase including data gathering, goals formation, institutional strategic planning, and programming. The second phase involved physical planning with open forums for Morehouse faculty and student input as well as with community input. The final phase included project schedule phasing and cost estimates for implementation. Brookwood has since provided design architect and development management services in implementing one component of the project, a 375 bed student housing development being financed by The University Financing Foundation. Also, since completion of the master plan, Brookwood has been appointed program manager for a 75,000 square foot Arts Center, helping the College select Ann Beha as architect. The Arts Center will serve as a part of a new south campus gateway and will be readily accessible to the off-campus community.

Top: Existing campus plan.
Above: Three-dimensional view of proposed campus.

Brookwood Group

Lakeside Commons II
Atlanta, Georgia

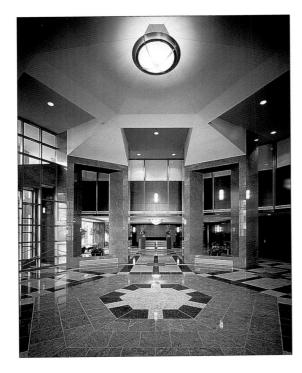

The location and configuration of this 539,000-square-foot office building and parking deck had to relate effectively to an existing office building and to the lake that is a prime amenity for both structures. The design solution involved developing a corner entrance for the new building, which is entered from a drop-off drive between the two buildings. The exterior wall treatment for the new structure creates an implied tower element above the entrance, which is distinguished from the plainer volumes adjoining it. The placement of the building allows generous lake views from offices along two of its facades. Brookwood served as designer and archiect of record with Kendall Heaton, of Houston, as its associate preparing the contract documents and assisting in the construction administration. Brookwood Group Inc. provides planning design, development management and program management services. Its staff consists of architects, planners, project managers, financial analysts, engineers and construction managers.

Above: *New building with corner entrance, seen from lakeside deck.*
Above left: *Lobby of new building.*

Brookwood Group

Proposed Peachtree Corridor Re-Construction Atlanta, Georgia

Commissioned by the Buckhead Community Improvement District, the project is a Smart Growth initiative. Objectives are to improve traffic circulation and safety, enhance the pedestrian environment, and improve mobility along Peachtree Road through the Buckhead commercial core. The area covered consists of 1.7 miles along Atlanta's signature thoroughfare, through one of the region's most vital centers of residential, office, hospitality, retail, and entertainment activity. The concept design includes landscaped buffers for sidewalks, boldly marked, accessible crosswalks, a landscaped median in the roadway, distinctive street furniture, bike lanes and storage facilities, enhanced signage, and transit stops. Planning and design team leader, Laura M. Heery, AIA, also included new pocket parks and larger green spaces to promote pedestrian activity, stimulate mixed use development, and enhance the experience of traveling along the corridor. One of the goals is increased use of the Buckhead MARTA transit station, now the least used in the entire system because pedestrian access to and from the area's destinations is difficult and hazardous. A proposed system of shuttle buses will link the station to workplaces, restaurants, retail areas, and entertainment venues. The project involves getting commitments of federal, state, and city funding for improvements and persuading some property owners to donate rights of way for this community improvement. Brookwood led a collaborative project team that included URS, HGOR and CommonArts. In addition to leading the planning and design work, Brookwood provided pre-construction program management services.

Below left: *Envisioned new construction along corridor.*
Bottom left: *Peachtree Road with bicycle lane, landscaping at curb, and central median.*
Below and bottom: *Intersection before and after proposed improvements.*

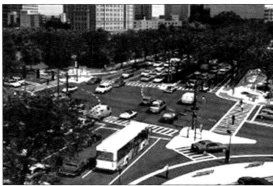

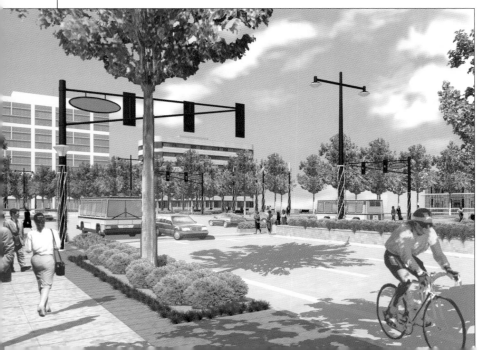

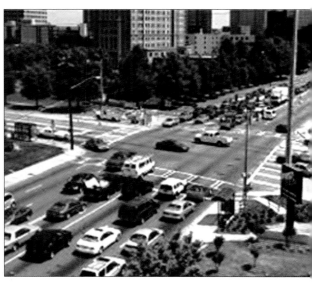

Right: *Brookwood Group's schematic design for the proposed Peachtree Corridor re-construction showing main landmarks and transit station.*

Phipps Plaza

Proposed Park

Lenox Square Mall

MARTA Buckhead Station

GEORGIA 400

Turner Techwood Campus
Master Plan & Architectural Concept
Atlanta, Georgia

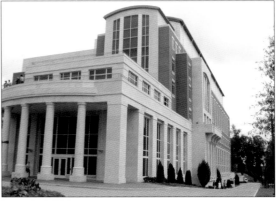

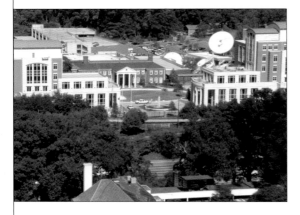

Having provided strategic real estate and facility planning services for all of the Turner Broadcasting System's Atlanta area real estate and facilities, Brookwood was then engaged to develop a master plan and architectural design concept for the Turner Broadcasting Entertainment Division's major campus expansion. TBS is a division of Time Warner. Located alongside

Georgia Tech's campus near downtown Atlanta, the $95-million complex has the collegiate character desired by TBS management while accommodating below-grade parking, high-tech facilities, and a large satellite dish field. Phase 1 construction, completed in 2002, consisted of 350,000 feet in Buildings A and B, plus 1,000 parking spaces, and was implemented by KPS

Architects. Additional buildings are also being constructed according to the master plan.

Top left: *Model, portion of campus with entrance on Techwood Drive.*
Top right: *New B Building.*
Above: *Construction to date.*
Right: *New campus open space.*
Far right: *Campus master plan.*

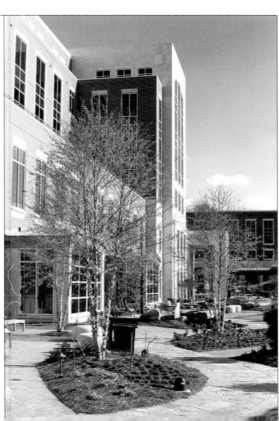

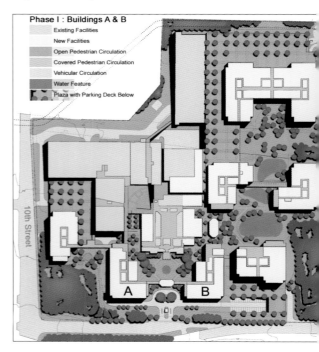

Phase I : Buildings A & B

Existing Facilities
New Facilities
Open Pedestrian Circulation
Covered Pedestrian Circulation
Vehicular Circulation
Water Feature
Plaza with Parking Deck Below

10th Street

A B

Centerbrook

67 Main Street

Post Office Box 955

Centerbrook

Connecticut 06409

860.767.0175

860.767.8719 (Fax)

Lastname@centerbrook.com

www.centerbrook.com

Centerbrook

Phelps Science Center
Phillips Exeter Academy
Exeter, New Hampshire

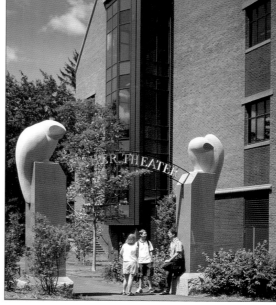

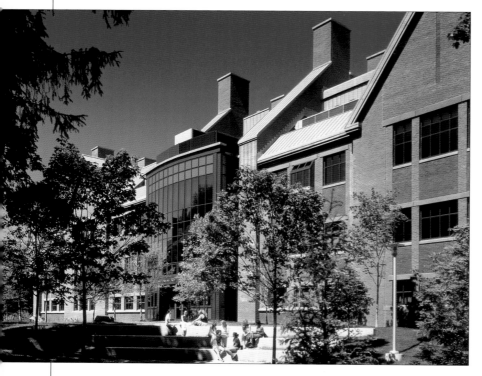

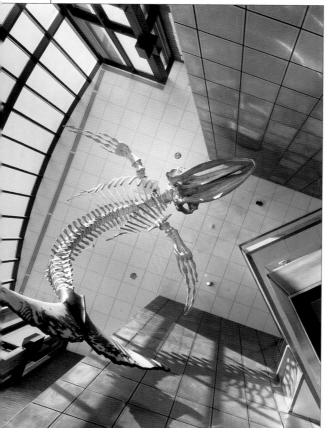

Left: *Lobby, with hanging whale skeleton.*
Above: *Façade overlooking amphitheater and wetlands study area.*
Above right: *Traditional campus space bounded by new building.*
Top right: *Theater gate adjoining science center.*
Facing page: *Entrance, with lobby atrium inside.*
Photography: *Jeff Goldberg/Esto.*

Built to accommodate a participatory teaching approach, as well as expanded capabilities, the 81,000-square-foot center also enhances the campus plan. Its long rectangular form helps define a campus street on one side and a wetlands study area on the other. Brick walls, pitched roofs, and stacks in the form of chimneys acknowledge the prevailing architecture of this 200-year-old campus. A central three-story lobby atrium stresses the symmetry typical of surrounding buildings. This skylighted space contains central stairs, a student lounge, a seawater aquarium, and the skeleton of a whale recovered by students from a Maine beach. Classrooms for each science discipline surround a glass-walled common lab where activities are visible to passersby. Every classroom is equipped with the latest in information technology; conference and meeting rooms are equipped for teleconferencing, as well. The flat-floored auditorium can be configured for a variety of events and holds up to 300 people. The project's secondary contribution to the campus is a streetfront gateway to the Fisher Theater, located down a walkway that skirts the wetlands.

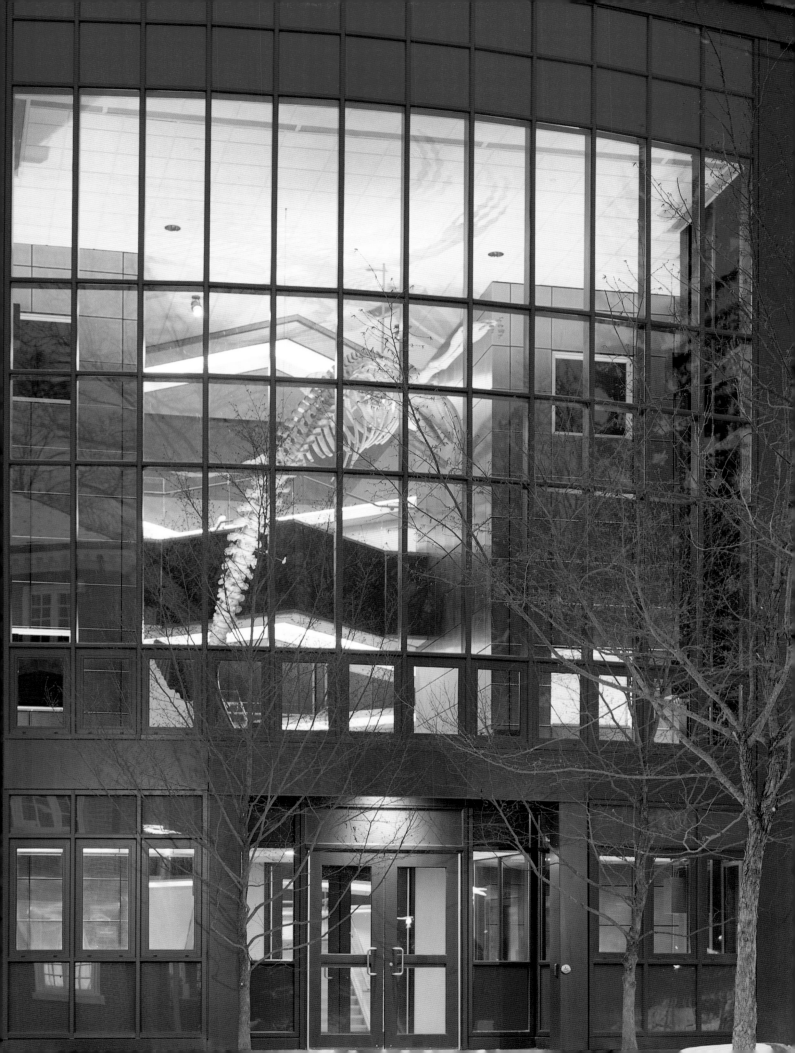

Centerbrook

Church House for
United Church of Christ World Headquarters
Cleveland, Ohio

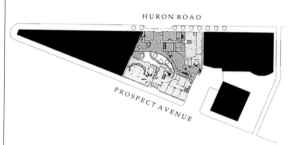

When the church moved its headquarters from New York to Cleveland, it decided to pattern the new complex after early Christian church houses, where worship was joined with hospitality for sojourners. With the church administration occupying a turn-of-the-century downtown office building, the architects were commissioned to design an hotel, meeting house, and chapel. These facilities are integrated into the lower floors of the old building and the first floor of the new hotel structure, surrounding a new mid-block garden. The interior has a fluid layout along a curving corridor, with garden views from the church and hotel lobbies and the meeting house. The chapel floats in the middle of an exhibition hall in the old building, with glass walls on both the street and the garden sides. The worship space is defined by a sculpted oval ceiling, lighted by dichroic prisms, which suggests both the joy of faith and the sorrow of Christ's crown of thorns.

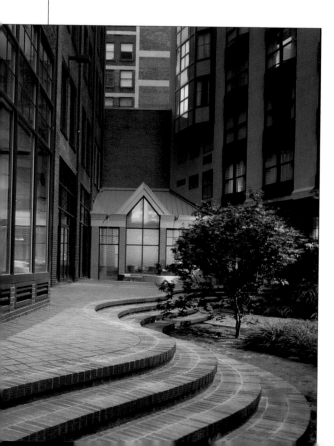

Top left: *Schematic rendering of complex.*
Above left: *Site plan.*
Above: *Chapel.*
Left: *Mid-block garden.*
Right: *Garden fountain, chapel visible through glass at left.*
Photography: *Jeff Goldberg/Esto.*

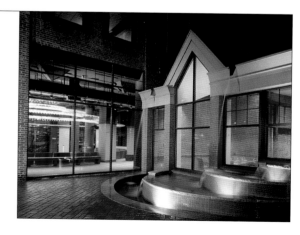

Centerbrook

Yale Child Study Center
New Haven, Connecticut

The world's leading institution for the study of children's psychology and development, the study center found limited locations for the new offices and meeting rooms it needed on the crowded medical school campus. The architects devised an octagonal addition that fits between the ends of two existing wings – thus blocking no views. The site had been a city street, with underground utilities still in use, hence the building's tall crown to house mechanical equipment that wouldn't fit below it. The building's form makes it an identifiable entrance to the study center. A second-floor auditorium opens to a porch overlooking a new play area developed at one end of the medical school courtyard.

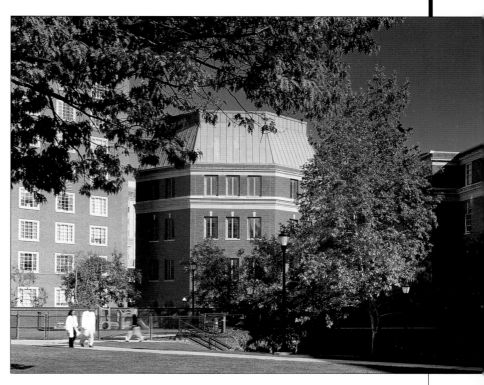

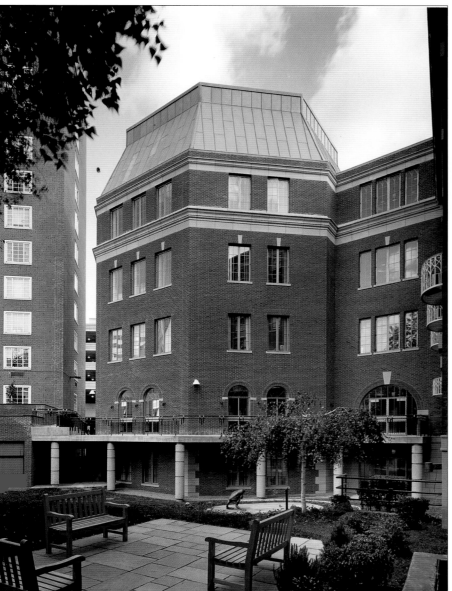

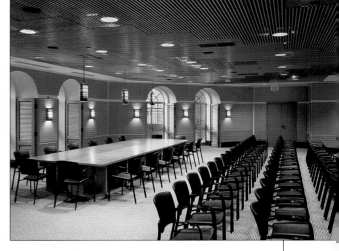

Left: Octagonal addition with auditorium porch overlooking play area.
Top: Addition seen from medical school courtyard.
Above: Auditorium.
Right: Fountain in play area.
Photography: Jeff Goldberg/Esto; Mark Simon (right).

Pfizer, Incorporated
Groton, Connecticut

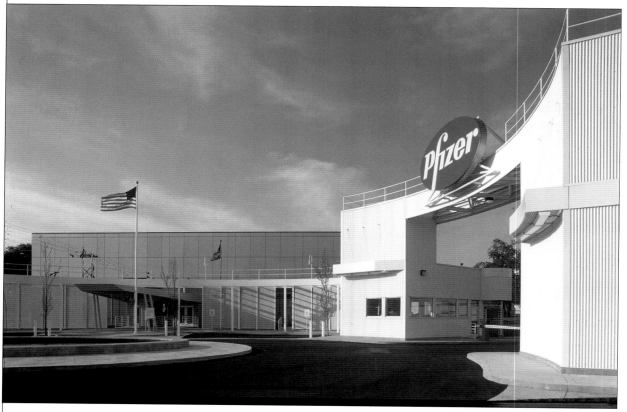

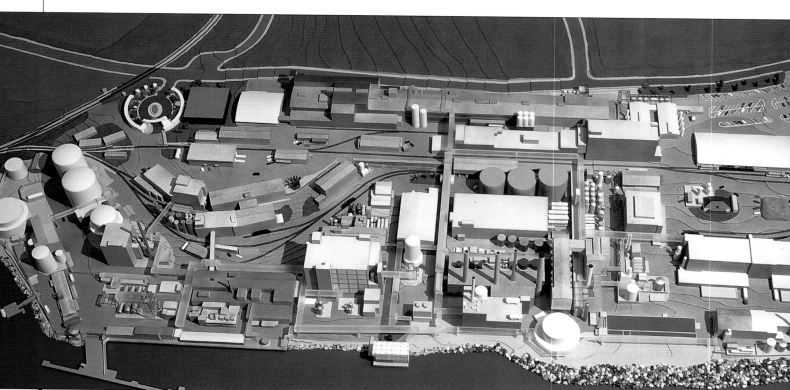

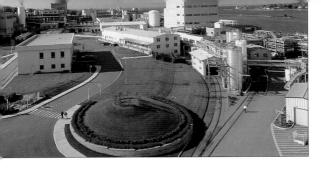

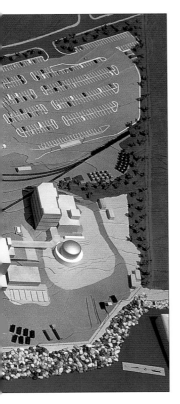

By 1989, the Pfizer chemical and pharmaceutical plant along the Thames River had grown into a 2-million-square-foot complex on 53 acres. At that time, a master plan was initiated to rationalize the previously ad hoc growth. The plan is updated as demands change. Problems of identity, circulation, and security were addressed by creating a new main gate, with an enclosure for its oval automobile court that recalls the maritime history of the area. A second gate leads to an extensive employee parking area. Departments with frequent visitors have been concentrated in a new administration building outside security at the main gate. Other plant functions are being logically organized as structures are replaced. Circulation is focused on two parallel roads running the length of the site. To improve legibility, a color palette was established juxtaposing beige-painted buildings to white circular elements such as tanks, pipes, and railings. Environmental investments include a new $40-million waste water treatment plant and more effective stack scrubbers. The employees' quality of life has been improved with new lunchrooms near shop areas and distinctive landscaping in key areas.

Facing page, top: Main gate, with glass-walled administration building in background.
Facing page, bottom: 1994 master plan, with main gate's oval court at top left.
Top left: New roads and landscaping.
Above left: Walkway, showing beige-painted building and white auxiliary elements.
Above: Oval court at main gate and new landscaping.
Model Photo: Kenneth Champlin.
Photography: Jeff Goldberg/Esto.

Centerbrook

National Outdoor Leadership School Headquarters
Lander, Wyoming

Though focused on natural settings, the school decided the environmentally and socially conscious location for its headquarters would be in the town of Lander (pop. 6,200), where the historic Noble Hotel provides its housing. The new building comprises three brick-clad volumes, compatible with downtown commercial structures, around a central courtyard. Part of the roof is developed as a roof garden, with river rocks and boxes of hardy plantings, offering views of the Wind River Mountains. A "leaf" canopy of unfinished steel protects the open stairway under the portico and serves as an icon for the school.

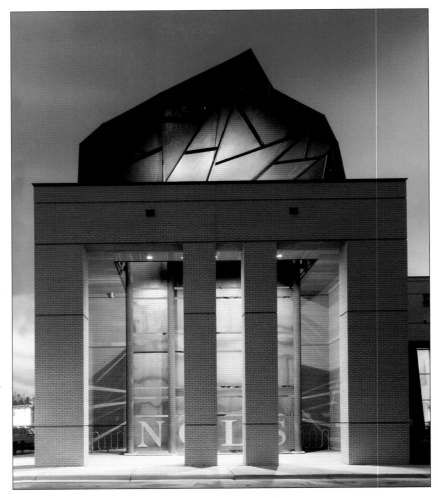

Left: *Portico crowned by steel canopy.*
Below: *Roof deck with canopy.*
Far left, below: *Headquarters from street.*
Below left: *Wings surrounding courtyard, showing windows with transoms and sun visors for optimum daylighting.*
Bottom right: *Courtyard details.*
Photography: *Jeff Goldberg/Esto.*

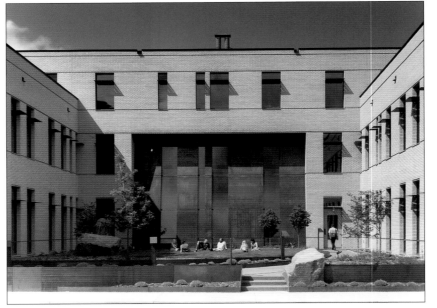

Charlan•Brock & Associates, Inc.

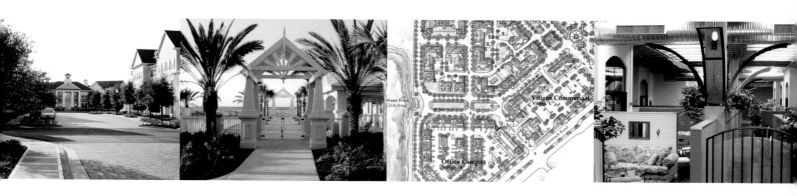

2600 Maitland Center Parkway

Suite 260

Maitland

Florida 32751

407.660.8900

407.875.9948 (Fax)

www.cbaarchitects.com

butch@cbaarchitects.com

Charlan•Brock & Associates, Inc. North Lake Park Apartments
Orlando, Florida

Situated at the entrance to a new community, this development of 165 apartments had to set the tone for an expanse of mostly traditional single-family houses beyond. For the apartment portion, the developer needed to attain a density of 20 units per acre within a three-story height limit. The solution was to create modules comprising a pair of townhomes above a single flat, which shares the first floor with garages opening to a back alley. Each module has the appearance of an ample townhouse, so that a 15-unit structure looks like a row of 5 townhouses. Units range in size from 750-square-foot, one-bedroom flats to 1,330-square-foot, three-bedroom townhomes. Eighty-two percent of the units have direct garage access, and parking lots are minimized, with many of the required spaces along the streets.

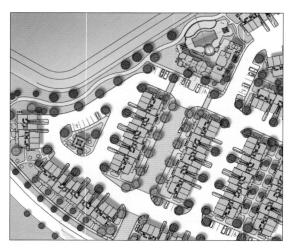

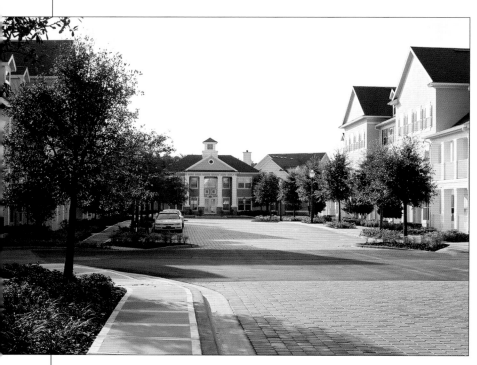

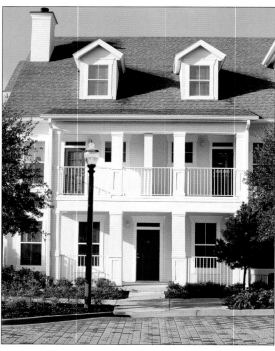

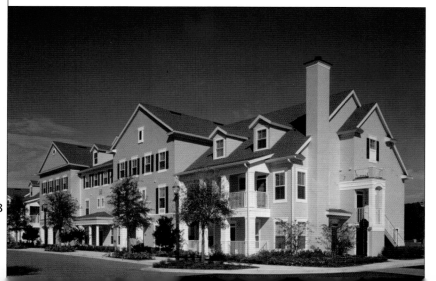

Top: Site plan.
Above: Porch of first-floor flat with balconies of townhome units above.
Above left: Broad central street.
Left: 15-unit structure.
Photography: Taylor Architectural Photography.

58

Charlan•Brock & Associates, Inc.

Garden Apartments
Main Street at Hampton Lakes
Tampa, Florida

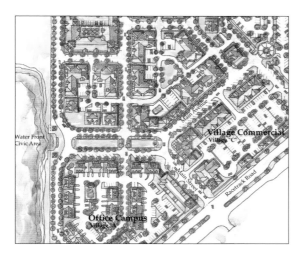

The typical American garden apartment development has been reinvented here and integrated into a traditional neighborhood, refining a plan and guidelines drawn up by Duany and Plater-Zyberk. Following DPZ's recommendations, parking lots, which often dominate such developments, have been replaced by parallel parking along traditional tree-lined streets and small hidden motor courts. Unit plans have been carefully organized to offer premium views from most apartments. Roof massing and traditional details enhance the traditional residential character.

Above left: Plan of garden apartment area.
Left: Club house (at right) in center of development.
Below: Typical apartment elevations.

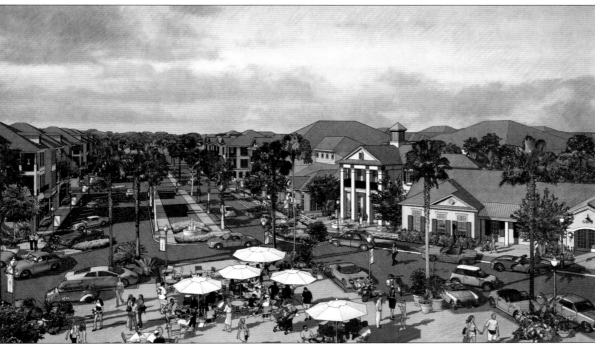

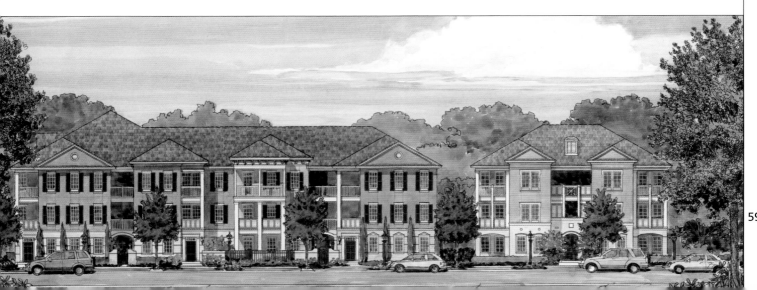

Charlan•Brock & Associates, Inc. Martinique
Fort Morgan, Alabama

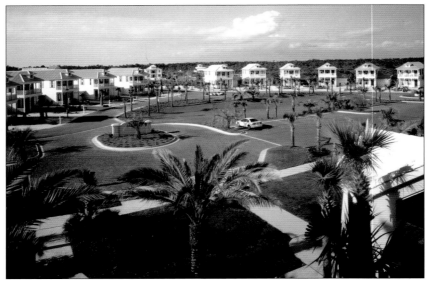

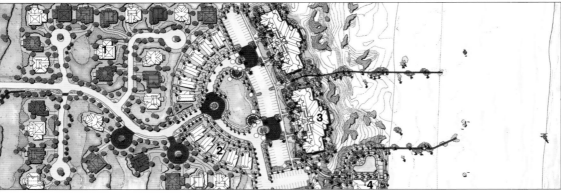

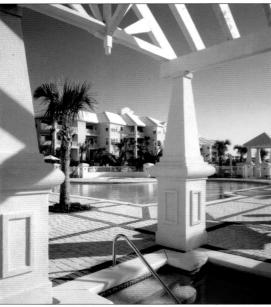

Top: Sales center, to become a community building.
Top right: Crescent of cottages around green.
Above: Site plan.
Right: Pool and gazebos.
Photography: Everett & Soule.
Rendering: Landscape Dymanics Incorporated.

On a deep, narrow 55-acre site along the Gulf of Mexico, the goal was to create a resort community that celebrates the beauty of dune and wetland habitats, while recalling the festive feeling of a Caribbean village. Seasonal residences range across several market segments. Two- to three-story Gulf-front condos adopt the tall columns and hipped tile roofs of plantation houses. A half-circle of two-story porched cottages defines a grassy crescent, which serves as a dry retention basin for parking lot runoff. A meandering road stretching back from the shore links clusters of fancifully detailed bungalows and duplexes interspersed with wetlands that are linked to an adjacent wild life refuge. The Caribbean theme is carried throughout in the beach club, gazebos, bridges, and signage.

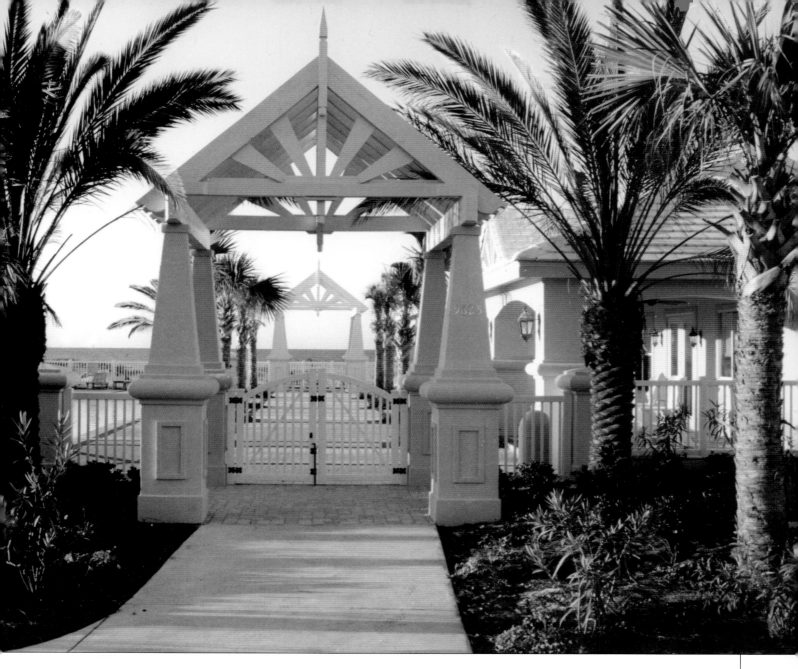

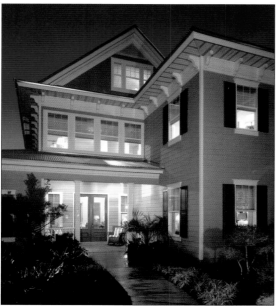

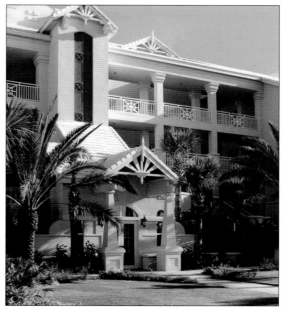

Charlan•Brock & Associates, Inc. NorthBridge at Millennium Lake
Orlando, Florida

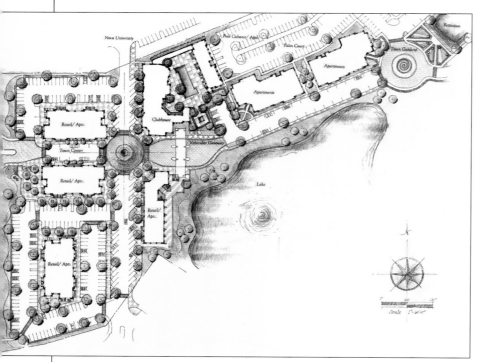

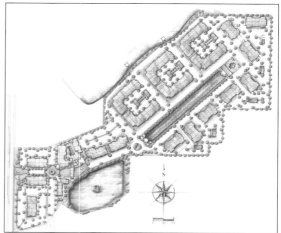

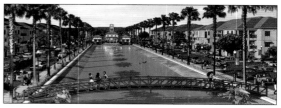

This mixed-use apartment development is designed to incorporate two very different environments. Along the commercial thoroughfare of Millennium Boulevard, 65 apartments over 24,000 square feet of ground-floor retail are laid out to create a town square with a suggested industrial character, intended to foster an atmosphere of energy and fun. Once one passes a gatehouse, the remaining 440 apartments are designed as a restrained residential neighborhood, with sidewalks, parallel parking, internal motor courts, and some individual garages. A lake and an axial lagoon reinforce the elegant urban feeling of this area. The 19,000-square-foot clubhouse located at the gatehouse will include facilities for basketball and bowling, as well as a fitness center, a pub, and a theater. A height limit of 45 feet required ingenuity to fit all these functions, with parking, into 33 developable acres.

Above left: Partial site plan with mixed use at left, all-residential at right, gatehouse and clubhouse at center.
Top: Site plan of entire development.
Above: View along central pond looking at waterside recreation hall.
Below: Elevation along Millennium Boulevard.
Rendering: Nperspective, Noni De Guzman, (above).

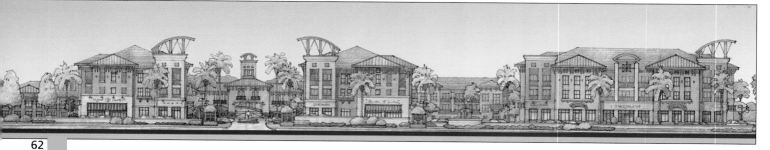

Charlan•Brock & Associates, Inc. Colonial Grand at Town Park Reserve
Lake Mary, Florida

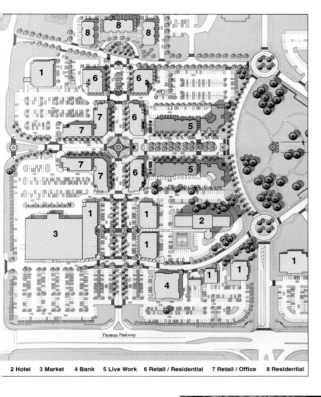

Left: *Site plan, mixed-use portion at middle right.*
Below: *Mixed-use buildings flanking avenue.*
Bottom: *Partial second-floor plan.*
Rendering: *Genesis Studios.*

2 Hotel 3 Market 4 Bank 5 Live Work 6 Retail / Residential 7 Retail / Office 8 Residential

Many developers shy away from the ideal walkable, mixed-use community because their experience is limited to housing, shopping centers, or offices. The client, which has divisions specializing in all these areas, is exploring a balanced mix of uses in this town center development. The project includes 9,000 square feet of retail, 38 standard apartments, and 12 live-work units, which have 500 square feet of flexible first-floor space with 1,000-square-foot apartments above. To make all parts of the project marketable, they are sited in a transitional zone at the edge of a retail development, along a tree-lined avenue adjoining a green park. The live-work units are accessible both from both street fronts and rear private motor courts, and the ground floor space can be rented flexibly, with the apartments above or separately.

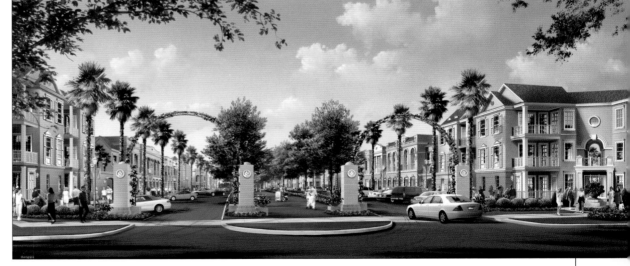

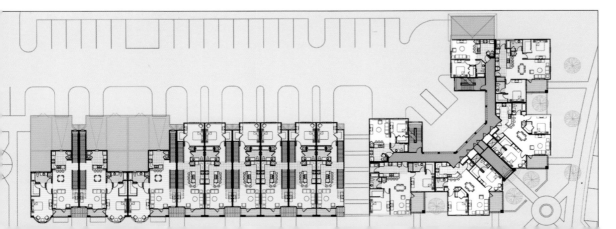

Charlan•Brock & Associates, Inc. Winter Park Village Lofts
Winter Park, Florida

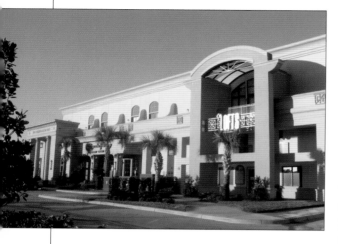

Top left: Exterior at lofts entry, showing some balconies.
Above left: Partial loft floor plan.
Above: Atrium with individual all-weather terraces.
Left: Corridor as art gallery.
Photography: Charlan•Brock & Associates, Inc.

A former department store has been re-used, with retail tenants on the first floor and 58 loft apartments on the second. The 16-foot ceiling heights on the upper floor were advantageous for lofts, but the 200-by-300-foot floor plate made it impossible to give all units exterior exposure. The innovative solution was to locate 22 units facing a skylighted central atrium, partitioned to give each one a private space for all-weather outdoor living. Exiting provisions were crucial, and a high rate of air exchange was essential. To provide utilities to loft interiors, sleeping areas were raised 3 feet above plenums, allowing them low privacy partitions. Long interior corridors were mitigated with jogs and with lighting concentrated on artworks.

CMH Architects, Inc.

1800 International Park Drive

Suite 300

Birmingham,

Alabama 35243

205.969.2696

205.969.3930 (Fax)

www.cmharchitects.com

oehatcher@cmharchitects.com

CMH Architects

Vanderbilt Collection
Naples, Florida

The image of a Mediterranean village, as interpreted for over a century in South Florida, is evoked in this open-air retail center. Occupying 25.5 acres at a key intersection in the rapidly growing, affluent Naples area, the development will contain 253,800 square feet of retail space. Tenants will include an upscale gourmet market, home furnishings stores, nationally recognized fashion retailers, and over 40,000 square feet of restaurants. The center's buildings will form a roughly horseshoe plan around a compact central structure, with parking occupying the half-circular space between. Other parking is in small-scaled areas close to the stores. Islands of planting divide the parking into intimate coves, and planted allees lead from parking to retail destinations. Buildings will be framed in light-gauge steel and clad with stucco veneer.

Above: Shop fronts recalling old Spain.
Below: Retail elevations with fountain court.

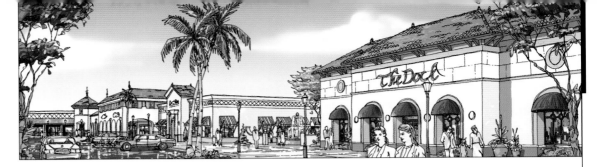

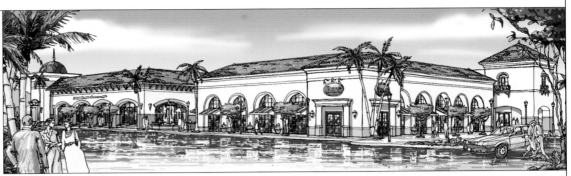

Above right: *Varied building forms facing parking area.*
Right: *Harmonious by varied retail frontage.*
Below right: *Aerial sketch showing layout.*

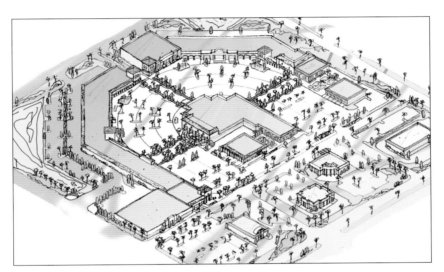

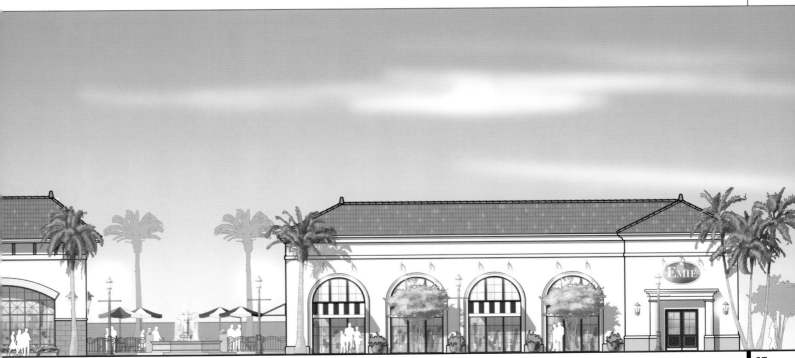

CMH Architects

The Avenue East Cobb
Atlanta, Georgia

Built on the site of a former golf driving range, this retail complex has filled a high-end retail void in Atlanta's eastern Cobb County suburbs. The 30.9-acre, 243,278-square-foot development includes some 50 retailers, many widely known nationally. For such tenants, the developer and the architect wanted to encourage individuality in storefronts, while maintaining a distinctive overall design character. This objective was met by drawing up a project tenant criteria manual

that listed approved materials and illustrated appropriate signage and architectural details. The application of these criteria was facilitated by appointment of a tenant coordinator. Overall, the development has a horseshoe-shaped plan configuration. Customers can proceed from step-out-of-the-car-into-the-shop parking along lushly landscaped walkways that lead through courtyards adorned by life-size bronze sculptures. Buildings are steel framed, with CMU,

brick veneer, and EIFS cladding, with standing-seam metal roofs. Landscape materials include tumbled brick pavers, cast stone urns, and patterned multi-colored brick walls.

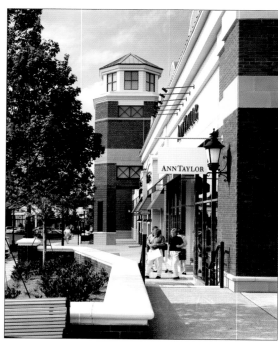

Above: Storefronts and signature tower.
Left: Typical fronts with fountain and seating area.
Photography: Dennis O'Kain.

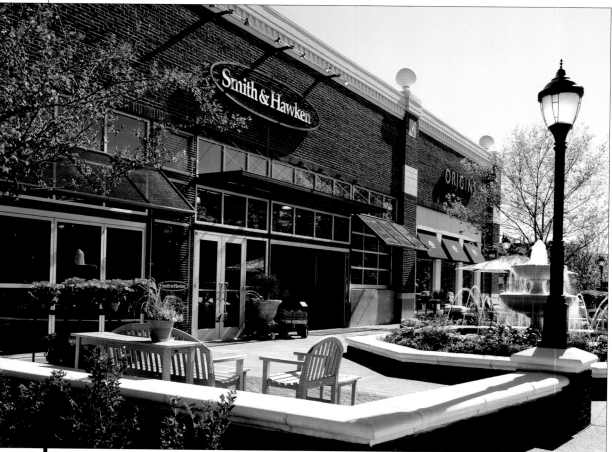

CMH Architects

The Avenue Peachtree City
Peachtree City, Georgia

Peachtree City is a unique community, with residential and commercial areas linked by golf cart paths. Following up on the success of The Avenue East Cobb (facing page), the architects and the developer, Cousins Properties Incorporated, followed similar procedures here, issuing a tenant criteria manual and appointing a tenant coordinator to make sure that diverse retail fronts contributed to the overall design intentions. The 17-acre complex comprises 175,000 square feet, with 155,000 square feet leasable for retail and restaurants. Bronze sculptures placed throughout the project depict children in various outdoor activities.

Below: Storefronts with sculpture, "Sunshowers," by Jane DeDecker.
Below right: Fountains and landscaping.
Right: Varied stores with landmark tower, DeDecker sculpture "Just Like Grandpa" in foreground.
Photography: Dennis O'Kain.

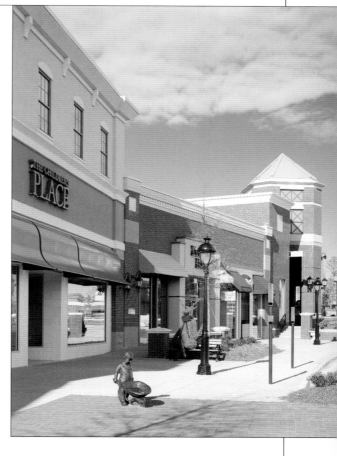

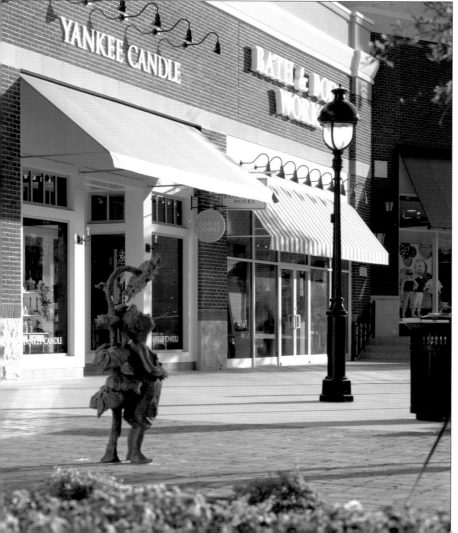

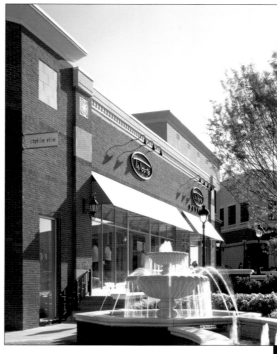

The Summit (Phases I – III)
Birmingham, Alabama

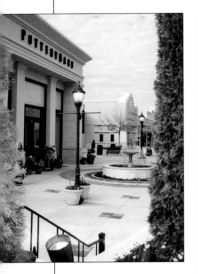

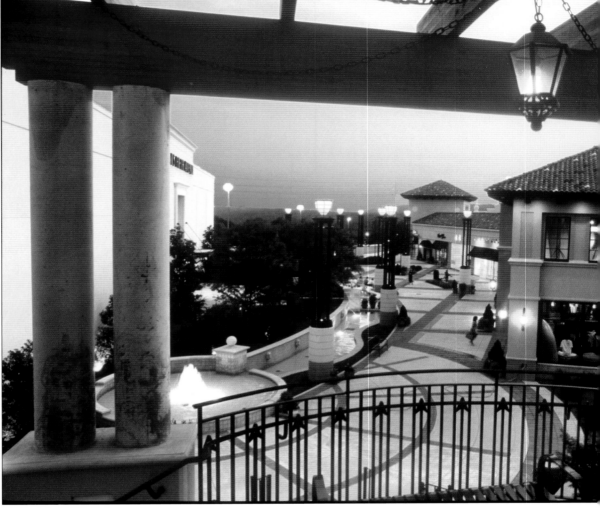

Top: Fountain court in European tradition.
Above: Stair as design feature.
Above right: Long view from hilltop loggia.
Photography: Charles Beck.

Several developers had previously attempted to place commercial projects on the small mountain rising above the intersection of US 280 and Interstate 459. All failed because of the expense of overcoming the site's hilly terrain. The successful developer, Bayer Properties, convinced the city that it was in the its interest to built a new road and provide infrastructure, which will be paid for by sales tax generated on the property. To develop an upscale retail/entertainment center, the architects took advantage of the terrain to generate the ambiance and vitality of a Mediterranean hill town. Varied tile-roofed building forms are interwoven with landscaping featuring geometric paving patterns, water features, statuary, and seating areas – all on a tight budget. The first phase of construction on the 87-acre site contained 475,000 square feet in three zones: an upscale retail zone including a 110,000-square-foot Parisian department store and 125,000 square feet of other retail; a entertainment/power center zone with a 16-screen cinema; and a neighborhood zone around a grocery and a deli, located closest to residential areas for convenience. Phase II added 103,000 square feet, including 18 new stores and a second-story day spa. Phase III added about 60,000 square feet of retail and restaurant space, as well as a 100,000-square-foot Saks Fifth Avenue anchor.

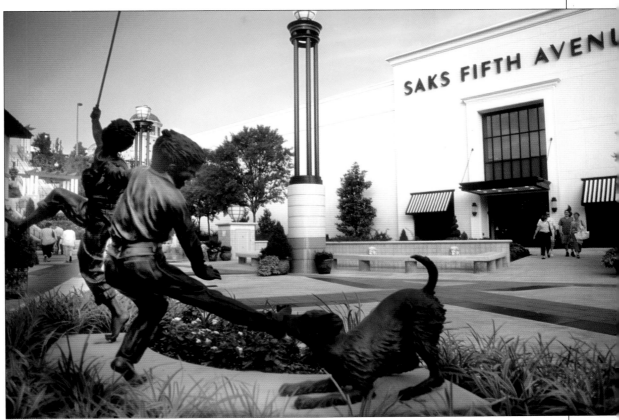

Top right: Landscape capitalizing on grade changes.
Above right: Sculpture and lighting pylons.
Right: Phase I arcades and promenades.
Far right: Storefront with fanciful cupola.

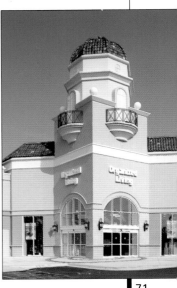

71

The Summit Louisville
Louisville, Kentucky

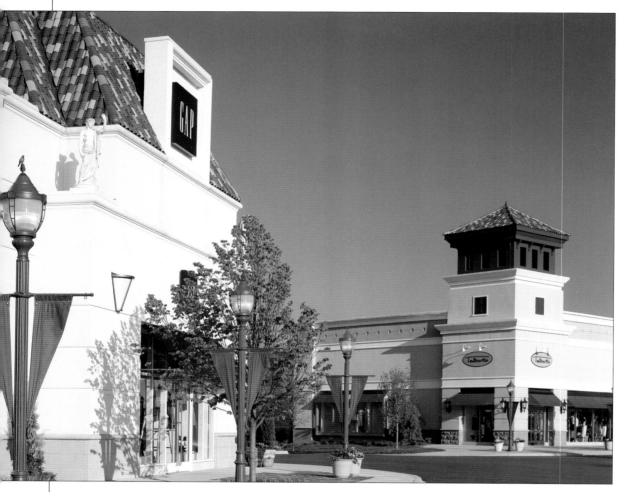

Located on a highly visible site at the intersection of two major highways, this upscale retail development is part of a larger mixed-use community that includes residential, office, and hotel facilities, as well. For the roughly 40-acre site, allowable retail was fixed by county requirements involving connections to major roadways and anticipated office development. The design objective was a pedestrian-friendly center, providing parking and sight lines required by retailers. The central retail plaza is conceived as a node for a network of walkways linking all parts of the mixed-use development.

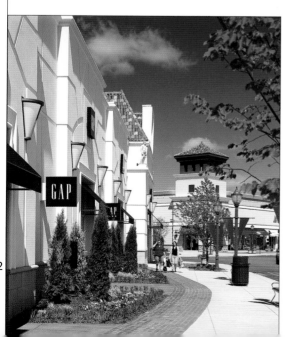

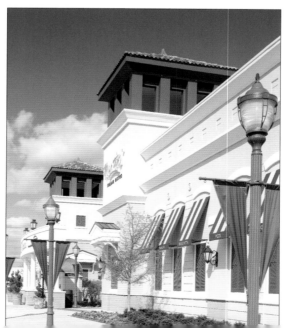

Above left: Prominent buildings at walkway intersection.
Far left: Typical walkway and plantings.
Left: Awnings and banners as design elements.
Photography: Dennis O'Kain.

CMSS Architects, P.C.

4505 Columbus Street Hampton Roads, VA

Suite 100 Washington, DC

Virginia Beach, VA 23462

757.222.2010

757.222.2022 (Fax)

www.cmssarchitects.com

staff@cmssarchitects.com

CMSS Architects, P.C.

City Center at Oyster Point
Newport News, Virginia

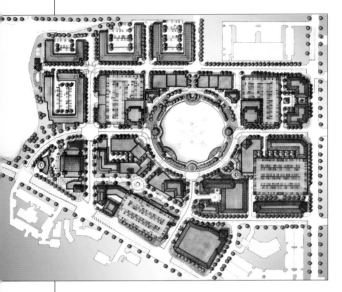

Left: Development plan.
Below left: Rendering of Fountain Plaza One office building and parking structure.
Right: Completed office buildings facing central fountain.

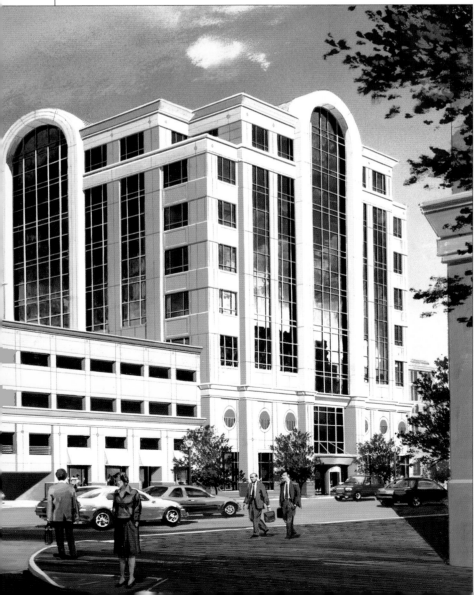

Over the past several decades, the population of Newport News has grown rapidly and shifted westward toward the Oyster Point area. The goal of this 48-acre project is to create a new mixed-use downtown that aligns with the city's current population center. The streets are being developed in a horizontal grid pattern within blocks, emphasizing convenient access. The mix of uses is vertically organized, with first and second floors devoted primarily to street-oriented retail, restaurants, and entertainment; upper floors are dedicated to concealed parking, offices, and residential uses. A city park surrounds a central five-acre fountain. The mix of programmed uses ensures that the development will be active around the clock. Build-out plans call for a total of 1 million square feet of office space, 250,000 square feet of retail, restaurant, and entertainment, a 249-room high-end hotel, 360 luxury rental apartments, 150 condominiums and lofts for sale, a 55,000-square-foot conference center, and four parking decks. Four commercial and office buildings, totaling 337,000 square feet, were completed in 2002

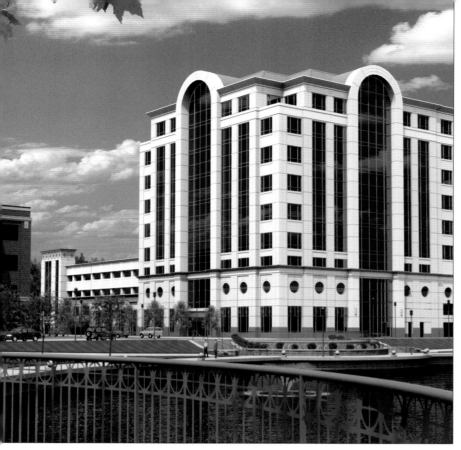

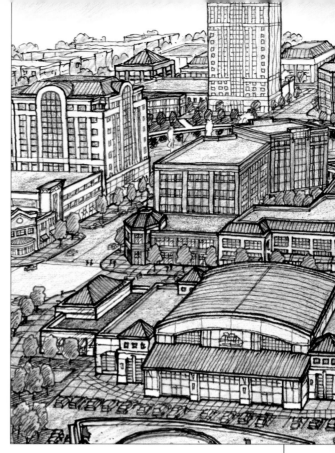

and 2003. The entire project is to be completed by 2009, with allowance for additional components in later years. To steer future development, CMSS also created design guidelines, as commissioned by the City of Newport News.

Above right: *Aerial view from waterfront toward office buildings around fountain plaza.* **Right, below right, and below:** *Proposed street-oriented retail and entertainment facilities, with offices, parking, and residential above.*

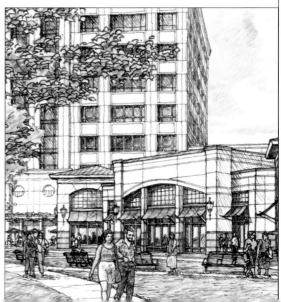

CMSS Architects, P.C.

Shockoe Plaza
Richmond, Virginia

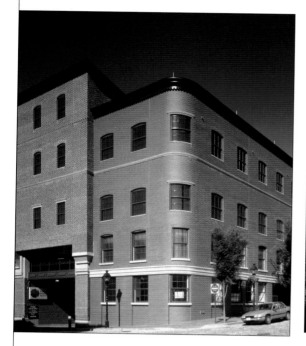

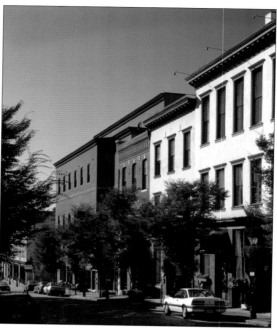

This project demonstrates the importance of community involvement during the design process. The Shockoe District includes 19th-century buildings ranging from Italianate commercial properties to more harsh industrial structures. Since the complex occupies the site of a failed high-rise project that was out of character with the district, local historic committees and neighboring businesses were very sensitive to this development. The design team met with these groups

Above, far left: Simple industrial brick walls on part of the complex.
Above left: New walls with adjoining commercial structures.
Left: Project's plaza, with two-story bridge linking buildings.
Facing page top: Third-floor employee terrace overlooking the Richmond skyline.
Facing page bottom: Aerial view.
Photography: Judy Davis.

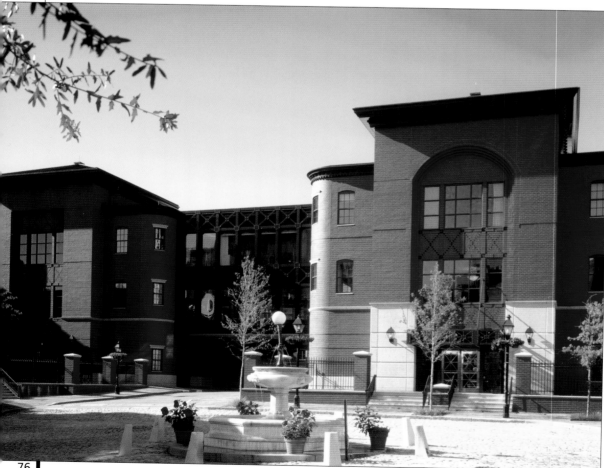

frequently to address concerns and obtain valuable input. The 123,000-square-foot building was custom designed to consolidate the 450-person staff of the Martin Agency, an international advertising firm. The starting point for the design was the irregular outline of the uncompleted parking garage of the failed project. The new complex comprises two three-story structures flanking a street, connected at the upper levels by a bridge. This bridge allows vehicles to pass beneath it and employees to work in and circulate through it. Each of the structure's facades references the street it fronts, ranging from dressy commercial to warehouse industrial, incorporating Italianate style details similar to neighboring buildings. The project's pocket plaza makes a graceful transition into the atrium, inviting the public to glimpse the agency's culture.

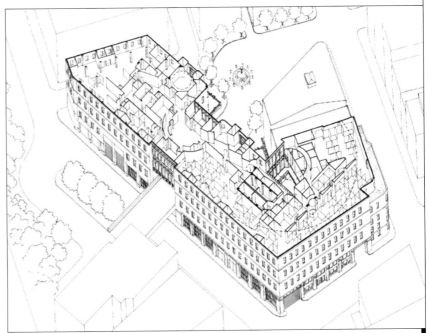

CMSS Architects, P.C.

Downtown Norfolk Renaissance
Norfolk, Virginia

In the 1980s Norfolk decided to embark on a massive program to revitalize its downtown waterfront district as a livable, vibrant community. In 1997, the city began to focus on the infill of historic Boush and Freemason Streets with housing, office space, parking, restaurants, and entertainment. CMSS Architects is responsible for the design of a variety of new and adaptive reuse projects for addressing the needs of the area. Project highlights follow:

• The Heritage Apartments at Freemason Harbour is an infill development of 182 units on 4 acres, with first floor retail and under-building parking.

• PierPointe Condominiums includes 72 luxury units on a renovated pier, with provisions for a future restaurant and deep water docking.

• The Boush Street Apartments mixes residential, parking, and retail; its first floor includes 17-foot-high loft units with mezzanine bedrooms.

• The NorVa Theater is a former vaudeville theater remodeled to house a 1,500-seat concert hall, music-themed restaurant-nightclub, and offices.

• The 20-story, 578,000-square-foot office building at SunTrust Tower contains 10 levels of camouflaged parking on

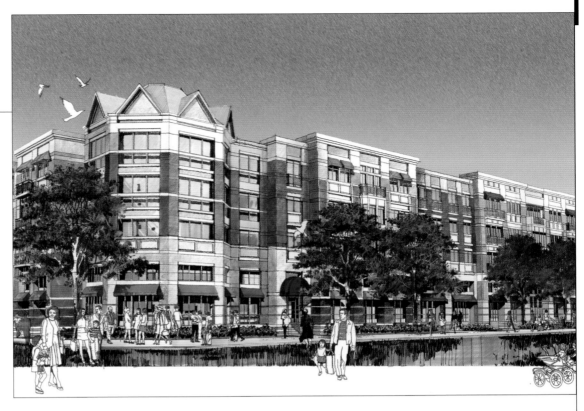

Facing page, left: Harbor with PierPointe Condominiums.

Facing page, top: Aerial view of district with CMSS projects highlighted.

Facing page, bottom: SunTrust Tower office building.

Right: Proposed Boush Street Apartments.

Bottom right and below: Completed Heritage Apartments at Freemason Harbor.

Photography: John Wadsworth (facing page, left), Hoachlander Davis (all other photos).

its lower half and commands sweeping views of the harbor.

• The 411 Granby Street project will transform a once-premier department store into luxury condominiums with ground-level restaurants, entered through a landscaped courtyard in the rear alley.

• Freemason Market at Tazewell Place will be a ten-story complex with first-floor retail, including a fresh produce market, and two stories of parking underpinning apartments and lofts on the upper floors. Projects such as these are helping to re-create a true mixed-use downtown reminiscent of the city's early days.

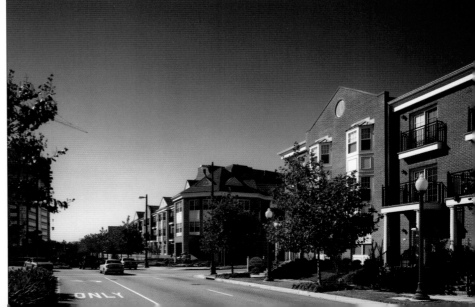

The Village of Rocketts Landing
Richmond, Virginia

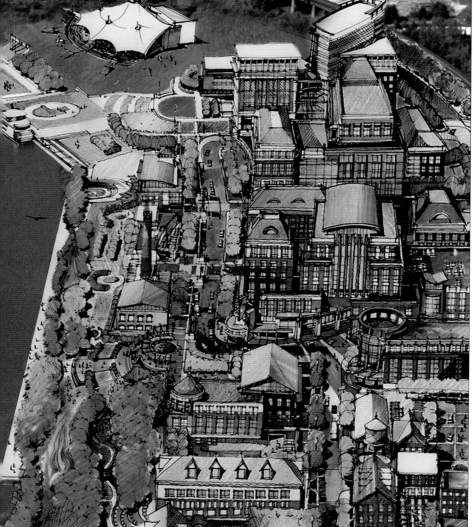

Initially settled in 1730 and now a brownfield site, this area along the James River will be redeveloped between 2003 and 2010 into a mixed-use urban style village. Featuring a "Main Street" style layout, it will incorporate 500,000 square feet of office space; 200,000 square feet of retail, restaurant, and entertainment space; some 2,000 residential units; a deluxe hotel; and parking structures. A variety of public spaces will include a mile-long riverfront park.

Additional amenities to be developed include festival plazas, outdoor markets and a 40-slip marina with boathouse. With its mixed-use components, public attractions, urban street grid, and view corridors open to the river, the development is expected to be a magnet for Richmond area residents and visitors.

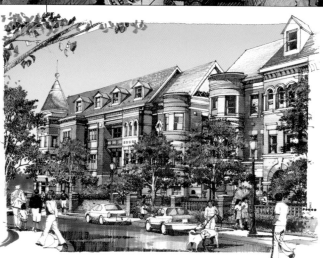

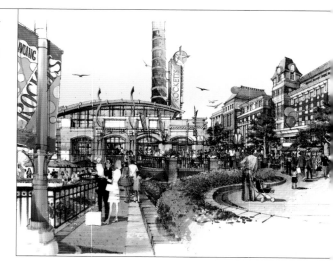

Top right: Close-up view of the East Village featuring various residential configurations.
Above: View of Festival Plaza, Rocketts Square and West Village neighborhoods.
Left: East Village Residential Street scene.
Right: View from a public plaza looking up the James River at the Richmond skyline.

Cottle Graybeal Yaw Architects

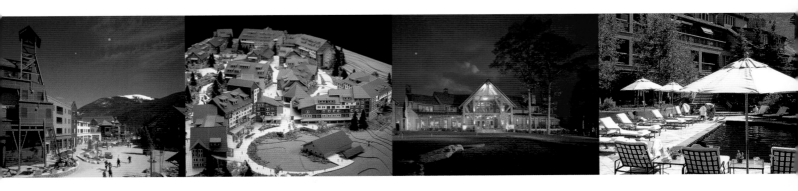

Post Office Box 529

Basalt

Colorado 81621

970.927.4925

970.927.8578 (Fax)

www.cgyarchitects.com

aspen@cgyarchitects.com

Aspen

Telluride

Vail

Cottle Graybeal Yaw Architects

Silver Mill, Black Bear Lodge, Jackpine Lodge
River Run at Keystone Resort
Keystone, Colorado

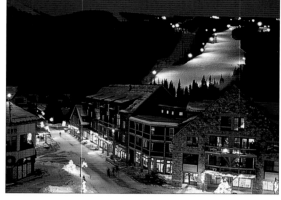

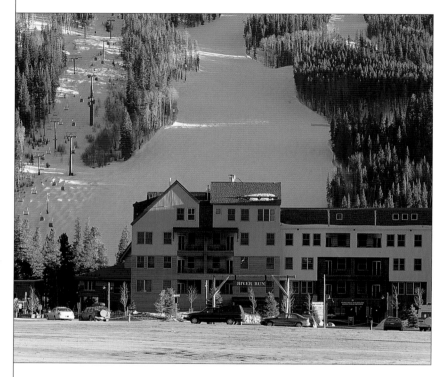

Above: Black Bear building at the foot of snowslope.
Left: Complex nestled at foot of slopes.
Below: Main town square and events plaza.
Facing page: Silver Mill tower's mineshaft imagery.
Photography: Douglas Kahn, this page; J. Curtis, facing page.

The three separate but coordinated structures of River Run village are designed to embody a Rocky Mountain experience, as well as a sense of community. The first two buildings, occupied in 1996, were the Black Bear Lodge, with 40 condo units, and the Jackpine Lodge, with 24 condos. Black Bear is identified by a prominent gabled stone façade, and Jackpine displays the logs and heavy timbers found in the great hotels of the West. The 130-unit Silver Mill, completed in 1998, uses the exposed steel, timber, and metal siding characteristic of old mining structures. It is broken up visually into distinct blocks with varying roof forms, culminating in its landmark tower. Throughout the village, ground floor retail and restaurant spaces have layered facades, with small-scaled details that slow down the perceived passage through the village, inviting pauses and exploration.

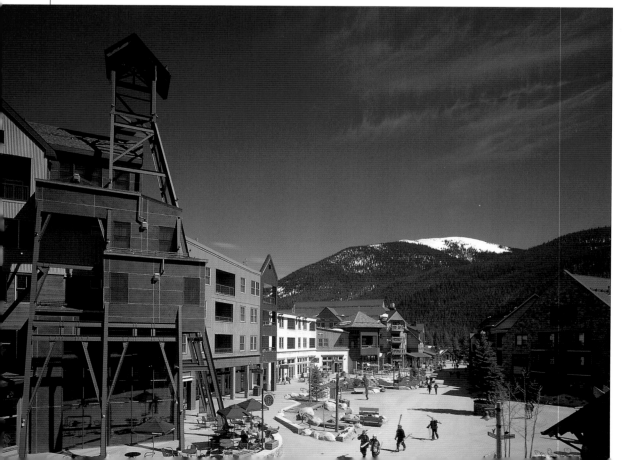

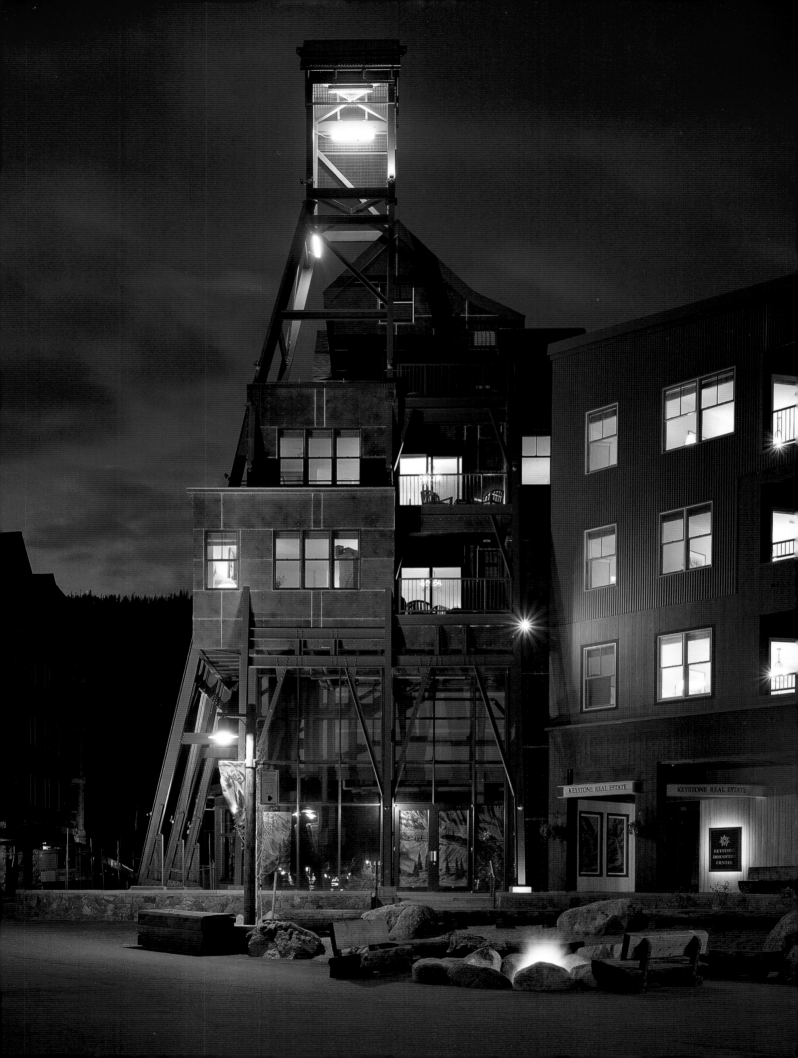

Cottle Graybeal Yaw Architects Zephyr Mountain Lodge
Winter Park, Colorado

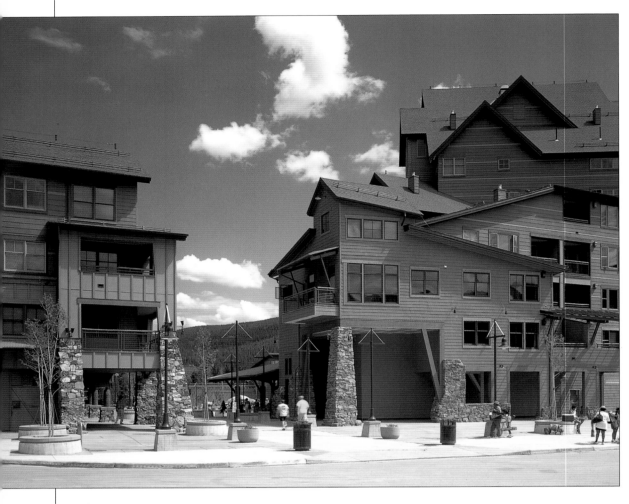

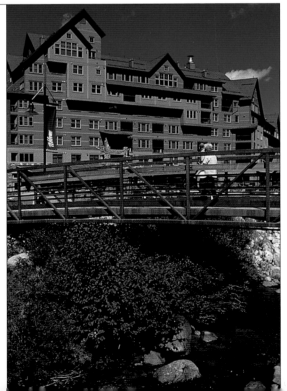

Above: Varied porches and windows lend individuality to units.
Right: Upper-floor projections reduce building scale; steel and wood recall area's railroads.
Photography: Douglas Kahn (above); Byron Hetzler (right).

Above right: Festivities around village green.
Right: Model of eventual build-out.
Far right: Stone and natural wood in public interiors.
Photography: Douglas Kahn (above right); Michael Shopenn (far right).

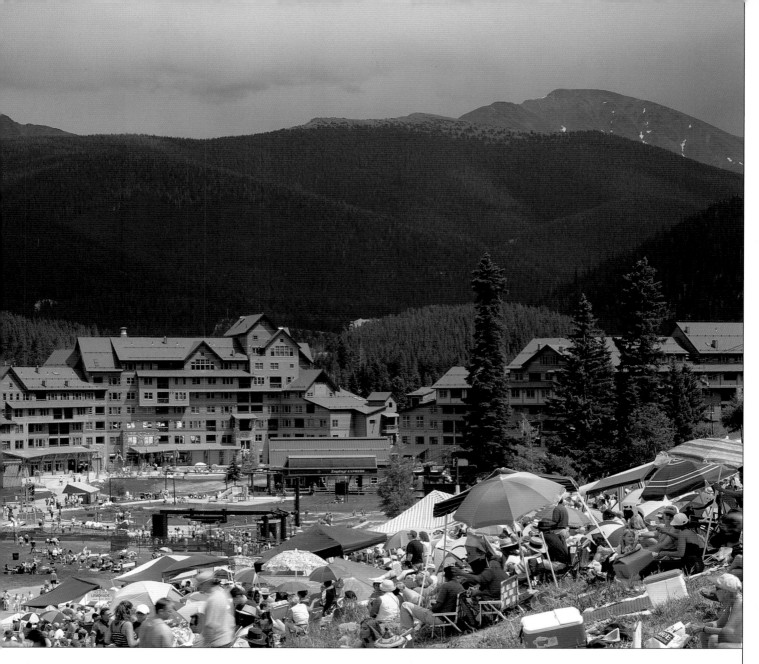

The two buildings that jointly compose Zephyr Mountain Lodge establish the character of Winter Park Village as an urban outpost adjoining the mountain wilderness. Named the Riverside and Slopeside buildings, the structures contain 230 resort/condo apartments plus 28,000 square feet of street-level retail. They present vigorous large-scale forms, with distinctive close-range detail enhanced by various muted colors. Their sinu-ous layouts and the var-ied use of stone, timber, steel, and cement board siding lend individual identity to the residential units, as well as character to the public spaces. The long-term village plan provides for carefully cali-brated streetscapes, which release into open spaces – all carefully con-sidered in terms of cap-turing sunlight and mountain views. As one approaches the resort through the Moffat Tunnel on the Rio Grande Railroad, the overall impression—with only two buildings completed so far—is of a cohesive community tucked into a mountain valley.

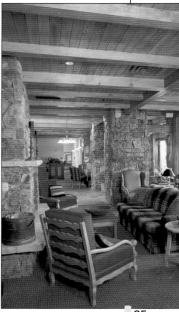

Cottle Graybeal Yaw Architects

Falling Leaf Lodge
Chautauqua and Fitness Center
Mountain Air Country Club
Burnsville, North Carolina

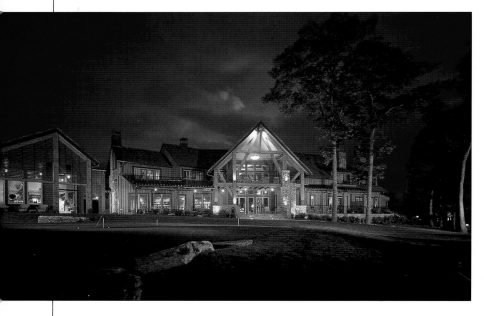

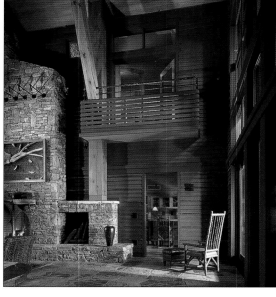

Top left: *Lodge from lawn.*
Top right: *Lodge interior.*
Right: *Complex overlooking Blue Ridge landscape.*
Below right: *Mountaintop fairway.*
Below far right: *Interior detail recalling tobacco barn construction.*
Photography: *Robert Thien.*

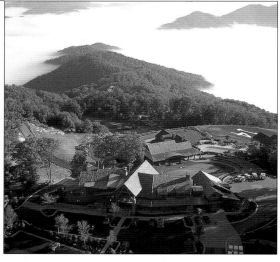

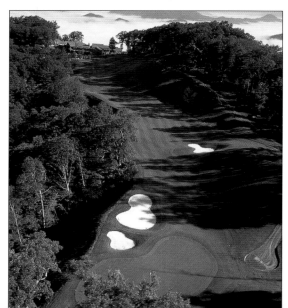

Mountain Air Country Club is a recreational and golf community perched on a 4,700-foot Blue Ridge peak. The architects were first commissioned to design townhomes as the next stage of development, but with their input it was decided that the community first needed a "heart" as a gathering place. With imaginative site design, this center rose from an existing parking lot. Housed in the 16,000-square-foot lodge are a post office, a grocery, a golf pro shop, a community living room, and seven guest rooms for visitors. Surrounded by porches and patios, the building readily encourages shared activities. Indoor exercise and meetings are accommodated in the 6,000-square-foot Chautauqua and Fitness building. The complex was inspired by the strong architectural traditions of the region, ranging from its painted clapboard farmhouses and natural wood tobacco barns to buildings representing the Arts and Crafts Movement, with its expert craftsmanship and occasional whimsy.

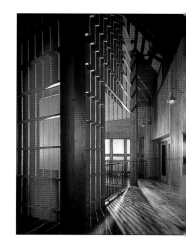

Cottle Graybeal Yaw Architects

The Little Nell
Aspen, Colorado

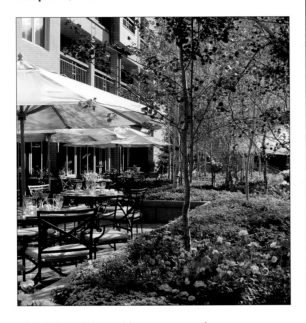

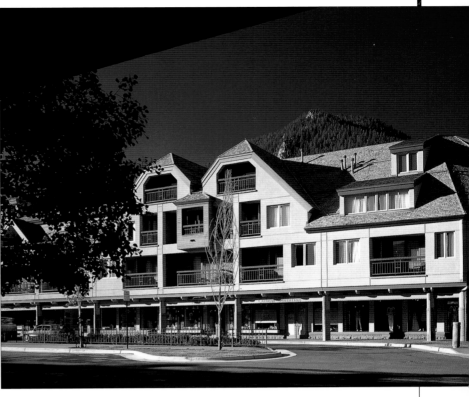

The Little Nell is considered more than a hotel; it is a community gathering place that links Aspen to the base of its mountain. The 92-guestroom structure is the second phase of a redevelopment project that included master planning of the entire mountain base. The hotel incorporates improved skier circulation, après-ski plazas, a health club, a swimming pool and outdoor spa, conference rooms, restaurants, bar, and retail. Guestrooms and suites feature balconies, and "attic" rooms with dormers are in great demand. Accommodating all this on a 1.98-acre site involved underground parking and the use of rooftop areas. Intense community input, as part of a zoned "Special Planned Area" ensured consideration of community needs, surrounding buildings, and view corridors. The result is a hotel with one of the highest annual occupancy rates in Colorado, helping to maintain Aspen's position as a vibrant year-around destination.

Above left: Dining patio.
Above: Street front, with mountain beyond.
Below, left to right: Pool deck; lively bar; lobby area with stone fireplace.
Photography: David O. Marlow.

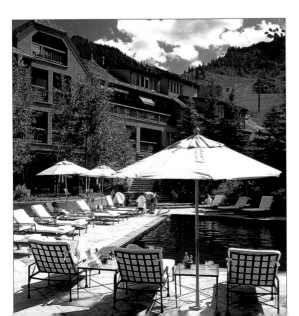

Cottle Graybeal Yaw Architects Architects' Studio
Basalt, Colorado

Set on a Western small town main street, the architects' own building maintains the scale and massing of existing structures with interpreted forms, materials, and details that express the firm's design principles. To make the transition to a residential area, the building is set back somewhat, with a front patio. A retail space occupies the street front, with the studio set back on street level and an entire second level. An iconic tower, with gapped boards reinterpreting local vernacular, provides an outdoor meeting space. Environmental concerns are reflected in the use of recycled stone, steel, and carpet tiles, strawboard workstations, exposed framing, operable windows, and native plantings.

Above: Main studio.
Below left: Rear patio.
Below right: Street front.
Photography: Pat Sudmeier.

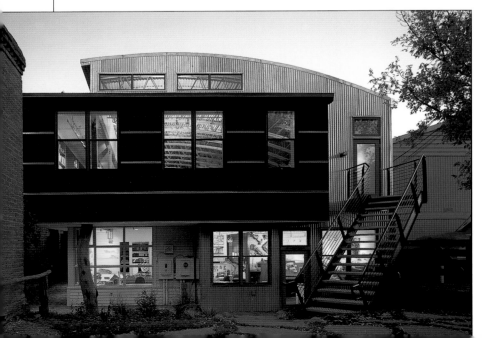

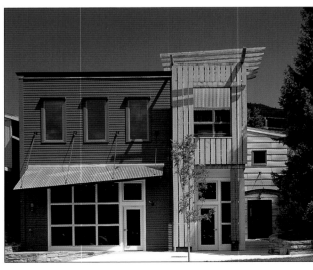

Crandall Arambula PC

520 SW Yamhill

Roof Suite 4

Portland

Oregon 97204

503.417.7879

503.417.7904 (Fax)

www.ca-city.com

debames@ca-city.com

Crandall Arambula PC

Downtown Development Plan
Racine, Wisconsin

Like many of America's turn-of-the-century city centers, Racine's downtown was severely depressed. It had received virtually no new private investment in over 30 years. Crandall Arambula prepared a downtown plan that reestablishes Main Street as the retail hub of the region. The plan includes a development framework, a design plan, design guidelines, and an implementation strategy for revitalizing the historic downtown. The plan links the city center to the Lake Michigan waterfront and integrates 500 housing units, new and existing open space, office space and retail. Strategic public sector projects are identified to foster private sector development including public squares, plazas, esplanades, parks, street improvements, and building and tenant improvement programs. The project received a 2001 national American Institute of Architects Honor Award for Regional and Urban Design, along with several other honors. To date, over $150 million in new private development has been designed or constructed.

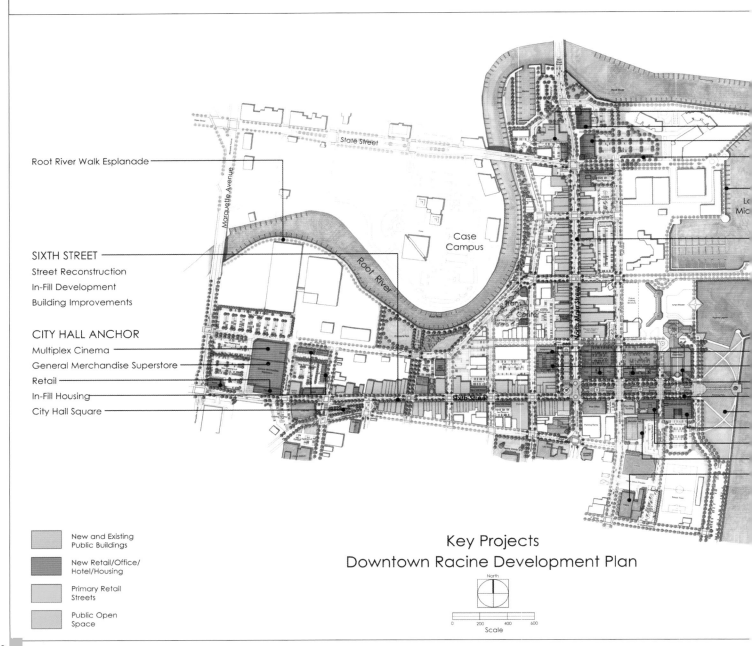

Root River Walk Esplanade

SIXTH STREET
Street Reconstruction
In-Fill Development
Building Improvements

CITY HALL ANCHOR
Multiplex Cinema
General Merchandise Superstore
Retail
In-Fill Housing
City Hall Square

New and Existing
Public Buildings

New Retail/Office/
Hotel/Housing

Primary Retail
Streets

Public Open
Space

Key Projects
Downtown Racine Development Plan

North

0 200 400 600
Scale

Left: Downtown Racine Development Plan with key projects. Public investment fosters private development in the heart of downtown.
Above: New Park Blocks connecting to Lake Michigan.
Above right: Fountain at waterfront park.
Right: Monument Square district before development.
Below right: Monument Square district development concept.

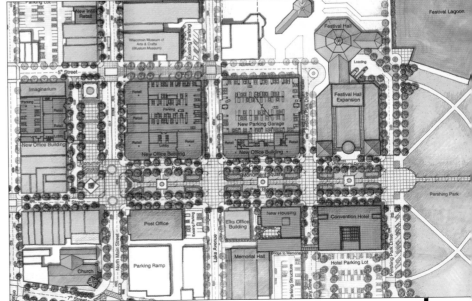

91

Crandall Arambula PC

Interstate MAX Station Area Revitalization Strategy
Portland, Oregon

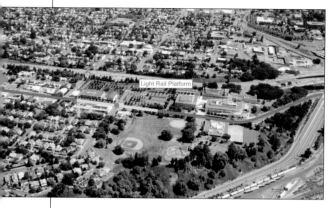

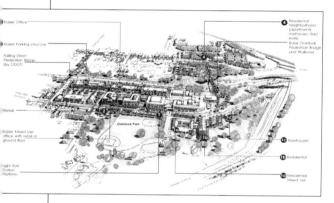

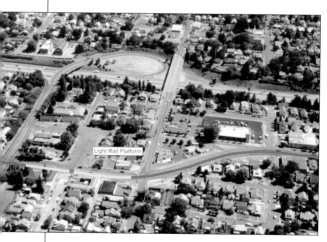

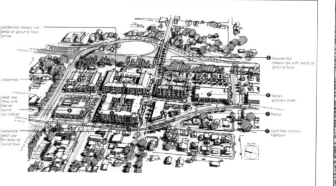

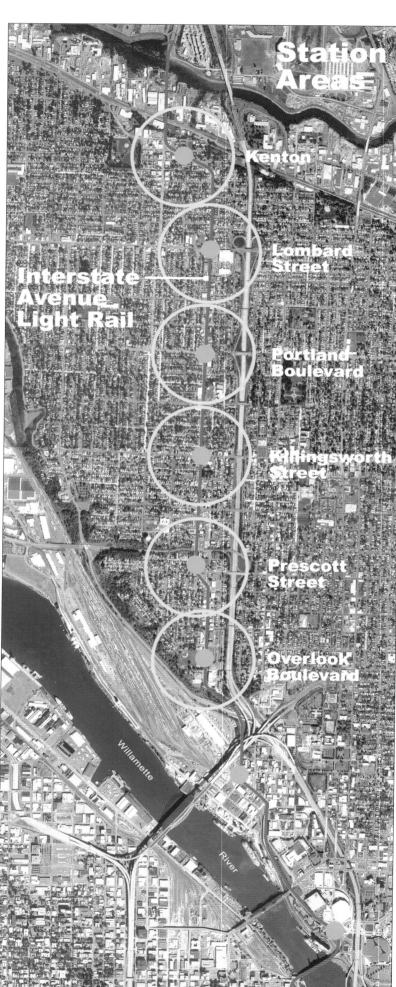

Station Areas

Kenton

Lombard Street

Interstate Avenue Light Rail

Portland Boulevard

Killingsworth Street

Prescott Street

Overlook Boulevard

Willamette River

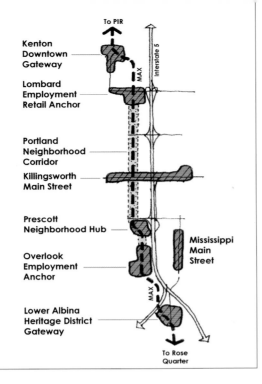

Like many economically challenged urban areas, North Portland was facing a rapid decline in affordable housing, employment, retail, transportation options, and public amenities. Crandall Arambula prepared revitalization plans for key parcels at six station areas along the 5.8-mile Interstate MAX Light Rail corridor. The strategy identifies concrete actions the Portland Development Commission and its partners must pursue to fulfill the community's expectations. It emphasizes specific steps to be taken within the first 6 to 12 months. Over 500 residents, business owners, and other interested community members participated in the broad grassroots public involvement process. Supplementing the corridor with a range of affordable housing opportunities was viewed as a high priority. Station area urban design plans were developed, illustrating sites for 3,500 added housing units. Implementation of the strategy will increase private investment from $80 to $300 million. The project received a 2003 national American Institute of Architects Honor Award for urban design. The awards jury called it a "sensitive integration of urban design and transit" and "a buildable, realistic project."

Crandall Arambula PC

Downtown Civic Vision
Knoxville, Tennessee

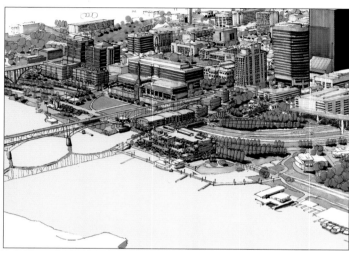

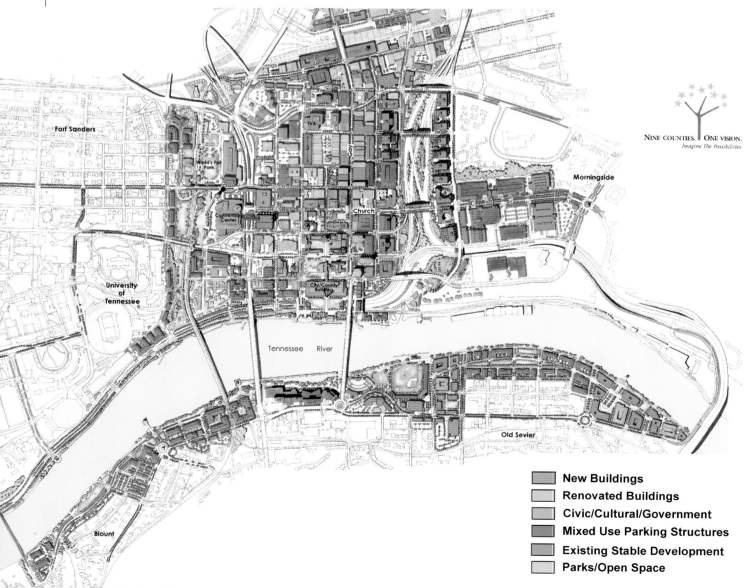

NINE COUNTIES. ONE VISION.
Imagine The Possibilities.

New Buildings
Renovated Buildings
Civic/Cultural/Government
Mixed Use Parking Structures
Existing Stable Development
Parks/Open Space

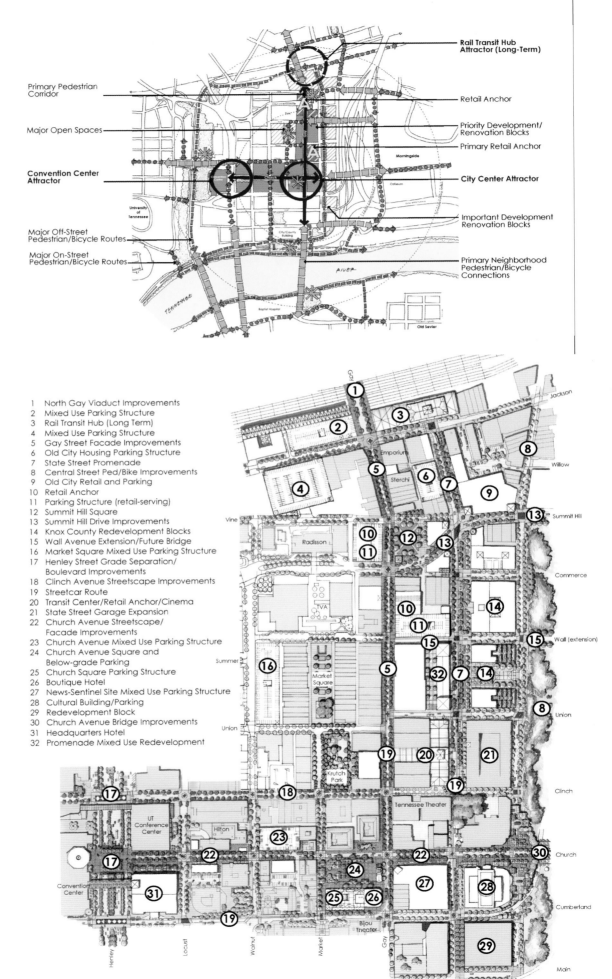

Primary Pedestrian Corridor

Major Open Spaces

Convention Center Attractor

Major Off-Street Pedestrian/Bicycle Routes

Major On-Street Pedestrian/Bicycle Routes

Rail Transit Hub Attractor (Long-Term)

Retail Anchor

Priority Development/ Renovation Blocks

Primary Retail Anchor

City Center Attractor

Important Development Renovation Blocks

Primary Neighborhood Pedestrian/Bicycle Connections

In association with Nine Counties. One Vision. the firm has developed a "Civic Vision" urban design plan for the revitalization of downtown Knoxville. The plan reestablishes the downtown as the civic, cultural, shopping, employment, and residential hub of the East Tennessee region. It identifies catalyst projects in the heart of downtown, along Church Avenue and Gay and State Streets. It also provides a strategy for creating a premier regional "main street" shopping district, new open space, and transit and pedestrian improvements that link the heart of downtown to the riverfront, nearby neighborhoods, and the adjacent University of Tennessee campus. Public involvement was a key component of the project's success. The firm held many public workshops and attended dozens of meetings with residents, politicians,

1 North Gay Viaduct Improvements
2 Mixed Use Parking Structure
3 Rail Transit Hub (Long Term)
4 Mixed Use Parking Structure
5 Gay Street Facade Improvements
6 Old City Housing Parking Structure
7 State Street Promenade
8 Central Street Ped/Bike Improvements
9 Old City Retail and Parking
10 Retail Anchor
11 Parking Structure (retail-serving)
12 Summit Hill Square
13 Summit Hill Drive Improvements
14 Knox County Redevelopment Blocks
15 Wall Avenue Extension/Future Bridge
16 Market Square Mixed Use Parking Structure
17 Henley Street Grade Separation/ Boulevard Improvements
18 Clinch Avenue Streetscape Improvements
19 Streetcar Route
20 Transit Center/Retail Anchor/Cinema
21 State Street Garage Expansion
22 Church Avenue Streetscape/ Facade Improvements
23 Church Avenue Mixed Use Parking Structure
24 Church Avenue Square and Below-grade Parking
25 Church Square Parking Structure
26 Boutique Hotel
27 News-Sentinel Site Mixed Use Parking Structure
28 Cultural Building/Parking
29 Redevelopment Block
30 Church Avenue Bridge Improvements
31 Headquarters Hotel
32 Promenade Mixed Use Redevelopment

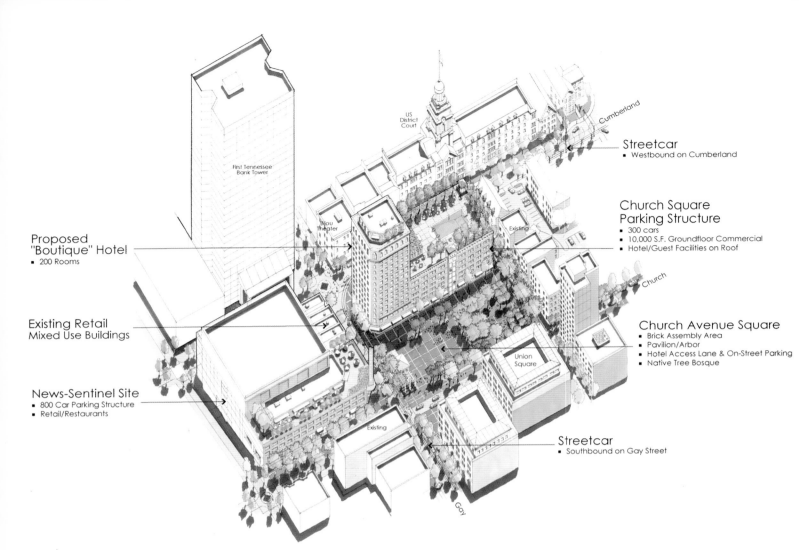

Proposed "Boutique" Hotel
- 200 Rooms

Existing Retail Mixed Use Buildings

News-Sentinel Site
- 800 Car Parking Structure
- Retail/Restaurants

First Tennessee Bank Tower

Bijou Theater

US District Court

Streetcar
- Westbound on Cumberland

Cumberland

Church Square Parking Structure
- 300 cars
- 10,000 S.F. Groundfloor Commercial
- Hotel/Guest Facilities on Roof

Existing

Church

Church Avenue Square
- Brick Assembly Area
- Pavilion/Arbor
- Hotel Access Lane & On-Street Parking
- Native Tree Bosque

Union Square

Existing

Streetcar
- Southbound on Gay Street

Gay

planning organizations, special interest groups, developers, and Nine Counties. One Vision. Over 800 individuals attended these meetings and contributed to development of the plan. In addition, the Knoxville Museum of Art Design Lab's inaugural show — *Designing a New Knoxville: The Work of Crandall Arambula* — showcased the downtown plan, giving the community another opportunity to comment on the plan's details before the project moved into the implementation phase. A prominent local business leader praised the plan as "a significant set of possibilities that are truly within our grasp,"

with "an implementation process that is doable." In summary, he called the plan "the best opportunity we've had in 30 years to move forward in a positive and determined way."

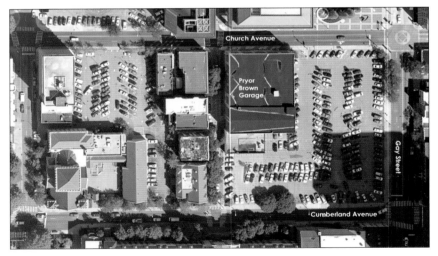

Church Avenue

Pryor Brown Garage

Gay Street

Cumberland Avenue

Above: *Concept sketch for Church Square, city center attractor.*
Above right: *Existing Church Square district.*
Right: *Church Square district development concept.*

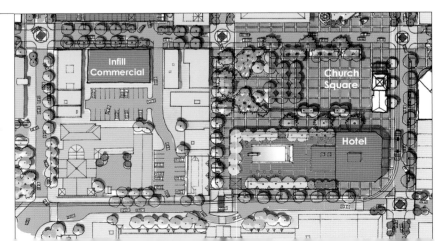

Infill Commercial

Church Square

Hotel

Dahlin Group

Corporate Headquarters:

2671 Crow Canyon Road
San Ramon
California 94583
925.837.8286
925.837.2543 (Fax)

www.dahlingroup.com

539 South Cedros Avenue
Splana Beach
California 92075
858.350.0544
858.350.0540 (Fax)

101 Townsend Street
Suite 209
San Francisco
California 94107
415.538.0933
415.512.1313 (Fax)

Dahlin Group

Alameda Point
Alameda, California

Above: Hangar Row before development.
Below: Park with pavilions.
Below right: Park with military memento

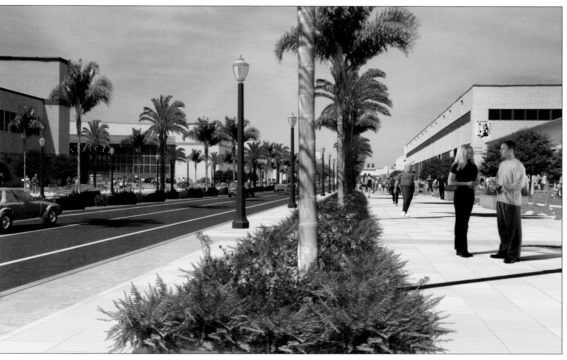

This conceptual master plan envisions transforming the former Alameda Point Naval Air Station into an exceptional waterfront community, capitalizing on its prime location on San Francisco Bay. By extending the traditional grid of Alameda Island, the new neighborhood will meld seamlessly with the existing commu-

nity. The community carefully balances residential areas, parks, waterfront recreation, a variety of office and light industrial uses, convenience and destination retail, and cultural and educational facilities — all woven together by an integrated system of pedestrian, bicycle and vehicular routes. Included is a

multi-modal transportation hub serving buses, ferries, and a state-of-the-art high-speed aerial gondola linked directly to the BART regional transit system. Existing hangars and other structures will be converted to recreational, civic, office, R&D, warehouse and light industrial uses. The community's residential

opportunities will include a wide range of housing options intended to meet a variety of market needs. Destination retail, restaurant, entertainment and possibly a boutique hotel are proposed along the marina promenade.

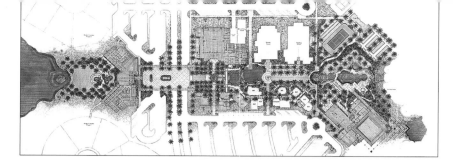

Dahlin Group

Sun City Grand
Surprise, Arizona

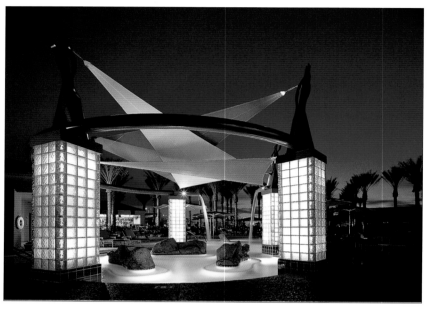

Twenty-eight acres of former cotton field have been transformed into a town center for a 10,000-unit active adult development. A pedestrian village was created by compressing the community buildings along a linear oasis of water features, patios and lush plantings. Focal points at the ends of this 10-acre axial open space are the Sales Center (future community library) and the multi-colored shade structure of the resort-style pool. To either side of this axis are a social center with ballroom and kitchen, a series of lecture and card rooms, and a fitness center, with an indoor pool and walking track in a prominent wing overlooking a lake. The structures built to date total over 100,000 square feet. Construction is of wood frame, stucco walls, concrete tile roofs, and native Arizona flagstone.

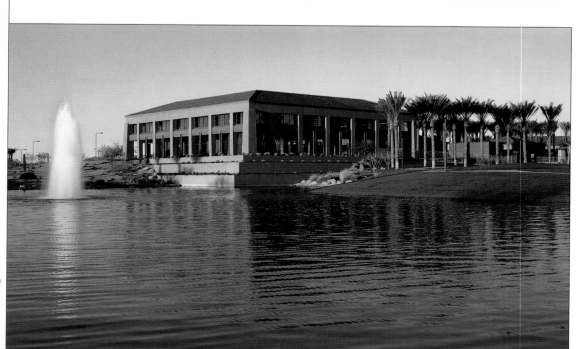

Top: Site plan, with community center at west (left) end and pool at east end.
Above: Spa pool.
Left: Pool wing of fitness center.
Facing page: Sales Center, to be future library.
Photography: Steve Whitaker.

100

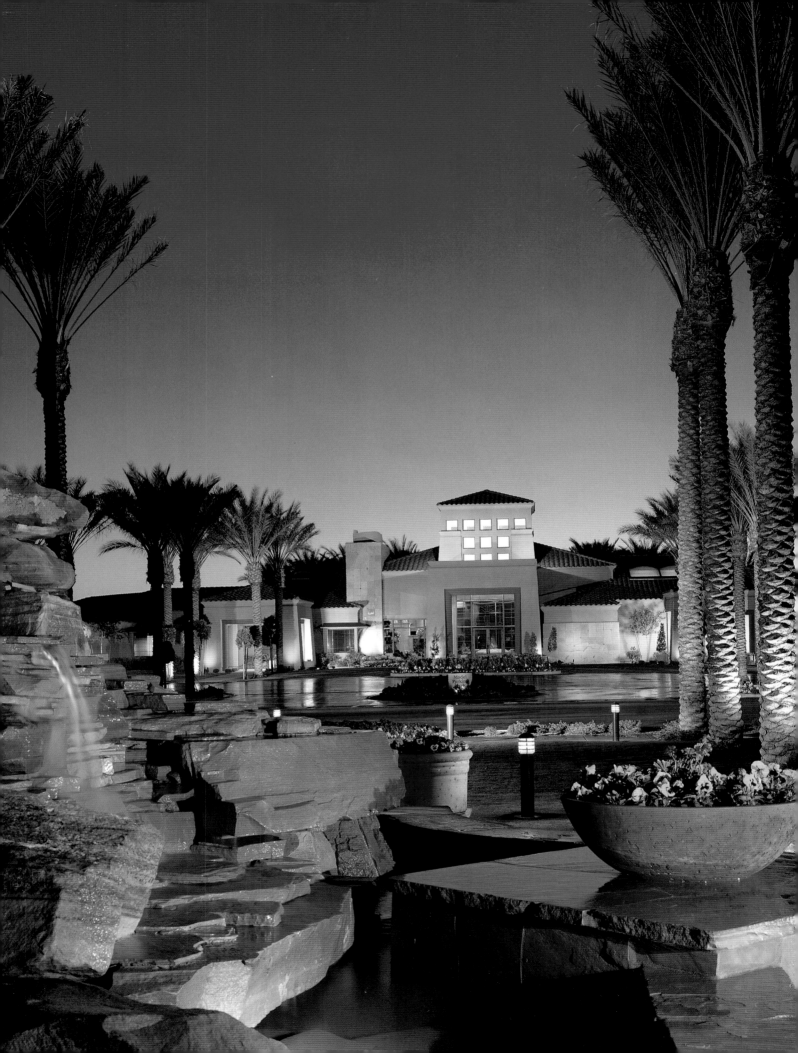

Dahlin Group

St. Vincent's
San Rafael, California

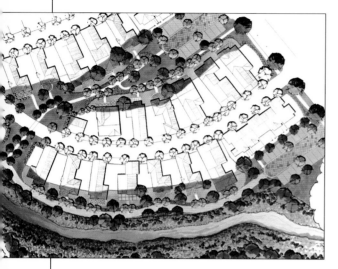

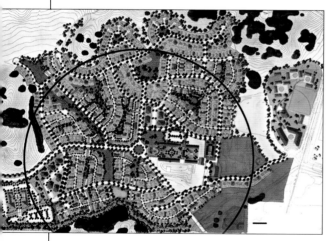

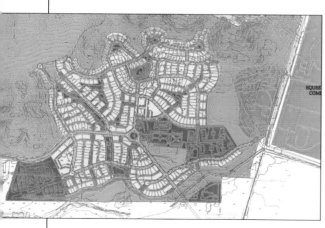

Above: Existing church, to be restored for traditional uses.
Below: Proposed house types.

Top left: Neighborhood plan with back alleys and green pedestrian ways.
Above left: Community plan, centered on old church complex.
Left: community set in open spaces.

For over a century, a church-based institution has supported orpheneed and at risk boys on this 836-acre site. Realizing that the land could support today's services in a different way, the organization decided to convert part of its acreage into a residential community in order to endow a new residential school for boys in need. As members of the chosen developer's team, the Dahlin Group has spent years shaping an environmentally sensitive plan. The proposal preserves large open areas, saves and celebrates the historic church and cloister, and accommodates a new residential boys' campus. Only 314 acres will be developed, conserving valued view corridors, natural hillsides, and wetlands. Most of the residences will be within a quarter-mile of the historic complex, which will serve as both a symbolic and a functional focus. A variety of residential types, attached and detached, some with secondary units on site, will be widely dispersed, rather than segregated

by neighborhood. Many units will have alley automobile access and fronts facing walkways; mews units will share small-scaled guest parking plazas. The original church and cloister will retain their traditional use, with remaining structures of the old institution adapted for community and neighborhood commercial use. A new boys' school campus will be developed to the east of the community, and a new office complex will be located to the west near a highway interchange.

Above: Boys' school buildings adapted for community use.
Below: Houses along pedestrian path.

Dahlin Group

Rivermark
Santa Clara, California

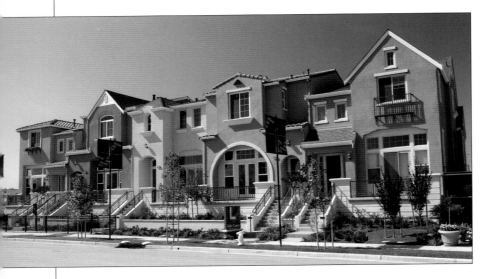

This infill master planned community is located on a 225-acre former hospital campus in the heart of Silicon Valley. Pedestrian, bicycle and light rail opportunities link nearby high technology employers. The master plan builds residential neighborhoods around shared-use K-8 school and park, branch library and main street retail district. An east/west paseo links residents to schools, parks, corporate campus, bus routes and regional light rail stops. The retail mixes both a main street drive with traditional storefronts, sidewalk cafes, and kiosks, with more conventional parking oriented convenience retail. Grocery anchored convenience retail and mid-rise hotel serve surrounding residential and business demand, as well as new residents. Residential neighborhoods offer approximately 1900 new market rate and affordable homes, including a mix of single family detached homes (8-14 du/acre), attached town homes (16-20 du/acre) and multi-family residences (up to 50 du/acre). An overall density of 20 units per acre is achieved, while including substantial proportion of single-family detached homes. The use of carriageway loaded plans, entry doors, and porches fronting pedestrian paseos rather than streets and reduced street widths provide a pedestrian friendly and sociable public realm. Strict common street tree program will facilitate a graceful neighborhood maturing.

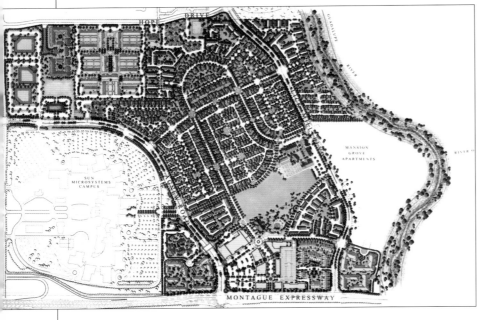

Top: *Completed attached houses.*
Above: *Community site plan.*
Right: *Library seen from retail street.*

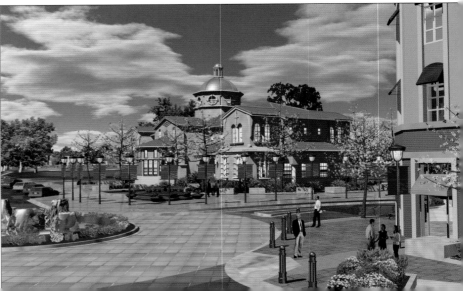

David Owen Tryba Architects

1620 Logan Street

Denver

Colorado 80203

303.831.4010

303.894.5363 (Fax)

www.dota.com

info@dota.com

David Owen Tryba Architects

Wellington E. Webb
Municipal Office Building
Denver, Colorado

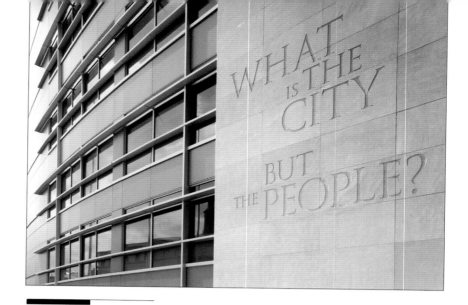

Above: *Inscriptions reflect building's civic purpose.*
Below: *Large-scale elements give facade presence from Civic Center Park.*
Photography: *Frank Ooms Photography.*

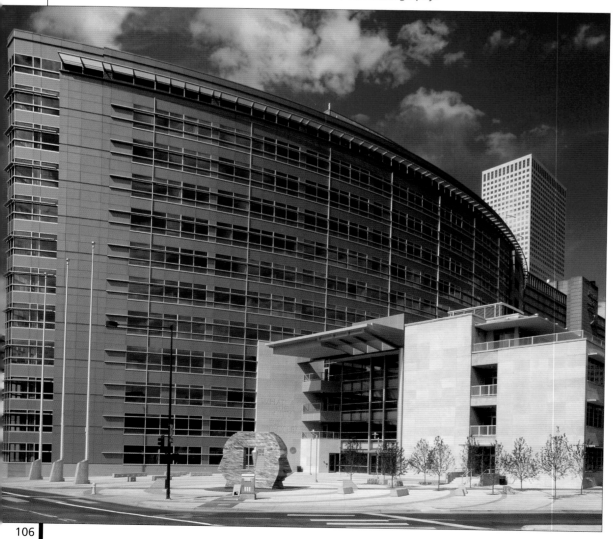

The winning entry in an international design competition, the $132-million Municipal Office Building makes a statement about the city's growth as a cultural, economic, and population center while setting a new standard for Modernism in the city's Civic Center. The government center for the city and county, a joint venture project with RNL Design, integrates a 1949 International Style historic structure, (the old Denver University Law School), with a new 12-story office tower. The building houses over 2,000 city employees from 46 agencies previously scattered throughout the city. The building's transparency makes

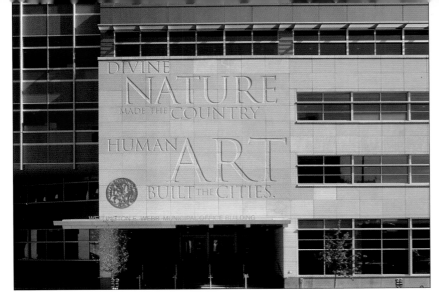

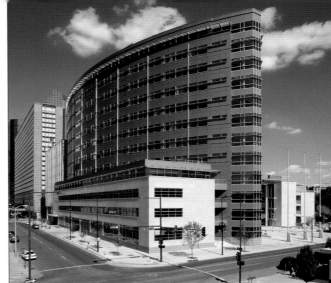

Above: Inscriptions reminding public of importance of civic art.
Above right: Building accessible from all sides, with curved facades respecting neighbors.
Right: Limestone and glass atrium links historic annex to new aluminum-clad tower.
Below: Mountain views reserved for stacked conference rooms.

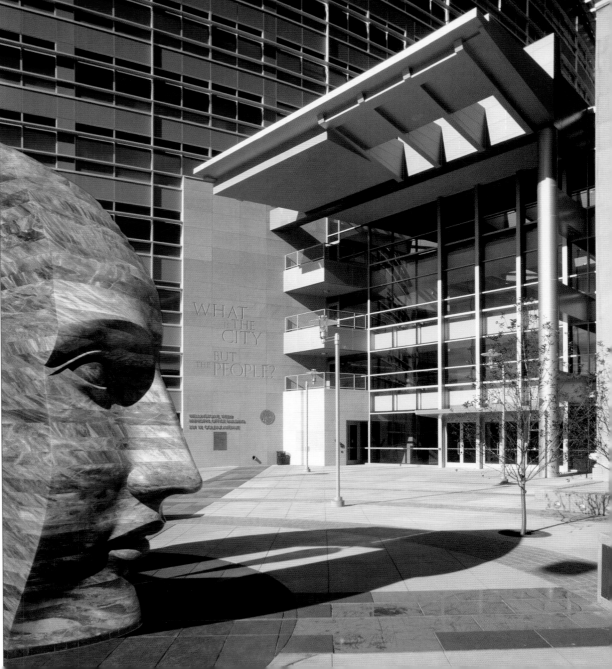

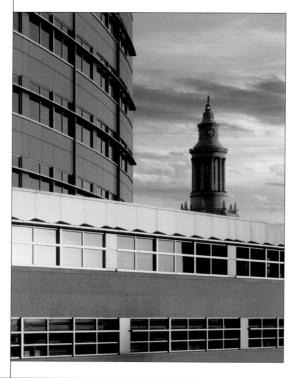

the workings of government visible to all. The tower's convex shape provides broad panoramic vistas. Its perimeter circulation gives visitors and employees continuous views to the mountains and civic park, while also animating the atrium. In keeping with the democratic floor plan, the corners where curved walls meet are reserved for public meeting and conference space, rather than executive offices. The plaza, the atrium, and the transparent ground floor facilitate the connection of the commercial district on one side with the Civic Center on the other. The inclusion of retail and restaurant spaces make this the city's first mixed-use public building The building is a fitting expression of Denver's civic pride.

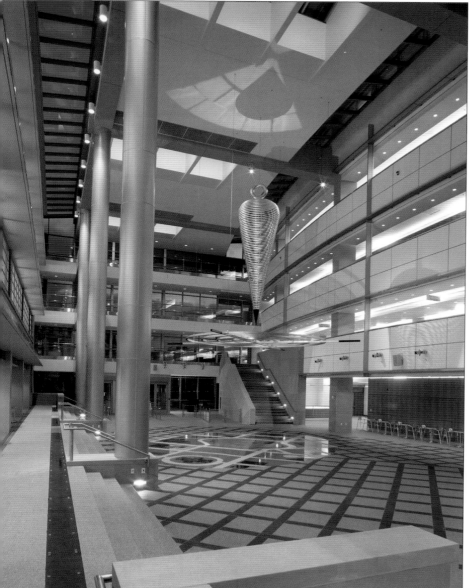

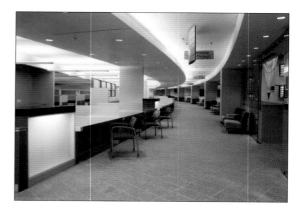

Top left: Sunlit curvilinear facade with views of historic City Hall cupola.
Above: Tower interior with perimeter circulation.
Left: Daylit atrium with major public art installation by Larry Kirkland.
Facing page: Tiered massing at one corner relates to pedestrian flow and neighboring structures.
Photography: Frank Ooms Photography.

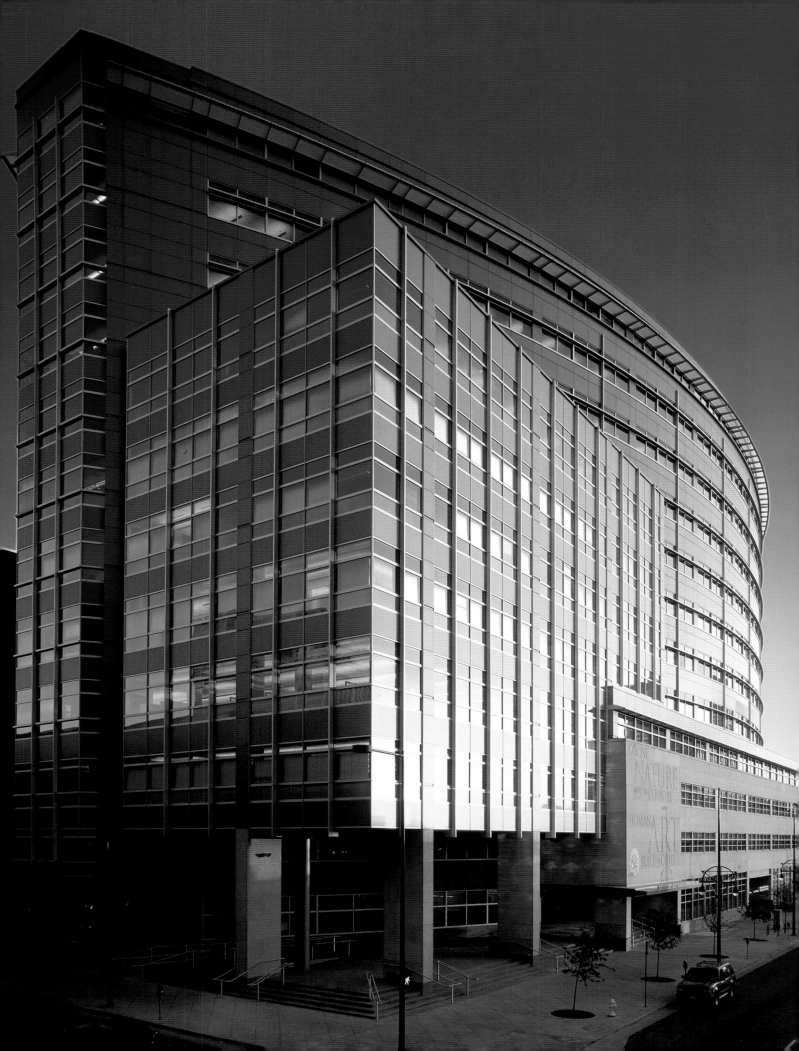

David Owen Tryba Architects

16th Street Center
Denver, Colorado

On a site previously occupied by surface parking, the $11.7-million contextually responsive structure provides six levels of covered parking above street level retail. Strongly influenced in its proportions by nearby historic buildings, yet modern in its articulation and materials, the center maintains the scale of buildings that line the lively 16th Street corridor.

110

Above: *The articulated sunshades and extruded mullions capture and screen sunlight on the west facade.*
Left and facing page: *Restaurants, retail, and convenient parking enhance the city's premier pedestrian mall.*
Photography: *Ron Pollard.*

David Owen Tryba Architects

RTD Light Rail/Intermodal Transit Facility
Englewood, Colorado

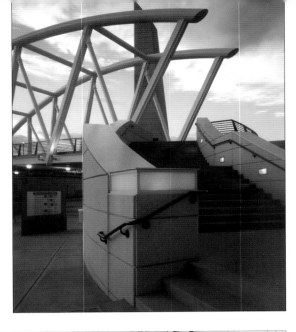

The Englewood transit facility provides access to Denver's regional light rail system, with an on-site parking structure and connections to local bus lines. The first facility of its kind in the Denver area, the project incorporates a 55-acre mixed-use development. A 110-foot steel truss "gateway" bridge, the project's centerpiece, spans a bus transfer facility and connects the light rail station to the project's central pedestrian plaza. The stairways descend from the bridge and form an elliptical amphitheater for both planned and impromptu events. The facility is part of a $140-million master plan for the redevelopment of an abandoned shopping mall into an urban, pedestrian-oriented, mixed-use environment. The total built area exceeds 600,000 square feet and includes 291 residential units, 380,000 square feet of retail and restaurants, and 150,000 square feet of offices. The Englewood Civic Center, which combines municipal offices, courtrooms and a public library, is located on the plaza.

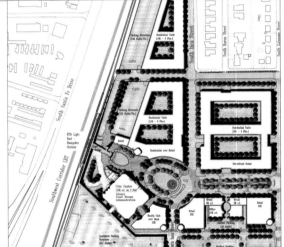

Top: Civic details frame the gateway from the light rail station to the plaza below.
Right: Redevelopment master plan emphasizes civic open space.
Below: The curvilinear bridge effectively connects the civic environment with the light rail above.
Photography: Ron Pollard.

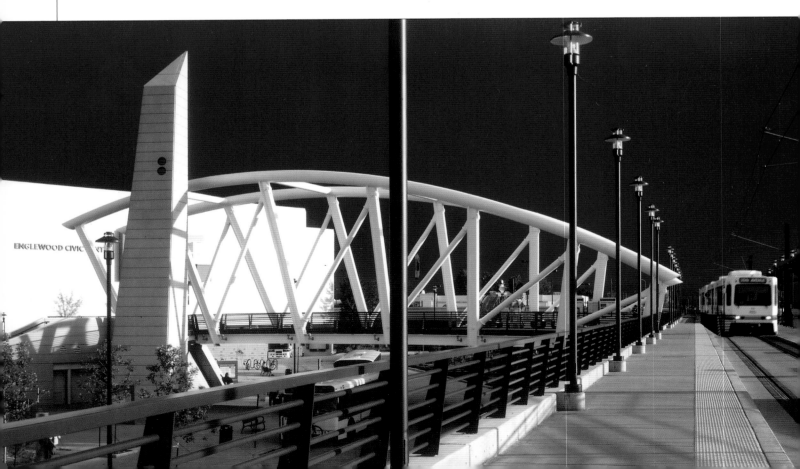

DeStefano Keating Partners

445 East Illinois Street

Suite 250

Chicago

Illinois 60611

312.836.4321

312.836.4322 (Fax)

www.destefanokeating.com

info@destefanokeating.com

Los Angeles

London

Naples, Florida

DeStefano Keating Partners

Streetscapes
Public Spaces

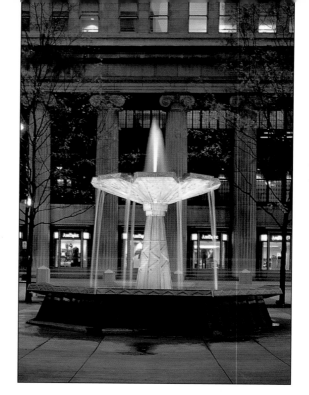

Left: Board of Trade fountain, reflecting Art Deco precedent of board's building – not seen here.
Photography: Hedrich Blessing.

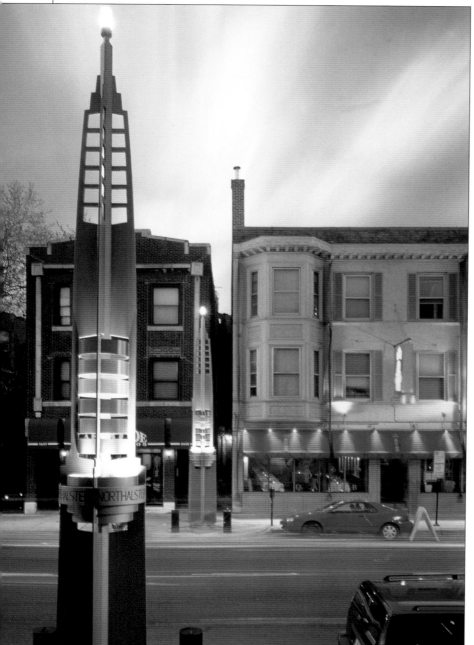

Above: Custom planters identify side street intersections.
Left: Lighting pylons using recognized rainbow symbolism.
Photography: Hedrich Blessing.

The firm has completed several streetscape improvement projects and public fountains, with more under way.

Fountain for the Chicago Board of Trade
Chicago, Illinois

Funded jointly by the city and the Board of Trade, the fountain commemorates the institution's 150th anniversary. The Art Deco design of the board's 1930 landmark building inspired the form and relief detail of the fountain's cast aluminum shaft and upper bowl and the precast terrazzo lower bowl.

North Halsted Streetscape
Chicago, Illinois

Much discussion and many meetings followed the city's decision to improve a mile-long stretch of street with one of the world's largest concentrations of gay and lesbian dining, shopping, and entertainment. Sidewalks were widened from 7 to 11 feet, and parking spaces on the narrowed roadway retained. Steel area markers identify the district at both ends, with pairs of rainbow-themed steel pylons occurring at least once per block. Planting and signage on "bump-outs" at each corner identify residential side streets and help separate them from activity on Halsted. The well-detailed, durable streetscape elements survived efforts to "Victorianize" them. Of the $3.5-million budget, 80 percent went to infrastructure work on the long-neglected street.

Division Street Gateways
Chicago, Illinois

A waving Puerto Rican flag is the motif of two symbolic portals installed by the city to define the ethnic identity of a stretch of Division Street. Designed to withstand winds of 100 mph, the pennants are made of steel plate and steel pipe. Concurrent street improvements include 45 sheet steel banners with various Puerto Rican symbols, mounted on existing utility poles, and 16 "plazitas" with bench/table groupings, special paving, and planters. Area business has boomed following these improvements.

Hammond Streetscape
Hammond, Indiana

The core of this city in northeast Indiana near Chicago is undergoing revival, but is little-known regionally and hard to find. Proposed in its streetscape program are 55-foot gateway markers that reflect Hammond's multiple connections in their computer-generated complexity, but can be built of simple steel components.

The firm's projects have added substantially to their city's public recreational resources.

Diversey Driving Range
Chicago, Illinois

Located in a heavily used lakefront park, the structure had to meet the needs of golfers yet be palatable to vastly larger numbers of park users. Oversight by the Chicago Plan Commission and many civic groups helped the architects to transform the utilitarian intrusion into a visually appealing "folly." A series of playfully arranged steel screen panels wrapped around the spidery structure serve as trellises for ivy and Virginia creepers.

Hayes Park New Natatorium
Chicago, Illinois

An addition to a 1970s field house includes an indoor swimming pool and an outdoor water play area for young children, along with support spaces. To respect the scale of neighborhood bungalows, the design takes a cue from the low front wing of the field house, extending a one-story brick "wrapper" around the new wing, with the pool and exercise room identified by their clerestoried upper volumes. Extending the wall around the water play area provides a much needed secure space for small children and allows part of the swimming pool's glazing to extend to the ground.

Fernwood Park Natatorium
Chicago, Illinois

Economical construction and resistance to vandalism conditioned the design of this 10,000-square-foot addition to a park field house. Abundant light enters the 25-meter pool through energy-efficient translucent clerestories between the unbroken wall and the steel-framed roofs.

North Park Village Gymnastics Center
Chicago, Illinois

The auditorium of a former city tuberculosis sanitarium, dating from 1915, has been adapted as a public facility for popular, expanding gymnastics programs. Its reuse follows a master plan by the architects for the many structures on this campus. Boarded up for decades, the auditorium required extensive restoration of its brick and terra cotta exterior details. Inside, a new steel structure from the ground up supports a new second floor, plus new stairs and an elevator. The completed structure can accommodate 13 Olympic events at a time, with seating for 130 spectators on each floor.

Above: Double-deck Diversey Driving Range structure.
Right: Computer rendering of Hayes Park Natatorium, exterior and interior.
Photography (above): Barbara Karant.

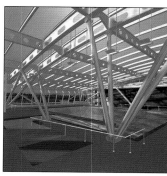

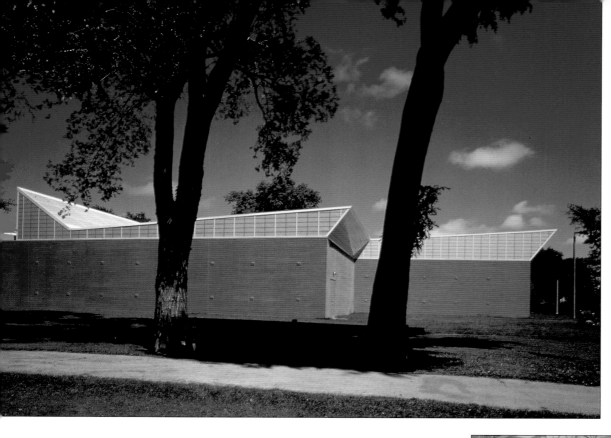

Left: Brick walls and translucent clerestories of Fernwood Park Natatorium.
Below: Swimming pool with spray feature.
Photography: Barbara Karant.

Right: Old North Park Village auditorium revived as gymnastics center.
Below right: Second-floor space for gymnasts.
Photography: Hedrich Blessing.

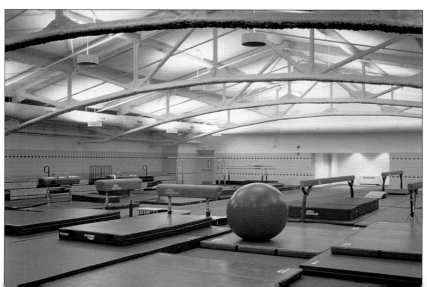

117

DeStefano Keating Partners

Korean International Exhibition Center Goyang, Korea

Located halfway between Seoul and its new international airport at Inchon, the Korean International Exhibition Center (KINTEX) will be completed in four phases between 2003 and 2005, with a final area of 116,571 square meters (about 1,339,000 square feet). The city of Goyang is noted for its parks and floral gardens, and the center's design maintains this motif in its generously landscaped grounds and winter garden lobby. DeStefano Keating Partners is a member of the Junglim Consortium of architects, which won the commission through a design competition.

DeStefano Keating Partners

The Residences at RiverBend
Chicago, Illinois

Rising on the west bank of the Chicago River, on a prominent site terminating a long view from the Loop, this 152-unit condominium tower responds to a number of urban design conditions. It is the first structure of a phased multi-use complex under a 1990 plan approved by the city. All apartments in the 37-story structure face east toward an extraordinary view of the Loop, with Lake Michigan beyond. Four townhouses are on a promenade level at the base of the tower. The fourth floor is devoted to shared business, meeting, party, spa, and health club facilities. Seven stories of valet parking underpin the major volume of apartments. Befitting the location in a transforming industrial area, the apartments have 11'– 8" ceiling heights, with exposed concrete framing and loft-like partial-height partitions. Corridors running along the building's west side are configured so that west light passes above them into the apartments.

Right: Straightforward design and fine materials in lobby.
Below right: Slightly concave river façade responding to bend in opposite bank, site of convex 333 Wacker Drive building.
Photography: Hedrich Blessing.

119

DeStefano Keating Partners

Dearborn Plaza
Chicago, Illinois

A site measuring only 100' x 300' posed a challenge in the design of an efficient 400,000-square-foot building in Chicago's developing River North district. Above an arcaded retail first floor, the building houses five stories of hotel, topped by offices. By devising a narrow core configuration, the architects were able to provide a marketable 37-foot office depth on either side. The exterior envelope respects the city's building tradition while demonstrating the architects' commitment to cutting-edge design. A frame of concrete, with Chicago School proportions, is visually "clipped" over a metallic curtain wall with clear glazing. This frame is deliberately cut back at the corners or wrapped beyond them to reveal its thinness. The wall planes engage a cylindrical volume at the intersection of two principal streets. Sunshades project from the south and west elevations, easing mechanical loads while allowing daylight to penetrate the floors. The required 10-foot setback of the top floor was turned to advantage with outdoor spaces covered by projecting cornices that crown the structure.

Above left: Lobby for office floors.
Left: Cylindrical corner, with top-floor setback under crowning cornice.
Below right: Wall detail, showing sunshades.
Photography: Hedrich Blessing.

Dover, Kohl & Partners

1571 Sunset Drive

Coral Gables

Florida 33143

305.666.0446

305.666.0360 (Fax)

www.doverkohl.com

Dover, Kohl & Partners

The Jupiter Waterfront Quarter
Jupiter, Florida

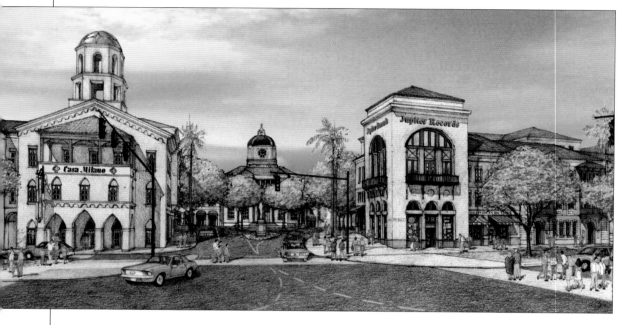

A 1997 study by Dover Kohl and the Treasure Coast Regional Planning Council for the U.S. 1 corridor — entitled Who Cares About U.S. 1? — inspired communities and developers to revitalize the patchy setting with planned infill projects. Along the 15-mile stretch studied, one "what if" site identified was a 9.7-acre tract on the Intracoastal Waterway that became the Waterfront Quarter. Dover Kohl, along with Chael, Cooper & Associates and Gentile, Holloway, O'Mahoney & Associates, have since been commissioned by developer Sheehan Realty, Inc., to produced a detailed design for the site. The proposal envisions some 364,000 square feet of mixed uses, about two-thirds of it residential, with 79,000 square feet of shops and restaurants, 38,000 square feet of offices, and 18,000

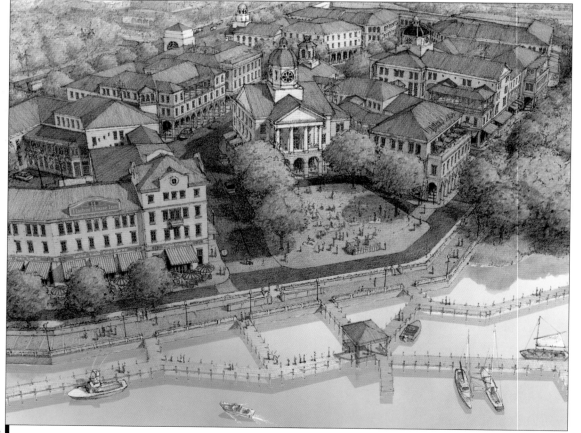

Above left: Entry to Quarter from U.S. 1.
Left: View from Intracoastal Waterway toward highway.
Renderings: James Dougherty.

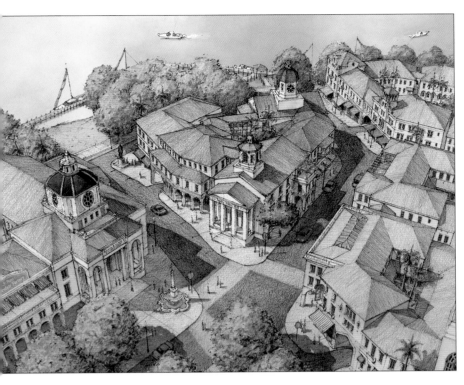

square feet of cultural facilities. The enclave is patterned after a historic Caribbean town. Buildings are closely set, with parking largely below grade to maintain a pedestrian environment. The concrete-framed buildings will be stucco walled, with tile roofs. Forms and details will be essentially Mediterranean Classical Revival in style, with variations recalling vernacular constructions of the 19th and early 20th centuries. The project meets the Riverwalk District zoning requirements adopted by the Town of Jupiter.

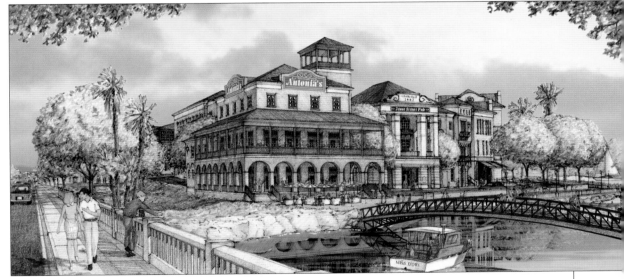

Top: View toward waterway.
Above right: View from U.S. 1 at waterway.
Right: Proposed building elevations.
Renderings: Elevations: James Dougherty/Pedro-Pablo Godoy (right).

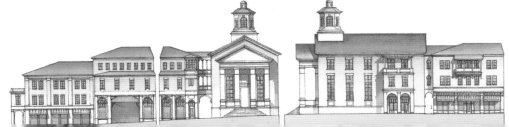

Dover, Kohl & Partners

A New Neighborhood in Old Davidson
Davidson, North Carolina

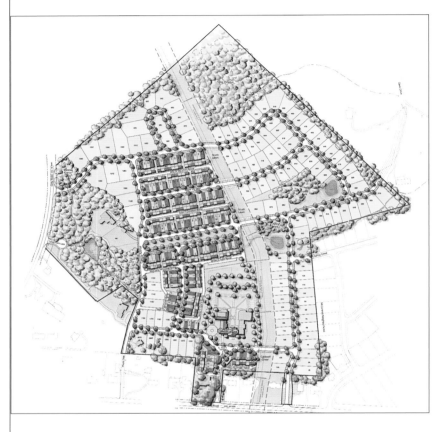

A new neighborhood near downtown and the Davidson College campus is being developed by Boone Communities LLC under a recently adopted town code, based on principles of the New Urbanism. The master plan merges seamlessly with the existing urban fabric and includes a variety of housing options, generous green spaces, and a mixture of uses. At a public charrette in 1997, participants were asked to choose between an "old code" plan that followed conventional suburban patterns and a "new code" version drawn up by Dover Kohl & Partners in collaboration with Turnbull Sigmon Design. An overwhelming majority favored the traditional plan under the new code, which is denser and more diverse, and has a highly connected street pattern. The plan calls for construction of single-family houses, rowhouses, live/work units, and a new church. The network of green spaces evolved around a gas pipeline easement through the site. Public spaces are designed to accommodate all age groups, with tot lots, soccer fields, manicured and natural park areas, and trails through the wooded Preserve.

Top: Site plan.
Above: Sand play.
Right: Neighborhood park/playground.

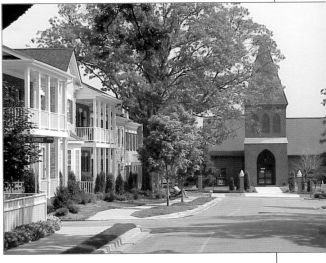

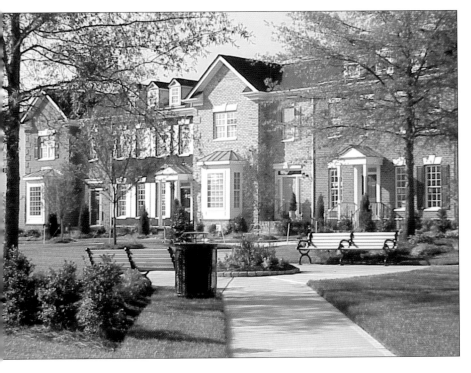

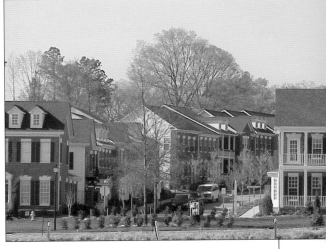

Above: Rowhouses on square.
Top right: Street leading to church.
Above right: Townhouse area.
Right: Single-family houses.
Photography: Boone Communities, LLC.

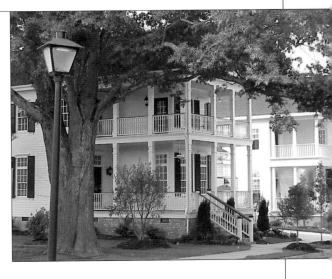

Dover, Kohl & Partners

Hammond's Ferry
North Augusta, South Carolina

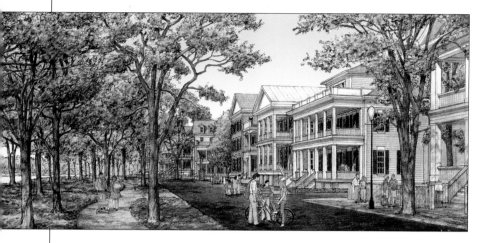

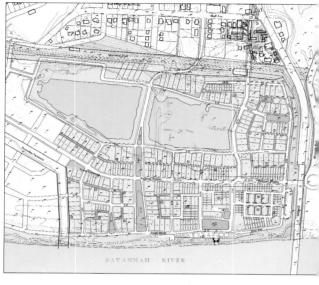

This 192-acre development, combining both brownfield and greenfield areas, is intended to reconnect North Augusta with its riverfront. The project envisions a variety of residential types, offices, retail, restaurants, and civic uses. Public spaces will vary from the formal town square on the river to more informal internal parks. The plan for the development grew out of a five-day charrette held with developers, architects, and more than 100 local citizens in 2002. That event confirmed a strong interest in the riverfront as a setting for public and private activities. Proposals from that event were widely disseminated in print and on TV. Design guidelines for the area's buildings were later submitted with the master plan for municipal approval.

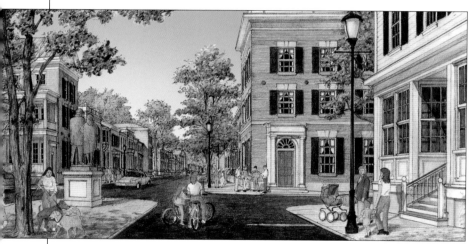

Top: *Front Street houses facing river.*
Above: *Mixed uses and mixed building types.*

Top right: *Master plan.*
Below: *Town square on river.*

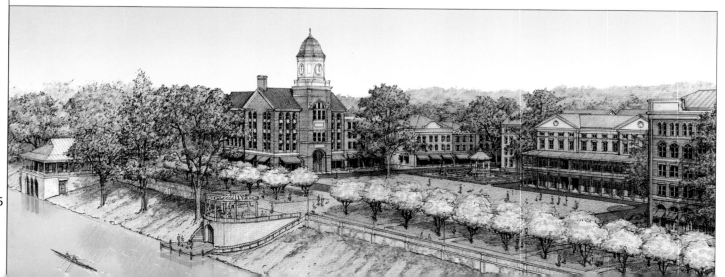

Dover, Kohl & Partners

Downtown Kendall
Miami-Dade County, Florida

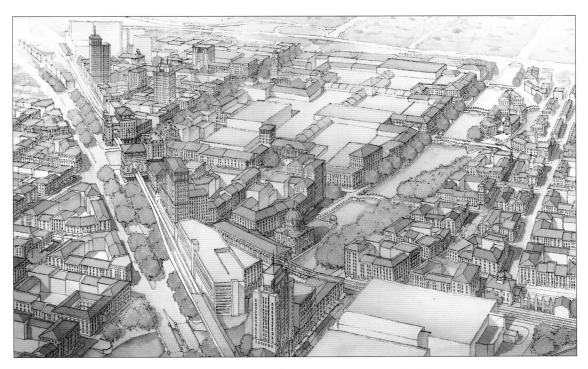

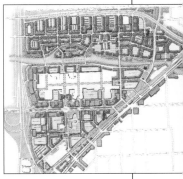

The master plan for the heart of Kendall will transform a 150-acre tract of sprawl into a walkable, mixed-use downtown. The plan and new zoning code grew out of a 1998 charrette led by Dover, Kohl & Partners and Duany Plater-Zyberk. New growth will be directed toward achieving a coherent fabric of retail, office, hotel, residential, and entertainment facilities. At an intersection for heavily traveled roads and Metrorail, the area has untapped potential. Land around the existing Dadeland Mall at the core of the area will be filled, in stages, with mixed-use buildings fronting on surrounding streets and forming new squares. Major streets will be enhanced with colonnaded sidewalks and trees in their medians. Residential areas along Snapper Creek will be rebuilt as dense pedestrian neighborhoods capitalizing on the waterway frontage.

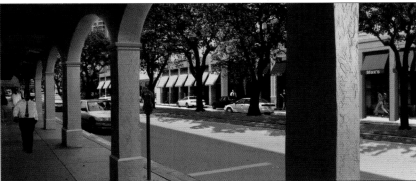

Above right: Master plan.
Above: Built-out vision for Kendall.
Left: Computer image of pedestrian-friendly Dadeland Boulevard.

Left: Current appearance of Dadeland Boulevard.
Renderings: James Dougherty.
Computer visualizations: Steve Price of UrbanAdvantage.

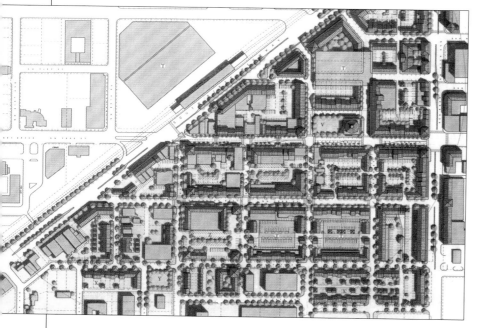

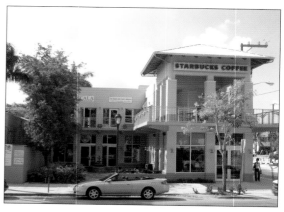

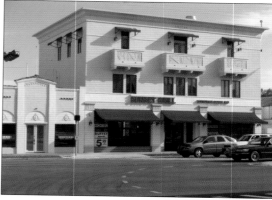

The area's grid of streets is to be reclaimed as people-friendly public space in this master plan and accompanying development regulations. The effort was initiated by a local non-profit, South Miami Hometown, Inc., based on charrettes conducted in 1992 and 1994. An implementation strategy stresses "100% model" projects, intended to transform locations, however small, into vivid demonstrations for neighbors, bankers, and potential residents and businesses. Using scarce resources, public or private, these projects can create one mixed-use infill building, for instance, or reconfigure all four corners at an intersection. Reuse of existing structures and introduction of residential units are encouraged. One large-scale proposal is converting the existing Metrorail station into "Hometown Station" by wrapping four-story mixed commercial/residential buildings around its parking garage and capping it with courtyard apartments. Zoning revisions make outdoor dining possible and allow shared-parking reductions for mixed-use sites.

Top left: *Master plan.*
Above: *Two new mixed-use infill structures by affiliated firm Chael, Cooper & Associates Architecture.*
Below: *Street with narrowed roadway, outdoor dining, and tree planting.*

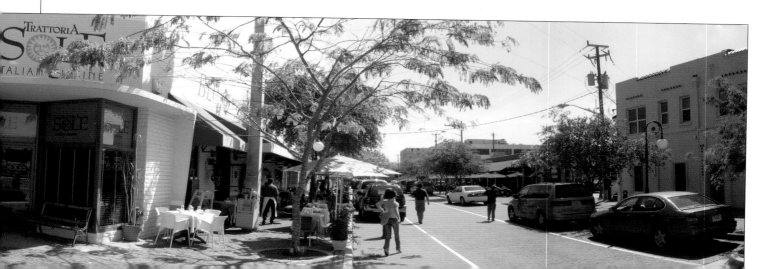

Duany Plater-Zyberk & Company

1023 Southwest 25th Avenue Washington

Miami Charlotte

Florida 33135 Kuala Lumpur

305.644.1023

305.644.1021 (Fax)

www.dpz.com

Duany Plater-Zyberk
& Company

Kemer Village
Istanbul, Turkey

Kemer Country, a 525-acre forested district north of Istanbul, is the site of a 25-acre village that offers the Turkish middle class an alternative to American style suburban development. Located near a 16th-century aqueduct, the village consists of 129 residential units and will include a school, shops, and a meeting hall. Distributed across the remaining 500 acres will be another 200 units, grouped in hamlets. The houses in the village are based on 13 models, all inspired by regional types, varying in form according to their relationship to the street and other buildings. The layout of the village addresses such aesthetic and climatic concerns as defining certain vistas, establishing

Above: *Village master plan.*
Above right: *Edge of Aqueduct Green, with aqueduct in distance.*
Right: *Typical street and house types.*
Photography: *Kemer Yapi Ve Turizm and DK & Partners.*

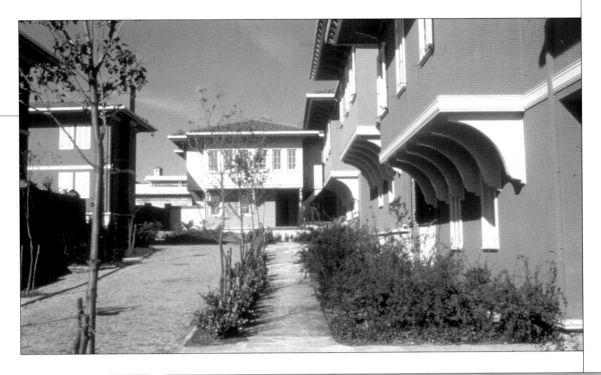

Right: A quiet narrow street of houses with traditional bracketed bays.
Below: Entry pavilions.
Below right: Aqueduct Green.
Bottom right: View of larger homes at the village edge.

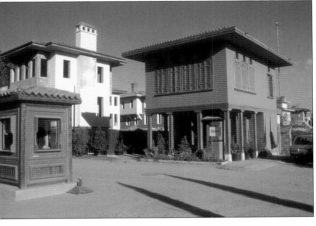

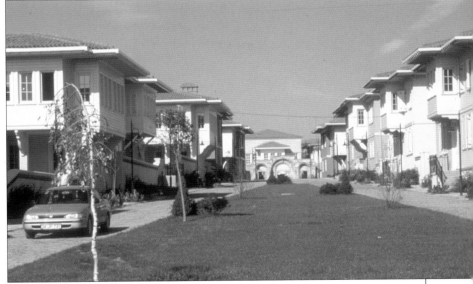

amenities such as squares, maximizing sunlight in gardens, preserving existing trees, and blocking cold north winds. Streets, alleys, and walkways are designed to encourage pedestrian movement and calm automobile traffic. Particular care was given to the separation of public and private spaces, a critical concern in Turkish urbanism. Continuous walls connect the houses throughout the village, not only defining the public space, but also providing enclosed courtyards and side gardens, the predominant traditional forms of private outdoor space in Turkey.

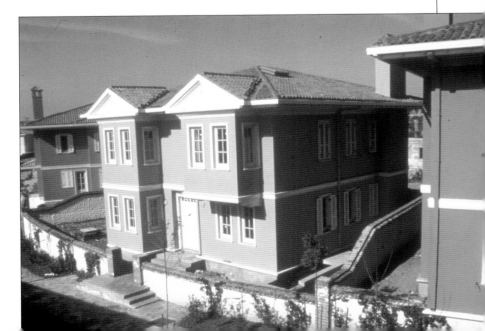

Duany Plater-Zyberk & Company

Dos Rios
Manila, Philippines

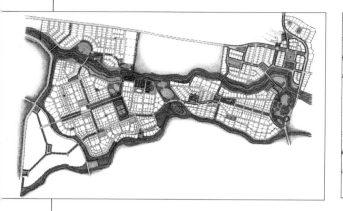

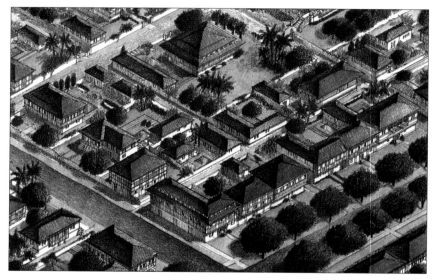

Dos Rios will be unique among contemporary Filipino developments in reviving the local tradition of the family compound. Averaging 2 hectares (5 acres) in area, each compound can house an extended family or be sold off in pieces, accommodating up to 14 housing units either way. Each compound offers two distinct frontages: one high-density, fronting major streets, for younger residents; the other, facing more rural lanes, for heads of families or retirees. Construction of each compound can proceed in phases over a long term. Two town centers will be located within a ten-minute walk of all residents, supporting local businesses and industries. They will be anchored by a satellite university campus, two schools, a small inn, and a jeepney station connecting to regional buses. Apartments and shophouses in the centers will offer additional housing options. Both the architecture and the landscape will follow sustainable principles, with cisterns to collect rain runoff, gray water sustaining native plantings, and buildings maximizing the cooling effects of high ceilings, louvered openings, and verandas.

Above: Master plan.
Top right: Compound development sequence.
Above right: True compound at end of long-term build-out.
Right: Sideyard houses.
Below right: Typical street.

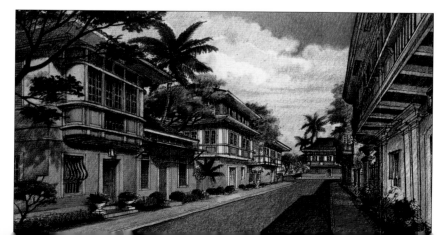

Duany Plater-Zyberk & Company

Putrajaya Diplomatic Enclave
Kuala Lumpur, Malaysia

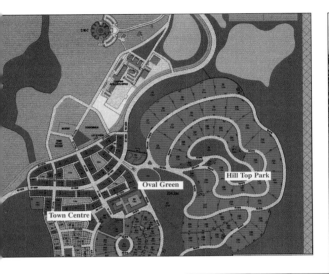

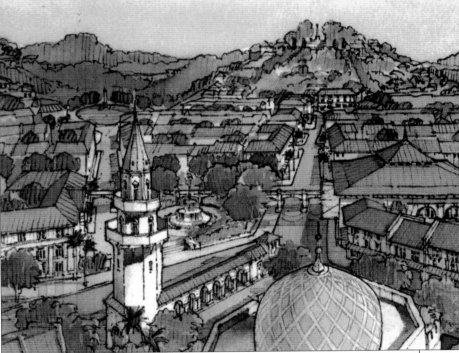

Above: Master plan.
Right: Town center and hilltop beyond.
Below right: Public buildings in town center.
Renderings: ©Michael Morrissey.

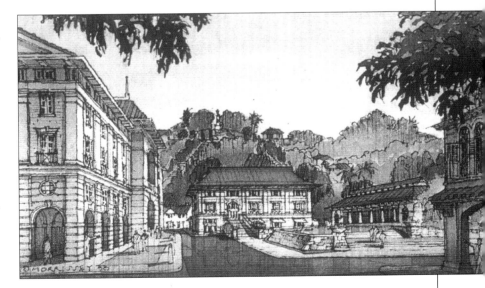

Putrajaya, Malaysia's new administrative capital, is located 15 miles south of Kuala Lumpur. Among several neighborhoods to be developed, the Diplomatic Enclave consists of 180 acres dominated by two hills. For security concerns, the embassies will be sited on the hills, with a single point of access for each group from the town center in the shallow valley below. Security considerations are balanced with the need to create a pedestrian-oriented environment attractive to foreign government personnel. A botanic garden sited in the saddle between the two hilltops will connect to a regional nature preserve. At build-out, the town center will include about 400,000 square feet of offices, 200,000 square feet of retail, a mosque, a visitors' center, an international school, 89 terrace houses, and 61 shophouses. This project was designed and managed in association with Teo Ah Khing & Associates.

133

Duany Plater-Zyberk & Company

Wustrow
Rerik, Germany

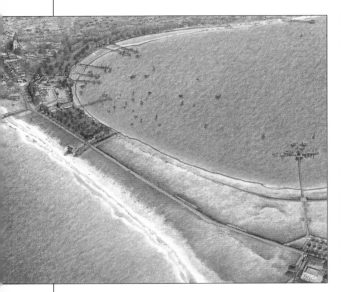

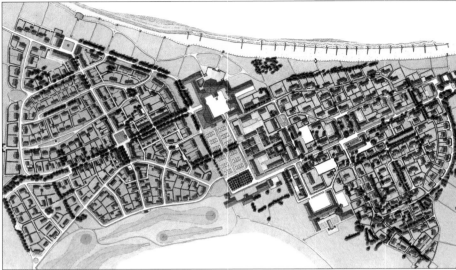

The site, on a peninsula projecting into the Baltic, has been the site of both German and Russian army bases, but most of its 5-km (3-mile) length remains essentially natural. Two mixed-use neighborhoods will be developed, one incorporating old army buildings, the other built from scratch on the site of demolished military facilities. The remainder of the peninsula will be maintained as a nature preserve. Wustrow has been conceived as an extension of Rerik, a real community rather than a resort. The planning and architecture of the two neighborhoods will be based on fine turn-of-the-last-century models: one of them following the principles of the German architect and theoretician Heinrich Tessenow (1876-1950), the other inspired by the work of the English architect C.F.A. Voysey (1857-1941), who was Tessenow's tutor.

Above left: *Isthmus, restored to natural condition, with Rerik beyond.*
Above: *Plan of the two neighborhoods.*
Below: *New neighborhood center.*
Below left: *A single family house on a close facing the bay.*

Duany Plater-Zyberk & Company

Heulebrug
Knokke-Heist, Belgium

The 25-hectare (62-acre) sector of Heulebrug is planned as a coherent neighborhood seamlessly attached to the coastal resort town of Knokke-Heist. While it is being developed to fill a need for social housing, its composition reflects the town's traditional urban fabric. The site is less than a 10-minute walk in width, with a clear center and edges, surrounded by a greenbelt. The community will support transit and accommodate a range of uses and incomes. Like older local neighborhoods, it has a central square. Major streets and a canal divide the area into quadrants, each with its own secondary square. Design standards control those aspects of private buildings that affect the public realm. Buildings must be positioned to reinforce the edges of streets and squares, while keeping garages and parking out of public view. Materials, roof pitches, window geometries, and architectural details are controlled to create an environment that is internally consistent and compatible with the town's older neighborhoods.

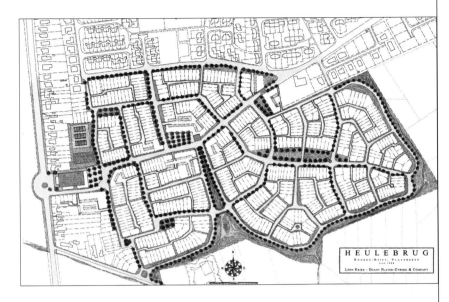

Above right: Master plan.
Right: View along canal toward central square.
Below right: Aerial view and detail of central square.
Renderings: ©Michael Morrissey.

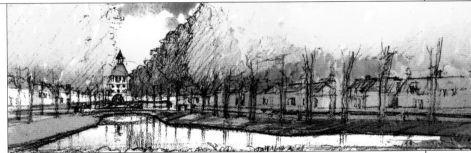

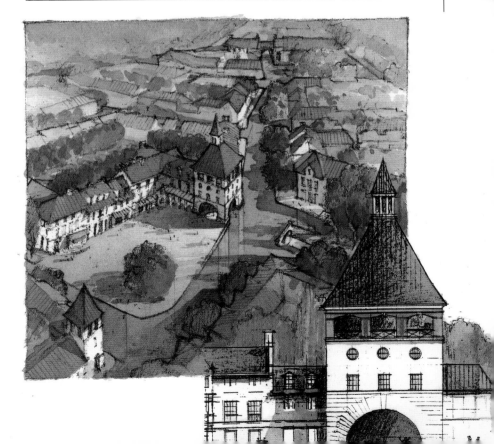

Duany Plater-Zyberk & Company

Quartier am Tacheles
Berlin, Germany

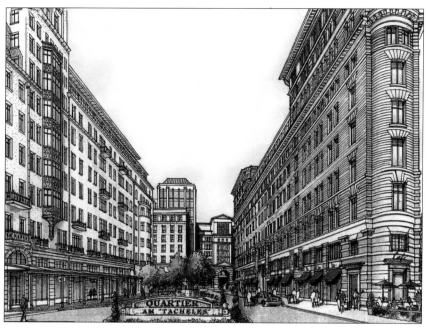

Above left: *Model with proposal in white.*
Above and below: *Views of main square, with apartment house on left, Flatiron Building on right.*
Below right: *Apartment house designed by Robert Stern.*

The project occupies the major part of a central block in Berlin that was largely leveled during World War II and left vacant during the East German period. The surviving Tacheles department store is now a tourist attraction occupied by squatter artists. This scheme differs from numerous previous proposals for the site in treating it not as an insular private development, but as an open network enhanced by several squares, in the tradition of Berlin. Some of its routes will be limited to pedestrians and service vehicles, others open to all traffic. Most of the buildings will contain apartments over street-level retail. Exceptions will be a 287-room hotel and a large house apartment with mainly professional offices at ground level. The design of individual buildings has been distributed to an international team of seven architects including Robert Stern, Thomas Beeby and Demetri Porphyrios.

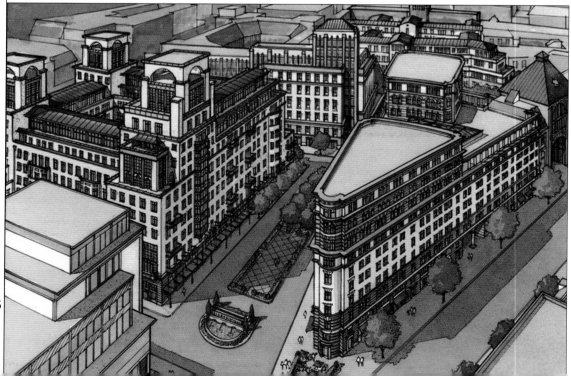

Earl Swensson Associates, Inc.

2100 West End Avenue

Suite 1200

Nashville

Tennessee 37203

615.329.9445

615.329.0046 (Fax)

www.esarch.com

info@esarch.com

Earl Swensson Associates, Inc.

One Century Place
Nashville, Tennessee

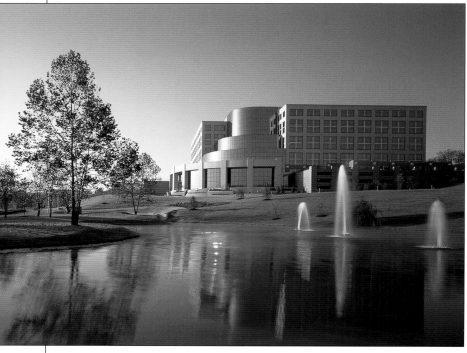

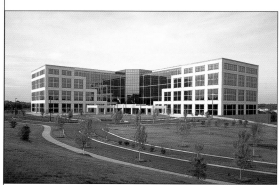

The 560,000-square-foot complex initially served as the headquarters for one of the world's largest insurance brokerage companies. The architects were challenged to give it a strong visual identity, an effective relationship to the landscape, optimum flexibility in its office spaces, and an appealing employee environment. The building is divided into two blocks, each with its own service core, linked by a central, circular atrium. For flexibility, all floors have convenient connections through the atrium. A precast exterior wall grid steps down toward the main entrance to signal its pivotal relationship to the two office blocks. A development center, for conferences and training, has its own lobby overlooking the pastoral site.

This lobby has a direct entrance for visiting attendees, as well as in-house access through the adjoining atrium. A four-level parking structure along one side of the building is tucked into the terrain so that each level can be entered at grade.

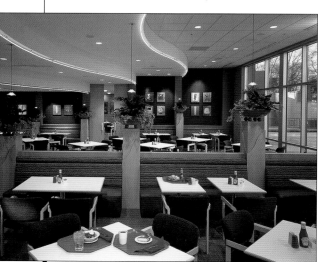

Above: Back view, showing cylindrical atrium and parking garage.
Above left: Front entrance.
Left: Dining area.
Right: Lobby.
Facing page: Atrium interior.
Photography: Gary Knight + Associates, Inc.

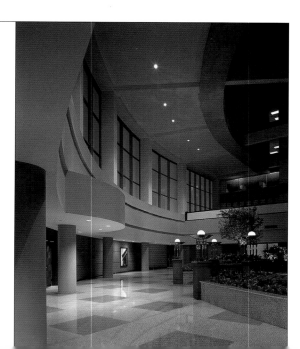

138

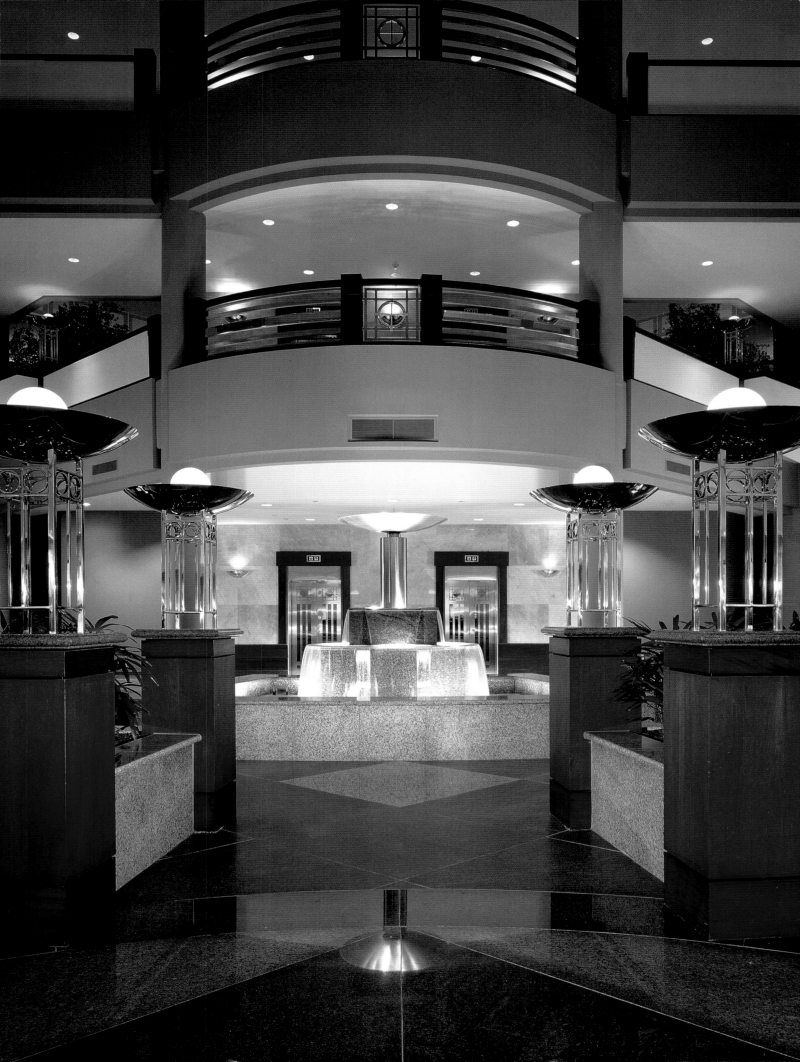

Earl Swensson Associates, Inc.

BellSouth Tennessee Headquarters
Nashville, Tennessee

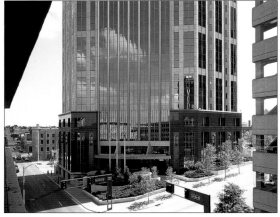

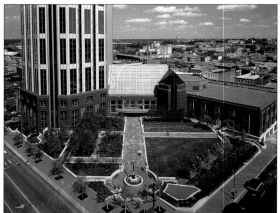

Above left: Winter garden entrance foyer.
Top: Entrance garden at one street corner.
Above: Complex surrounding green plaza.

The tallest building in Tennessee at 630.5 feet, this corporate headquarters offers extensive public spaces at its base, accounting for 40 percent of the 2.73-acre site. An 8,000-square-foot enclosed winter garden serves as the entrance foyer and connects the tower to a two-story economic development center that includes a 250-seat auditorium, a 250-seat public dining room, and other facilities. A 1,308-space underground garage underpins the complex. The design exploits the 36-foot drop across the site. A geometrically planned park on the uphill side includes a prominent sculpture and groves of ornamental trees. A picturesque rock garden running downhill links the winter garden to the street below. Inside the tower, structural columns are located three feet inside the walls, allowing for perimeter corridors that offer all employees daylight and views. The iconic twin spires at the top of the building accommodate communications equipment.

Right: Steeply sloping garden from winter garden to street.
Facing page: Tower topping city's skyline.
Photography: Norman McGrath.

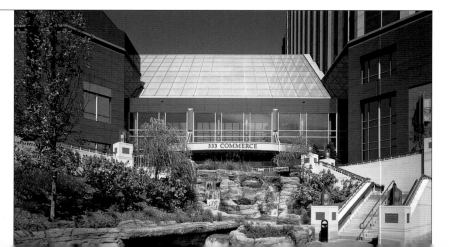

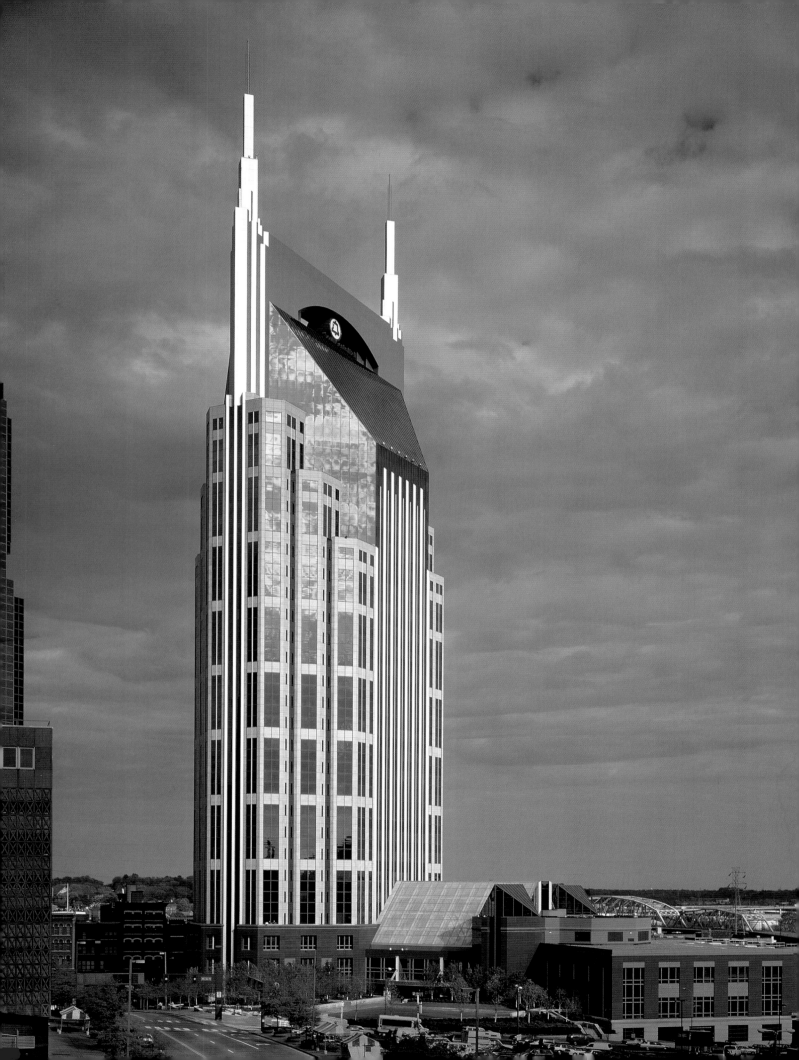

Earl Swensson Associates, Inc.

The Commerce Center/ Pinnacle National Bank Nashville, Tennessee

Sited between the historic commercial buildings of Second Avenue and the BellSouth Tower (see previous pages), this complex combines their design languages. Areas of curtain wall recalling the tower are interspersed with vertical masonry bands, which display the variety of brick colors and the crowning cornices typical of the old avenue. A tall stone arch at the main entrance introduces a traditional element at the building's larger scale. A 14,000-square-foot urban park at the rear of the building, topping part of the parking garage, relates to a planned greenway leading to the river and city landmarks. The interiors of Pinnacle Bank, which occupies two floors, express its intention to be a "no-hard-sell" banking firm in a consulting environment, with emphasis on education and community involvement. A centrally located coffee bar offers a casual setting for consultations, and conference rooms are individualized with themes such as sports, performing arts, and community history. The glass-walled learning center has movable furniture and a variety of high-tech audio-visual equipment.

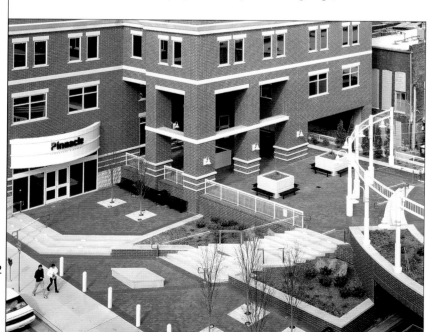

Top left: *Pinnacle Bank learning center.*
Top right: *Lobby water-wall.*
Left: *Stepped park area at rear of building.*
Facing page: *Building in setting.*
Photography: *Scott McDonald/Hedrich Blessing, except left, Robt. Ames Cook.*

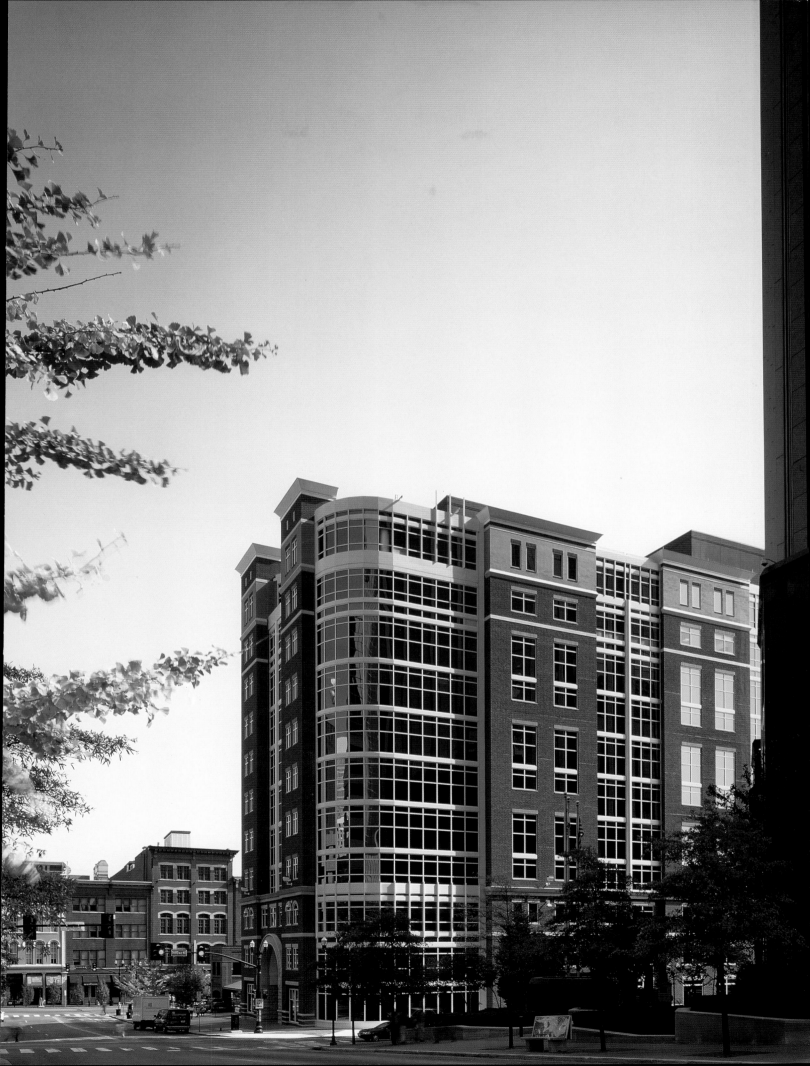

Earl Swensson Associates, Inc.

Smith Travel Research Headquarters
Hendersonville, Tennessee

At first glance, this 26,000-square-foot building looks like a retreat lodge, but in fact it is the headquarters for a company that generates statistics for the hospitality industry. The design characteristics of a Tennessee lodge answer the goals of the owner, who chose the wooded site to express his own love of the outdoors and who wanted his building to embody the qualities of a fine hotel or resort. The solid masonry walls of the closed offices contrast with open-office spaces that have exposed wood trusses reminiscent of rustic lodges. A spacious, windowed conference room, with connecting kitchen, supports the company's industry seminars and other meetings. Interior stone elements, natural wood, and slate floors, suggesting the outdoors, are mixed with the highly detailed millwork and sleek furniture associated with upscale hotels. Exterior lighting fixtures are used indoors. A large three-sided fireplace is the lobby's focal point, creating an instant impression of warmth and hospitality.

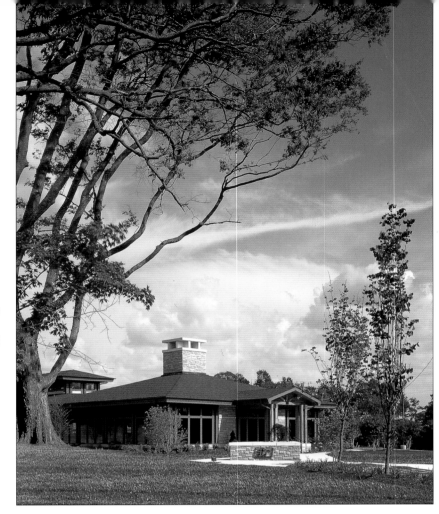

Above: *Headquarters on wooded site.*
Below left: *Conference room with large windows and fine wood details.*
Below: *Lobby fireplace.*
Photography: *Scott McDonald/Hedrich Blessing.*

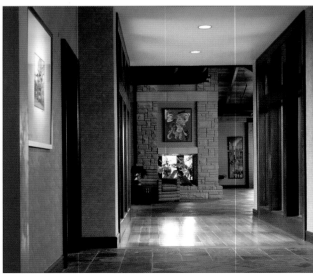

Eric R. Kuhne & Associates

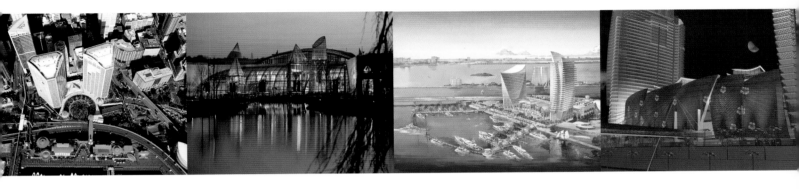

15-27 Gee Street
Clerkenwell
London
United Kingdom EC1V 3RE
44.207.549.8499
44.207.549.8449 (Fax)
www.civicart.com
erka@civicart.com

50 Walker Street
New York
New York 10013
212.966.6332
212.334.4392 (Fax)

Eric R. Kuhne & Associates

Bluewater
Kent, United Kingdom

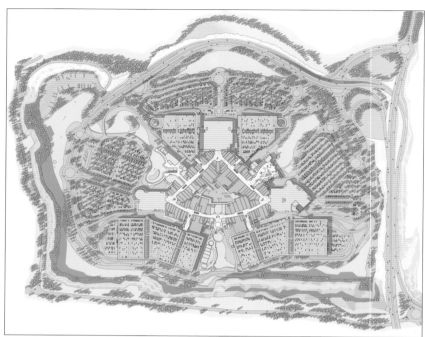

Top and above: Cliffs and lakes of site.
Above right: Site plan, showing central triangle of buildings, with three retail malls, entered primarily through three "leisure villages" containing 48 restaurants.
Right: The Wintergarden.
Far right: The Sun Court.
Photography: Eric R. Kuhne & Associates.

The largest retail and leisure center in Europe, with 1,625,000 square feet, Bluewater is built in an abandoned chalk quarry, surrounded by 50-meter (160-foot) cliffs. The 240-acre development includes 320 shops, three department stores, and 13 cinemas. Some 48 restaurants, with seating for nearly 9,000, are contained in three "leisure villages," Wintergarden, Water Circus, and Town Square, which serve as gateways to the retail. Each of the three retail malls represents a particular Kentish heritage: The Rose Gallery (gardens of England), Thames Walk (maritime Kent), and the Guild Hall (the history of guilds). Extensive parkland, including 50 acres of gardens and 26 acres of lakes, makes the project

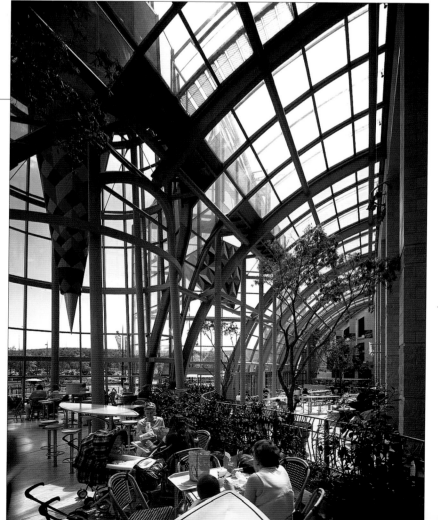

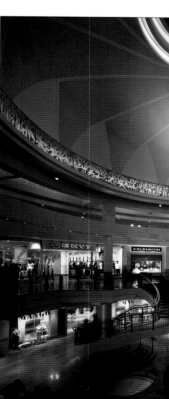

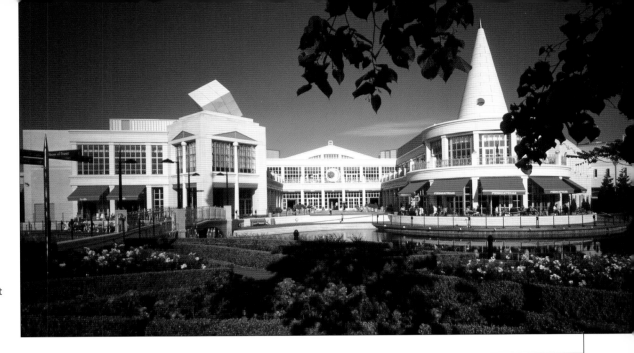

into a kind of "retail resort," which has become a day-trip experience for over 27 million guests per year. It continues to exceed all performance records for such projects throughout Europe. The Kuhne firm's services for the development ranged from initial research through master planning, architecture, and landscape design, to graphics and civic art.

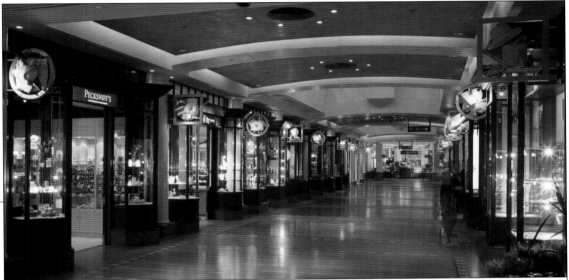

Top: *Town Square and Rose Garden.*
Right and bottom right: *Retail arcade and Guild Hall.*

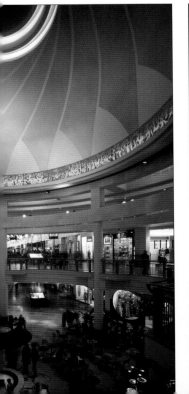

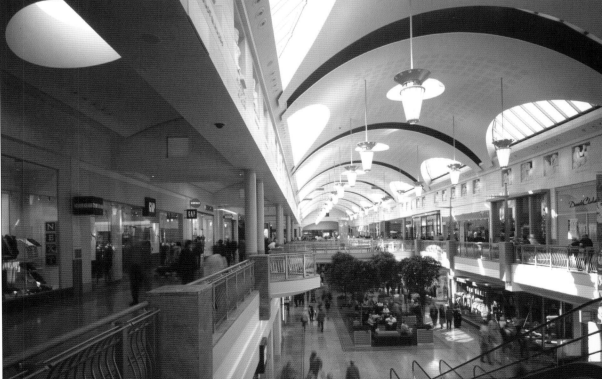

Eric R. Kuhne & Associates

Darling Park
Sydney, Australia

The 3.6-hectare (8.9-acre) Darling Park project includes two 30-story office towers atop freeways. The entire ground plane of the development has been restored to the public as an array of gardens, restaurants, terraces, reception rooms, lobbies, and galleries dedicated to Australian arts. A sculptural frieze illustrates the 300-year history of the nation's commerce. Surrounding the central Waratah Garden are extensive public amenities insired by the hospitality industry. The Star Court reception room between the towers has a large mural covering its handkerchief dome, which uses 728 fiber optic lights to represent the stars of the Southern hemisphere, with constellations representing Australian and aboriginal myths and legends.

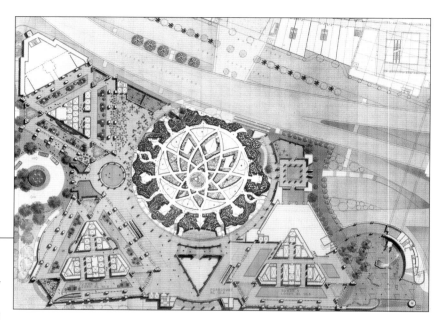

Right: Site plan.
Below: Aerial view, showing paired triangular towers.
Bottom: Waratah Garden
Below right: Star Court reception room.
Photography: Eric R. Kuhne & Associates.

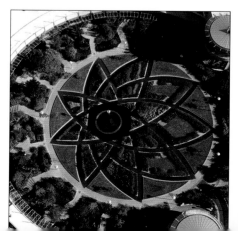

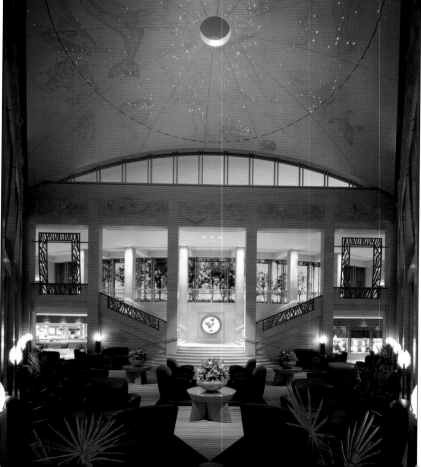

Eric R. Kuhne & Associates

Cockle Bay Wharf
Darling Harbour
Sydney, Australia

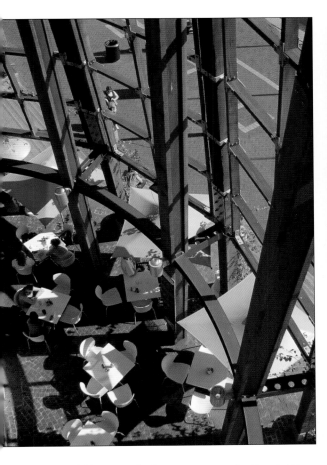

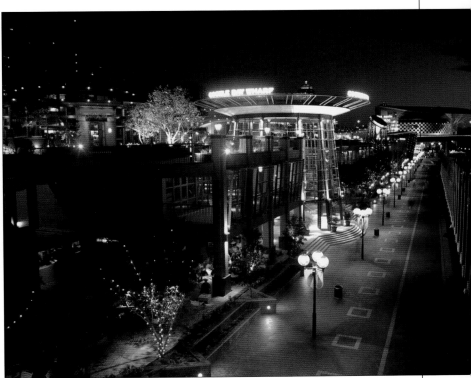

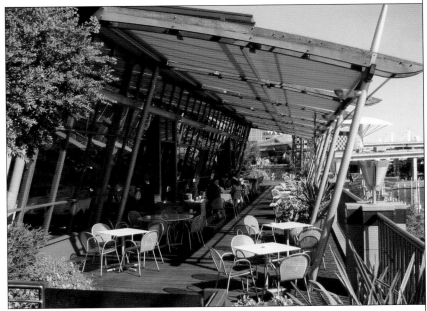

An 80,000-square-foot development, Cockle Bay Wharf is sited on the waterfront, directly across the highway from Darling Park, to which it is connected by an enclosed footbridge. Its 19 restaurants provide a diverse collection of menu selections and price points for the residents, workers, and tourists of Darling Harbour. Designed with reworked wharf timbers, boardwalks, trellises, and rooftop gardens, its pavilions front on a fig-tree-shaded dining terrace overlooking an 800-foot-long bay-front promenade. Fountains, clocks, and flower gardens enliven its public spaces.

Top left: *Indoor-outdoor dining.*
Top: *Cockle Bay waterfront promenade.*
Above: *Rooftop dining terrace.*
Photography: *Eric R. Kuhne & Associates.*

Eric R. Kuhne & Associates

Touchwood
Solihull, United Kingdom

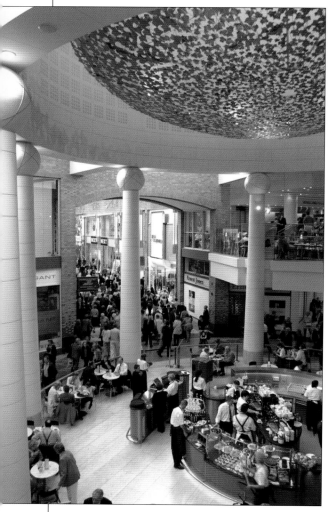

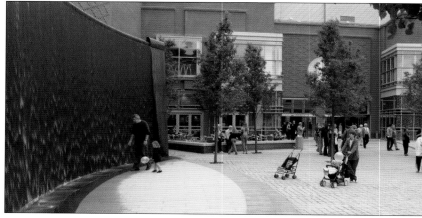

Former car park areas have been transformed into a 650,000-square-foot retail and leisure development, almost doubling the retail space in this Warwickshire village. The property now has a sequence of retail arcades, more than a dozen restaurants, and a nine-screen cinema. Outdoor public spaces include four gardens embodying the village character of Solihull. The project is closely tied to the local library, civic theater, and town hall, reinforcing the heart of the community. The Parasol Room, under a canopy of stainless steel beech leaves, has become the meeting place for high-end shoppers from throughout the Midlands. The firm's work here ranged from initial research through master planning, architecture, landscape design, and civic art.

Above: *Water Cascade in Library Square.*
Left: *John Lewis café in Parasol Room.*
Below left: *Skylighted retail arcade.*
Below: *British market towns in Map Room.*
Photography: *Eric R. Kuhne & Associates.*

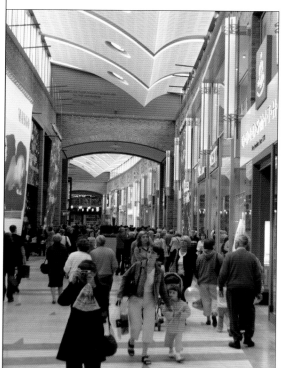

Eric R. Kuhne & Associates

Island Gardens
Miami, Florida

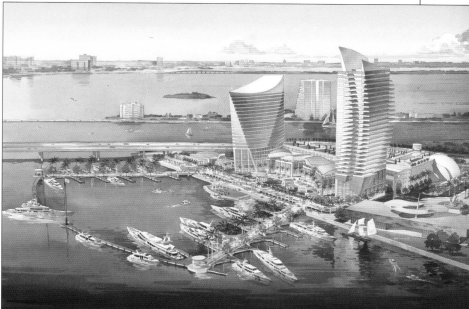

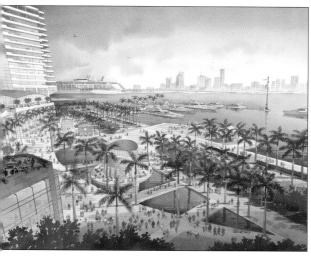

Above: *Overall view.*
Top left: *Waterfront promenade.*
Left: *View of marina from hotel.*
Below: *Master plan.*

Scheduled to open in 2006, Island Gardens is centrally located between downtown Miami and South Beach. Responding to the City of Miami's international design competition for development of a 10.3-acre site on Watson Island, Island Gardens is being built around a 52-slip "mega yacht" marina. Containing a combination of two hotels, 200,000 square feet of retail, 15 varied restaurants, and cultural facilities, the project will include fountains, sculpture, murals, mosaics, and carved epigrams. An array of exotic gardens will celebrate the 500-year maritime history of the site. Developed by Flagstone Properties, Island Gardens promises to become one of the most appealing integrated tourist and day-trip destinations in North America.

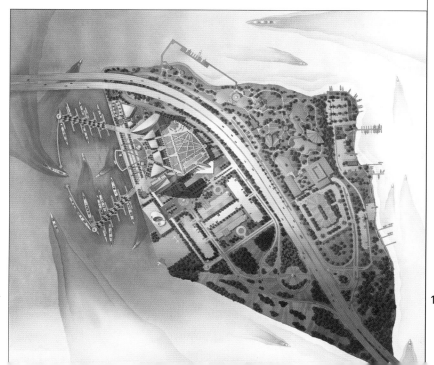

151

Eric R. Kuhne & Associates

Mid Valley Gardens
Kuala Lumpur, Malaysia

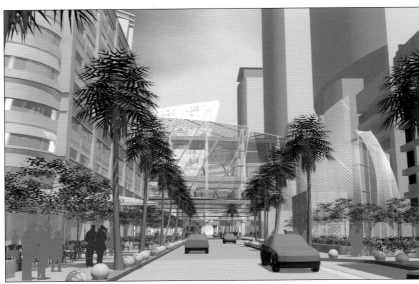

Built along the Klang River just outside downtown Kuala Lumpur, this project will become one of the highest-density mixed-use development in Asia. Almost 3 million square feet of retail, 1,500 hotel rooms, and 3 million square feet of offices are planned for the site, half of which is already completed. Stage Two, under construction, includes two new office towers, two hotels, and dozens of restaurants, all linked by a retail podium. New gardens, boulevards, ceremonial courtyards, and museum galleries are being added. Links to transit lines, monorail, and road systems make this one of the most accessible developments in Malaysia.

Above: *New office tower.*
Above right: *View of internal boulevard.*
Right: *Aerial view of project when completed.*
Below right: *Crystal Bridge at night.*
Below: *Gardens and restaurant pavilions atop retail podium.*

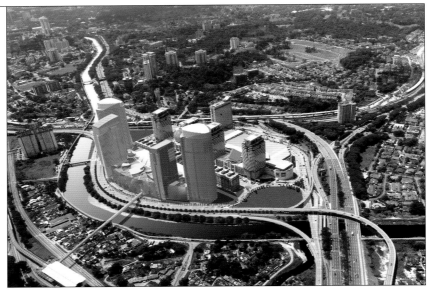

152

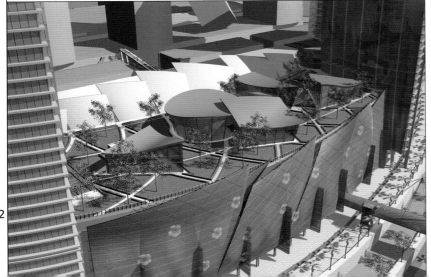

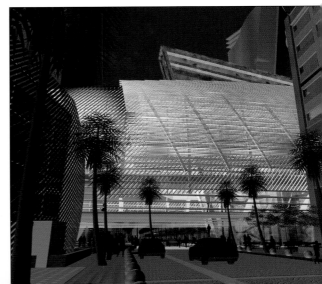

Garcia Brenner Stromberg

751 Park of Commerce Drive
Suite 118
Boca Raton
Florida 33487
561.241.6736
561.241.8248 (Fax)
www.garciabrennerstromberg.com

1001 SE Monterey Commons Boulevard
Suite 100
Stuart
Florida 33487
772.220.9501
772.220.9516 (Fax)

Garcia Brenner Stromberg

Abacoa Town Center
Jupiter, Florida

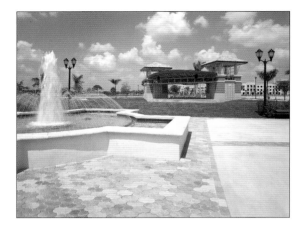

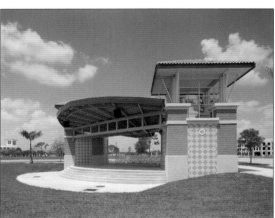

Designed as the core of a new town, the center is linked by walkways to several single-family and townhouse neighborhoods built around it. Within the project itself are 412 residential units, all of them rental apartments on the second, third and fourth floors of its mixed-use structures. About 92,000 square feet of retail and restaurants are located on the first floor. Apartment and restaurant balconies overlook the public spaces. Professional offices are in separate buildings. Except for parallel parking along the streets, cars are parked behind buildings and in parking structures linked to apartments through secured elevator lobbies. Commercial spaces are serviced from back alleys. The amphitheater at the town's main intersection is used for music, film, plays, and community gatherings. Land is reserved for planned expansion as this becomes the center of a new municipality of Abacoa.

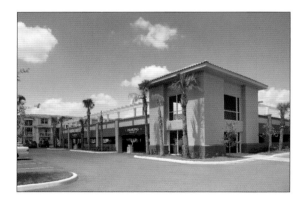

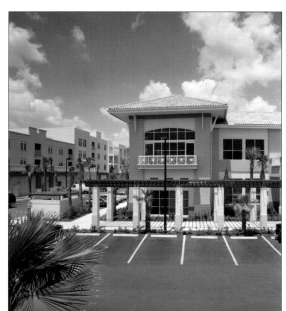

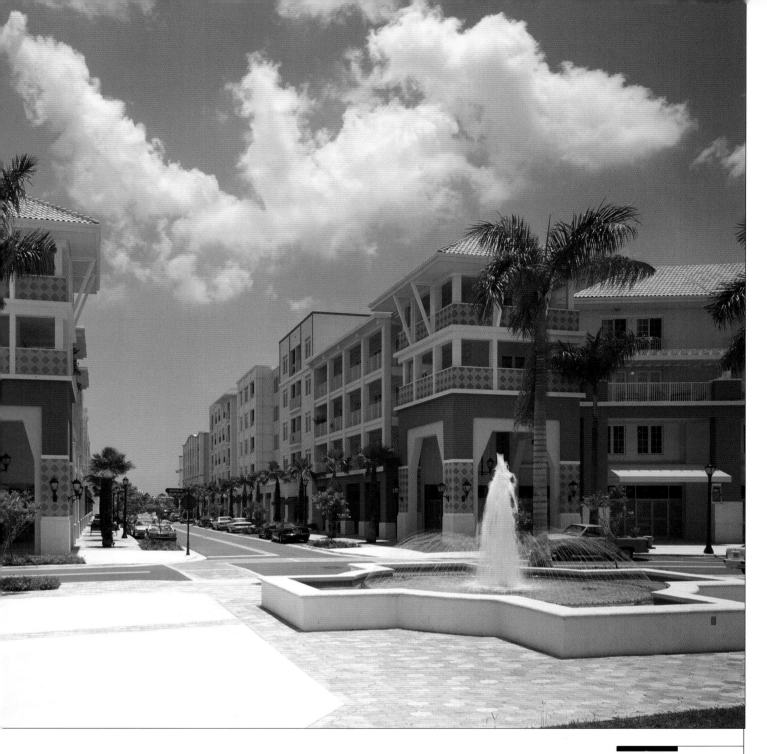

Above: Central fountain and main retail street.
Left, upper: Elevations of buildings facing fountain and amphitheater.
Left, lower: Elevation along main street.

Garcia Brenner Stromberg

Costa del Este
Ciudad de Panama, Panama

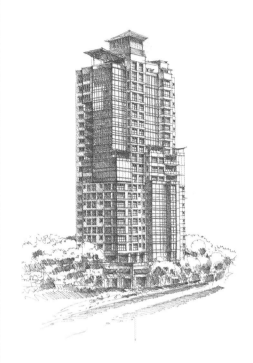

A 24-story tower is planned to rise in Panama, with views extending to nearby Panama City. The building is intended to be both a landmark and a prototype for a series of residential, commercial, and mixed-use structures on a boulevard along the Bay of Panama. The tower's composition of concrete, steel, glass, and stuccoed elements exhibits international Modernist influences, combined with Panamanian culture. The building will house only 24 residential units, ranging in size from 4,500 to 8,000 square feet each. The 21 residential floors will have no more than two apartments each, and some units will extend over two or more floors. At the base of the building will be two levels of parking and one level of amenities and recreational facilities, including a large landscaped pool deck. The total area of the building will be 232,996 square feet.

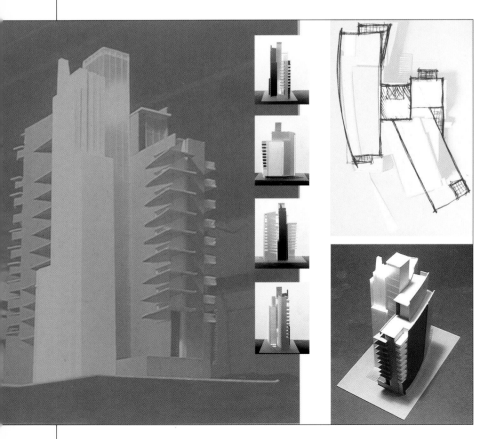

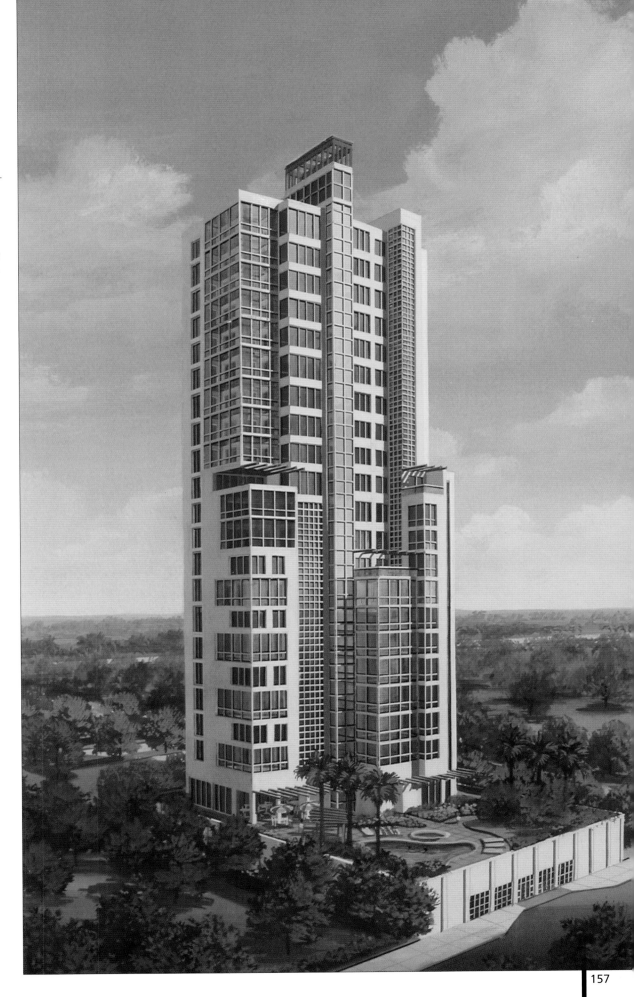

Below left: *Two of six alternative schemes studied for client.*
Far left: *Semi-final design, with variations in roof canopies and fenestration.*
Right: *Final design.*

Garcia Brenner Stromberg

Monterey Medical Center
Stuart, Florida

This 65,000-square-foot medical center on U.S. Highway 1 in central Stuart provides twelve medical suites to accommodate a variety of general and specialist practices. For an area with new residents arriving daily, the building provides a visible concentration of medical services, bringing together a variety of practitioners and advanced diagnostic technology. Access to a range services from general practice from ophthalmology to orthopaedics under the same roof is a valuable convenience for patients and health care professionals alike. For maximum efficiency, the building is divided into three functional zones: a circulation zone leading from a central lobby, a zone of individual offices, and a service/core zone. Each suite features a conference room for consultations, and the fourth-floor orthopaedics and sports medicine suite has an oversized conference hall for the popular health seminars its occupants offer. For patients with limited mobility, there is ample parking, with handicapped-access spaces adjacent to the building. A dramatic canopy shelters the entrance from the subtropical sunlight and drenching rains. Constructed of steel and cast-in-place concrete, the building has a curtain wall combining transparent, translucent, and reflective glass. Exterior lighting accents the vertical elements of the structure by night and highlights the

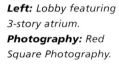

Left: Lobby featuring 3-story atrium.
Photography: Red Square Photography.

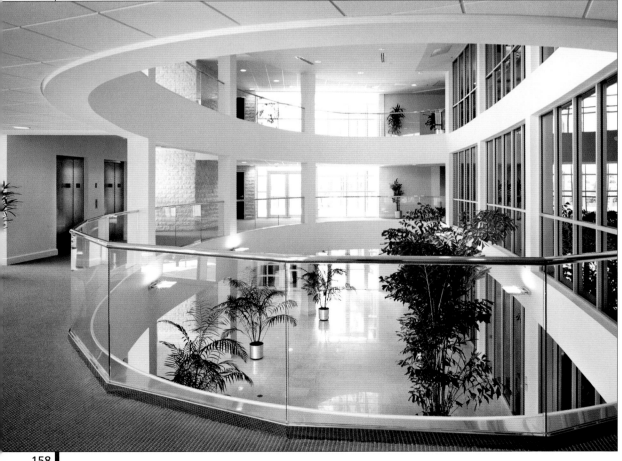

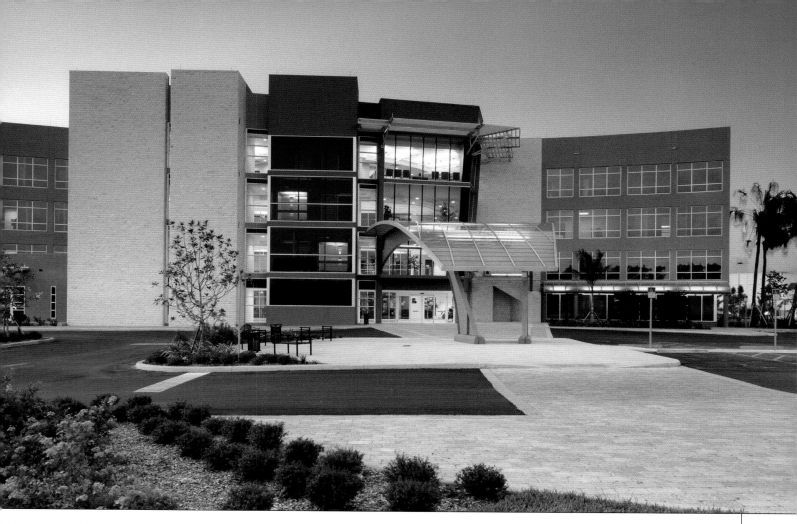

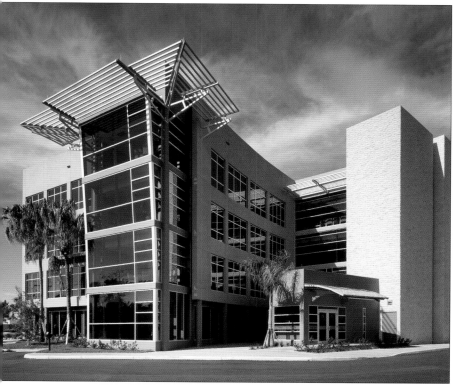

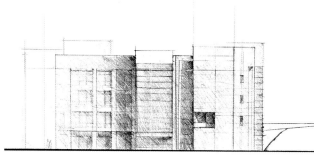

Top: *Approach to center, showing large, translucent entrance canopy.*
Above: *Early sketch of west elevation.*
Left: *West elevation.*

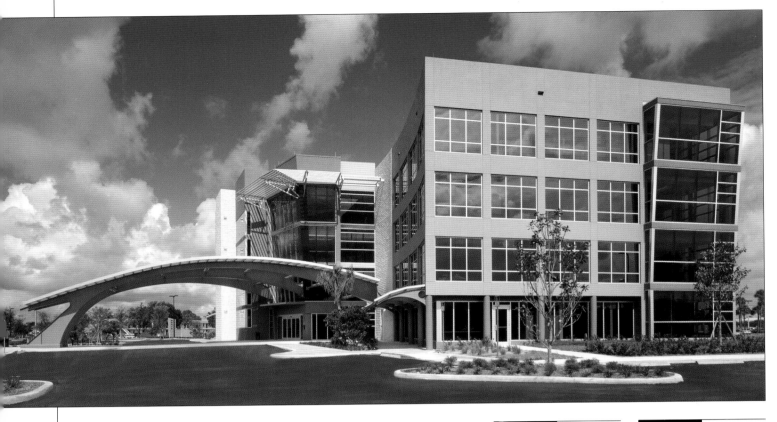

translucent entrance canopy as an iconic element at the entrance to the city of Stuart. Plans are already being made for expansion of the center on its six-acre site.

Above: *Different view of approach to center.*

Below, left to right: *Detail of windows and sunshades; canopy detail showing translucent panels; detail of projecting bay.*

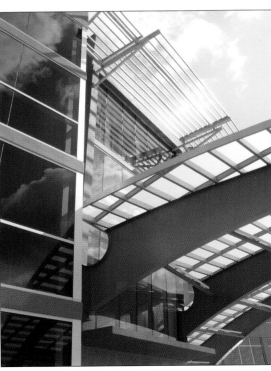

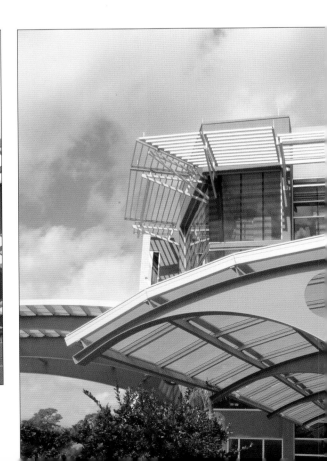

Gary Edward Handel + Associates

1995 Broadway

4th Floor

New York

New York 10023

212.595.4112

212.595.9032 (Fax)

www.garyhandel.com

postmaster@garyhandel.com

Gary Edward Handel + Associates

Millennium Place
Boston, Massachusetts

In a pivotal location at one corner of the Boston Common, this project created an attractive mixed-use development in the former "Combat Zone," once known for its X-rated entertainment. The project's total of 1.8 million square feet includes apartments, retail, parking, a hotel, theaters, and a fitness center. Through its strong architectural forms and fine-tuning of density, scale, and mix of uses, the development is meant to transform the neighborhood. An infill project on parts of two city blocks – both divided by alleys – the development reestablishes the street edge around its perimeters. As a Planned Development Area, the

project required a full public approval process, and the outcome represents an effective dialogue involving the city, the developer, and the architects. On the skyline, the towers mark the corner of the Common and form a south gateway to the city's main commercial district along Washington Street. At pedestrian level, entries to various functions are from the streets, with internal activities revealed through large windows. The project has been an economic success. Apartments have sold well at prices ranging from $455,000 to $6.6 million, with the developer holding some units for rental in anticipation of rising prices as

the neighborhood improves. With 6500 members, the fitness club is exceeding expectations, and the cinema ranks among the top ten nationally in revenues.

Right: *Generous glass areas and welcoming canopies link project to streets.*
Below, left to right: *Aerial view, Common at lower left; street-level plan; section; towers flanking Washington Street.*
Photography: *David Desroches (right); Aero Photo (below left); Steve Dunwell (below right).*

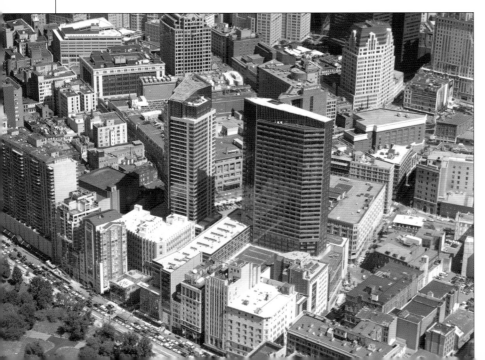

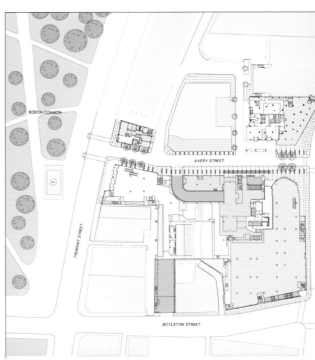

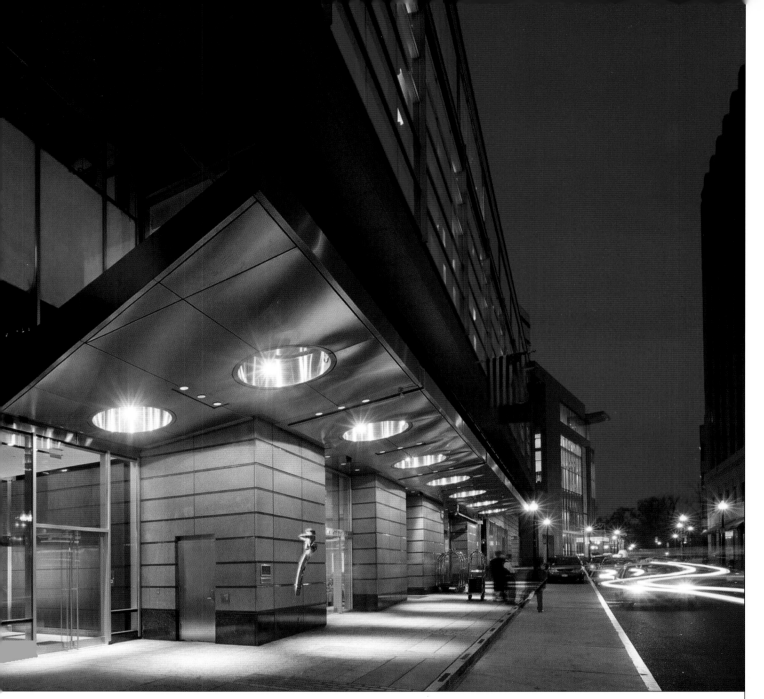

RETAIL

RESIDENTIAL

HOTEL

THEATERS

SPORTS CLUB

PARKING

MECHANICAL

SUBWAY

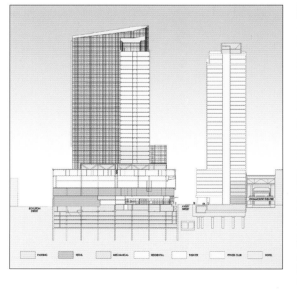

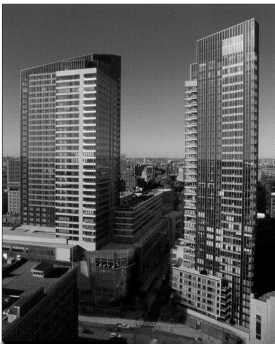

163

Gary Edward Handel + Associates

High Line
New York, New York

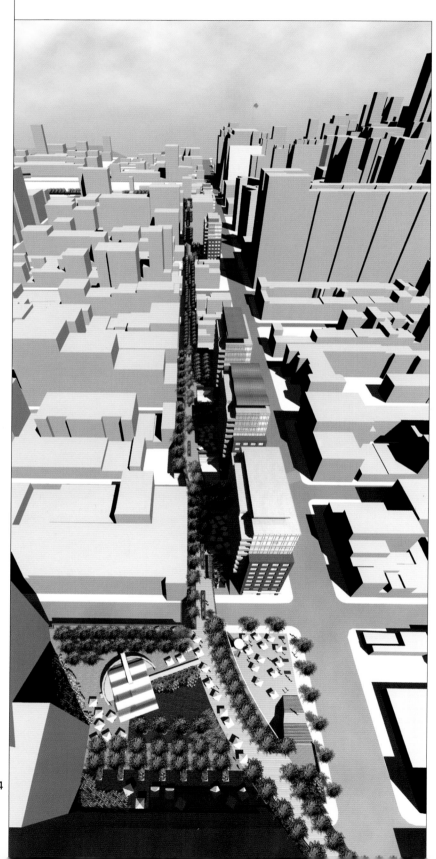

The High Line is an elevated railroad constructed through 1.45 miles of Manhattan's far West Side in the 1930s to remove freight trains from the area's streets. Abandoned since 1980, the line was scheduled for demolition by a previous city administration. Persistent efforts — and a court victory — by the non-profit Friends of the High Line have recently led the city to consider the line's rehabilitation as a greenway consistent with the National Trails Systems Act. Gary Edward Handel, a founder and board member of the Friends, led his firm in a pro bono study of the economic ramifications of retaining the High Line under various possible zoning scenarios. Among its recommendations for this once all industrial area are the introduction of residential uses, the reinforcement of current art uses, and zoning incentives for properties that are integrated with the proposed pedestrian way. The firm's findings are considerably within the city's official feasibility study of the greenway proposal.

Left: *View along 10th Avenue.*
Below: *Proposed High Line deck with landscaping and retail access*

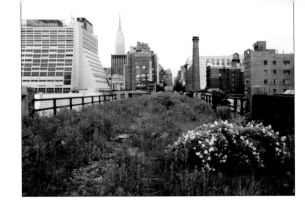

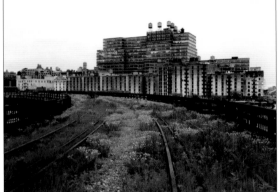

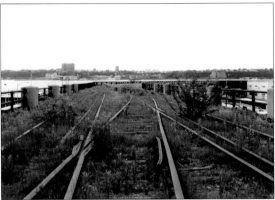

Gary Edward Handel + Associates

Four Seasons Hotel + Tower
San Francisco, California

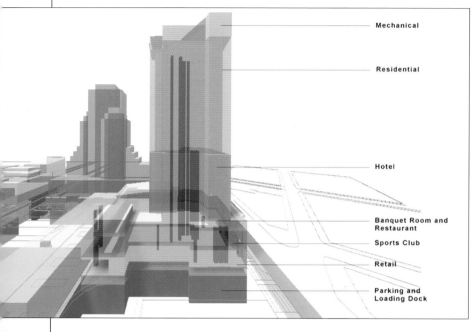

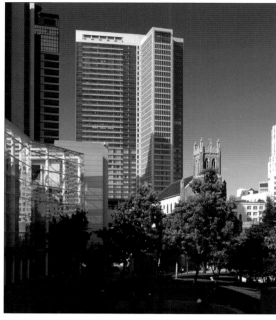

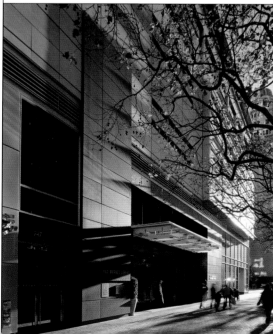

Above: Diagram of key functions.
Left: Porte-cochere.
Below left: Street entrance.
Above right: Tower from Yerba Buena Gardens.
Facing page: Market Street front, seen from Grant Street.
Photography: Tim Griffith.

This hotel and residential project is the second phase of a development that included the Metreon entertainment center, by the same architects. Both follow the 1975 master plan for the Yerba Buena District, just south of the city's main shopping and office zone. While Metreon completed one edge of the central Yerba Buena Gardens open space and marked the western boundary of the redevelopment, the new 40-story, 1-million-square-foot structure gives the development a prominent presence on Market Street, the city core's main artery. Conceived as an "inhabited billboard," its façade terminates busy Grant Street. This front also incorporates access to a new transit station and to the Connector, a retail-lined passage leading to Yerba Buena Gardens. The hotel enjoys a healthy occupancy percentage, and apartments have been selling at 40 percent above area's prevailing value per square foot. The Metreon is the city's highest-grossing cinema complex.

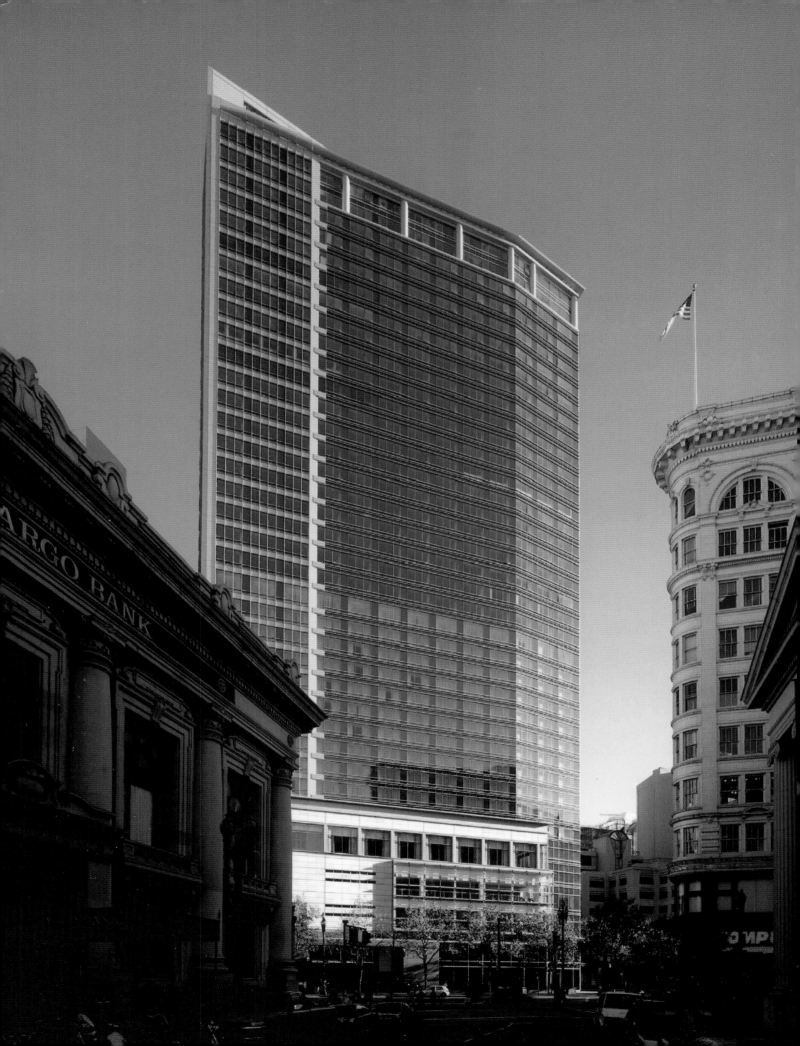

Gary Edward Handel + Associates

Ritz-Carlton - Georgetown
Washington, DC

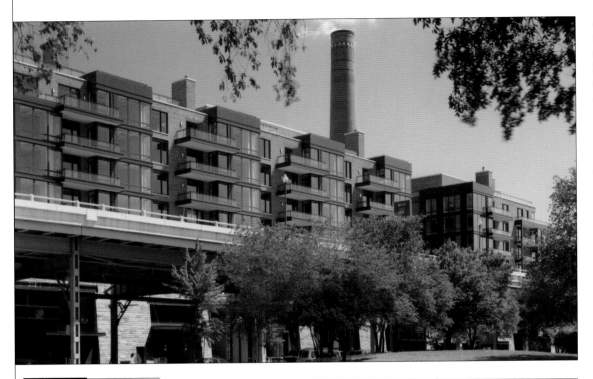

A combination of factors made this project unusually complex. Its location in Georgetown's historic district imposed a 40-foot height limit and required extensive reviews to ensure community-sensitive scale, massing, and materials. Three historic houses and an incinerator building in the site had to be retained. The land slopes 40 feet down toward K Street, which is overshadowed by an elevated highway. The 600,000-square-foot development includes: several below-grade parking levels; retail and cinemas in a granite-clad plinth; four floors of hotel and apartments above, entered through landscaped courts. Hotel rooms are located along the intimate side streets. Apartments with generous glazing and balconies offer views above the elevated highway to the Potomac. The old smokestack, (now housing a meeting room at its base), rises from the landmark incinerator structure, which contains the hotel lobby, restaurant, and additional meeting rooms.

Above: *South front, which overlooks elevated highway and Potomac.*
Right: *North-south section showing layering of functions.*
Below right: *View from north side.*
Photography: *Maxwell MacKenzie.*

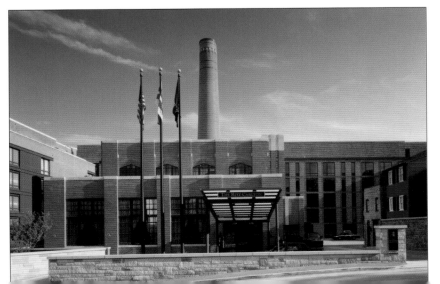

The HNTB Companies

Headquarters:

715 Kirk Drive

Kansas City

Missouri 64105

816.472.1201

816.472.5004 (Fax)

More than 60 offices nationwide www.hntb.com

The HNTB Companies

INVESCO Field at Mile High
Denver, Colorado

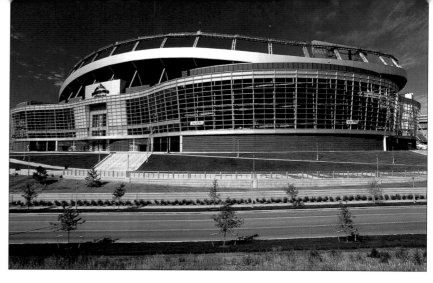

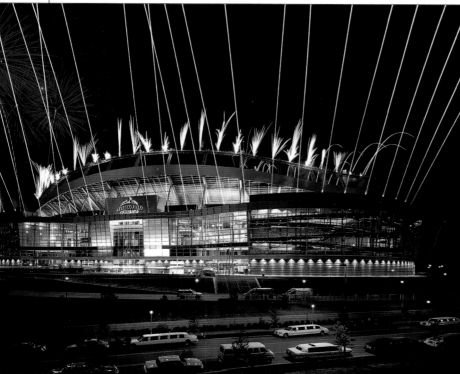

Top: Stadium by day.
Above: Opening day/evening celebration.
Left: Retail along one of five concrete-framed concourses.

Photography: Jackie Shumaker (top and above); to Brad Feinknopf (below).

INVESCO Field at Mile High with its horseshoe-shaped design and intimate seating bowl, continues to celebrate the Broncos' football tradition of excellence. Turner Construction and HNTB Sports Architecture, worked closely with the Denver Broncos to build a signature stadium—one that maintains the character and traditions of old Mile High while stretching toward the future. Opened in August 2001 the stadium reveals its magnificence and unique identity through graceful design details, respect for the past and a vision for future requirements. The local personality of Denver is a key design element of the stadium. The stadium's extensive landscape forms an extension of the South Platte River sports, entertainment and cultural park. The 87-acre site includes landscaping, public and private art projects, the Colorado Sports Hall of Fame and Broncos Museum. The stadium is constructed primarily of brick, glass, aluminum and steel, materials reflective of Denver's high technology culture, vast natural resources and love of the outdoors. The 76,500-seat stadium incorporates several traditions from the old Mile High Stadium. Maintaining the fans' close proximity to the action was the number one priority. This stadium is the most intimate in the NFL, placing fans on top of the action. Another feature favored by the Broncos was the ability of fans to make "Rocky Mountain Thunder"—an intimidating rumble made by fans stomping their feet on the steel treads and risers. Five concourse levels wrap the three seating bowls—providing ease of circulation and a variety of menu options. The upper and middle bowls are cantilevered over the suites below, moving the seats as close to the action as possible. The curvilinear shape of the upper bowl maximizes the number of seats where the fans like to sit — the 50-yard line. This undulating bowl is symbolic of the mountains to the west and south of the stadium, at the same time allowing views from within the bowl to the Rocky Mountains and Denver skyline. INVESCO Field at Mile High is uniquely identifiable as Denver's stadium.

The HNTB Companies

Fifth Third Field
Toledo, Ohio

The new home of the Toledo Mud Hens, the Class AAA affiliate of the Detroit Tigers, has had considerable impact on the city since opening in April 2002. Located at the edge of Toledo's commercial core in the Warehouse District, the field has drawn a new clientele to the downtown area and spurred redevelopment of warehouse buildings. Business at existing restaurants has increased and new ones have opened in restored structures. The 10,000-seat stadium is extremely functional yet traditional. Utilizing existing warehouse buildings as a backdrop, "The Roost," is a unique seating area extending over the right field wall that has been very popular with fans. There are 28 luxury suites incorporated into the design and the playing field is nestled into the site, allowing views into the bullpen. Durable, low-maintenance materials integrate well with the downtown cityscape. The central location and inviting design of the field have helped make Toledo a leader in the current revival of minor league baseball.

Above left: Downtown towers seen above left field.
Top: Ticket and retail concourse.
Above: Game in progress.
Photography: Brad Feinkopf.

The HNTB Companies

Downtown Joliet
Joliet, Illinois

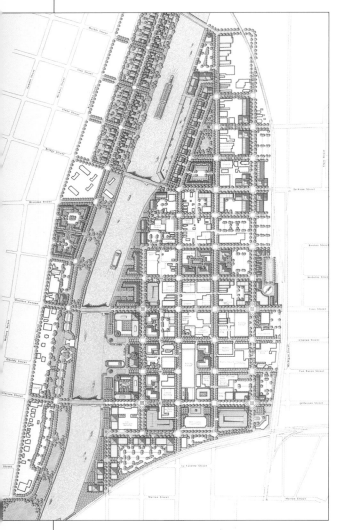

The core of Joliet, a small city near Chicago, had recently suffered decline. As part of an economic development strategy, a master plan for the downtown is being carried out. The Des Plaines River, between high flood walls, presented both an obstacle and an opportunity. Two early steps in the plan were carving out a new downtown harbor and the extension of Bicentennial Park along the opposite shore. Parcels around the harbor have been set aside for a new convention center, a hotel and office buildings. River-oriented housing sites have been identified along both banks. Downtown's architectural riches are being enhanced through the renovation of Union Station and expansion of the Public Library. Plans also call for specialized retail areas for fashion and home furnishings, and enlarged campuses for higher education and government offices.

Left: Plan of downtown, showing development proposals.
Below left: City core, with new harbor in foreground.
Below: Future view across river to downtown.
Photography: HNTB Corporation.

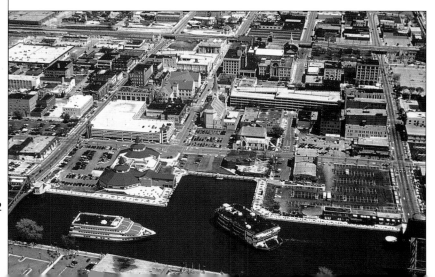

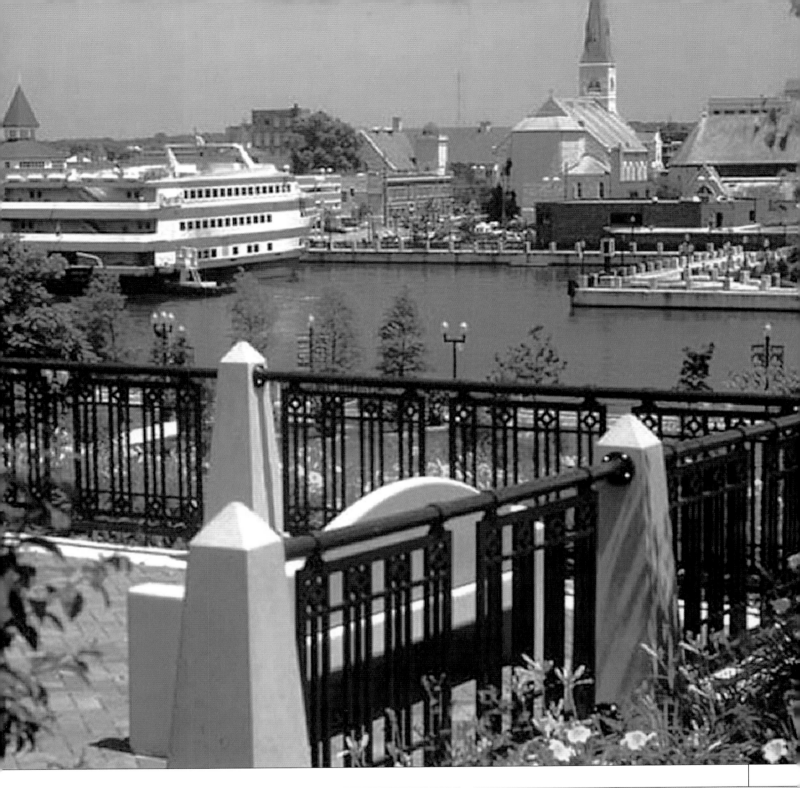

Above: View of new downtown harbor from Bicentennial Park.
Right: Typical street improvement.
Far right: New riverfront esplanade.

The HNTB Companies

Manchester Regional Centre
Manchester, England

A 1000-acre area in Manchester, Salford, and Trafford was the subject of a Strategic Development Initiative sponsored by the English Tourist Board in a program to spur urban regeneration and employment through tourism. Reviving unused canals and rivers emerged as the key strategy because of their potential as significant open space amenities and generators of adjacent development. Emphasis was on pedestrian environments. The private sector responded with a lively mixture of residences, shops, cafes and leisure activities. In the Canal District, illustrated here, canals and railroad viaducts lend distinctive identity to a mixed-use urban neighborhood close to Manchester's commercial core. One canal has been reopened and canal edges enhanced with stone paving, trees, street furniture and lighting. The vast Middle Warehouse has been renovated, with restaurants and shops on the ground level, offices and apartments above. Other historic buildings are being rehabilitated as artists' studios, galleries, pubs, and housing, while parking areas are being developed and sites established for new housing.

Above left: *Historic warehouse and canal bridge.*
Above: *Middle Warehouse before renovation.*
Right: *Middle Warehouse renovated for commercial and residential use.*
Below: *Dining terraces where canal boats dock.*
Photography: *HNTB Corporation.*

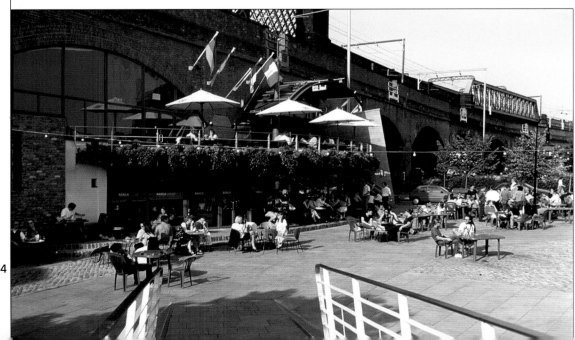

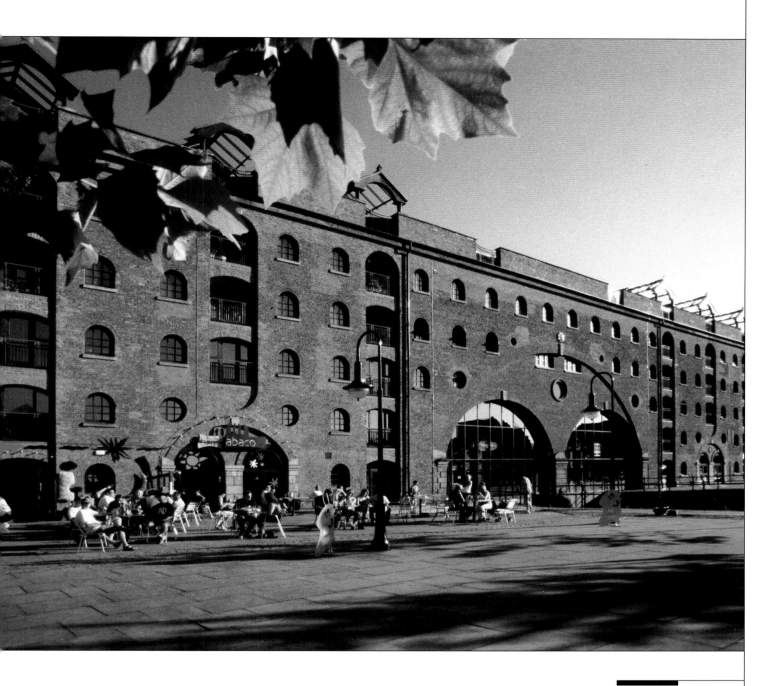

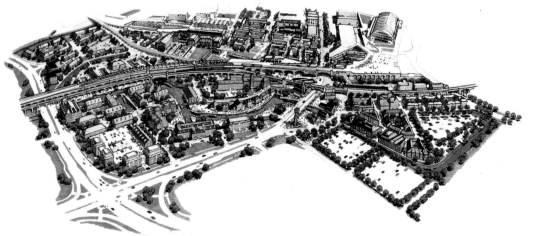

Left: Bird's-eye view of projected Canal District development, with GMEX exposition structure at upper right, in another district covered in this development initiative.

Belfast City Centre
Belfast, Northern Ireland

A detailed planning framework was developed for Belfast's urban core to guide growth and encourage investment. Proposals included conservation of the historic fabric and redesign of streets to ease congestion and address the conflict between traffic and pedestrians. An initiative carried out so far is the renovation of Donegal Square in front of the landmark City Hall. Bus stops have been reorganized adjacent to the public space, the largest open space in the city core. Improvements include a new wrought-iron fence and ceremonial gates, street furniture, pathways and lighting. The handsome City Hall and some fine surrounding structures now have a setting befitting their architectural distinction.

Top left: Streets around City Hall redesigned for "pedestrian priority."
Top right: New ceremonial gates to square.
Above: Expanded lawn in Donegal Square.
Photography: HNTB Corporation.

Heller • Manus Architects

221 Main Street

Suite 940

San Francisco

California 94105

415.247.1100

415.247.1111 (Fax)

www.hellermanus.com

info@hellermanus.com

**San Francisco City Hall
San Francisco,
California**

Designed by Bakewell & Brown in 1915, the centerpiece of the city's Beaux-Arts Civic Center has been transformed into a modern fuctional building, while restoring its architectural excellence. Upgrading includes new mechanical, electrical, and lighting systems, along with modern communications networks. The rotunda and light courts have been converted to special event spaces. Mayoral and legislative suites and courtrooms have been refurbished. All spaces are now accessible. Exterior rehabilitation includes gilding on the dome. The landmark structure is now ready for the 21st century.

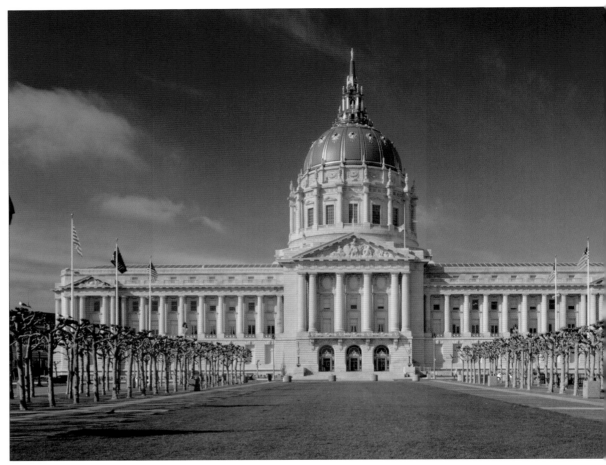

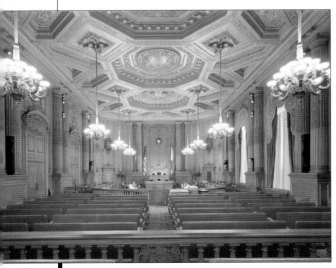

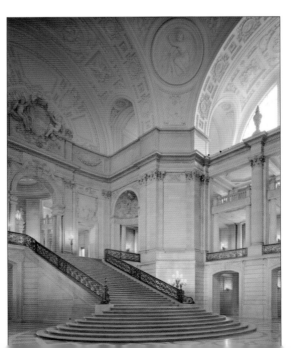

Above: City Hall seen along Civic Center axis.
Far left: Restored hearing room.
Left: Central rotunda.
Photography: Robert Canfield.

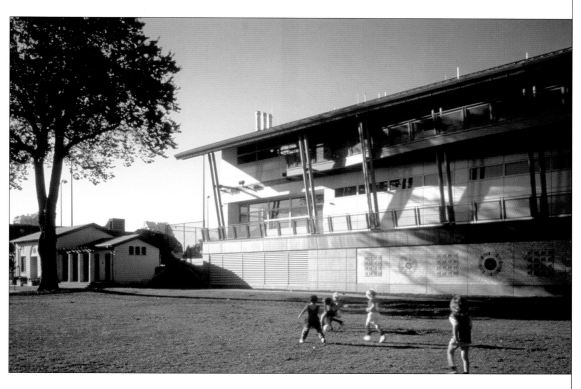

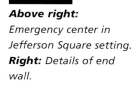

Above right:
*Emergency center in
Jefferson Square setting.*
Right: *Details of end
wall.*

9-1-1 Emergency
Communications
Center
San Francisco,
California

Located near the city's
Civic Center, this facility
contains 55,000 square
feet of dispatch, train-
ing, support, and admin-
istration space. It is
designed as an essential-
services center, with
building systems that
can deal with everyday
emergencies, as well as
major seismic events. A
computer-aided system
manages evaluation and
dispatch of 911 calls for
police, fire, parking and
traffic, and paramedic
services. The building
also houses the Mayor's
Office of Emergency
Services, the Emergency
Command Center, and

support facilities for the
Department of Electricity
and Telecommunication.
There are 70 subter-
ranean parking spaces.
Exterior surfaces of
porcelain panels and
laminated, bullet-resist-
ant glass under a zinc
clad roof address securi-
ty concerns while provid-
ing a light-filled work
environment.

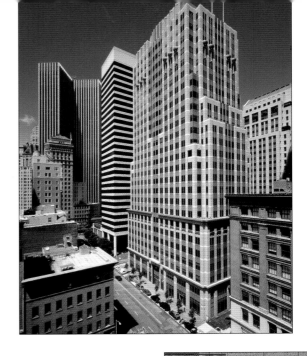

Heller • Manus Architects

Commercial Projects

275 Sacramento Street
San Francisco, California

With a height change midway through its site to respect the scale of a historic conservation district, this retail and office building responds to San Francisco's Downtown Plan Guidelines. Although not literally historical, its facades are richly detailed, recalling the early 20th-century period of neighboring buildings in their composition of broad windows and brick pilasters. The local tradition of bay windows is echoed in upper-floor projections. The lower rooftop provides an opportunity for a boldly geometrical roof garden.

55 Second Street
San Francisco, California

The building presents a sheer vertically articulated façade along Second Street, while stepping back on the opposite side, adjoining a small historic commercial building. The design responds to criteria of the city's Downtown Plan, including rules for height, bulk, and building separation. Linking it to the historic structure is a new galleria, which leads toward a nearby vest pocket park, enhancing pedestrian circulation through the south-of-Market area of the Financial District.

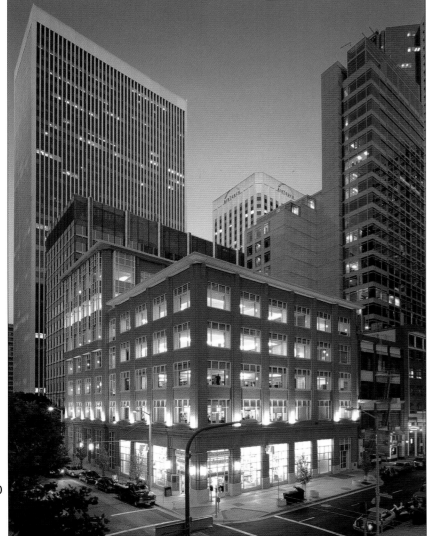

Left: 275 Sacramento Street.
Below: Rooftop garden.
Above: Entrance to 55 Second Street's galleria, adjoining low neighboring structures.
Right: Detail of 55 Second Street entrance.
Photography:
Carl Wilmington (275 Sacramento), Heller • Manus (55 Second).

Top left: Torchiere
motifs near top of
building.
Top right: 55 Second
Street.

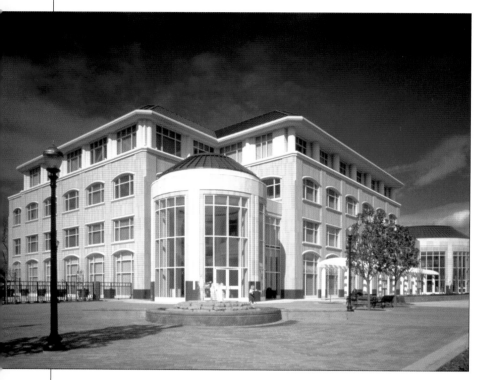

Hayward City Hall, Hayward, California
The 98,000-square-foot structure adjoins a multimodal BART transit station and is the focal point of a Civic Center Plan that also includes residential, commercial, and retail components. Major and minor glazed rotundas and a galleria provide public event spaces, enhance access to city departments, and create effective links between the downtown and the station. A grand stair in the taller rotunda leads to the second-floor council chamber. The building's exterior treatment harmonizes with the district's architectural character, and the recessed top story helps reconcile it in scale with lower surrounding buildings.

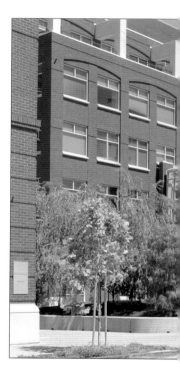

Above: Train station with EmeryStation Plaza beyond.
Above right: *EmeryStation North building.*
Right: *The Terraces, with traditional and loft-type apartments above parking decks.*

Top: *City Hall, showing two glazed rotundas and sheltered walk.*
Above: *City Council chamber.*
Photography: *Russell Abrahams.*

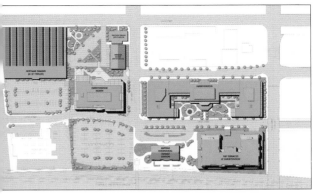

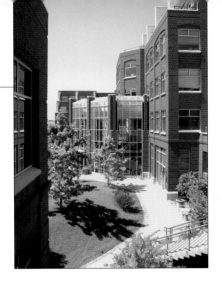

Left: *Overall site plan, with station at bottom center, The Terraces to its right, EmeryStation Plaza above it, and EmeryStation North above it to left.*
Right: *Outdoor spaces of EmeryStation Plaza.*

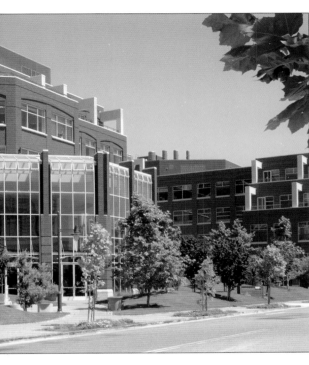

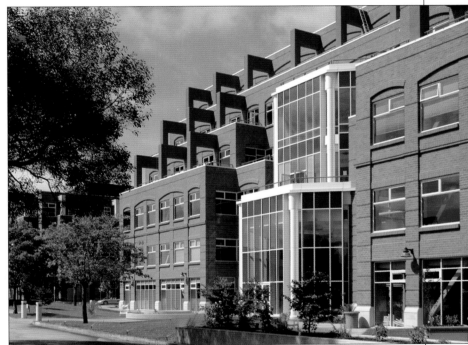

EmeryStation
Emeryville, California

EmeryStation is a transit village development on a 10.64-acre site. Focused on a new Amtrak station, the development includes the 384,000-square-foot EmeryStation Plaza and The Terraces, a mixed-use structure with five stories of living units above four parking levels with ground-floor retail. The EmeryStation office buildings also have ground-floor retail, with almost all of the parking concealed in the base. Glazed atriums serve as entrances and winter gardens opening to the outdoors. Operable windows and functioning balconies create energy-conscious, user-friendly workplaces. The brick-clad volumes harmonize with Emeryville's existing brick warehouses, and exposed structural bracing responds visibly to the region's seismic challenges.

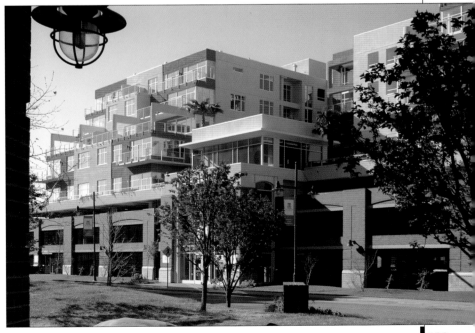

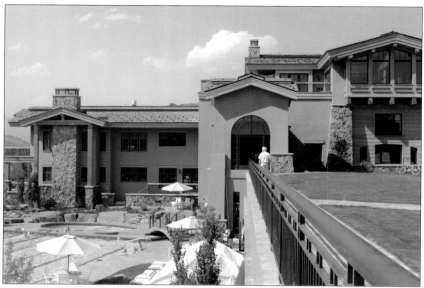

Far left: *Condominium balconies with mountain views.*
Left: *Health center opening to multilevel open spaces.*
Photography: *Heller • Manus.*

ThunderSpring
Ketchum, Idaho

This multi-building luxury resort includes a large concealed parking structure, several two-four condominium buildings – with some stores over the parking podium – and a health center with indoor tennis courts and retail spaces. The podium level includes landscaping with ponds and other water features. To provide for more large residential units, an innovative retrofit solution approach incorporates units atop an existing tennis facility. All structures are designed to withstand heavy snow loads and sub-zero temperatures.

300 Spear Street
San Francisco.,
California

The project seeks to fill regional housing needs in an underutilized area with easy transit access, between the Financial District and the Bay Bridge. An 80-foot-high podium, meeting the area's dominant building height, is the base for two slender towers, of 350 and 400 feet, placed at opposite corners of the block to respect neighboring properties and preserve view corridors. The complex includes 820 apartments, a variety of common facilities embracing an oval entry court, 30,000 square feet of street-front retail, and 5 levels of underground parking.

Below left: *Aerial view of project, which includes two foreground towers, showing possible similar development beyond.*
Below: *Street view.*

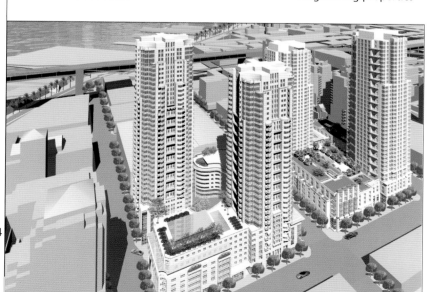

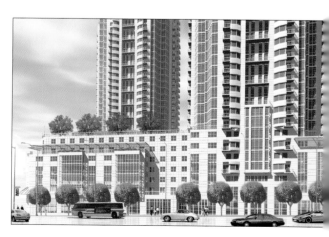

Hughes, Good, O'Leary & Ryan, Inc.

6 Executive Park Drive

Suite 300

Atlanta

Georgia 30329

404.248.1960

404.248.1092 (Fax)

www.hgor.com

hgor@hgor.com

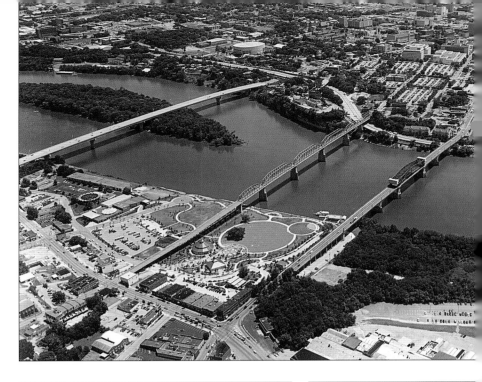

Hughes, Good, O'Leary & Ryan, Inc.

Coolidge Park
Chattanooga, Tennessee

This 7.5-acre park is the first major element of the Chattanooga Urban Plan to be developed on the north side of the Tennessee River. Envisioned for both active and passive recreation, the park is expected to spur revitalization of emerging neighborhoods. The program called for elements that serve both the neighborhood scale and citywide activities. Clustering of active elements such as the carousel pavilion and the interactive water garden near the adjacent street-front retail enhances the relationship of the park to the surrounding area. Major open areas are preserved for active play and long views as the site descends toward the river's edge.

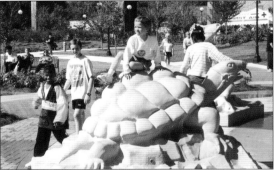

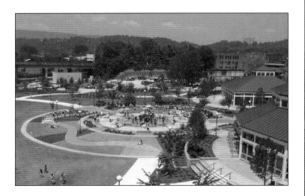

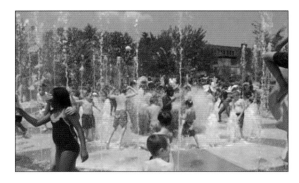

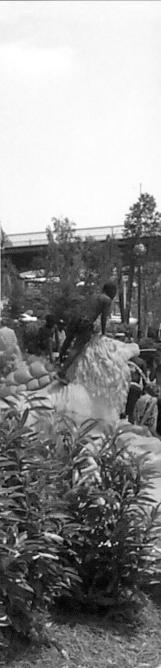

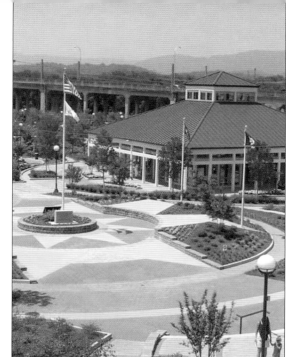

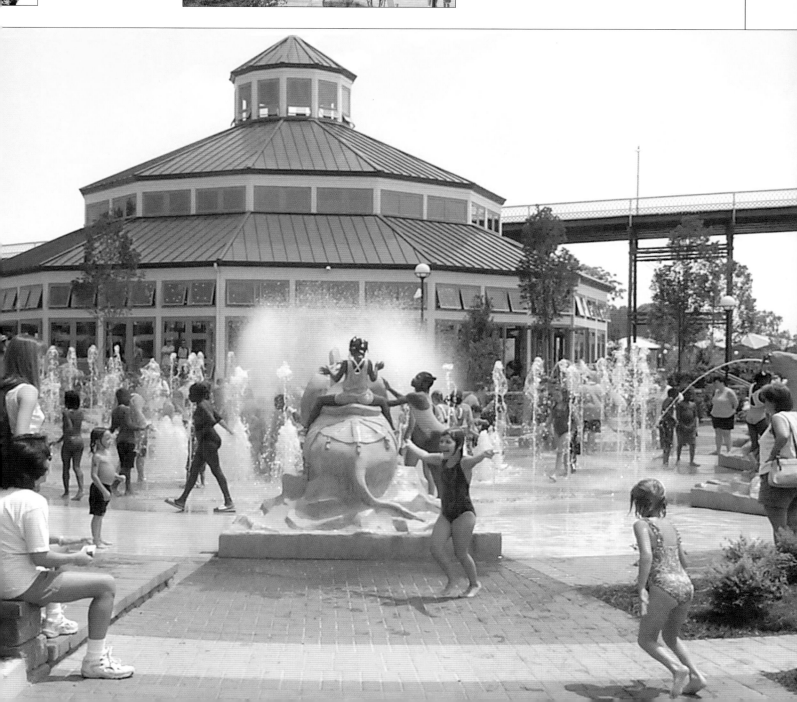

Hughes, Good, O'Leary & Ryan, Inc.

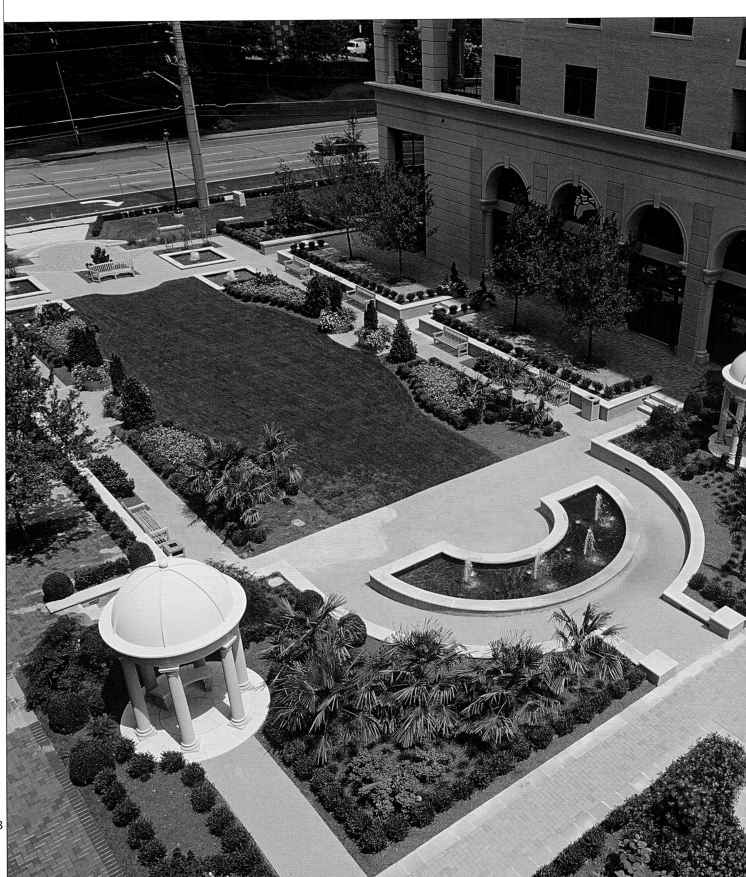

The Piazza at Paces is a multi-phase, mixed-use 7-acre development designed to include 1 million square feet of office space, 250 condominiums, and 300 rental apartments, plus retail space. Its open space design is programmed to provide a series of spaces recalling the historical residential gardens found in the surrounding area. As the name indicates, an Italian design theme has been maintained throughout the project. The Phase 1 courtyard links the Forum office building and the Borghese condominiums in an axial composition that flows from a drop-off area through terraced lawns and gardens to the street. Flanked by a series of water jets and enriched by lush plantings, the garden is an oasis in the urban environment. Outdoor dining extends along its sides for the pleasure of restaurant patrons.

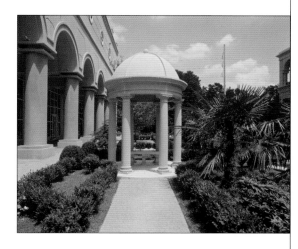

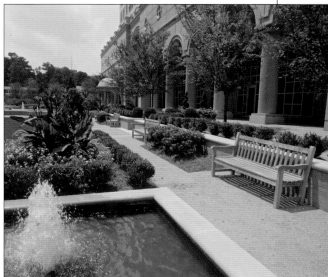

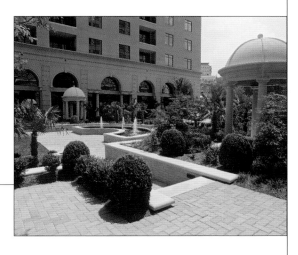

Left: *Overall view of Phase 1 courtyard.*
Right, top to bottom: *Temple-form pavilion; pool among plantings; upper terrace from drop-off area.*

Hughes, Good, O'Leary & Ryan, Inc.

The Carillon
Charlotte, North Carolina

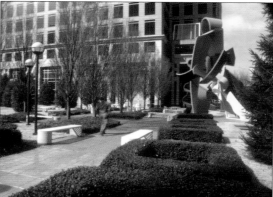

Constructed above a privately owned underground garage, this public open space is part of a mixed-use development designed by architects Thompson, Ventulett & Stainback & Associates, Inc. It presents a varied blend of green spaces, stepping back from the street in a receptive gesture opposite the historic Trinity Church greensward. Intricate geometric landscaping layouts dissolve into open lawn. A large-scale sculpture serves as a visual focal point. A variety of seating and outdoor tables provide for outdoor activities. The presence of the garage below is indicated only by at-grade ventilation screens.

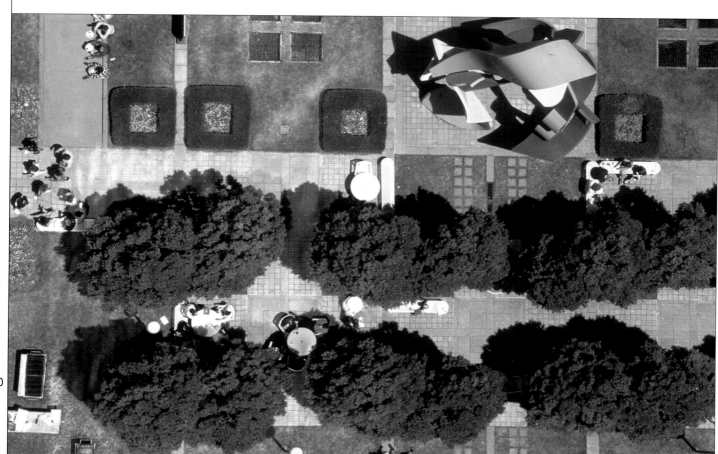

Hughes, Good, O'Leary & Ryan, Inc.

Columbus Streetscape
Columbus, Georgia

Once energized by shipping on the Chattahoochee River, downtown Columbus has declined in recent decades. In a revitalization effort, the city decided to develop major park spaces along the river and reconnect the riverfront to the downtown. The master plan proposes extensive streetscape plantings along streets in the waterfront area, with wide sidewalks that will encourage outdoor sales and dining. The city's unusual 300' x 600' block pattern called for the development of safe, attractive mid-block pedestrian ways, identified along the streets with special mid-block crosswalk treatment and water features. The connection of the riverfront park to the city fabric is to be reinforced by the development of a large water feature flanked by tall pylons at the end of a major street. Closely adjoining this prominent park entry will be a lawn ringed by shade trees, focused on an outdoor performance stage.

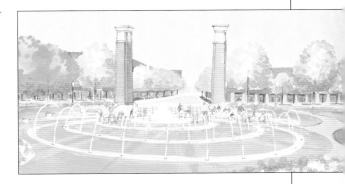

Right: Major water feature with pylons at 10th Street entrance to park.
Below right: Partial plan of riverfront park, showing water feature and concert lawn.
Below: Plan of area improvements, including parks, street plantings, and parking decks.

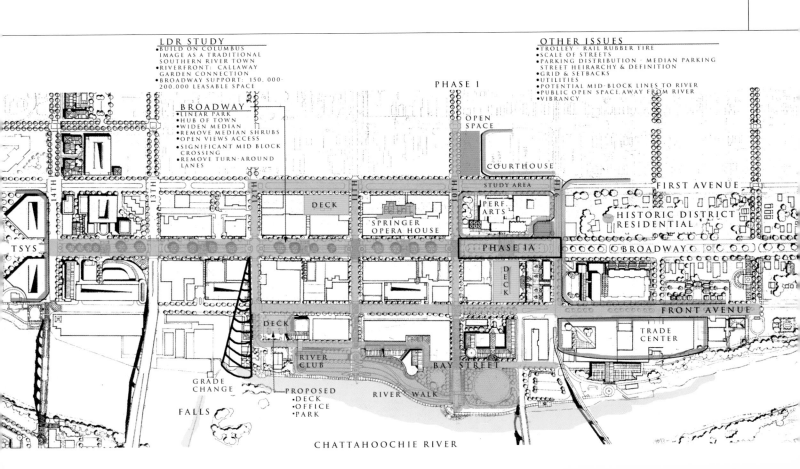

Hughes, Good, O'Leary & Ryan, Inc.

The 16-acre Liberty Landing project is one of the first redevelopments on the city's Delaware River frontage south of downtown. The site is now occupied by decayed shipping piers and brownfield conditions left by former industrial uses. The master plan, drawn up by HGOR with architects Burt Hill Kosar Ritterman Associates, envisions a mix of residential high-rises, townhouses, offices, and retail, wrapped in a crescent around a new pleasure-craft marina. The design takes maximum advantage of its riverside site and carefully articulates a new sense of place, extending the tradition of a city long defined by its urban parks and squares.

Above: Overall view, with downtown Philadelphia in distance.
Below: View towards west.

Joseph Wong Design Associates, Inc.

2359 Fourth Avenue

Suite 300

San Diego

California 92101

619.233.6777

619.237.0541 (Fax)

jwda@jwdainc.com

www.jwdainc.com

Joseph Wong Design Associates

Xiamen International Bank Tower
SK Development Company
Xiamen, China

Designed in collaboration with Kai Chan Architects + Planners, the 34-story, 600,000-square-foot structure takes its place in the skyline of this Fujian province city as "an icon of the new China." Located on the waterfront, the project proceeded concurrently with the city's planned redevelopment of the area, which included widening of streets and creation of a harborside pedestrian promenade. The area includes a rich combination of residential, commercial, manufacturing, and shipping functions. The building's site, though constricted, has been landscaped with usable outdoor spaces and effective links to the street. The tower includes generous areas of open office with harbor views, and its base contains a bank and retail facilities, as well as three level of parking below ground.

Below left: Tower on its waterfront site.
Below: Detail views of lower floors and entrance canopy.
Photography: Kai Chan.

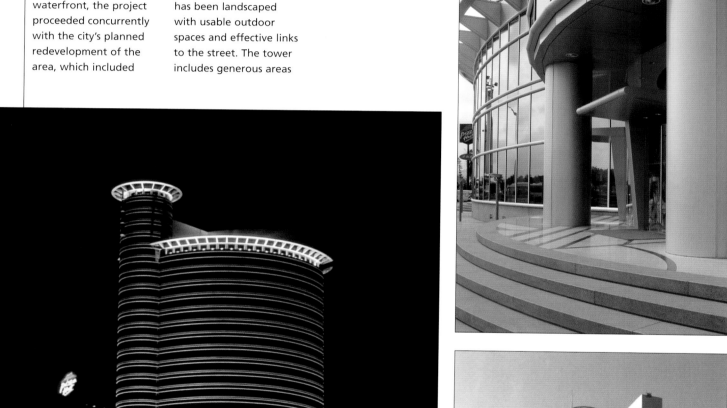

Joseph Wong Design Associates

Industrial & Commercial Bank of China
Shanghai, China

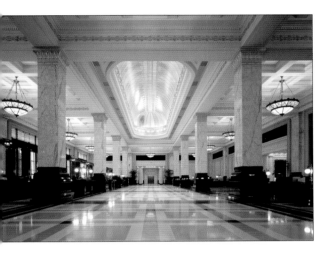

For the bank's branch in the historic Bund district, the architects restored and renovated a monumental 230,000-square-foot structure dating from before World War II. The goal was to was to return the building as much as possible to its original state. Since the Bund was originally the center of Western economic power in China, the building embodies the eclectic style of financial institutions worldwide. The remodeling included structural upgrading, new mechanical, plumbing, and electrical systems, and removal of a mezzanine added in less sensitive renovations. Subtle early-20th-century decorative features were added to highlight the principal architectural features and make the entire building more cohesive.

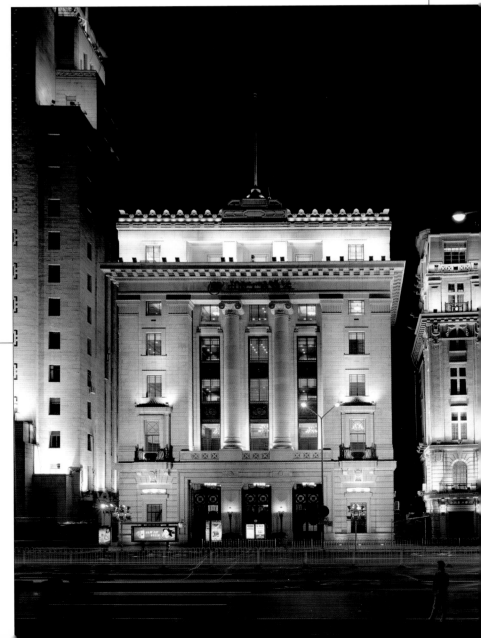

Top: Skylighted 20,000-sq-ft lobby.
Above: Light well above lobby.
Right: Façade facing still prestigious Zhongshan Road.
Photography: Kerun Ip.

Joseph Wong Design Associates

Industrial & Commercial Bank of China
Data Center
Shanghai, China

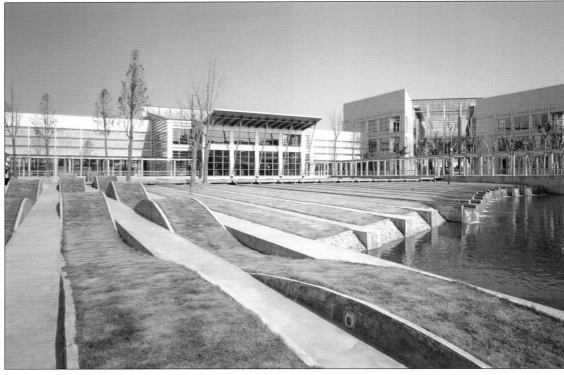

Above: Geometric land-scape at center of com-plex.
Above left: Site plan.
Left: Bamboo in atrium.
Below left: Aluminum and glass details.
Below right: Building around garden.
Facing page: Entrance hall canopy over pool.
Photography: Kerun Ip.

Located outside the city limits, the project is an autonomous campus with 200,000 square feet of facilities including a data center, a training center, an office building, a hotel, and a central utility plant. Six build-ings, arrayed along an irregularly laid out "Main Street," include a 5-year-old structure remodeled and integrated into the complex. The principal blocks contain offices, data center facilities, meeting and training rooms, and an auditorium. Their low-rise volumes are punctuated with smaller-scaled elements accommodating entrance lobbies, stairs, conference rooms, and an employee dining hall. A variety of gridded exterior treat-ments are juxtaposed to stone-clad walls to tie the development together. Paved walkways and ter-races extend the activities of the building out into the 220,000-square-foot site. A 300-foot-long pool visible from many of the interiors is the focus of a landscaping scheme that is geometrically bold yet serene.

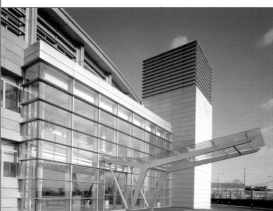

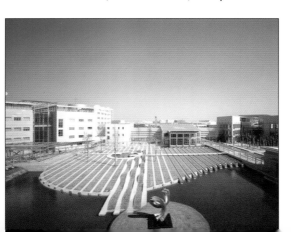

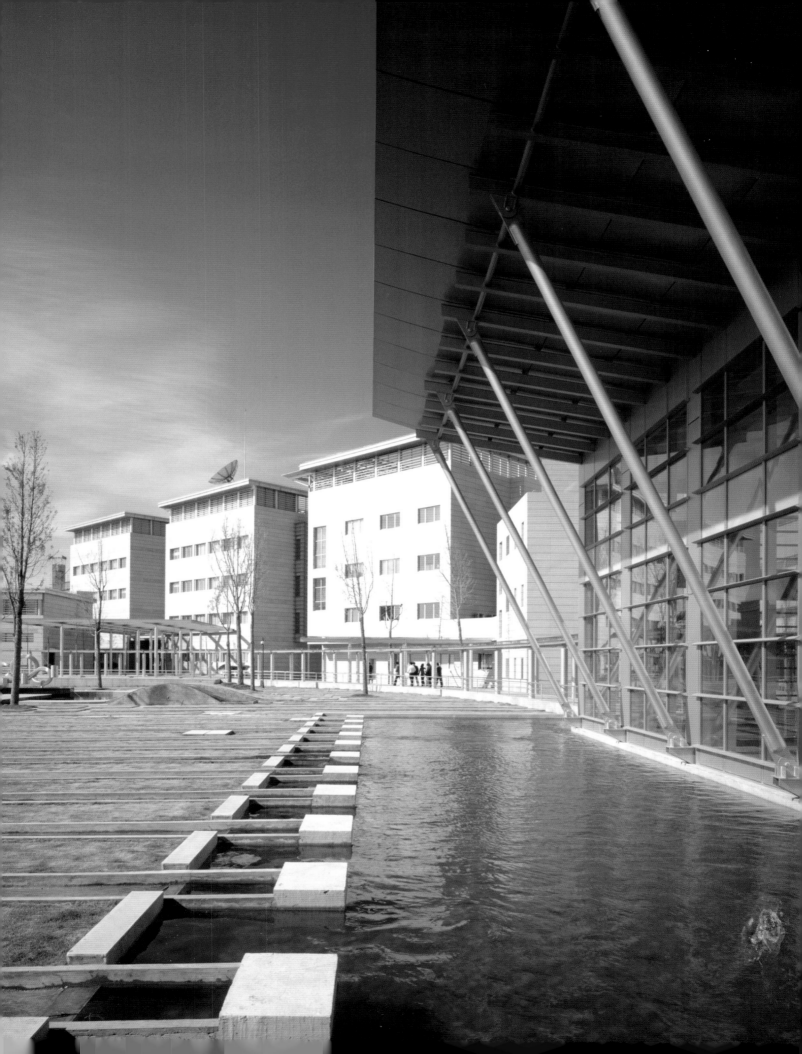

Joseph Wong Design Associates Shanghai Telephone Building
Shanghai, China

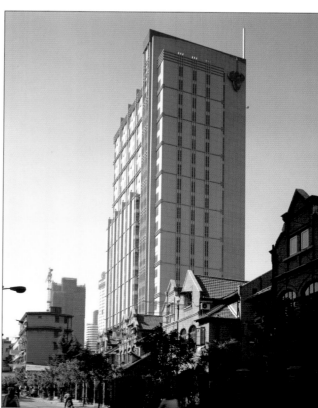

Photos: *Tower in neighborhood.*
Photography: *Kerun Ip.*

The architects won this commission through an invited international design competition. The telephone company's 250,000-square-foot regional headquarters occupies a prominent but small site on Beijing Road in the Jin An district. Its architectural form reflects the vibrant street life of the district and the energy of modern China. It also adheres to local requirements, including a 100-meter height limit and minimum of two hours of direct sunlight daily to all neighboring residences. Over two-thirds of the 22-story building houses telecommunications network equipment serving the company's over four million customers. The rest is office space, conference rooms, auditoriums, and a three-story lobby visible from the street, which communicates the company's cutting-edge technology.

198

Joseph Wong Design Associates

Shanghai International Tennis Center and Regal Hotel & East Asia Residential Towers Shanghai, China

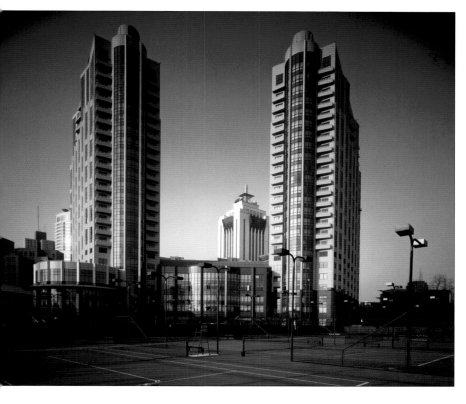

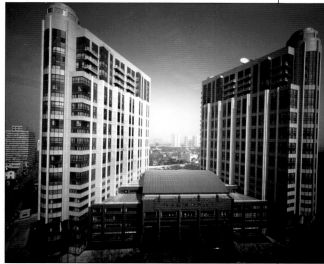

Twin 22-story towers, one housing a hotel and other condominiums, identify this 800,000-square-foot mixed-use project on the Shanghai skyline. Their shared four-story base contains a sports club and spa, a conference center, two restaurants, offices, and retail spaces. The facades combine stone cladding, recalling the historic architecture of the French district setting, with blue reflective glass, in harmony with the area's contemporary buildings. Transparent areas increase as the structures rise. The development's public interiors also combine Modernism with echoes of the eclectic Classicism prevalent in the area in the early 20th century.

Above: Hotel and condominium towers above mixed-use base.
Above right: Tower with large glass areas and balconies toward top.
Right: Hotel lobby and restaurant.
Photography: Wang Gang-feng.

Joseph Wong Design Associates

Del Mar Marriott
San Diego, California

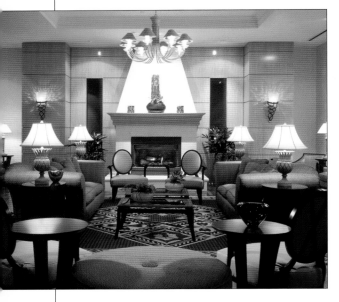

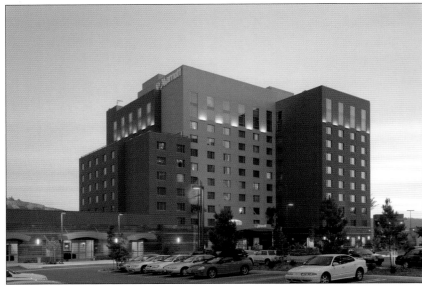

Above: Lobby lounge.
Above left: Hotel at dusk.
Left: Bar.
Below left: Restaurant.
Photography: Jim Brady (exterior); Ed Golich (interiors).

The 284-room hotel is part of the Del Mar Gateway Center, which also includes a 175,000-square-foot Class A office complex. They share a 900-space parking structure that forms an open plaza for the two structures and a focal outdoor space for the Del Mar/Gateway Plaza. Local zoning requirements set a height limit and substantial setbacks affecting the massing of the buildings. Preferences of the surrounding community were incorporated through participatory workshops. Night lighting adds interest to the simple facades. The richly appointed hotel includes a ballroom, meeting spaces, a health club, and an outdoor pool with a garden terrace. Retail space is located on the ground floor of the office structure.

JPRA Architects

31000 Northwestern Highway

Suite 100

Farmington Hills

Michigan 48334

248.737.0180

248.737.9161 (Fax)

www.jpra.com

info@jpra.com

The Mall at Robinson
Robinson Township, Pennsylvania

This 840,000-square-foot mall northwest of Pittsburgh connects to an existing Kaufmann's department store and adds three new anchors. Both of the two shopping levels have entrances directly from parking on opposite sides of the complex. An efficient plan and cross-section made possible an inviting mall on a tight budget. Design treatment is classically Modern, with no obsolescent theming, reserving richer materials for high-impact areas. Indirect lighting creates the illusion of floating ceiling planes. A spacious glass pavilion provides access to 10 food court restaurants seating 600 diners.

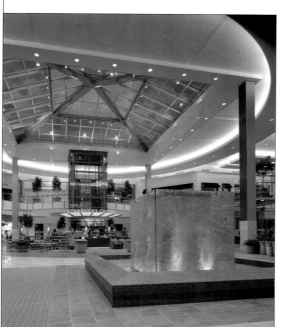

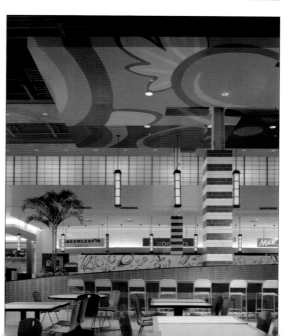

Top: Entry to Cafés with dramatic graphics.
Above, far left: *Glass-roofed Grand Court.*
Far left: *Glass fountain in Grand Court.*
Above left, left, and Facing page: *Cafés' seating area.*
Photography: *Matt Wargo.*

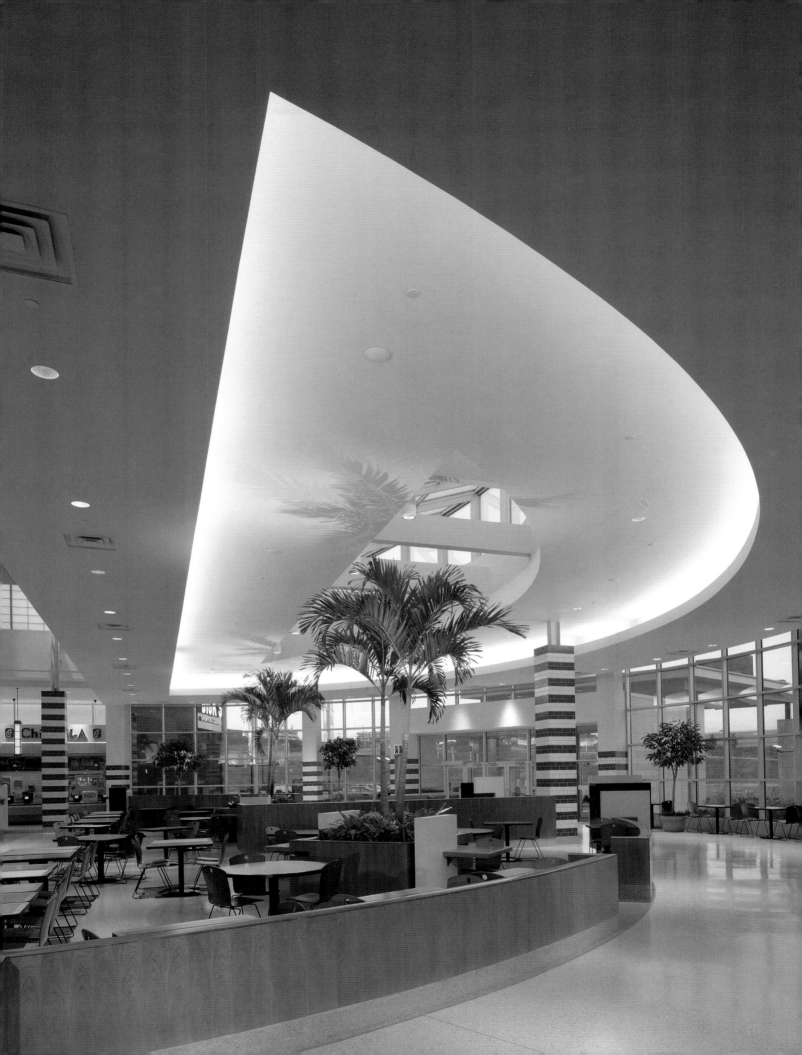

JPRA Architects

The Shops at Willow Bend
Plano, Texas

Five anchor stores, including Neiman Marcus, Saks Fifth Avenue, Lord & Taylor, Dillard's, and Foley's, are featured in this 571,000-square-foot mall 20 miles north of Dallas. A combination of decked and grade-level parking allows for 6,900 cars to park close to mall entrances on the 82-acre site. The symmetrical interior layout features five small courts at regular intervals, each linked to an anchor store. A separate hexagonal Cafés Court is flanked by four major restaurants and has its own distinctive exterior entrance, with a porte-cochere and valet parking. Architectural features recalling various international sources from the dawn of Modernism are executed in stone, hardwoods, etched glass, tile, and metalwork, with amenities such as pendant lanterns, grilles, trellises, and fountains. The willow-foliage-motif is interpreted in several different craft materials at locations throughout the mall.

Above left: Typical entrance with willow-leaf screen.
Left: Court with clerestory lighting and Craftsman-inspired furniture.
Below: One of the mall courts seen from second level.

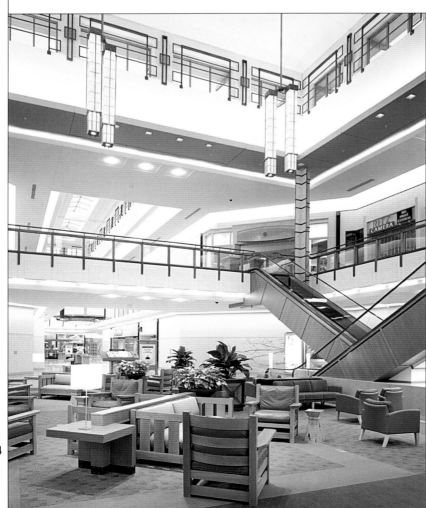

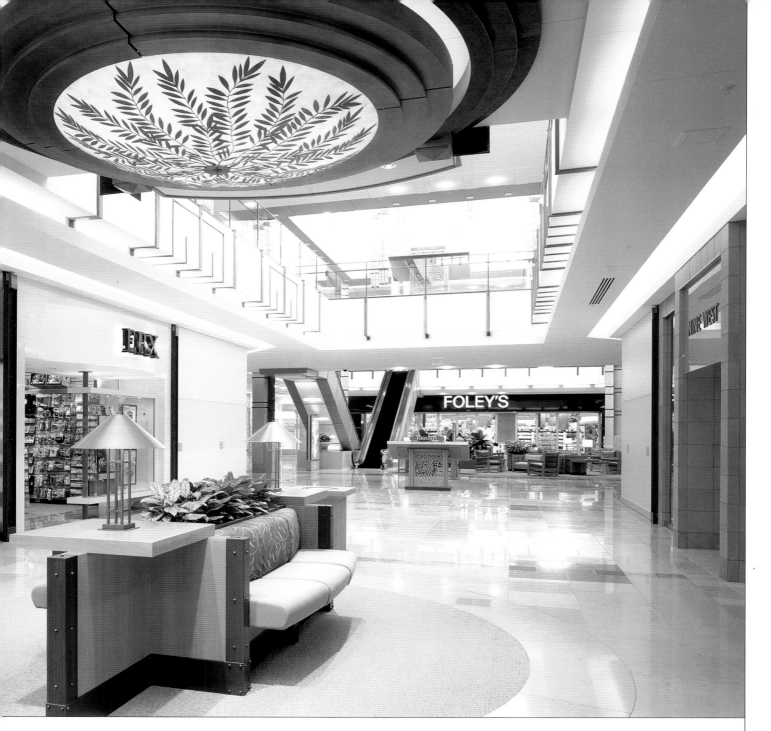

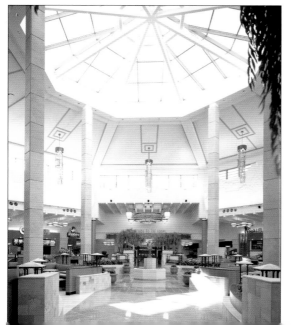

Above: Retail corridor with willow-foliage-motif lighting.
Left: Skylighted Cafés Court, with central fountain and c. 1900 details.
Right: Canopy at Cafés Court entrance.
Photography: John Benoist.

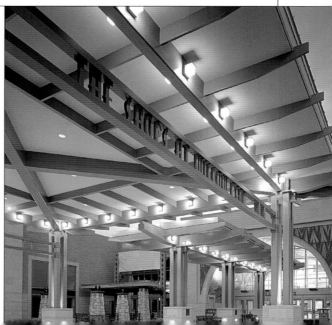

JPRA Architects

The Mall at Millenia
Orlando, Florida

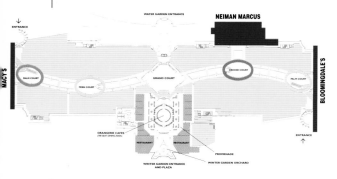

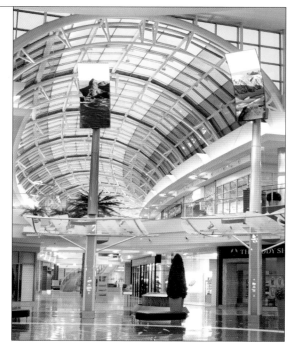

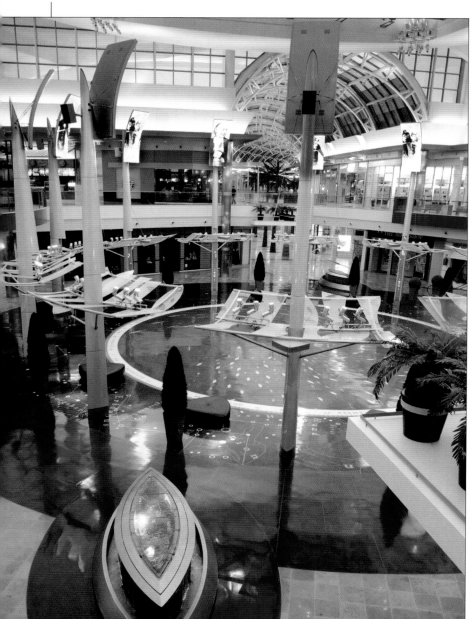

The architecture of this mall is based on universally recognized geometrical forms such as circle and sphere, triangle and pyramid, square and cube, interpreted largely in glass and steel. The complex occupies an 87-acre portion of the 405-acre Millenia development, strategically located within a few miles of Orlando's major attractions. Anchored by Macy's, Bloomingdale's, and Neiman Marcus, the mall includes 525,000 square feet of retail. Its spine follows a soft S in plan, interspersed with elliptical skylighted courts.

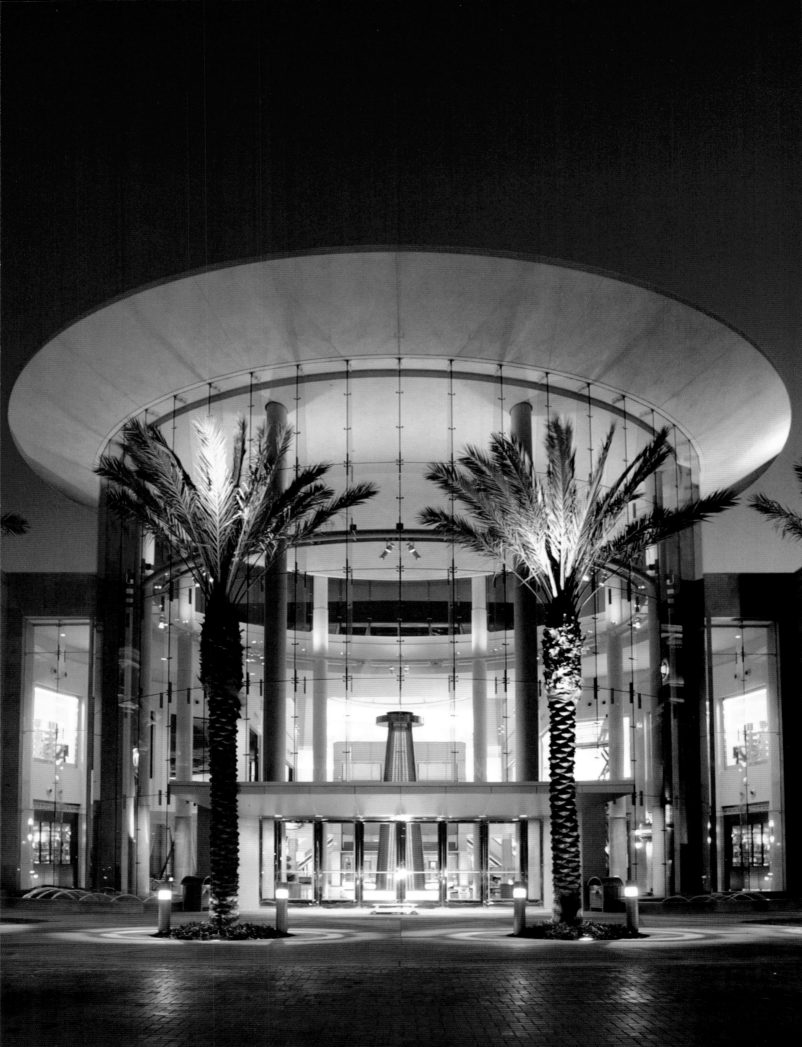

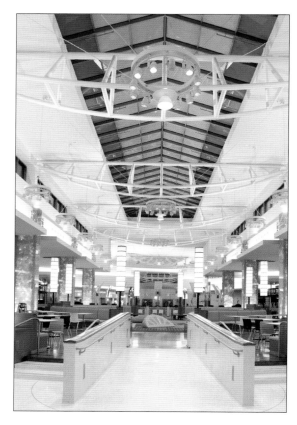

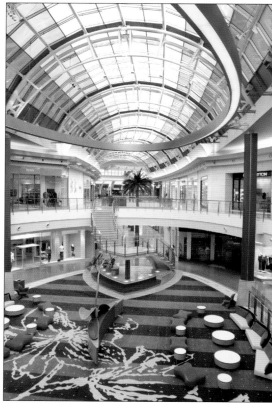

In addition to entrances through the major stores, the complex has impressive central entries on both the upper and lower level. The lower-level, valet-attended entry features a 56-foot-high glass-walled rotunda leading to a Water Garden with programmed fountains. On axis with this entrance, 400 feet away, is the 41-foot-high triangular upper-level entry lobby, with a Winter Garden atmosphere. Adjoining this entrance is the Orangery Cafés, a group of 12 restaurants seating 790 diners in a skylighted space with illuminated frosted glass columns. Of special note is the innovative use of LED screens. Twelve LED videoscreens are mounted atop 35-foot-high masts located in a circular pattern in the Grand Court. The use of large-format signage as an entertainment and advertising system is the first such application in a retail shopping mall venue other than the outdoor public spaces where they have been featured in the past.

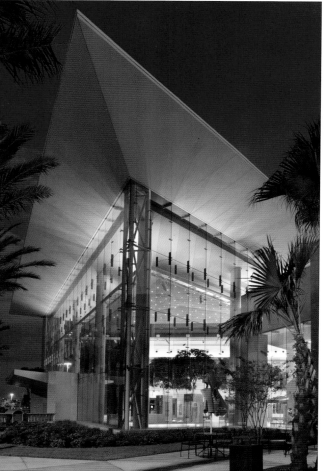

Above: Orangerie Cafés Dining Area.
Above Right: Orchid Court, one of four elliptical courts.
Left: Triangular, upper-level Winter Garden entry.
Right: Orange orchard in upper-level Winter Garden entry.

Looney Ricks Kiss

19 Vandeventer Avenue
Princeton
New Jersey 08542
609.683.3600
609.683.0054 (Fax)

175 Toyota Plaza
Suite 600
Memphis
Tennessee 38103
901.521.1440
901.525.2760 (Fax)

66 Main Street
Suite 200
Rosemary Beach
Florida 32461
850.231.6833
850.231.6838 (Fax)

209 10th Avenue South
Suite 408
Nashville
Tennessee 37203
615.726.1110
615.726.1112 (Fax)

610 Sycamore Street
Suite 120
Celebration
Florida 34747
407.566.2575
407.566.2576 (Fax)

www.lrk.com
info@lrk.com

Looney Ricks Kiss

Memphis Ballpark District
Memphis, Tennessee

Abandoned buildings, empty lots, and X-rated movie theaters recently dotted this eight-city-block area at the edge of downtown Memphis. Today, 24-hour activity is generated by several complementary developments. The 14,000-seat AutoZone Park triple-A baseball stadium is routinely filled, in large measure by suburbanites who have not ventured downtown in years. The Toyota Center, a 200,000-square-foot rehabilitated building, contains offices, retail, ballpark kitchens, team offices, a dining club, and an automobile showroom, with a new parking garage adjacent. The Echelon at the Ballpark residential community includes 361 new high-density apartments and a 24-unit loft conversion of an old YMCA. Another historic building is being adapted as a 60,000-square-foot museum of minor-league baseball. The 700-student elementary school is the first to be built downtown for over a century. The various components are intensely interdependent – the success of the Toyota Center depending on that of the ballpark, the appeal of the once-scorned district secured by the hundreds of new residents, with the restaurants and retailers that they sustain.

Top: Plan of District.
Above left: Exterior street lighting and landscape detail.
Left: New apartment buildings.
Right: Toyota Center.
Below right: Aerial view of District.
Facing page: Ballpark entrance, with brick and steel details.
Photography: Mark J. Istvanko (above left); Terry Sweeney (left); Jeffrey Jacobs, Architectural Photography (right); Jim Hilliard Aerial Photography (below right); Mark J. Istvanko (facing page).

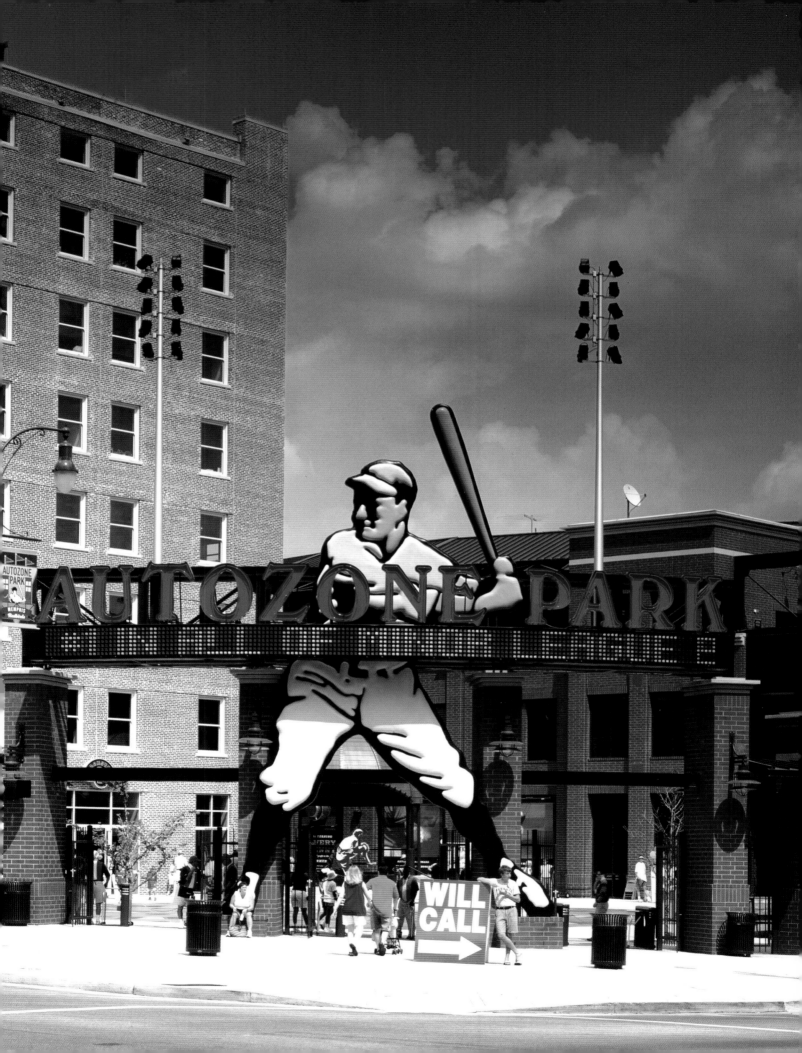

Looney Ricks Kiss

Harbor Town
Memphis, Tennessee

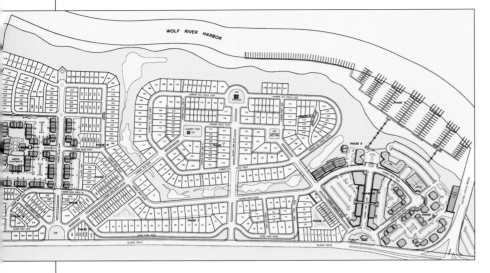

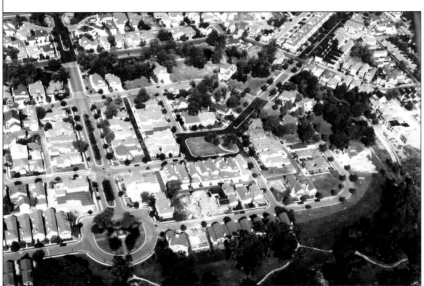

Begun in 1989, Harbor Town violated the planning and zoning ordinances of the time, and was permitted only because all infrastructure would remain private. Today, zoning officials view it a model for responsible development. Adjacent to downtown Memphis and almost surrounded by rivers, the barren 135-acre site was miles from any recent housing development. LRK helped to modify an existing land plan, drafted design guidelines, and designed most of the buildings. The result is one of the most complete examples in the nation of traditional town planning – or New Urbanism. It includes a traditional street grid, walkable distances to community facilities, formally planned squares, and architectural forms based on historical prototypes. There is a fine-grained mix of housing types, sizes, and price ranges. Automobile access from alleys permits narrower lots and uninterrupted sidewalks. The development includes a school, an office building, a grocery store, a 25-room inn which includes two restaurants, a yacht club, a 50-slip marina, and a mixed-use center with rental apartments over shops and restaurants.

Top: Community plan, with north to left, Mississippi riverfront park at bottom.
Above: Aerial view showing squares and boulevards.
Photography: Jim Hilliard Aerial Photography.

Above: Condominiums at edge of town center.
Right: Gateway to community.
Far right: Townhouses complement surrounding single family homes.
Photography: Jeffrey Jacobs/Architectural Photography (above); Robt Ames Cook (right); Jeffrey Jacobs/Mims Studio (far right).

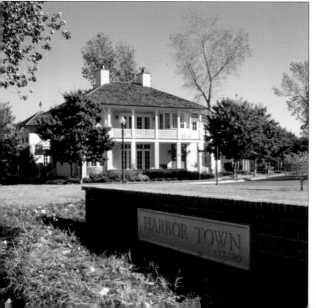

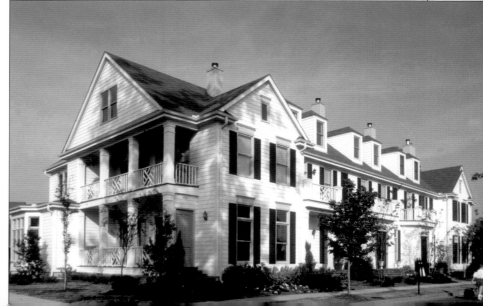

Looney Ricks Kiss

Cherry Hill Village
Canton Township, Michigan

Left: Development plan.
Right: New houses.
Below right: Historic crossroads school house.

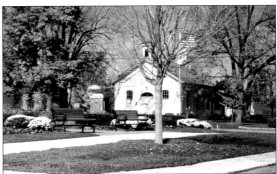

Above: *Multiple units in house-like structures which follow guideline principles.*
Left: *Central square, setting for old church and new mixed-use buildings.*
Photography: *Looney Rick Kiss.*

A 150-year-old crossroads hamlet with a historic school house is at the center of this 455-acre development. The project's plan evolved through exceptional public/private interaction, including a computer-based survey open to all citizens, numerous meetings with officials, and a public planning charrette on site. This shared vision is underscored by the municipality's adoption of the plan's principles for a township-wide master plan and its provision of anchor facilities for the village center, including a 400-seat performing arts theater and a township human services building. Other community facilities are being provided by the developer. Street layouts create vista-terminating locations for key buildings, echoing the way the school house terminates the view from one of the approach roads at the offset crossroads. Surrounding neighborhoods are planned to contain 1,891 dwellings in a mix of widely varying types. Twenty-five percent of the land has been reserved for open space, ranging from small squares to large tracts conserving woodlands and river corridors. The project and the process behind it offer a prototype for planning at the metropolitan fringe and for plans that accommodate historic preservation.

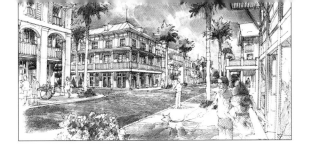

Looney Ricks Kiss

Main Street
Baldwin Park Village Center
Orlando, Florida

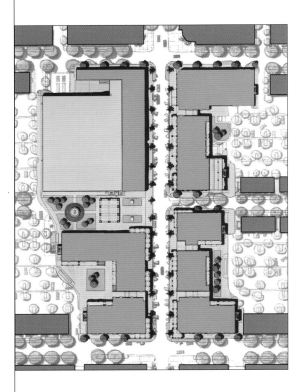

Baldwin Park is an 1,100-acre development on the site of a former naval training center three miles from downtown Orlando. The Main Street edge of its proposed 54-acre village center consists of four urban core blocks lined with three-story buildings containing residential units above retail and service-oriented spaces. The other three sides of these blocks are intended to accommodate live-work dwellings, making the transition to surrounding single family neighborhoods. Along Main Street, ample sidewalks, arcades, awnings and balconies provide outdoor spaces for both commercial and residential users. Residential entry courts at the rear of the buildings are buffered from mid-block parking lots by gardens and landscaping. The location of Baldwin Park within an otherwise built-up metropolitan area should ensure commercial prosperity for the village center as surrounding neighborhoods are built. Looney Ricks Kiss serves as Town Architect as well as Architect of a significant amount of single family residential development.

Top right: *Main Street view.*
Above: *Village center plan.*
Right: *Proposed building fronts along Main Street.*

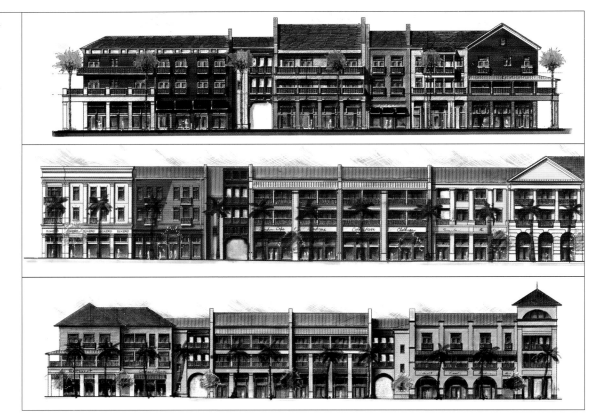

Lucien Lagrange Architects

605 North Michigan Avenue

Chicago

Illinois 60611

312.751.7400

312.751.7460 (Fax)

www.lucienlagrange.com

Lucien Lagrange Architects

Park Tower
Chicago, Illinois

Rising 67 stories just to the west of Chicago's landmark Water Tower, Park Tower fits 840,000 square feet onto a 27,000-square-foot site. Its mix of uses includes 20 floors luxury Park Hyatt Hotel, 45 floors of residential condominiums, 92,000 square feet of parking, and 20,000 square feet of retail. To appeal to upscale residents, the condominium entrance has been separated from the hotel's, and buyers were offered the option of a finished unit or raw space to configure as they wished—an option that demanded close coordination and redundancy of building systems. To relate the exterior to the Water Tower and the area's elegant buildings, the soaring façades were softened with devices such as setbacks, columns, and curved balconies. The landmark three-story structure just to the north, built in 1917 as architects' studios, now houses some hotel and retail functions behind its meticulously restored façade.

Left: Tower's slender east façade.
Top: Terrace at 7th floor.
Above: Street frontage.
Facing page: East front rising above historic Water Tower.
Photography: Barbara Karant (above and left); others by architects.

Lucien Lagrange Architects

175 West Jackson
Chicago, Illinois

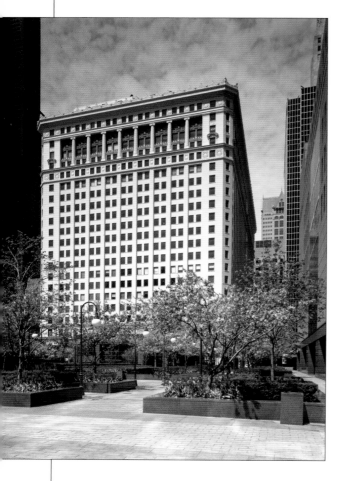

A comprehensive renovation has returned Chicago's fifth largest office building to a strong position in the office market. Built in two phases in 1912 and 1928 and designed by the renowned D.H. Burnham & Company and successor firm Graham, Anderson, Probst & White, the structure contains 1.8 million square feet. The facades, stripped of much detail in a 1950s renovation, have been meticulously restored. But interior public spaces, altered beyond recognition, have been transformed in 21st-century style around a striking three-story atrium, lined with retail at the street level. The atrium's glass ceiling allows the light court above to serve as return air plenum. Mechanical and electrical systems have been replaced and moved up from the basement, which now houses a 250-car garage.

Below: Current floor plan and view of main lobby.
Facing page: New atrium at base of original light court.

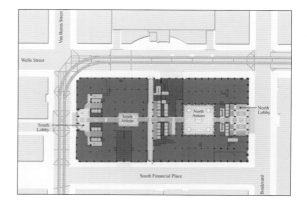

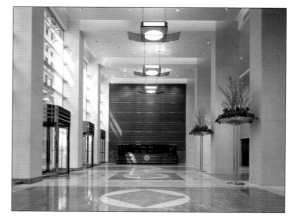

Above: Restored exterior.
Right: New glass and steel canopy at main entrance.
Photography: Barbara Karant (all except top left).

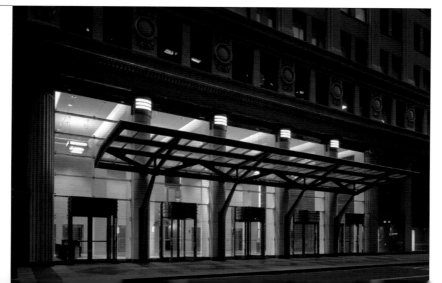

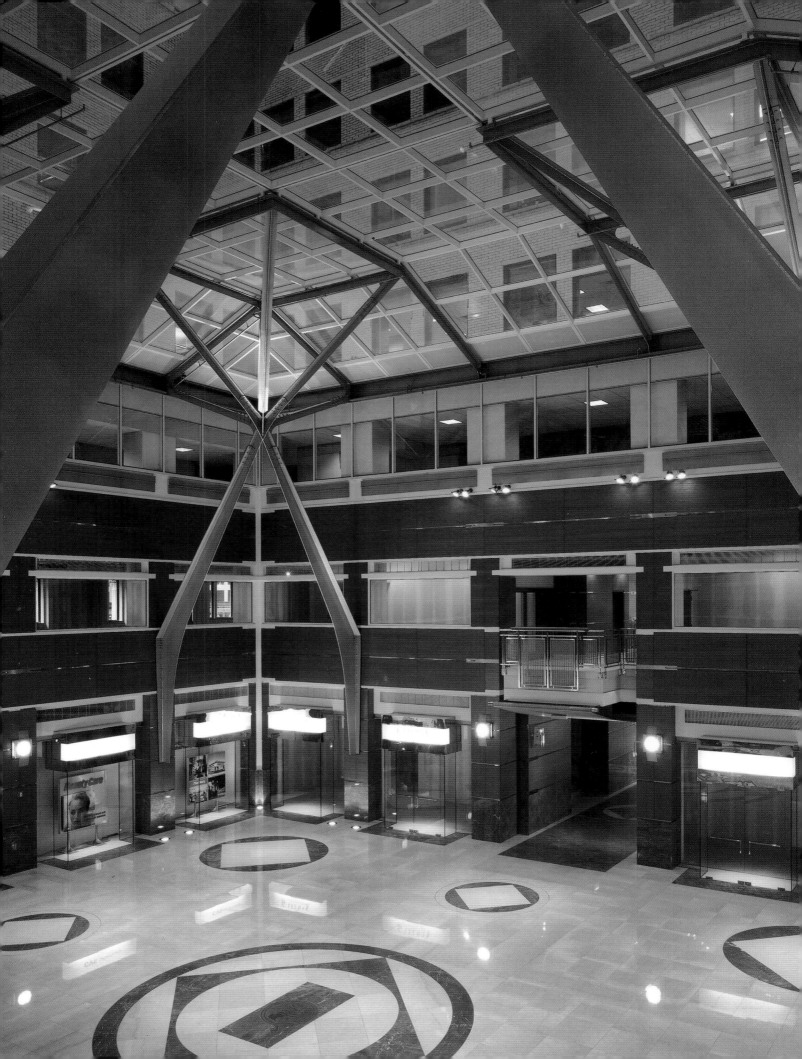

Lucien Lagrange Architects

Erie on the Park
Chicago, Illinois

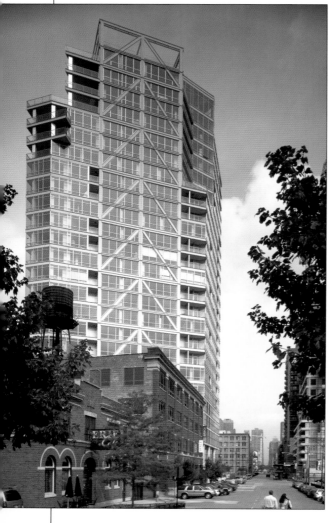

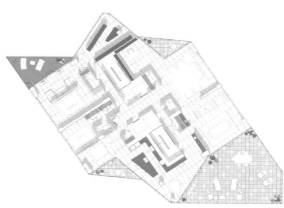

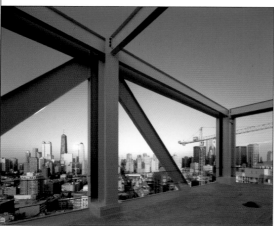

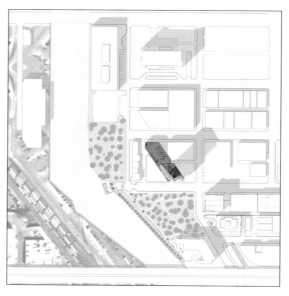

The 25-story steel and glass tower rises among mid-rise masonry building in River North, an area in transition from industrial to residential uses. Its parallelogram-shaped plan follows the boundaries of its site, 10,000 square feet of abandoned railroad land slipped between existing structures. Above a concrete base, the tower is framed in steel, with visible diagonal bracing. Exploiting the adaptability of the steel framing, the building offers over 20 unit plans, including duplexes, with outdoor spaces ranging from balconies to expansive terraces. The first level of living units is 60 feet above ground, assuring city and river views. Parking is accommodated in the lower levels and a separate, connected structure. The 30-foot-high lobby opens from a landscaped plaza, linked visually to green areas along the river.

Far left: Views from street and outward from rooftop.
Top left: Entry plaza and lobby.
Above left: Penthouse plan.
Left: Site plan.
Photography: Steve Hall, Hedrich Blessing.

Lucien Lagrange Architects

65 East Goethe
Chicago, Illinois

Inspired by classic Parisian architecture, the eight-story limestone-clad structure sets a standard of elegance appropriate to its Gold Coast location near Lake Michigan. A curved, standing-seam, zinc-coated mansard roof encloses the top floor, and its parapets shield the 6,000-square-foot rooftop garden, open to all residents, which features full-sized trees, gardens, gazebos, and water features. Rich architectural elements throughout include mahogany windows and doors, hand-forged iron railings and grilles. Four townhouses occupy the first two floors, with 15 condominium units on the floors above, all featuring private balconies or terraces. A below-ground garage provides each resident with two parking spaces. Public opposition to an original proposal for a 32-story building led to four height reductions over a three-year period, eventually yielding the final eight-story structure. As completed, the building preserves unobstructed lake views for many neighbors and admits ample sunlight to adjacent Goudy Park, enhancing its neighborhood while providing exceptional homes for its residents.

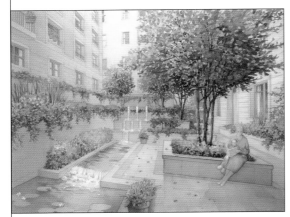

Above: *Rendering of building as seen from Lake Shore Drive.*
Left: *Courtyard.*
Below left: *Lower facades adjoining park.*
Below: *Roof garden.*
Photography: *Image Fiction (above).*
Watercolor renderings: *Gil Gorski.*

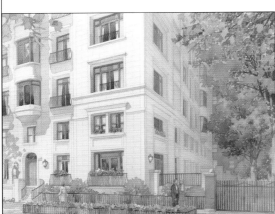

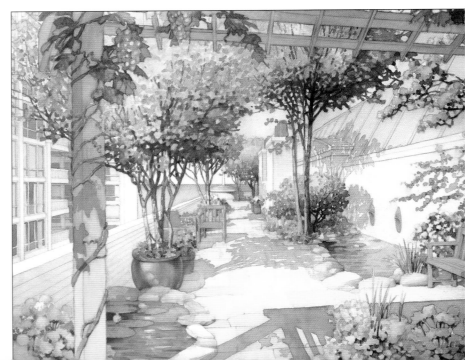

MBH Architects

1115 Atlantic Avenue

Alameda

California 94501

510.865.8663

510.865.1611 (Fax)

www.mbharch.com

1300 Dove Street

Suite 100

Newport Beach

California 92660

949.757.3240

949.757.3290 (Fax)

MBH Architects North Beach Malt House
San Francisco, California

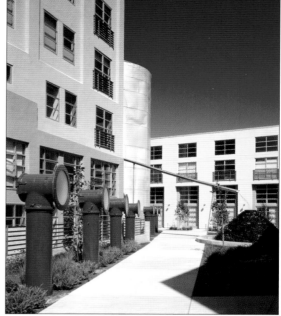

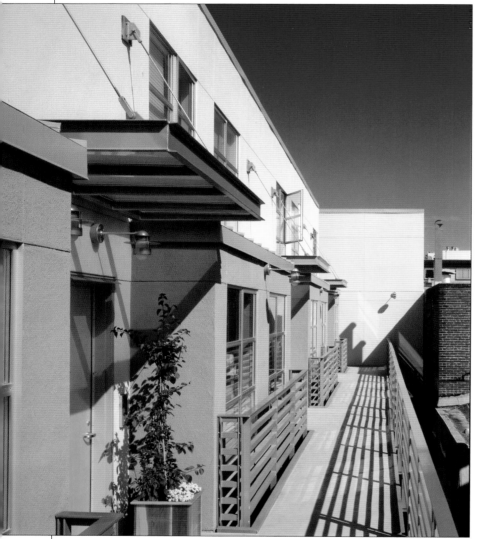

A complex of 88 loft residences around a landscaped court takes its identity from the renovated 1906 tower/kiln structure of the Bauer & Schweitzer Malting Company. Required to preserve the landmark exteriors to the maximum extent feasible, the architects retained the existing windows, gantries, flagpole, and rooftop appendages of the concrete tower. To preserve its solid appearance, the new openings required for dwelling use have tinted glass and are clustered and held flush with the exterior surface, in contrast to the deeply recessed original windows. The three new buildings in the complex take formal cues from the older structure, making a transition to the neighboring residential fabric. Holding the street line, these buildings have a horizontal emphasis and articulation of trellises, handrails, and grilles. One of the two remaining grain silos has been adapted as an entrance lobby, and a flume carries water to a basalt lava stone fountain simulating a grain pile.

Above: Balconies on new structure.
Left: Loft interior.
Right: Façade of new building.
Above right: Landscaped courtyard, with nautical-style lighting.
Facing page: Landmark tower, silos, and flume feeding fountain.
Photography: Assassi, except photo at left, Jim Pyle.

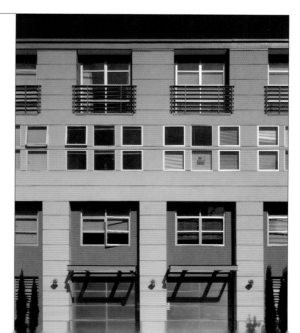

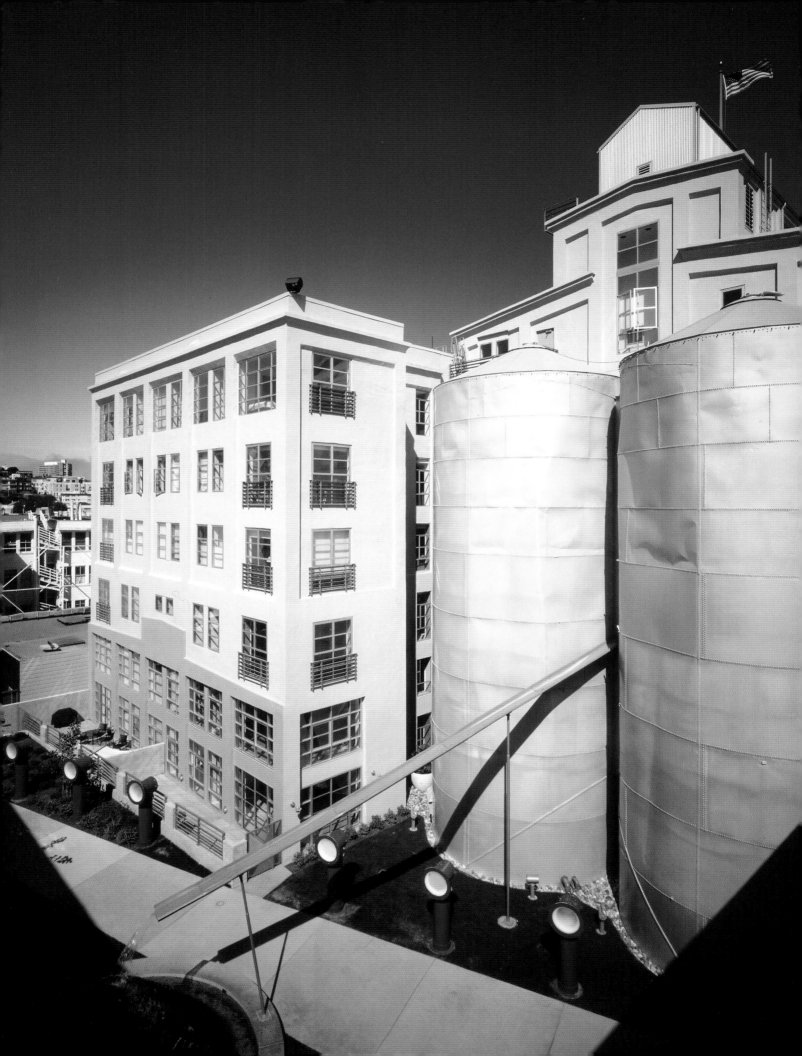

MBH Architects

San Francisco Fire Credit Union
San Francisco, California

The building is conceived as a life-time structure representing SFFCU, a municipal credit union. With Gary Gee Architects, collaborating on exterior design, MBH had to ensure that its structure and systems would last as long as the institution. Since the building is exposed on all sides, all surfaces had to represent the dignity and durability of the SFFCU. In its height, the building makes a transition between large nearby university structures and smaller ones along the street. For visual impact, a double-height curved window wall, 150 by 25 feet, faces an adjoining intersection. Initially considered impossible within the $5.1 million budget for this 35,000 square foot building, the wall was made feasible with a structure of solid stainless batwings bracing the glazing over the 10-foot spans between 8-inch double strength pipe columns.

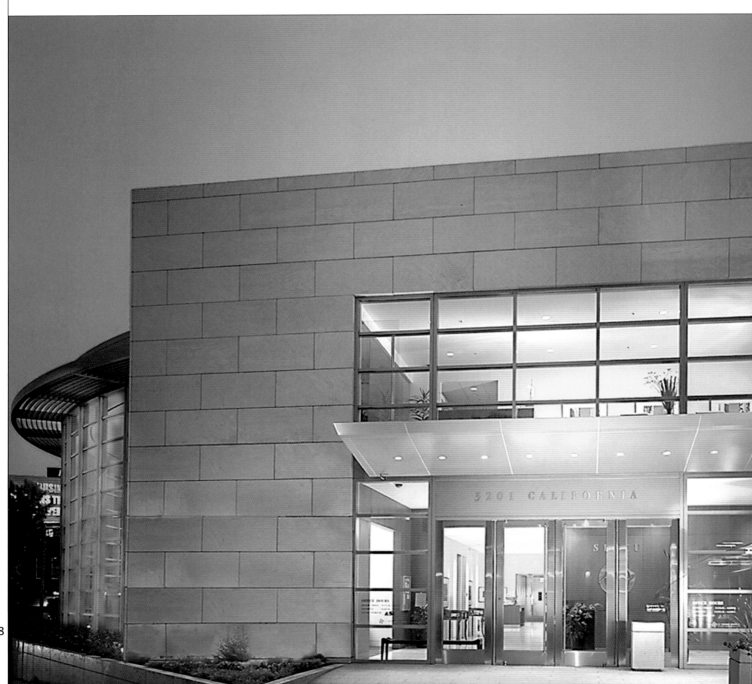

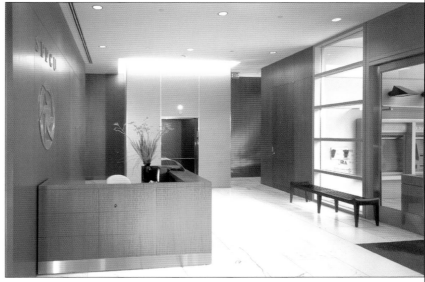

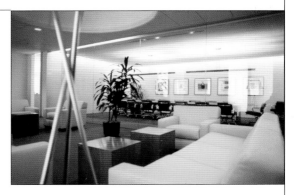

Left: *Entrance, with curved glass wall facing intersection at left.*
Top: *Inside curved wall.*
Above: *Lobby.*
Right: *Reception and conference rooms.*
Photography: *Dennis Anderson.*

MBH Architects

Embarcadero Lofts
San Francisco, California

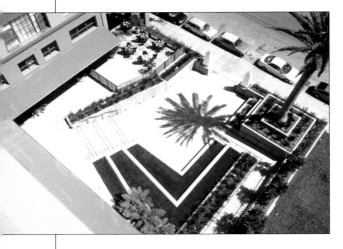

Known as the Coffin-Reddington Building when it was constructed in 1937, the building housed a pioneering drug, chemical, and liquor wholesaler. Considered a significant commercial structure of its time, it is listed on the National Register of Historic Places. The architects developed a thorough seismic and infrastructure upgrade program for the building and adapted it for reuse as 59 loft-type apartments. The occurrence of different ceiling heights on various floors raised challenges for inserting raised sleeping areas with required fire exiting. Radiant in-floor heating was installed to save energy. An additional floor was added to a large portion of the structure, increasing its size to 150,000 square feet and allowing for ten two-story residences, with exterior decks offering dramatic views. The project demonstrates how thoughtful adaptive reuse can return activity to historic buildings and maintain the character of their neighborhoods.

Above: Entry plaza with industrial metal canopy along two sides.
Right: Building renovation including landscaped plaza.
Photography: Dennis Anderson.

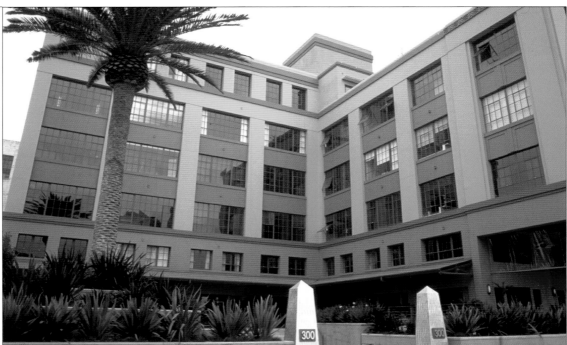

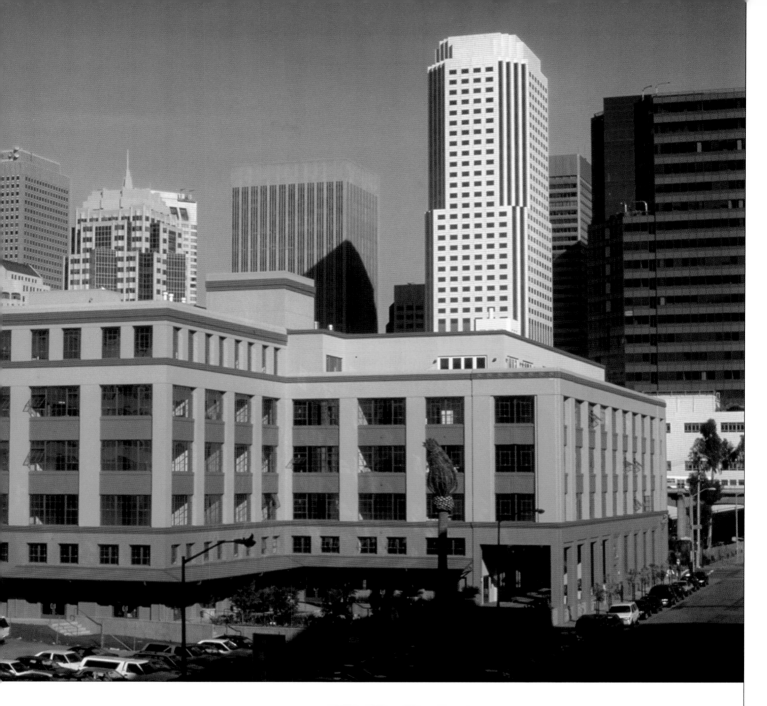

Above: *Restored building with downtown skyline beyond.*
Right: *Lobby in 1930s spirit.*

MBH Architects

Harbor Lofts
San Francisco, California

Constructed in 1856, the Hathaway Warehouse is one of the city's oldest buildings and a national historic landmark. The city's plan for its South of Market district urged retention of the historic fabric adapted for new uses. The renovated warehouse includes 46 live/work units in a variety of sizes and configurations based on the unique geometry of the building. At the center of the structure is a 40-by-100-foot courtyard providing access, light, and air to the dwelling units, as well as the fire department's required access to all individual sleeping areas. Zoning regulations allowed for a building addition to be made along the edge of the property. Seismic upgrading of the structure, originally unreinforced masonry bearing walls with heavy timber framing, required that the framing be supported independently from the exterior shell for all vertical loads. New shear walls were introduced within the walls between units, and a horizontal shear diaphragm was introduced within the second-floor structural system.

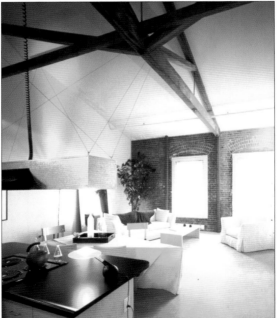

Above: Upper-level walkways in court.
Left: Top-floor unit with exposed original framing.
Below left: New low-rise structures on site.
Below: Steel walkway on concrete columns.
Photography: Dennis Anderson.

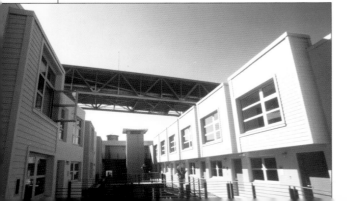

Moore Iacofano Goltsman, Inc.

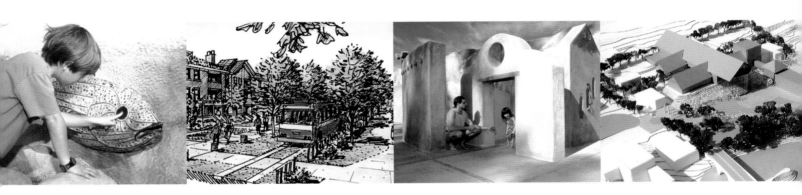

800 Hearst Avenue
Berkeley
California 94710
510.845.7549
510.845.8750 (Fax)

2778 Viking Drive 1B
Green Bay
Wisconsin 54303
920.498.8873
920.498.8784 (Fax)

412 NW 13th Avenue
Portland
Oregon 97209
503.297.1005
503.297.3195 (Fax)

613 G Street
Davis
California 95616
530.753.9606
530.753.9608 (Fax)

709 W. North Street
Raleigh
North Carolina 27603
919.821.4913
919.834.8446 (Fax)

169 N. Marengo Avenue
Pasadena
California 91101
626.744.9872
626.744.9873 (Fax)

199 E. 5th Avenue
Suite 33
Eugene
Oregon 97401
541.683.3193
541.683.4079 (Fax)

www.migcom.com

MIG, Inc.

Chase Palm Park
Santa Barbara, California

Above: *Whale climbing sculpture.*
Far left: *Sand play area for toddlers.*
Left: *Fish fountain, embedded in sand wall.*
Below left: *Child-size Santa Barbara façades.*

Children respond most enthusiastically to nature-based settings that offer choice, surprise, diversity, and sensory stimulation. This one-acre play and learning area, across from the beach, tells the story of the site and the relationship between Santa Barbara and the ocean. It contains an underwater garden of sea life, a full-size pod of whales spouting water, a sand and water play area, sea caves, a marooned village, a large model of a shipwreck, a lighthouse with a kaleidoscope, fishing pier and docks, and child-size building façades in the style of Santa Barbara. The project embodies the city's desire to make this new oceanfront park a unique and cohesive play area. MIG in association with George Girvin Associates, involved city staff and the community in the design process. The park won an Award of Excellence and Special Honor from the California Park and Recreation Society and was chosen for a cover story in *Landscape Architecture* magazine.

MIG, Inc.

Ibach Park
Tualatin, Oregon

The park's play area meets the city's desire for a connection to the river by representing a voyage through the history of Tualatin, from prehistoric to early settlement days. MIG designed three distinct spaces linked by the Tualatin "river" – made of water and blue resilient safety surfacing. The river begins in prehistory with an archaeological dig, buried "fossils," and a large mastodon rib cage. The Atfalati American Indian area includes drums and a redwood boat. The early European settlement area has a ferry, a synthetic logjam, a wagon train, farmhouses, and a sculptured cow under a shade structure. The park was featured in *Landscape Architecture* magazine, received the 1996 design award from the Oregon Recreation and Parks Association, and was called "Best Park Playground" by *Portland Parent* magazine.

Top right: *Beginning of "river."*
Above right: *Sculptured boat in Native American area.*
Right: *"Log jam" in river.*
Far right: *Mastodon rib cage.*

MIG, Inc.

Stafford Park
Redwood City, California

This interactive three-acre community park can be enjoyed by people of many different ages, year round. Community workshops brought residents into the design process. A striking redwood rose arbor arches over the central promenade, with benches for adults to enjoy the shade with a clear view of their children at play. Children can activate the three water columns that are placed in a large, colorfully patterned circle of soft paving. A sand and water play area includes a fountain that channels water to the sand. The play structure area includes equipment that engages older children. Picnic tables on cobblestone paving provide areas for parties and meals. A strolling and sitting garden also serves as a backdrop for summer evening music presentations.

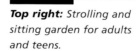

Top right: Strolling and sitting garden for adults and teens.
Above right: Arbor offering adults clear view of children.
Above: Water sprays.
Left: Fountain in sand play area channeling water.

MIG, Inc.

**Cisco Systems
Cupertino, California**

In planning a children's environment for an employee child care center, MIG emphasized "curriculum of place" – meaningful learning occurs when children feel empowered to explore a rich physical setting. The 50,000-square-foot outdoor play and learning space features many different park and play areas, each geared to a specific age group. All are accessible to people of all abilities. The infant area has a play maze, sand and water play station, multilevel sinks, and vegetation. The toddler setting includes a small stream, a sand construction area, a tricycle path, and open grass areas. And the pre-school area has full-body water sprays, bridges over water, an art area, gardens, and a multipurpose activity area for games and gathering.

Top right: *Open grass area for three-year-olds.*
Top: *Faucet for toddler sand play.*
Above: *Preschool setting with small stream.*
Right: *Sand play area.*

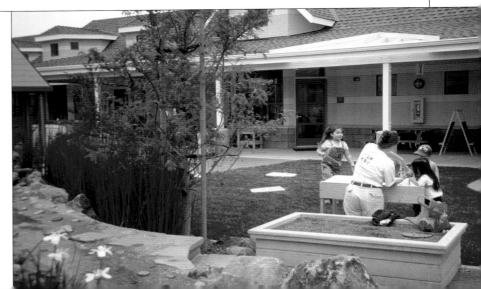

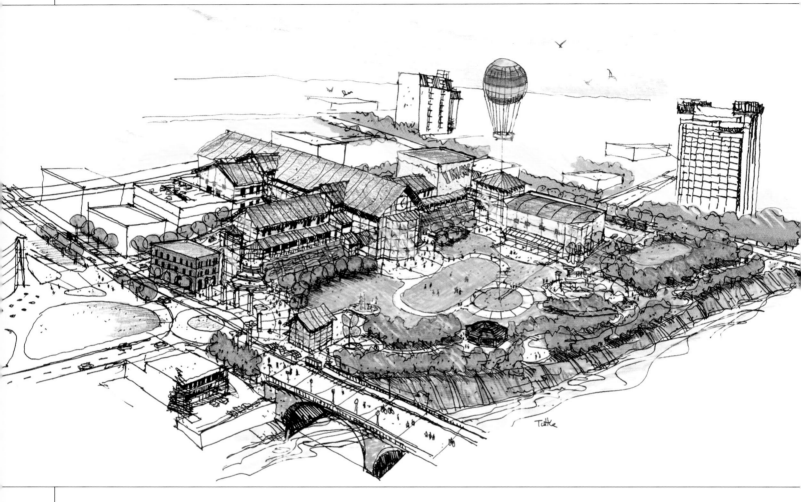

Above: *Concept for north bank sports and entertainment district.*
Right: *Model of IMAX theater, Science Technology Center, park offices, and indoor/outdoor ice skating rink.*
Facing page, top: *Landmark clock tower in park.*
Facing page, center: *South entrance to park, with trolley.*
Facing page, bottom: *Riverfront park area.*

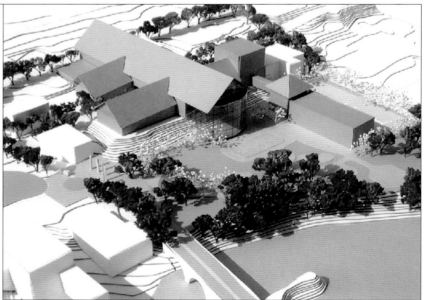

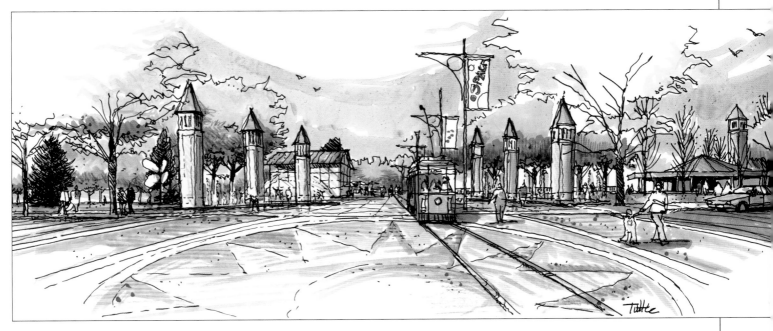

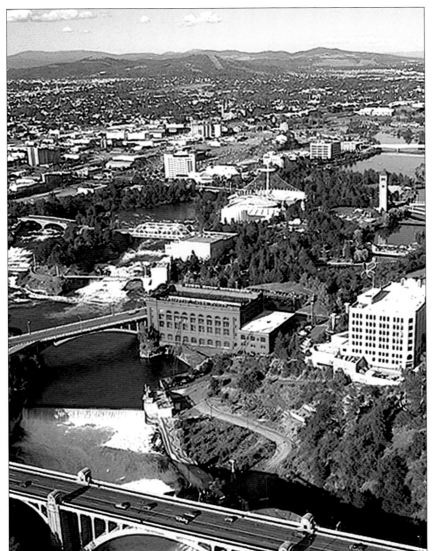

The city's history was built on the Spokane River, but as a result of an aging infrastructure and economic and urban decline, the city no longer connected effectively with the river. MIG developed a master plan for a 100-acre Riverfront Park with an economically viable entertainment area that provides a link to the downtown retail core. In the North Bank, planners had to deal with the constraints of land ownership and the need for new design elements to fit between existing buildings and complement existing uses. The south entrance includes a new plaza, a water feature, and a renovated carousel. The Pavilion area features an open-air theater, promenades, play areas, and gardens.

The North Bank includes park offices – moved out of the park – a new 3-D IMAX theater, a new Science Technology Center, a winter garden atrium, an indoor/outdoor skating rink, and pedestrian links to the sports arena. New trolleys run through the park between downtown commercial areas on the north and south banks.

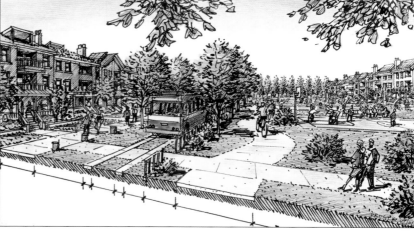

Top: *Students with their primary transportation mode: bicycles.*
Center above: *Compact housing mix with public spaces.*
Above: *Design workshop participation by faculty, staff, students, and community.*

Top right: *Bus Rapid Transit green through development.*
Illustrations: *Thomas Prosek.*

UC Davis needs to expand and house 4,300 additional students, faculty, staff, and their families. Much of the university's unbuilt land is used for long-term agricultural research, and the surrounding community was very concerned about growth and traffic. So minimal impact on the environment was essential. MIG, working with William McDonough + Partners, developed a mixed-use, transit-oriented, sustainable neighborhood plan combining several innovative solutions: compact housing that offers choices including single-family detached houses, townhouses, apartments, live/work units, and cottages; buses running every six minutes on a Bus Rapid Transit green to minimize use of cars; tree-lined, traffic-calmed streets; 30,000 square feet of office/commercial space as a neighborhood amenity; extensive landscaping to mitigate visual and aural impacts; drainage ponds for storm water re-use on site; 70 acres of open space, with extensive bike and pedestrian trails; an elementary school and recreation fields to reduce impact on the surrounding community; and a phased plan that accommodates the long-term needs of agricultural research projects.

Otak Inc.

117 S Main Street
Suite 400
Seattle
Washington 98104
206.224.7221
206.224.9230 (Fax)

620 Kirkland Way
Suite 100
Kirkland
Washington 98033
425.822.4446
425.827.9577 (Fax)

36 N Fourth Street
Carbondale
Colorado 81623
970.963.1971
970.963.1622 (Fax)

1345 NW Wall Street
Suite 100
Bend
Oregon 97701
541.385.9960
541.312.8704 (Fax)

435 NW Fifth Street
Suite D
Corvallis
Oregon 97330
541.738.1611
541.738.1612 (Fax)

Corporate Office

Lake Oswego
17355 SW Boones Ferry Road
Lake Oswego
Oregon 97035
503.635.3618
503.635.5395 (Fax)

www.otak.com

105 W Evergreen Boulevard
Suite 300
Vancouver
Washington 98660
360.737.9613
360.737.9651 (Fax)

51 W Third Street
Suite 201
Tempe
Arizona 85281
480.557.6670
480.557.6506 (Fax)

Otak Inc.

King Street Station Redevelopment
Seattle, Washington

This project combines extensive transportation improvements with preservation of the King Street Station, a 1906 structure listed in the National Register. To avoid obstruction or detracting from views of this landmark, new construction presents minimal forms with many transparent elements and integrated artwork. Besides the landmark terminal served by Amtrak, the redeveloped project comprises a new commuter rail station to serve a growing regional network and access improvements to the station area, including new pedestrian and transit plazas, improved sidewalks, and revised traffic signals. Improvements to King Street Station have been ongoing for several years with the current interim improvement project to be completed in 2006.

Left: *Amtrak inter-city platform (left) and commuter platforms (right).*
Below: *Narrow, center-loaded platform demanded attention to detailing and placement of platform accessories.*
Bottom left: *Minimal but distinctive entrances, landmark station in background.*
Photography: *Art Grice.*

Otak Inc.

Obermeyer Place
Aspen, Colorado

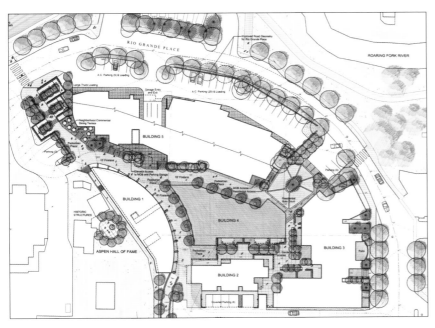

Characteristic of Aspen's history and environmental sensitivity, Obermeyer Place fits 230,000 square feet of mixed uses onto a 2.6-acre downtown site. It includes structured parking, medical offices, facilities for existing commercial and light industrial tenants, 21 residential condominiums, and 21 affordable dwelling units. Its five buildings feature exterior materials, such as brick and rose sandstone, common to Aspen's historic structures and are organized to retain exceptional mountain views. A one-acre central plaza sits atop structured parking and the central building is only a single story, with a sod roof planted in native wildflowers. Accessibility for the steeply sloping riverside site is accomplished through a series of stairs and ramps leading through a landscape of native trees, alpine perennials, and natural rock walls. The project was planned under a new review process for projects "deemed reasonably necessary for the convenience and welfare of the public," which provided flexibility in land use code and encouraged innovative design. Otak worked in conjunction with Cottle Graybeal Yaw Architects.

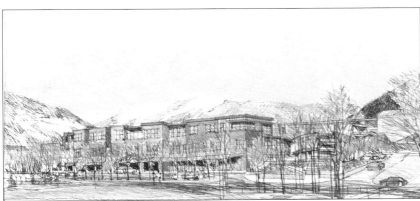

Above: Conceptual elevation of the center of the residential drop-off, which abstracts the nature of a stream cutting through the mountainous terrain of the Aspen area.
Top left: Site plan.
Center left: View from city side.

Bottom left: Utilizing intriguing building forms within the project plaza areas creates memorable pedestrian experiences.
Renderings: Mark Henthorn (center left and bottom left).

Otak Inc.

Portland Streetcar
Portland, Oregon

Otak led a multidiscipline team that reconsidered the essence of the streetcar for the 21st-century city. By using a relatively short, maneuverable vehicle, the team was able to run the streetcars over streets with tight corners and substantial inclines. The light weight of the cars made possible shallow (12-inch) track slabs, which greatly reduced cost, construction time, and utility relocation. The system was made a reality through the nonprofit Portland Streetcar Incorporated, initiated jointly by the business community and the city, using a financing model that could be effective nationwide. The Phase I lines extend from Portland State University to the south, through the central business district, to Northwest Portland. The effect of the streetcar system, which is expected to expand, is to reduce automobile dependence and its attendant congestion. It provides essential local transportation, connections to the regional light rail system, and links to re-emerging urban neighborhoods. Over $1 billion in development activity has occurred in the streetcar corridor since the inception of the project.

Right: *Urban revitalization scene.*
Below left: *Streetcar stop.*
Below: *Streetcar at Portland Art Museum.*

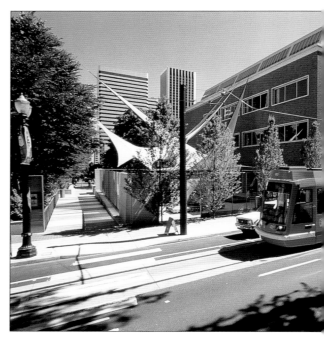

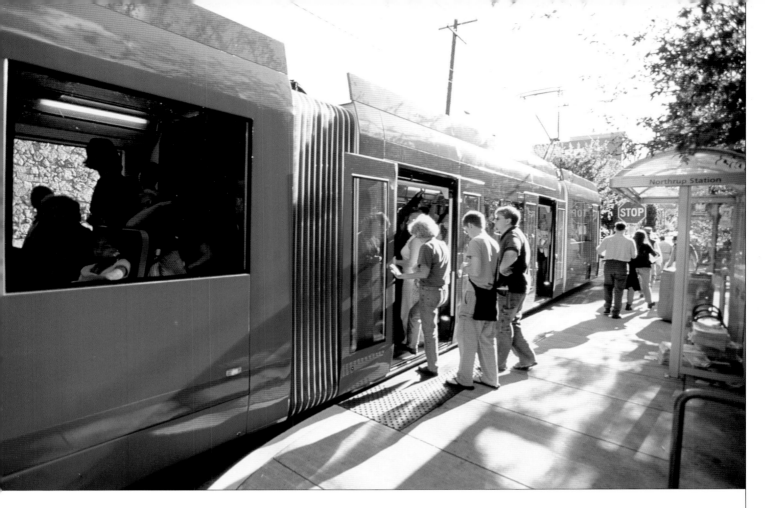

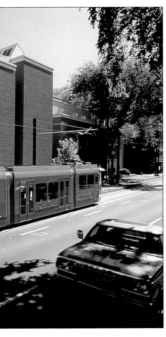

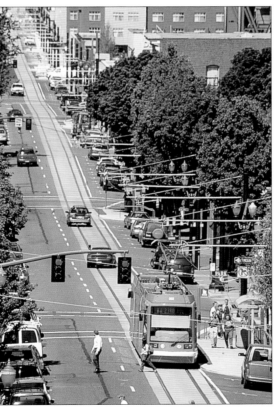

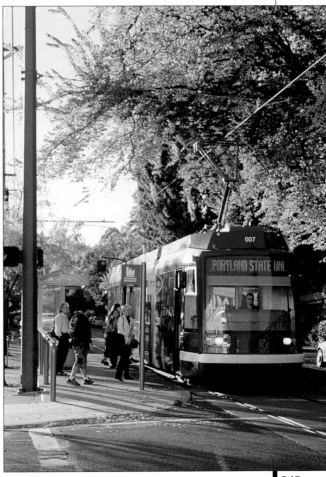

Top: Boarding at a stop.
Right: Through the CBD.
Far right: Stop in northwest Portland neighborhood.
Photography: C. Bruce Forster, except far right, Otak.

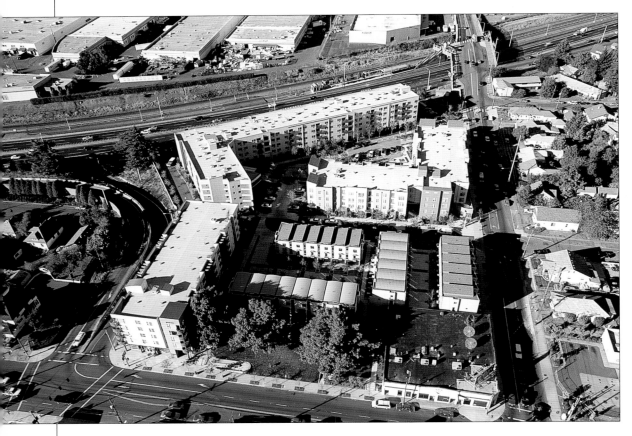

Left: *Aerial view, with freeway and transit station at top.*
Below and bottom left: *Central open space with mix of autos, walkways, and play area.*
Below: *Close-up of townhouses.*
Photography: *C. Bruce Forster, except facing page, top right, Strode Photographic.*

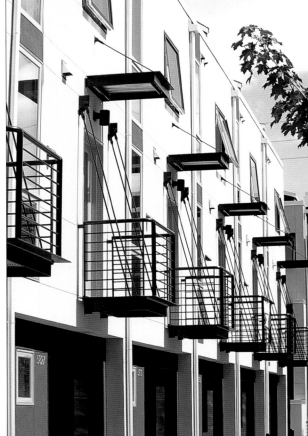

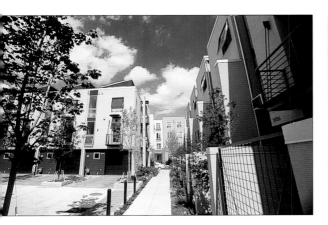

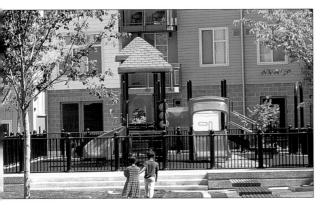

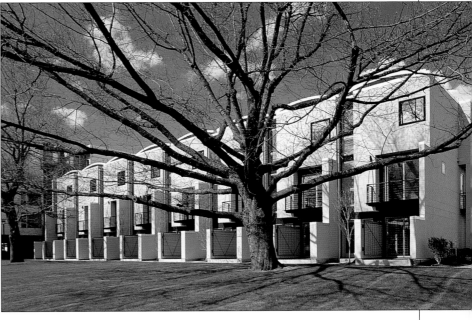

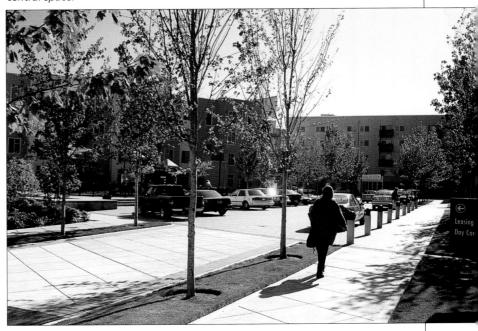

Above left: *Townhouses around paved auto/pedestrian court.*
Left: *Playground in central space.*

Above: *Townhouses with front entry terraces.*
Below: *Main walkway to transit through central space.*

Regarded as a model for transit-oriented development, the project occupies 4 acres adjacent to a light rail station. Its 314 units include market-rate, affordable, and senior housing, as well as for-sale townhouses, along with retail space, a daycare center, and management offices. The focal point of the development is a central open space that pointedly combines parking, drop-off zones, a playground, a bosque of trees, and generous pedestrian walks providing short cuts to the transit station. A large, continuous building paralleling the adjacent freeway serves as a sound wall, reducing noise in the project's public spaces. The 26 townhouses serve as a transition in scale to the neighboring detached houses. An urban forest of mature oak trees has been preserved and set off with lawns as an amenity for both the complex and the surrounding area. Previously the site of underused highway and motor vehicle offices, Center Commons is now a catalyst for the revitalization in its neighborhood.

Otak Inc.

The Yards at Union Station
Portland, Oregon

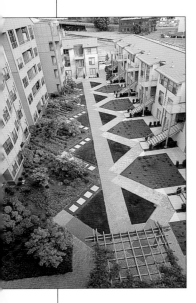

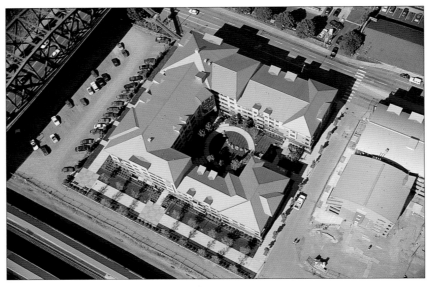

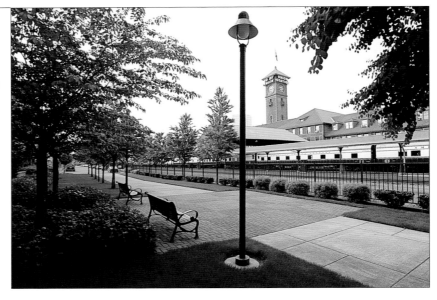

Above: Courtyard between unit types.
Above right: Aerial view, part of project.
Right: Station seen from site.
Below right: Central courtyard.
Below: Units around central courtyard.
Photography: C. Bruce Forster (above, right, and below right); others Otak.

Portland's 100-acre River District is being transformed from an under-utilized quasi-industrial area into a diverse, mixed-use community. As the first new residential project, The Yards occupies 7.5 acres adjacent to historic Union Station. As part of the former railyards, the site required brownfield mitigation. The project includes 724 rental and for-sale units in 4-to-5-story buildings, a portion built over a basement-level garage. The units range in affordability, with 15-25 percent targeted for low-income households and 20-30 percent for moderate-income. The intensely landscaped open spaces recall the semi-enclosed courtyards found in the city's older urban residential districts.

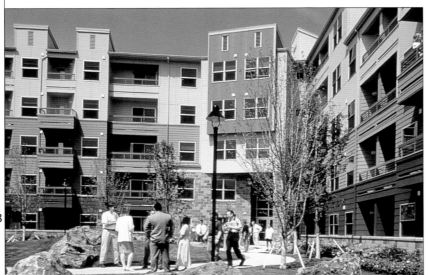

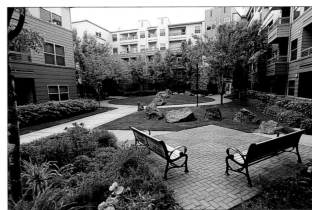

OWP/P

111 West Washington Street

Suite 2100

Chicago

Illinois 60602.2714

312.332.9600

312.332.9601 (Fax)

www.owpp.com

OWP/P

Hotel and Shops at North Bridge
Chicago, Illinois

North Bridge is a $900 million, 9-block, hotel, retail and entertainment development on North Michigan Avenue. The Shops at North Bridge is the development's literal pivotal building. The five-story, 114,000 SF of GLA retail arcade is the gateway that links Michigan Avenue to the LeMeridien hotel and Nordstrom department store, which do not have direct Michigan Avenue frontage. The public is introduced to The Shops at North Bridge through the 90-foot steel and glass main entry atrium located over Grand Avenue. Another atrium is constructed over Rush Street and defines the entrance to Nordstrom's. The curved retail arcade, including 35 specialty shops and a floor of restaurants, connects both atria and captures the feel of a winding European arcade. To achieve the necessary frontage and volume required required the reconstruction of the 1929, Art Deco McGraw Hill building which had received landmark status in 1998. The limestone was carefully removed, the old structure taken down and re-installed, largely in their original location, on a new steel structure.

Above: Entry pavilion on Michigan Avenue, with retail-hotel structure to left.
Below left: Grand Avenue entrance: Lounge outside Nordstrom.
Below right: Retail arcade.
Facing page: Grand Avenue atrium.
Photography: Jon Miller, Hedrich Blessing.

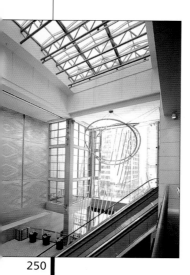

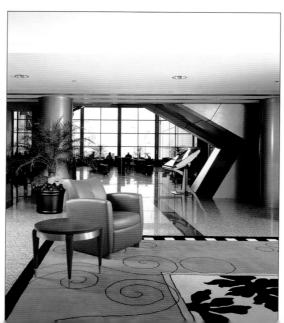

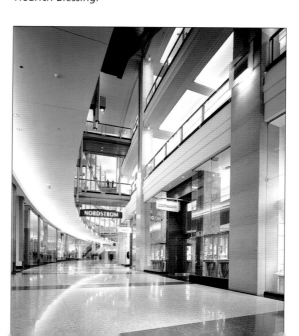

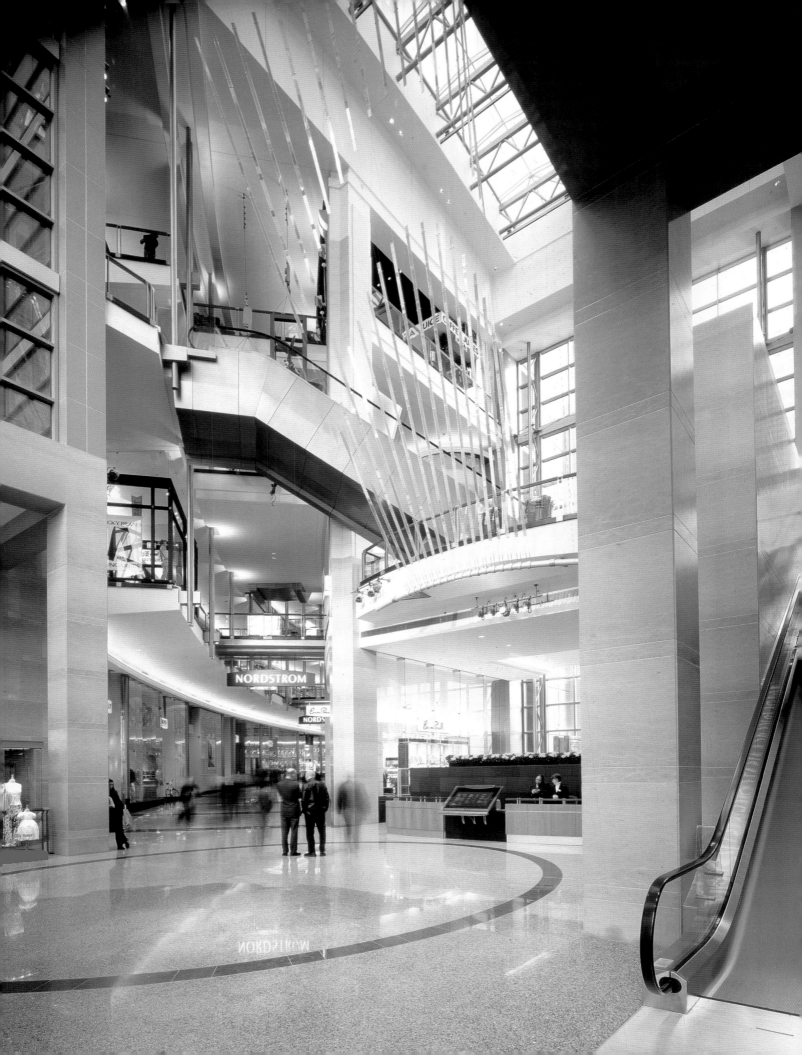

Tabor Center Renovation
Denver, Colorado

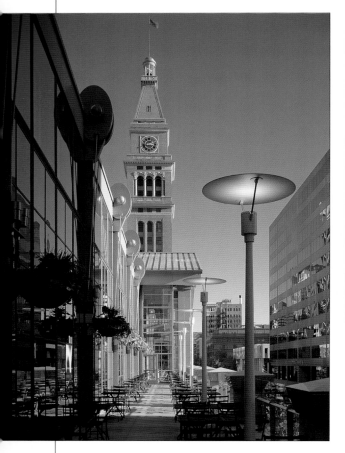

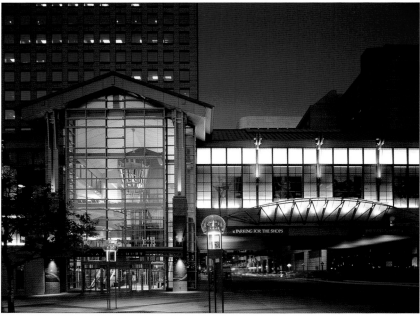

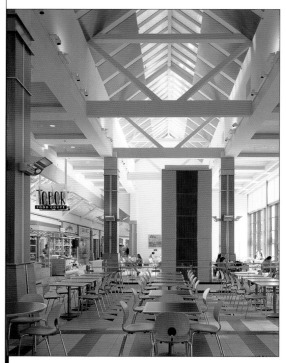

Above: Main entrance and bridge over street.
Left: Upper-level dining terrace along 16th Street.
Below left: Skylighted food court.
Facing page: 16th Street front of complex.
Photography: Nick Merrick, Hedrich Blessing.

Prominently located on Denver's 16th Street transit mall, the redevelopment of Tabor Center creates an appealing new façade for a former multi-story, single-loaded retail center. Expansion of the complex yields 20 percent more retail space, for a total of 135,000 gross leasable square feet in a 170,000-square-foot property. Tenants in the renovated center have high street-side visibility and opportunities for public expression of their individuality. A complete renovation of the interior includes the addition of all-glass elevators, new escalators, and the redesign of public spaces. A new food court with an exterior, upper-level terrace is expected to attract lunchtime patrons year round. A new stairway-corridor links the lobby of the adjoining office building with the redeveloped retail complex.

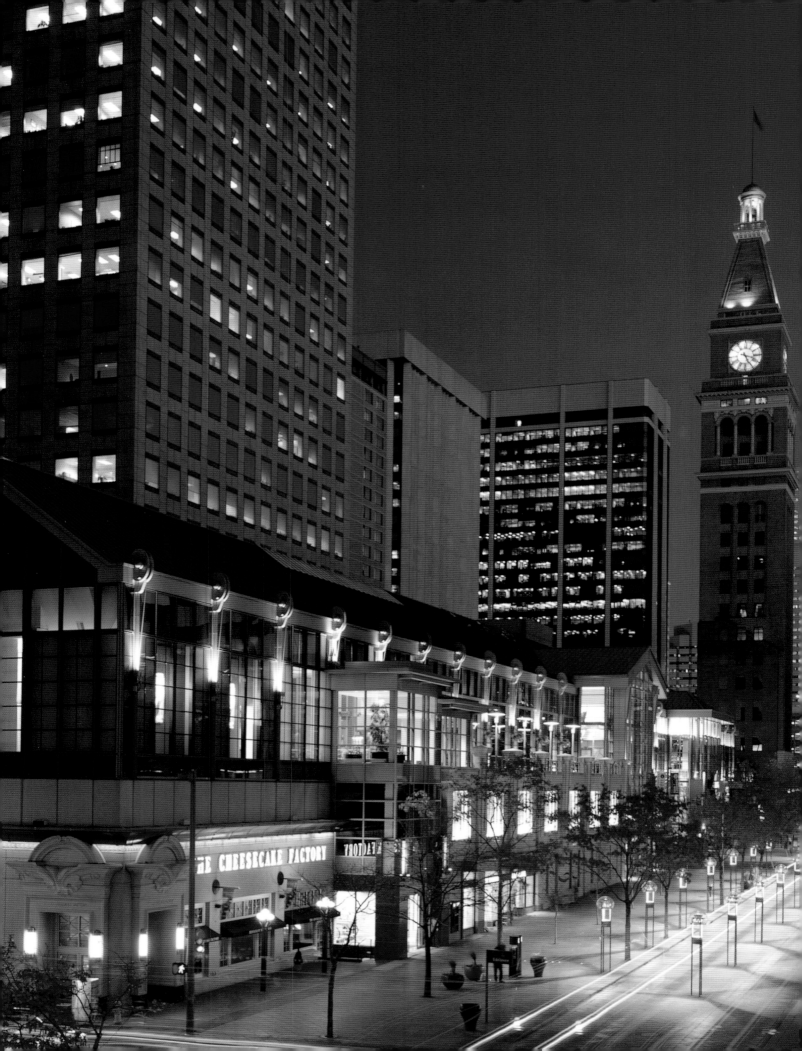

Aspen Grove
Littleton, Colorado

Right: Varied shop fronts along landscaped parking area.
Below: Architectural variations on rural Colorado theme.
Photography: Nick Merrick, Hedrich Blessing.

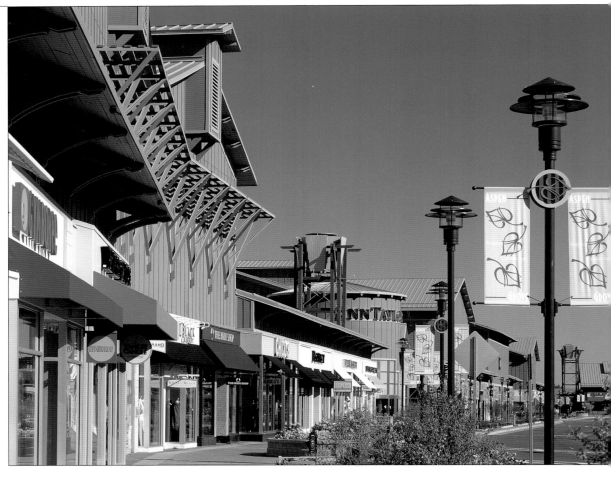

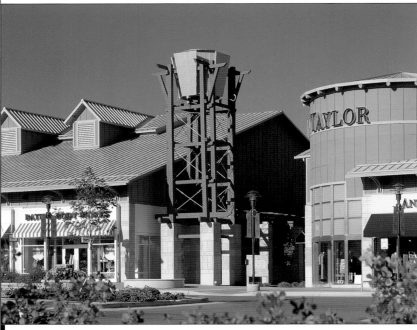

The Aspen Grove Lifestyle Center accommodates upscale retailers and restaurants to serve Littleton's affluent population in an open-air setting. Representing a recent trend to design retail environments for people with limited time to shop, the plan allows them to park in front of their destination stores for more efficient shopping trips. Centers such as this offer retailers the benefit of lower occupancy costs, as well as high visibility. Ample planting, awnings, lighting, banners, sidewalk dining, and discreet signage distinguish the center as a setting for upscale commerce.

OWP/P

550 West Jackson Boulevard
Chicago, Illinois

Above: *Facade detail.*
Right: *Building in West Loop context.*
Below right: *Lobby.*
Photography: *Bob Harr, Hedrich Blessing.*

Conveniently located adjacent to Union Station in the West Loop, the building expands an existing four-story building upward to 20 stories. An existing MCI switching station on the ground floor remained in operation throughout the construction. Outer structural columns were strengthened and a stacked series of inverted V-shaped trusses was inserted above the station to transfer loads around it to foundations. The new curtain wall incorporates stainless steel spandrels and a coated metal grid. Limestone and granite cladding at the street-level arcades and the symmetrical composition of the main façade relate the building to the neighboring Classical Revival railroad station. The structure incorporates upgraded, redundant electrical and air-conditioning systems to support tenants' technological requirements.

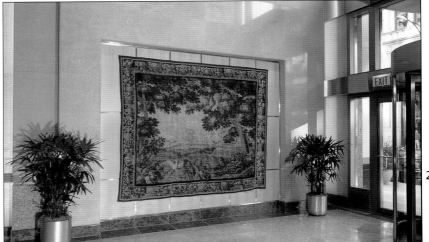

909 Davis Street
Evanston, Illinois

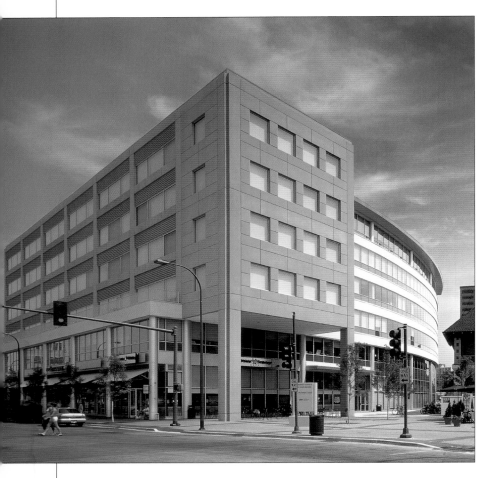

A 245,000 square foot build-to-suit office building successfully participates in creating a lively retail/entertainment destination. The 140,000 square foot headquarters of McDougal Littell, the secondary school publishing division of Houghton Mifflin and its 10,000 square feet of retail space is a critical part of a planned development that includes a 175-room hotel, a 1,400-car municipal parking structure, 200 condominiums and 175,000 square feet for retail, restaurant and entertainment tenants. The ultimate driver of the design was the trapezoidal site bordered by commuter rail lines at the west and east and a new 18-screen cinema directly across the street at the north. The curved west elevation protects an existing pedestrian circulation pattern needed to maintain the connections among transit, entertainment, office, residential and retail uses. At the south entrance, a plaza with a cul-de-sac meets McDougal Littell's desire for its own prominent entrance, and also maintains the pedestrian flow between the stations and the building. In the northwest corner, office floors overhang a plaza, defining an inviting space for outdoor dining. The office building is a boon to the area, providing customers at lunchtime and in the evening.

Above: NW corner of Church Street.
Right: Site plan.
Far right: Office entrance.
Photography: James Steinkamp, Steinkamp/Ballogg.

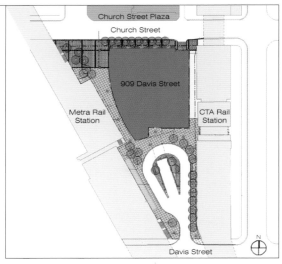

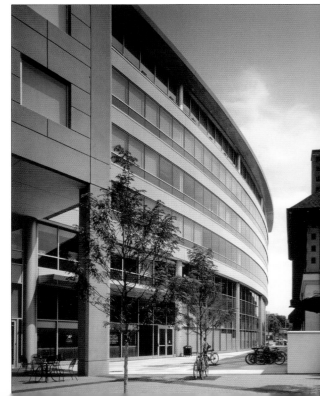

Perkowitz + Ruth Architects

1111 West Ocean Boulevard **Newport Beach, CA**

21st Floor **Washington, DC**

Long Beach, CA 90802 **Las Vegas, NV**

562.628.8000 **Portland, OR**

562.628.8004 (Fax)

www.prarchitects.com

mschafer@prarchitects.com

Perkowitz + Ruth Architects

Long Beach Towne Center
Long Beach, California

This one-million-square-foot retail and entertainment center is designed to draw customers from the nearby freeway, then appeal to them as pedestrians. Entertainment is sited at the heart of the development, with the theater facing inward toward a public plaza that is buffered from the main street. Tree-lined, pedestrian-friendly avenues lead from the plaza to retail destina-tions located toward the perimeter of the 100-acre site. Tenants include a 26-screen Edwards Cinema, several national retailers such as Old Navy, Lowe's, and Barnes & Noble, along with a varied collection of restaurants and bou-tiques. The project's architectural character is inspired by the key ele-ments of the Long Beach economy: shipping, aero-space, and the beach.

Metal elements such as the long arched canopies visible from the highway reflect shipping and aerospace activities. The beach inspired some the more rustic elements and the plain wall sur-faces in neutral and taupe hues, accented with strong colors such as purples and blues. Amusing details that make the project fun for visitors to explore include a gridded seat-ing area that looks like a huge checkerboard being rolled up for the night.

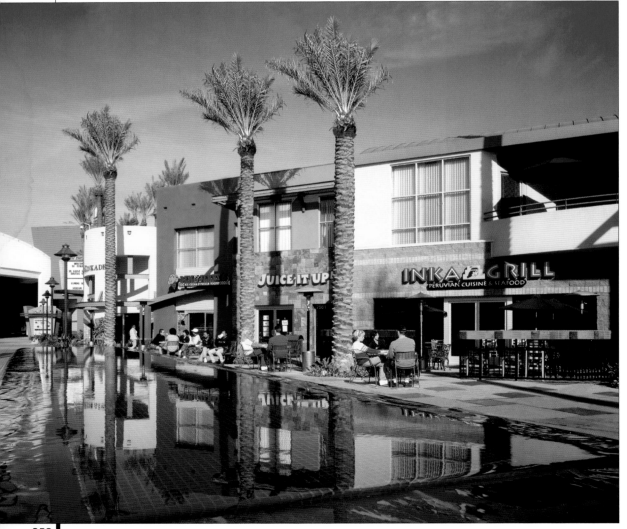

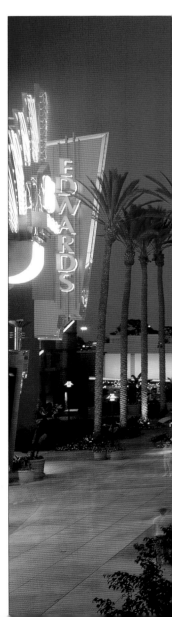

Facing page: Dining areas along a palm-lined pool.
Below: Central plaza with radiating pedestrian avenues.
Right: Walkway approaching 26-screen cinema.
Photography: RMA Photography (facing page); Paul Turang Photography (below and right).

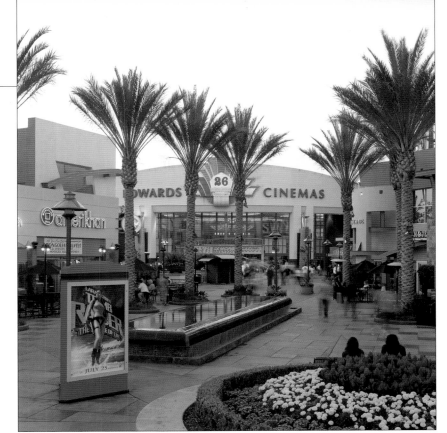

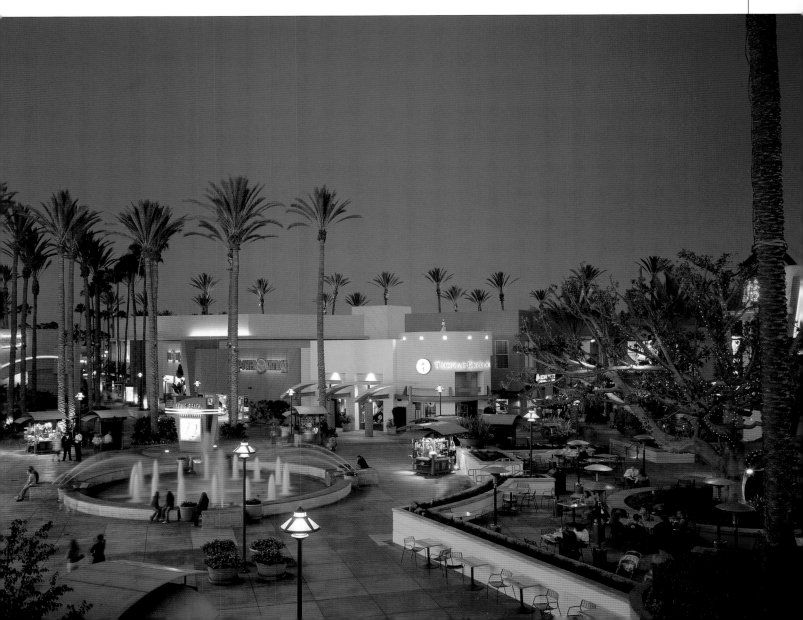

Perkowitz + Ruth Architects

Buena Park Downtown
Buena Park, California

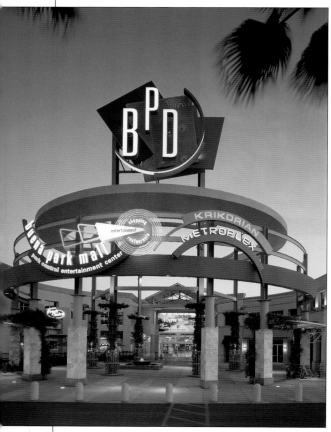

Left: *Signature entrance rotunda.*
Bottom left: *Indoor lobby.*
Below: *Entrance rotunda at night.*
Photography: *Paul Turang Photography, this page; RMA Photography, Inc., opposite.*

The final phase of an extensive repositioning of the Buena Park Mall is a 150,000-square-foot entertainment district designed as a downtown hub for this suburban community. Developed by the Festival Companies and Pritzker Realty Group, the project is anchored by a 91,000-square-foot, 5,000-seat Krikorian Premiere Theatres multiplex and includes space for restaurants and other specialty retailers. A welcoming atmosphere has been the objective throughout, from the drop-off area and the public plazas to the theaters. The district is centered on an urban park with European style kiosks and pavilions. A plaza with four distinctive fountains is designed as a meeting place where friends can gather prior to a show or meal and linger afterward, making a day trip of the visit. Benches under shade trees, café-style seating and storefront awnings create an ambiance that takes full advantage of the Southern California cli-

mate. Illuminated signs and festive lights energize the space, while new landmark signs at the perimeter access points attract visitors from beyond the immediate neighborhood. Buildings have been designed to form an urban streetscape, with an eclectic mix of the styles found in historic urban environments where buildings were completed in different eras. Each building has been given a character appropriate to its use. Retail facades have var-ied colors, textures, and heights. Undulating storefronts with wide-open entryways encourage window-shopping and views of restaurant activities. Structures forming a backdrop around the project's public plaza include a very contemporary glass-walled building, a Neoclassical building in the Italian tradition, and the multiplex in Art Deco style reminiscent of the grand American movie palaces.

Below: *Multiplex façade, recalling early movie palaces, with plaza fountains in foreground.*

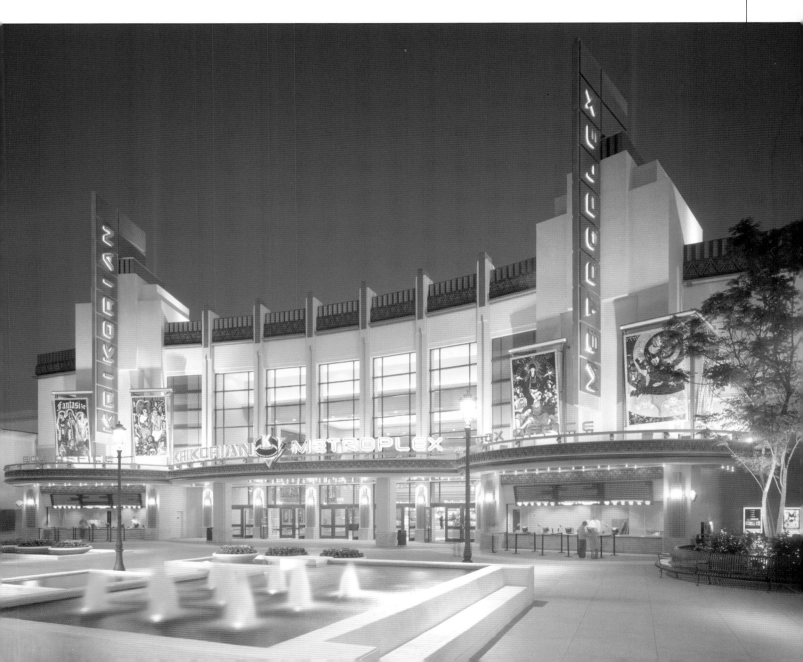

Perkowitz + Ruth Architects

Gresham Station
Gresham, Oregon

The fourth largest city in Oregon, with 84,000 people, the Portland suburb of Gresham had undergone rapid growth that eroded its identity. To create a sense of community, the city made a farsighted planning decision to develop neighborhood districts at stops on the MAX light-rail line. Gresham Station, the first phase of a larger transit-oriented project, includes 300,000 square feet of retail. Designed in the spirit of New Urbanism, the project de-emphasizes the car, encourages walking, and has individual storefronts assembled into groups at the scale of city blocks. Perkowitz + Ruth Architects established design guidelines within which individual retail properties were designed. The site was once a lumber mill, and the adjoining two-acre pond has been recov-

Top: *Natural habitat preserved adjoining project.*
Above: *Typical street scene.*
Photography: *Strode Photographic, LLC.*

Opposite top: *Varied storefronts.*
Right: *Streetscape with natural grove in background.*

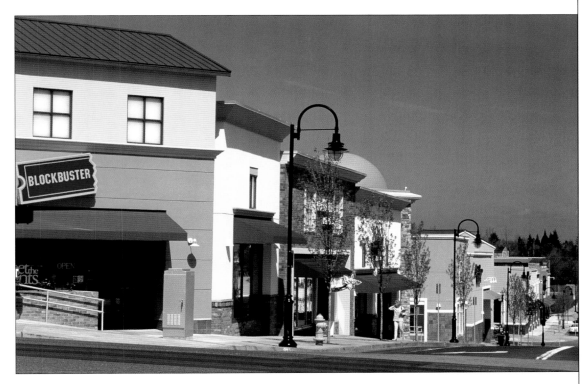

ered as a natural habitat. The plan was based on widespread participation and consultation, and was approved in a public meeting without a single objection. The 1.3-million-square-foot second phase will add 1,800 residential units, along with retail, office space, and a medical facility. A "Center for Advanced Learning" will offer courses in medical arts, technology, and science.

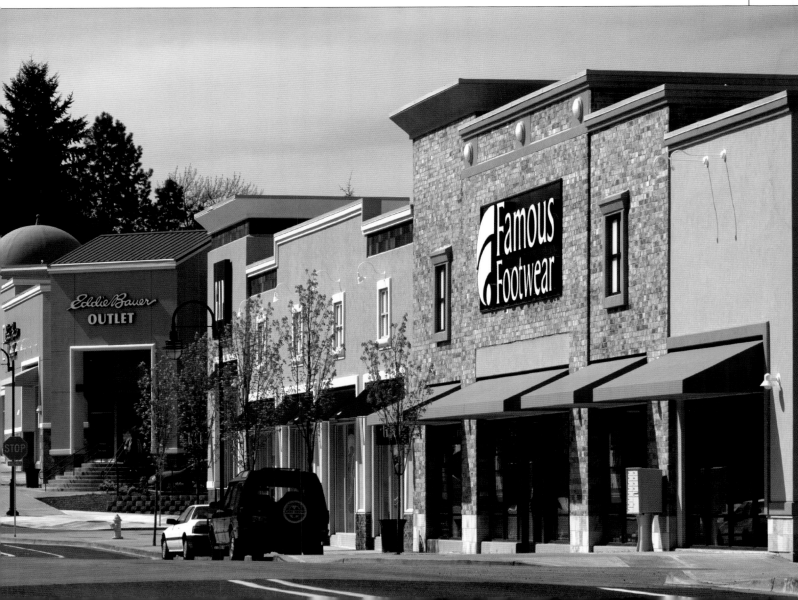

Perkowitz + Ruth Architects

Pacific's The Grove Theatres
Los Angeles, California

Designed by Perkowitz + Ruth Architects in collaboration with developer Caruso Affiliated Holdings, the multiplex blends Classical and Art Deco design elements in the manner of the city's early movie palaces. The distinctive motifs of the exterior are reflected in a circular, balustraded pond. In the lobby, mahogany, limestone, and onyx, along with Venetian glass chandeliers, establish an opulent tone. Generous club chairs and large artworks created for the space add to the sense of luxury. A coffee and dessert bar opens into the space, and the balcony of Madame Wu's restaurant overlooks it.

Right: *Lobby.*
Below: *Exterior seen across pond.*
Photography: *RMA Photography, Inc.*

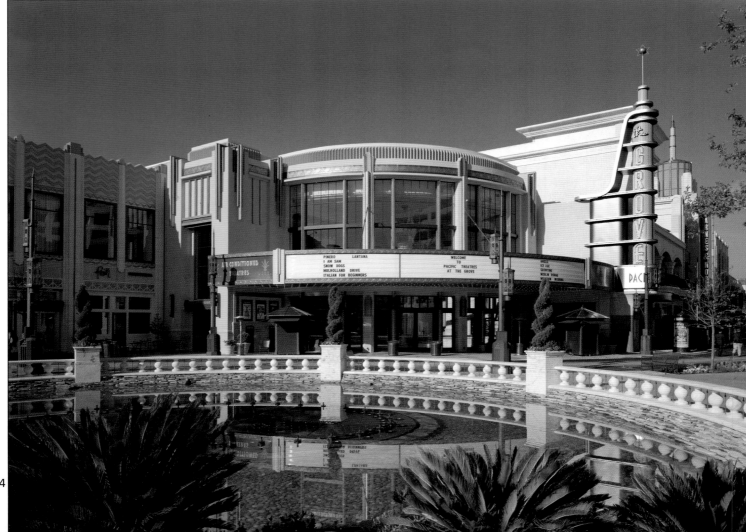

Retzsch Lanao Caycedo Architects

137 West Royal Palm Road

Boca Raton

Florida 33432

561.393.6555

561.395.0007 (Fax)

www.rlcarchitects.com

Retzsch Lanao Caycedo Architects

First Union Plaza
Boca Raton, Florida

Carried out in collaboration with design architects Philip Johnson/Alan Ritchie, this investment office tower and banking pavilion are the first phases of a larger project. The six-acre development in the heart of Boca Raton also includes residential structures. The two initial buildings have been treated as sculptural volumes framing a plaza. The abstract traditional treatment of walls with punched windows is interrupted by the contemporary stroke of curved glazing that relates the two structures to each other and the focal plaza. At the ground level of the banking pavilion, the glazing system is transformed into an open grid defining a pedestrian arcade that links the two structures to the street. At the center of the development is a six-level parking garage that serves the commercial and residential occupants. Interior spaces are designed to maintain the bold geometries of the exterior with the finer finishes of French limestone and stainless steel. The floor area of the tower is 70,000 square feet, and the banking pavilion 30,000.

Left: *Public interior with French limestone and stainless steel inserts.*
Above: *Complex curves cut from buildings define entry plaza.*

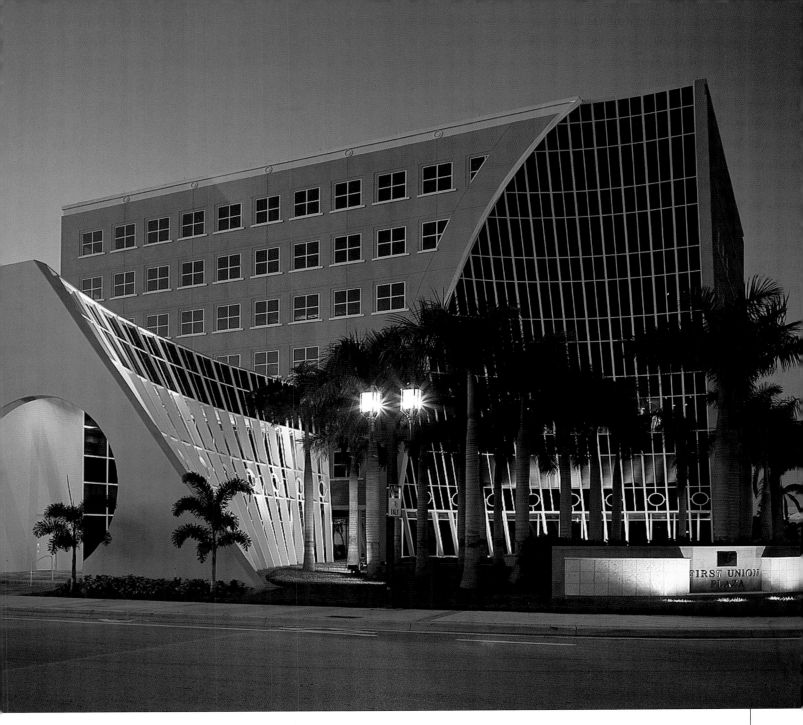

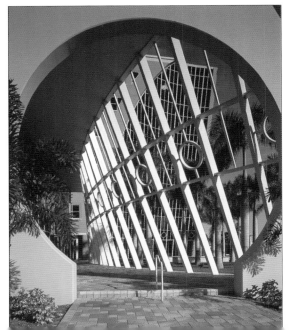

Left: Open arcade reinterpreting tradition of noted local designer Addison Mizner.
Right: Geometry of wall seeming to shift with angle of view.
Photography: Chuck Wilkins Photography.

Retzsch Lanao Caycedo Architects

IBM at Beacon Square
Boca Raton, Florida

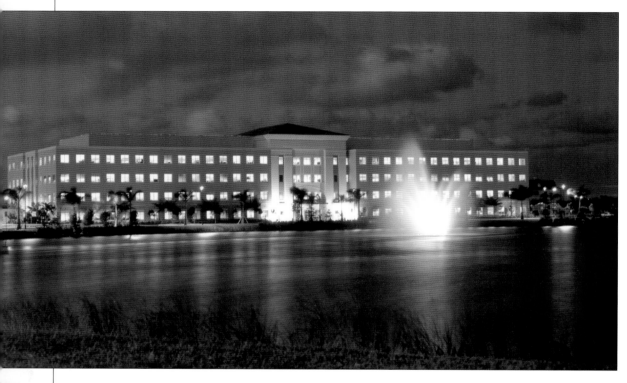

As the first building in the Beacon Square development, the IBM Building follows the planning concepts the architects developed for the 11.83-acre tract. The 168,000-square-foot structure fronts on the street that runs along the lake, with parking to the sides and rear. The 42,000-square-foot floors meet the need for construction economy and the client's requirement for interior flexibility. Each floor is divided into two blocks, each with a service core, on either side of one central elevator core. The building's massing reflects this internal organization and is appropriate in scale for the intended pedestrian experience of the site. The design vocabulary is described as abstracted Mediterranean Classical, responding to the prevailing Mediterranean inspiration of the area's buildings. Porticos in relief frame the entrances on the long facades, with smaller versions on the ends of the building. A base story is implied by the special detail around first floor windows.

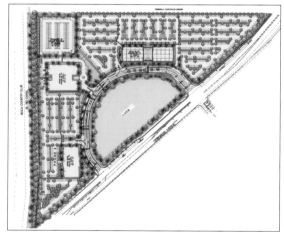

Top: Building seen across lake.
Left: Lobby.
Above: Site plan, IBM Building at top center.
Facing page: Main entrance.
Photography: Chuck Wilkins Photography.

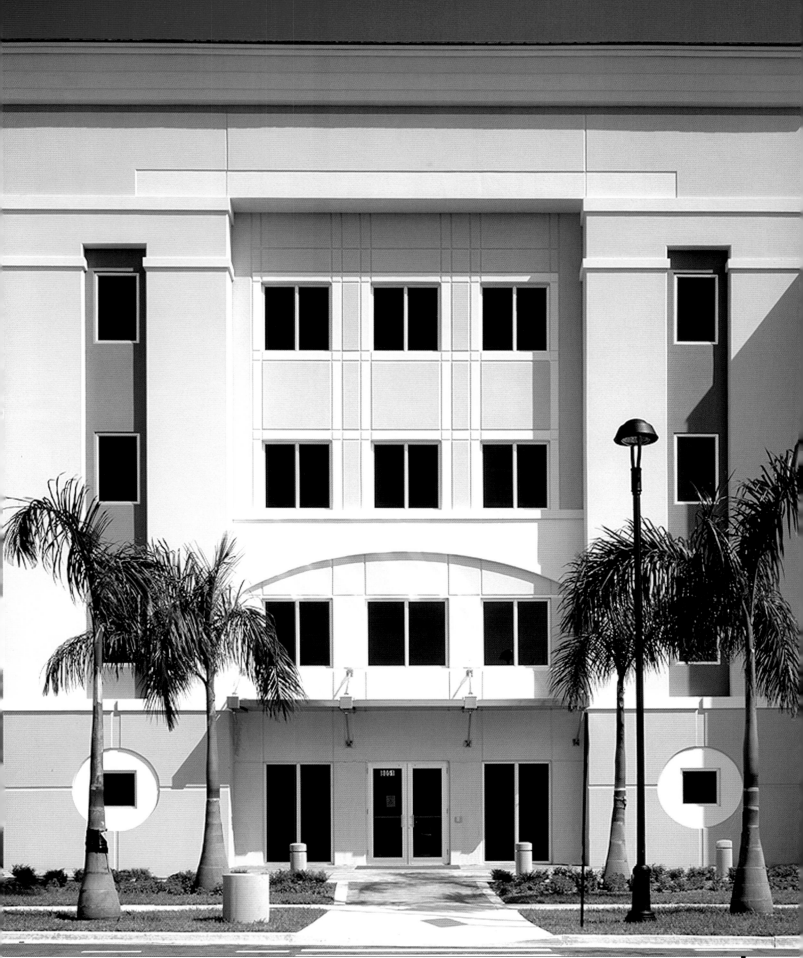

Retzsch Lanao Caycedo Architects

The Ellington
Fort Lauderdale, Florida

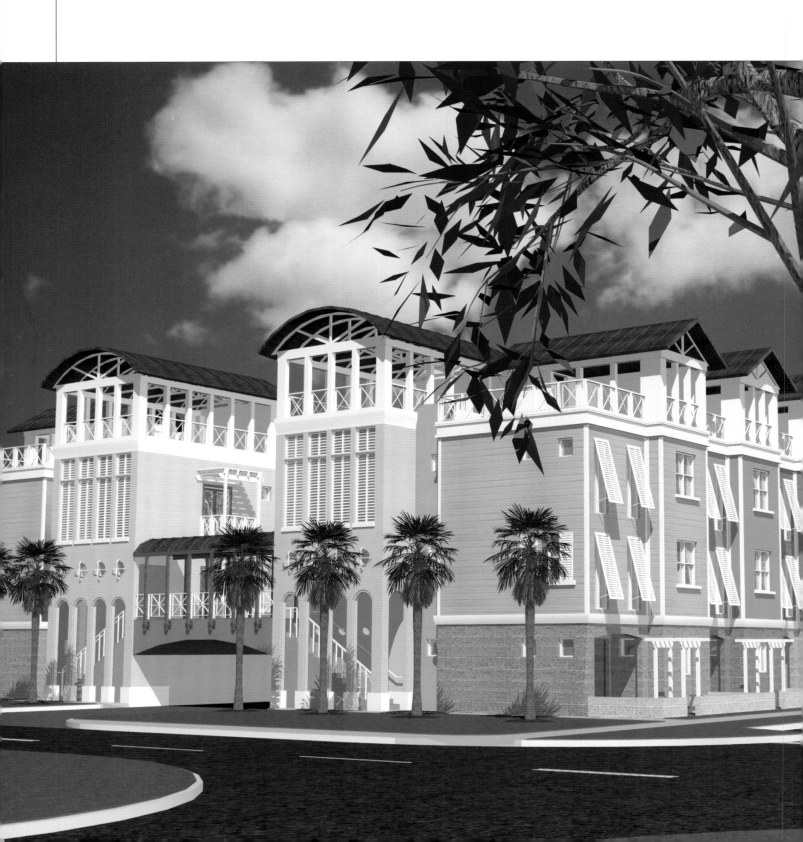

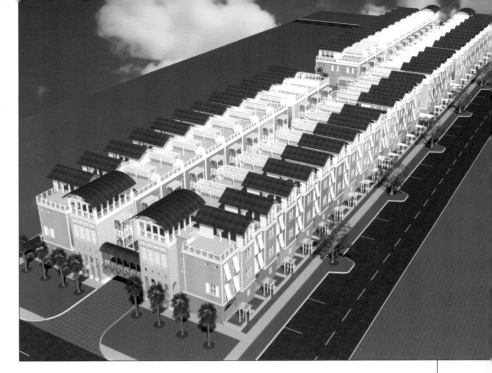

Right: *Aerial view.*
Below right: *Site plan.*
Bottom, left to right:
Entrance between row houses; pedestrian deck and pool.
Images: *Jose Baella of Retzsch Lanao Caycedo.*

Located in the core of Fort Lauderdale, just one block from the main commercial thoroughfare, the Ellington is in an area noted for its urban pedestrian life. The development's row houses create a streetscape reminiscent of the traditional city, with private entrances and gardens for each clearly defined unit. Each unit has a private two-car garage and a guest or workplace studio at street level, with living spaces above topped by a rooftop loggia large enough to serve as a pseudo "back yard" and offering views of the city skyline. The exterior design is a translation of Florida vernacular, with a variety of stucco wall colors accented with white details. Between the rows of houses is an elevated pedestrian promenade that recovers the public alleyway and connects the houses to the shared pool and recreation areas.

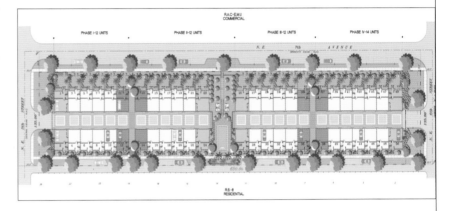

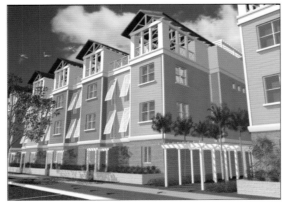

Retzsch Lanao Caycedo Architects

Hillsboro Commons
Deerfield Beach, Florida

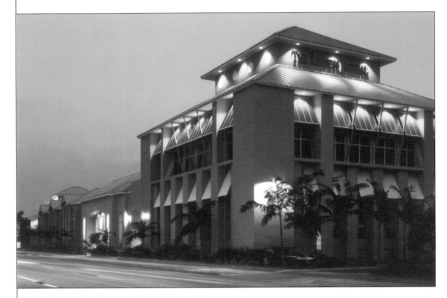

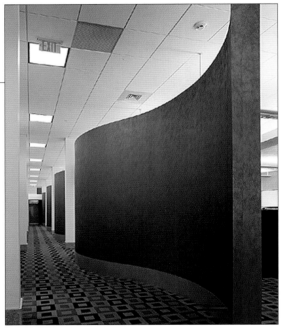

An abandoned existing shopping mall building at the entrance to the city's downtown has been converted to new office and parking uses. The 82,000-square-foot structure consisted of a one-level parking garage topped by one story of potential office space, with a mezzanine at the center of the floor. Retaining the existing structural elements, the architects enhanced the exterior by rescaling its components' elements, creating a building that is inviting to the passer-by. The use of skylights, along with clean geo-metrical surfaces, gives the interiors a character appropriate to Florida. This was a major adap-tive re-use/renovation in the City of Deerfield Beach that helped revitalize Hillsboro Boulevard and sparked development of sur-rounding areas. It was also recognized by *NAIOP* (National Association of Industrial and Office Properties) South Florida Chapter, as the 2002 Renovation of the Year.

Above and right: *New and before exterior.*
Right: *Interior corridor.*
Below left: *Two-level atrium.*
Below right: *High skylit corridor around central two-level volume.*
Photography: *Chuck Wilkins Photography.*

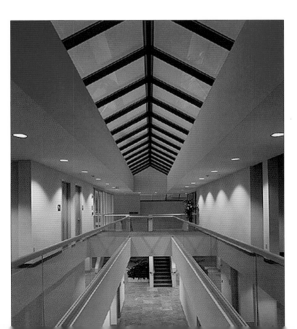

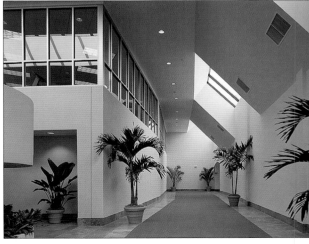

ROMA Design Group

1527 Stockton Street
San Francisco
California 94133
415.616.9900
415.788.8728 (Fax)
www.roma.com
roma@roma.com

ROMA Design Group

Dr. Martin Luther King, Jr. National Memorial Washington, DC

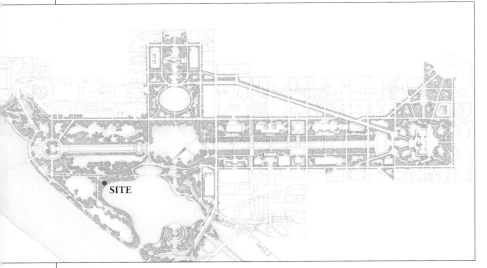

Above: Site of MLK Memorial on Tidal Basin, centered on axis between Jefferson and Lincoln Memorials.

Facing page: Layout of site reflects cove-like shape of shoreline, creating places for gathering as well as private contemplation.

The memorial is designed to increase our awareness of Dr. King's message regarding human rights and civil liberties, to help us understand his role as a leader in the Civil Rights Movement and his legacy in shaping the meaning of democracy in America. The Memorial embraces the Tidal Basin and creates a space that, in its form, nurtures inclusivity and a sense of community. Within the space, the words of Dr. King are incised on a curving wall of water which heightens the sensory experience of the visitor (through the cooling effect of water in summer months and the sound of rushing water) and adds to the understanding of his message of freedom, justice, and peace. The design of the memorial strengthens the axial relationship between the King, Jefferson, and Lincoln Memorials and expresses the evolving message of democracy through the continuum of time, from the Declaration of Independence and the Gettysburg Address to the civil rights speech that Dr. King delivered on the steps of the Lincoln Memorial in 1963. ROMA's submission was selected out of over 800 entries from the United States and 32 foreign countries for a National Memorial to honor Dr. Martin Luther King, Jr.

Right: Memorial revealing struggle of Civil Rights Movement and promise of democracy, with "Mountain of Despair" (twin portals of stone flanking entry) opening onto "Stone of Hope" (single monolith hewn from the two entry masses).

Illustrations: Christopher Grubbs.

Photography: Gerald Ratto.

274

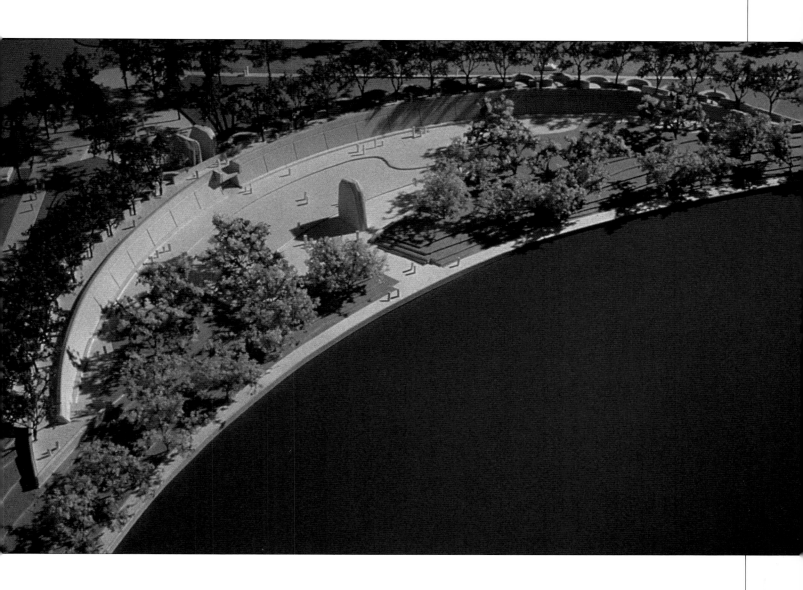

Left: *Image of Dr. King emerging from "Stone of Hope," standing vigil and awaiting delivery of promise"that all men, yes, black men as well as white men, would be guaranteed the 'unalienable rights of life, liberty, and the pursuit of happiness'." View from Jefferson Memorial across the Tidal Basin to the King Memorial, with the Lincoln Memorial in the background.*

Master Plan and Open Space
Suisun, California

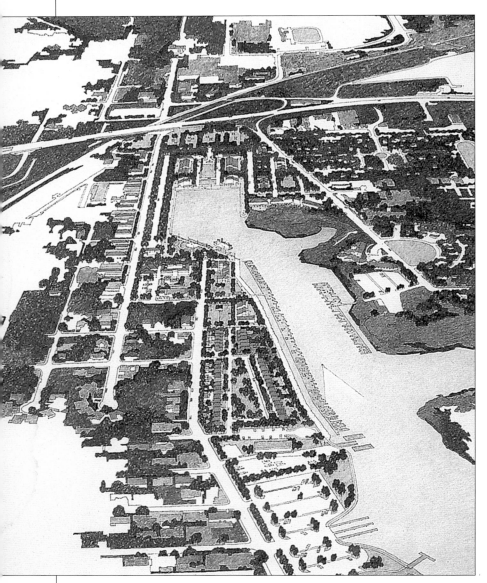

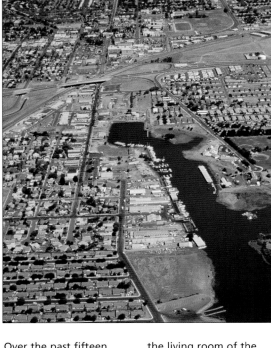

Over the past fifteen years, ROMA has acted as the master plan architects for Suisun City's dramatic revitalization, preparing the downtown master plan and serving as architects and landscape architects on numerous related building projects and public improvements. The redevelopment project has created a sense of focus for the community, replacing an unsightly environment of ship repair sheds, warehouses, and an oil refinery, with a plaza, promenades, a marina, and a mixture of new uses that reconnect the community with its downtown and waterfront. Key elements of the urban design plan include: a new Town Plaza that has become the living room of the city, where community-wide festivals take place and where residents come to relax and meet friends; a new 300-slip marina with a waterfront promenade and associated public spaces; a Harbormaster's Building; mixed-use, live/work, and residential buildings comprising a new waterfront neighborhood; a rehabilitated downtown train station, intermodal facility, and rail plaza. Other contributing efforts include preservation and rehabilitation of existing historic structures and infill commercial development.

Above: Bird's-eye illustration of downtown revitalization plan.
Above right: Matching aerial before redevelopment.
Facing page, top left: View across plaza to harbor and City Hall.
Facing page, top right: Headmaster's Building.
Facing page, bottom: Suisun Town Plaza.
Photography: Jane Lidz.
Illustration: Jim Leritz.

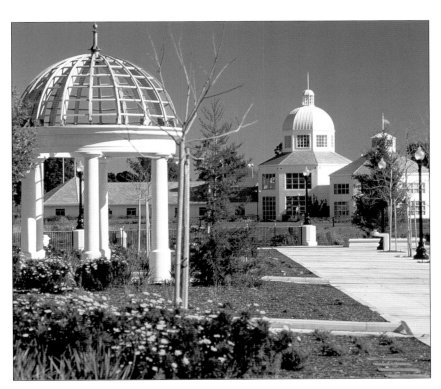

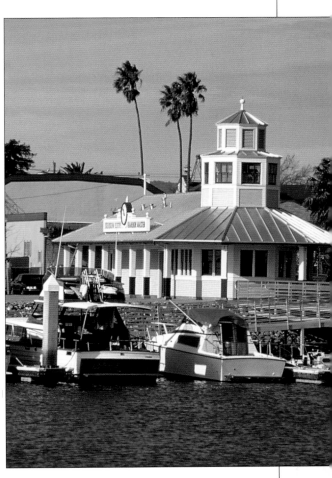

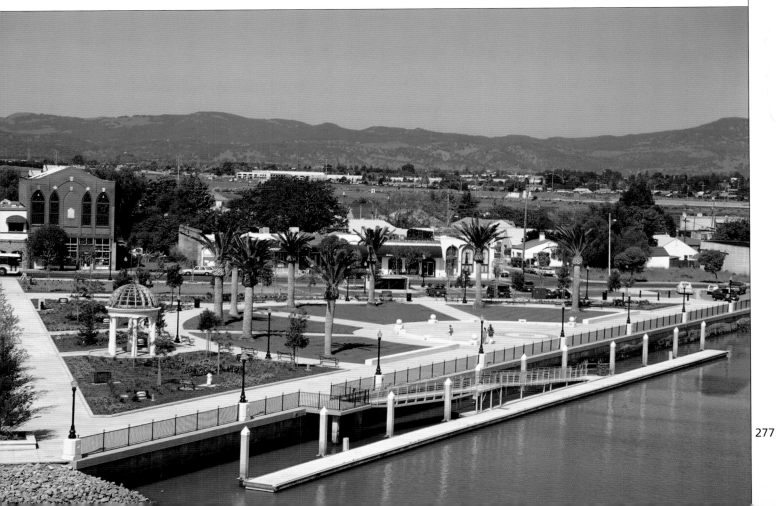

ROMA Design Group

Downtown Santa Monica
Santa Monica, California

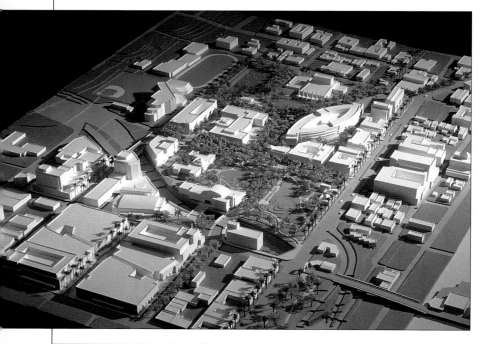

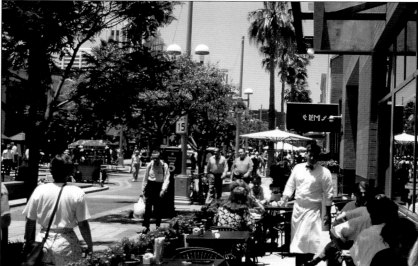

The redesign of an outmoded pedestrian mall and the creation of the Third Street Promenade in 1989 were major events in the revitalization of downtown Santa Monica, contributing greatly to the success of the retail district and the creation of a more attractive pedestrian environment. The Third Street Promenade demonstrates how retail, dining, and entertainment uses can serve as part of an effective strategy for the revitalization of a city center. It illustrates how the experience of a place is as important as the mix of retail uses to the success of a shopping environment. This experience is not gained by simply removing the automobile, but is based upon a clear organization of public space that is oriented and scaled to the pedestrian. In contrast to many of the more recent retail developments, this project was not developed by a single property owner or developer, but involved numerous property owners and business interests, as well as the city government. In order to extend the success of the Third Street Promenade into the surrounding downtown, the City of Santa Monica together with ROMA Design Group has established a plan for improvement to cross streets, emphasizing transit, pedestrian, and bicycle movement. This plan includes the creation of a new Transit Mall on two downtown streets as well as the reinstatement of two-way auto traffic on previously one-way streets. Furthermore, ROMA recently prepared plans that would extend Third Street through Santa Monica Place, an existing enclosed shopping mall located on an assembled parcel at one end of Third Street. As a part of this plan, the shopping mall would be redeveloped for a mixtures of residential and office uses over ground-floor retail, and Third Street would extend one additional block as an open-air street to connect with major new open spaces and residential development planned within the nearby Civic Center.

Top: Model showing plans for new open spaces and housing in Civic Center.
Above: Outdoor dining facilitated in cafe zones along Promenade.

Facing page: Jacarandas and palms frame activities on the Third Street Promenade.
Photography: Gerald Ratto and Jane Lidz.

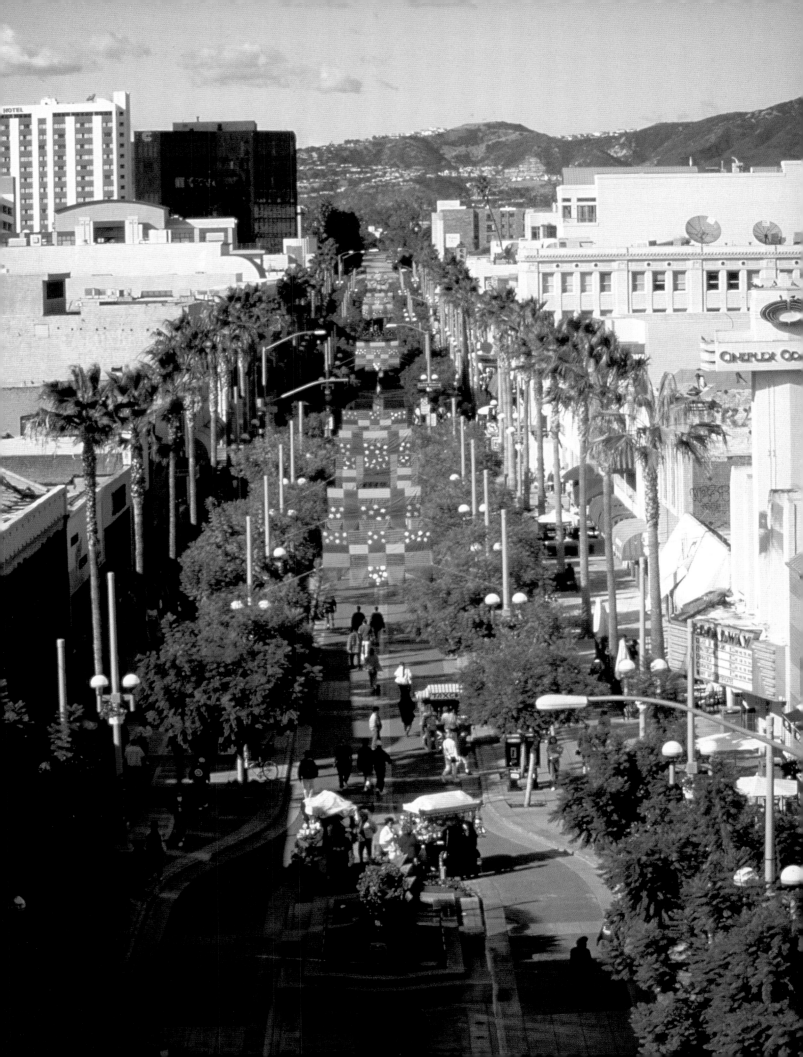

ROMA Design Group

North Park Community
San Jose, California

The 97-acre North Park community is situated in North San Jose in the heart of Silicon Valley. The new community will provide badly needed housing opportunities for employees, many of whom are forced to commute long distances to find suitable accommodations. The location of the property, within close walking distance of both the Guadalupe and Tasman Light Rail corridors, will also offer residents the highest levels of transit access. As such the development is considered an important regional opportunity to reinforce Santa Clara County's burgeoning light rail transit system. Irvine Apartment Communities intends to develop the northerly 60 acres of the former Moitozo Ranch with 2,400 to 2,800 rental units. ROMA'S role on the project was to prepare the architectural master plan for the entire property and design all public spaces on the site, including the five-acre park, which will become the centerpiece of the new community.

Above: Network of public, semi-public, and private open spaces to draw community together, giving it structure and identity.
Right: View of Phase One development with Phase Two under construction.
Photography: Patrick Carney.

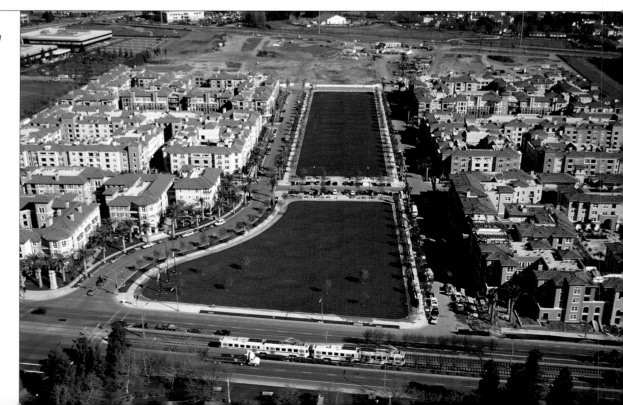

RTKL

Baltimore
410.528.8600

Miami
786.268.3200

Dallas
214.871.8877

London
44.207.306.0404

Washington
202.833.4400

Tokyo
81.33583.3401

Los Angeles
213.627.7373

Shanghai
86.21.6279.7657

Chicago
312.704.9900

Madrid
34.91.426.0980

Denver
303.824.2727

www.rtkl.com

RTKL

North Bund District Master Plan
Shanghai, China

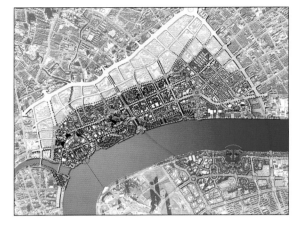

In this era of global competition, the future of world-class cities depends as much on community livability as on traditional factors such as strategic location, transportation infrastructure, and labor force. Responding to that need, RTKL's plan won a design competition for a 3.14-acre riverfront tract to the north of Shanghai's famous Bund. The plan envisions modern mixed-use development, including historic preservation and adaptive re-use, in an area now occupied by dilapidated warehouses, dock, and residential complexes. The project is designed to offer a vibrant mix of uses, a sustainable economic base, people-friendly open spaces, and a memorable identity for the district. Three areas are organized along a mixed-use spine. Anchoring one end of the spine is a prominent business area for service industries, international trade, banking, hotels, riverfront retail, and entertainment. The second area is a shipping business district, with offices for shipping companies and cargo-forwarding agencies and a shipping exchange, as well as major open spaces and a high-end residential neighborhood. The third focus area is based on the historic Tilanqiao commercial street, incorporating regional shopping, "Old Shanghai" tourism and historic attractions, neighborhood retail, residential infill, community parks, and a riverfront promenade.

Above: Plan of entire district.
Below: View from river, with historic Bund at left, Pudong district in right foreground.
Right: Principal service business area.
Below right: Rendering of entire district.
Renderings: RTKL.

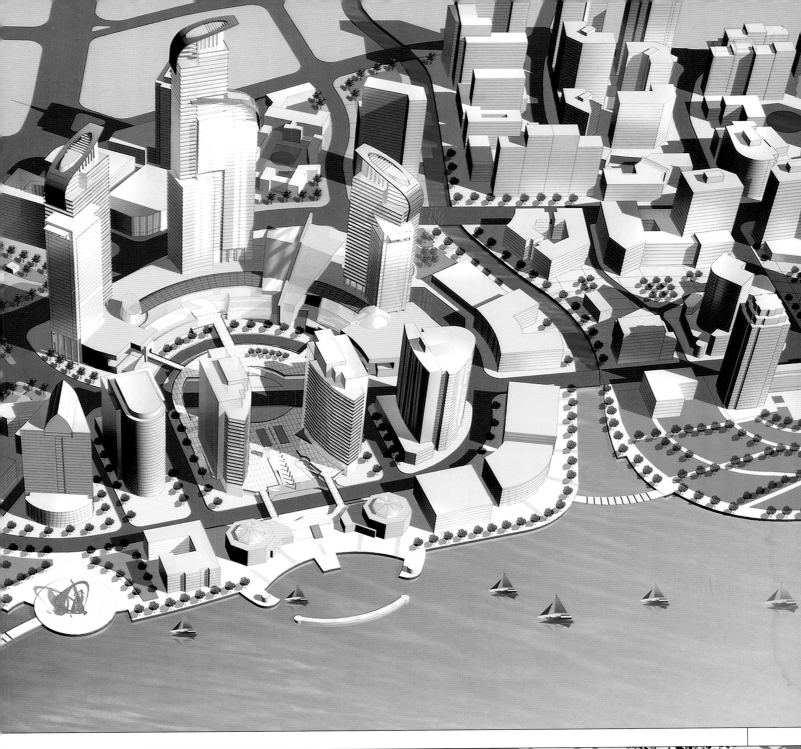

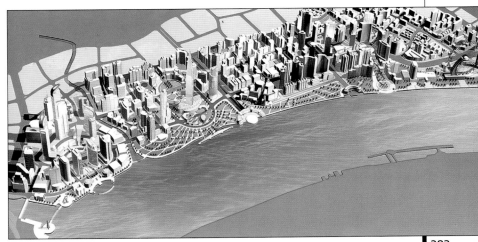

RTKL

Salamanca Train Station
Salamanca, Spain

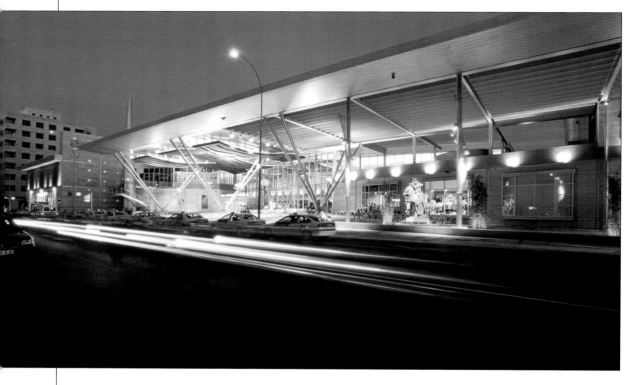

An inventive example of mixed use, the Salamanca Train Station is a retail development wrapped around an existing railroad station. The new construction creates a "front door" for the station, a vital retail and entertainment venue, and an exciting new public space. When RTKL took on the project, the building was already under construction and over budget. A unique development had to be created within a tight budget, absorbing what had been built. In terms of expression, the rail authority's and local government's requirement for a formal image had to be reconciled with the developer's wish for colorful, varied forms. The unique solution was to present a simple form, clad in Salamanca stone, by day, then use creative lighting to generate a more playful environment at night. An exterior forecourt accommodates a range of public uses, under a canopy of blue glass-reinforced gypsum "blankets" that change color with night lighting from blue to red to yellow. A conical tower, a sedate landmark by day, also displays changing colors at night.

Top: Canopied forecourt and stone-walled structure.
Above: Local gentlemen in forecourt.
Left: Colorful "blankets" over forecourt.
Facing page: Conical tower and canopy.
Photography: Paul Bock.

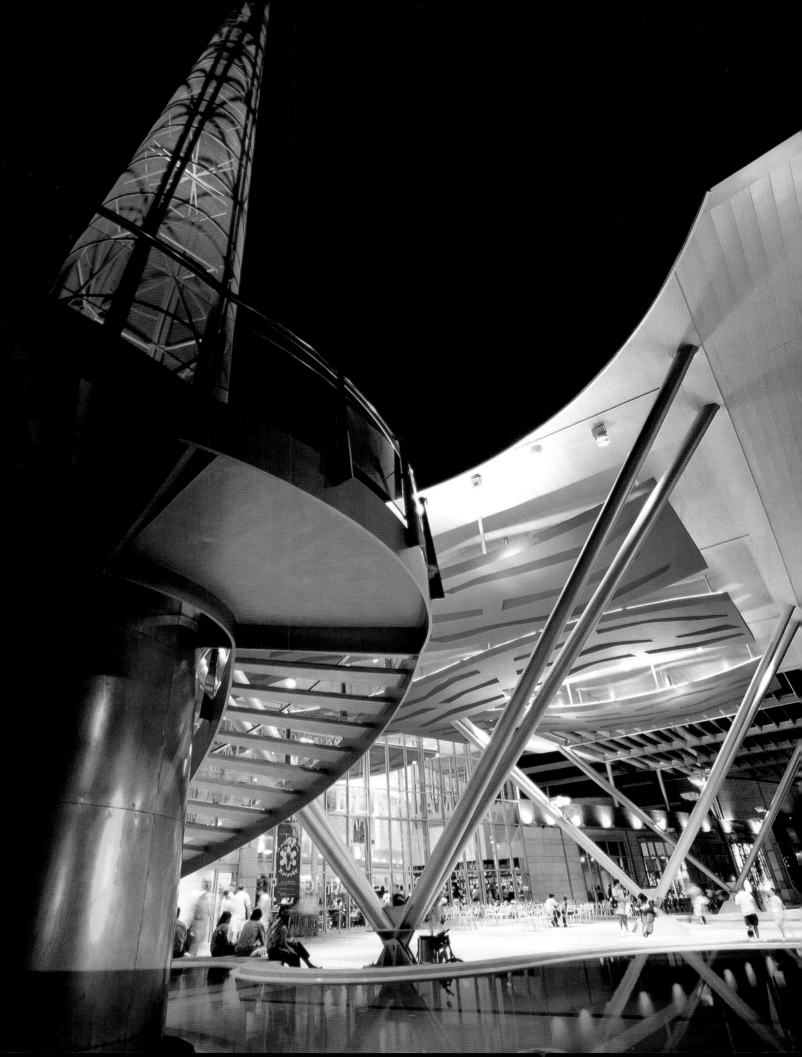

Mockingbird Station
Dallas, Texas

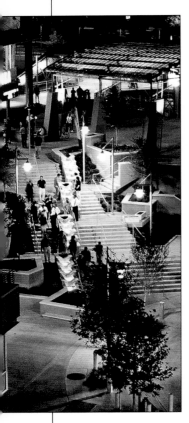

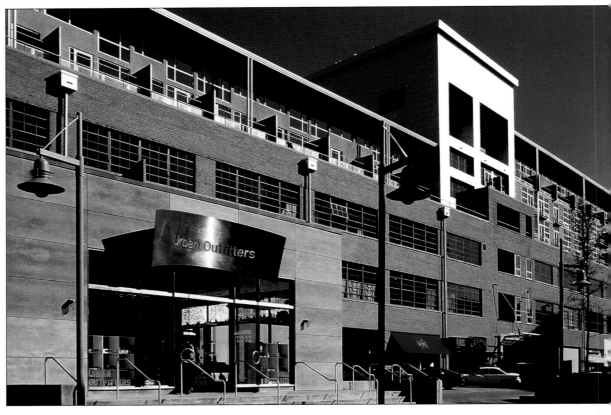

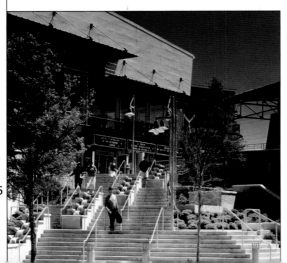

Above left: Elevated film center plaza with pergola.
Above: Former warehouse with lofts above retail.
Left: Light rail platform below film center.
Below left: Film center stairs featuring cascading fountains.
Photography: Randy Shortidge (above left); Craig Blackman (above); Timothy Street-Porter (left, below left).

A 10-acre development at the center of Dallas's Southern Methodist University district, adjoining a recently opened light rail and bus station, is a model of adaptive re-use. The project incorporates a three-story 1940s warehouse building, with street-level shops and two floors of residential lofts, expanding it with five more stories of loft apartments for a total to 211. A 12-story curtain-walled office tower from the 1970s has been reclad to reduce its apparent scale, and a four-story lobby addition relates it to pedestrian scale. A portion of its original garage has been adapted as a Virgin Megastore. A new eight-screen film center building, with parking below it, is conceived as a civic center, its auditoriums available for the university film school and special events. Portions of existing buildings, removed to allow site access, provided brick, girders, sash, and other components that were re-used in the project. With completion of a proposed 140,000-square-foot building (for hotel or residential use, plus retail) construction will total 783,500 square feet.

RTKL

835 Market Street
San Francisco, California

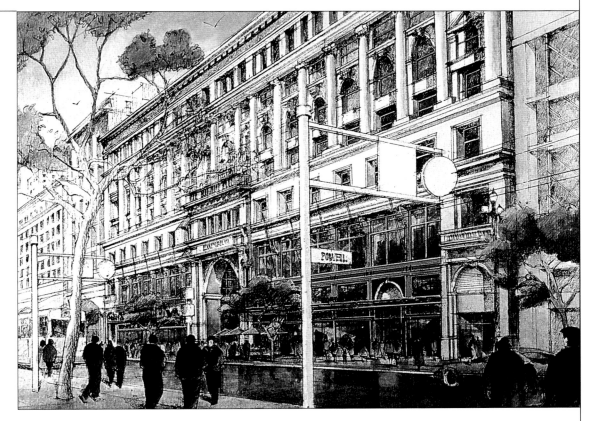

The landmark Emporium Building on San Francisco's Market Street will be redeveloped into a full-city-block, 1,585,000-square-foot urban complex above a major transit station. A 45-foot-wide arcade passing through the structure will connect the Union Square shopping district to the Yerba Buena area's convention hall and cultural facilities. The Emporium structure will house 325,000 square feet of retail and cafes on four levels, with offices above. Its 1896 façade, which survived the 1906 earthquake and fire, will be restored, and a new glass canopy will provide weather protection without obstructing vision. The 102-foot-diameter domed rotunda at the heart of the original department store will be restored. A new 370,000-square-foot Bloomingdale's store will have a glass façade along Mission Street. Above the store will be an entertainment complex, including a nine-screen cinema, and the lobby, ballroom, and health club for a 450-room hotel to rise above the complex.

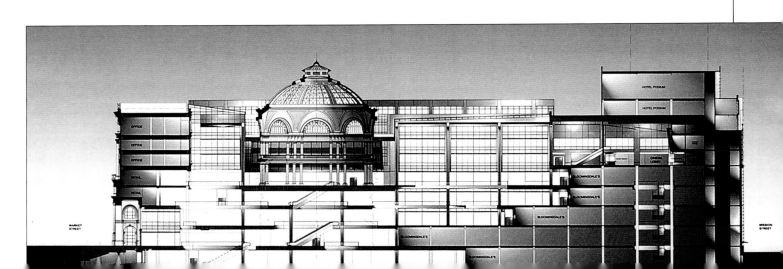

**Veso Mare
Patras, Greece**

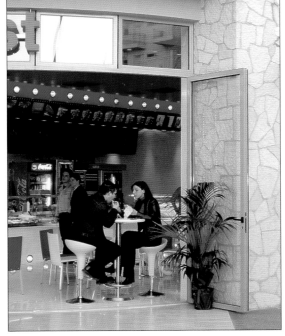

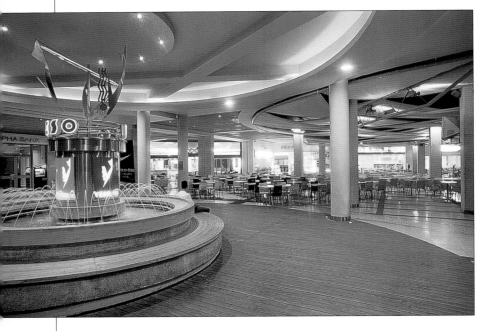

Taking advantage of a location at a major ferry crossing from Italy, Veso Mare is the first leisure-only development in Greece. Its leasable area of 11,500 square meters (124,200 square feet) includes 1700 square meters of rehabilitated historic buildings. Included are an eight-screen cinema, a 16-lane bowling alley/bar, and such chain restaurants as TGI Fridays and La Pasteria. Restaurants spill out onto a pergola-shaded boardwalk, and upper dining terraces enjoy broad waterfront views. Spaces range from intimate corners for romantic meals to areas for large groups. The success of facilities here, including the first Europlex cinemas in Greece, has inspired a similar project for Athens.

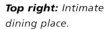

Top right: Intimate dining place.
Top left: Large areas opening to terraces.
Center: Outdoor terrace/view.
Right: Street front.
Photography: Paul Bock.

Sasaki Associates, Inc.

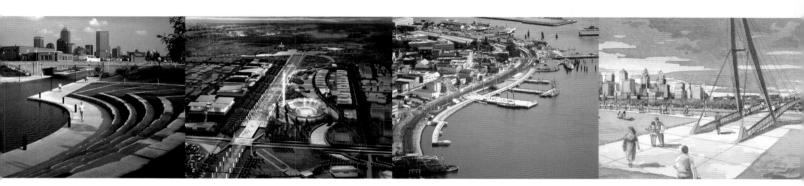

64 Pleasant Street
Watertown
Massachusetts 02472
617.926.3300
617.924.2748 (Fax)
info@sasaki.com
www.sasaki.com

900 North Point Street
Suite B300
San Francisco
California 94109
415.776.7272
415.202.8970 (Fax)
sanfrancisco@sasaki.com

Sasaki Associates, Inc.

Central Indianapolis Riverfront
Upper Canal
Indianapolis, Indiana

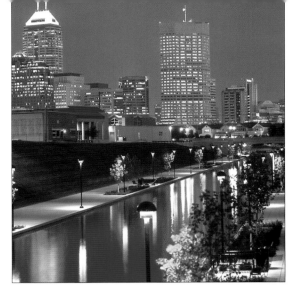

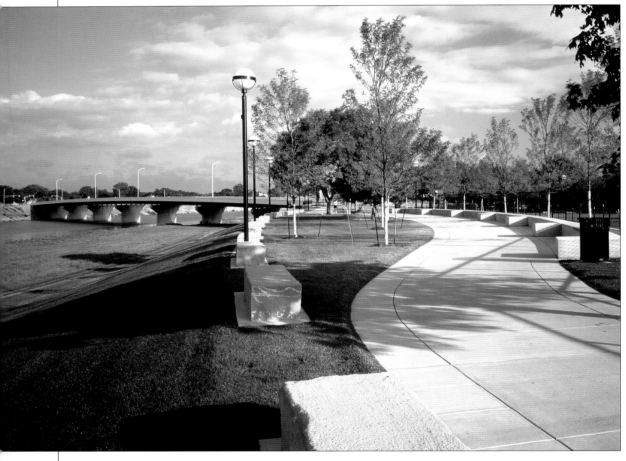

Top: City seen beyond Washington Street Bridge.
Above: Riverbank promenade and new bridge.
Left: Historic floodgates.
Photography: Jim Barnett.

The Central Indianapolis Riverfront has transformed the unused urban reaches of the White River into a unified open space system, which includes the historic central canal. This decade long project was initiated with a concept master plan, funded by the Army Core of Engineers, for the nine-mile corridor of the White River that runs through

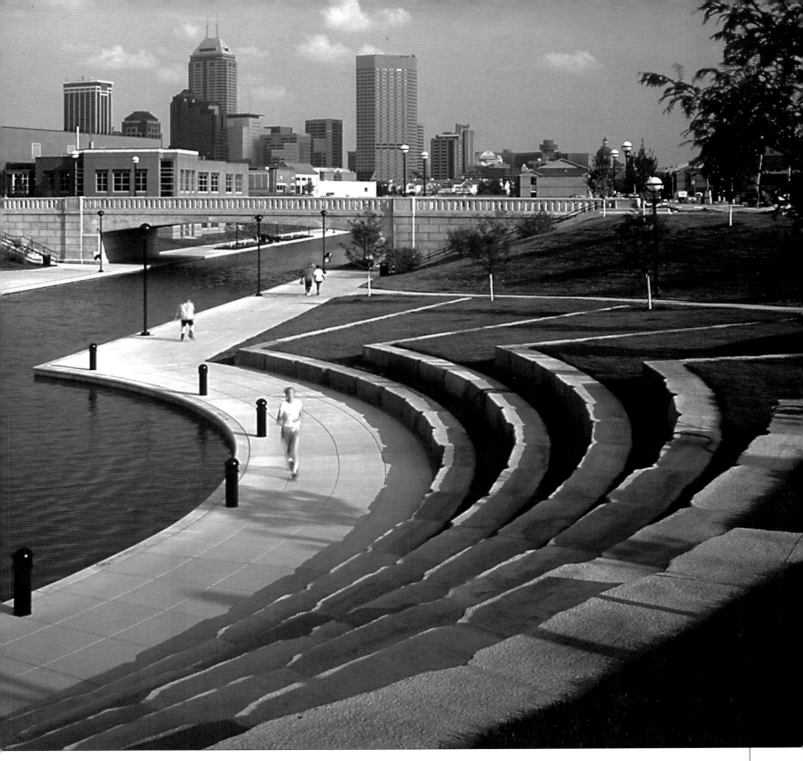

central Indianapolis, Indiana. The aims of this master plan were three fold: first, to reclaim the river as a civic resource for the daily life of the inhabitants and visitors to the city; second, to make the river an identifying topographic symbol of the city and finally, to reverse the environmental and economic decline of this district. These goals were embodied in a vision for an urban park system that integrated the downtown with the river and the canal and also created the civic context for new developments that would face onto the parks and fuel the economic, social and cultural recovery of this inner city area of Indianapolis. A key component of this integration was the canal, which threads through the downtown districts of the city and connects to the White River within the park. The new portions of the central canal add a second city waterfront to the urban life of Indianapolis. Generous walkways, fountains, and re-used historic elements of the original canal add to the character of the spaces on the waterfront. The objectives of the plan - creating a magnet for recreation in the downtown area, creating a location for public and private investment have been achieved and importantly, the river is no longer the city's "backyard", but is fast becoming the topographic heart of Indianapolis.

Above: *Informal amphitheater overlooking canal and city skyline.*

Sasaki Associates, Inc.

2008 Beijing Olympic Green
Beijing, China

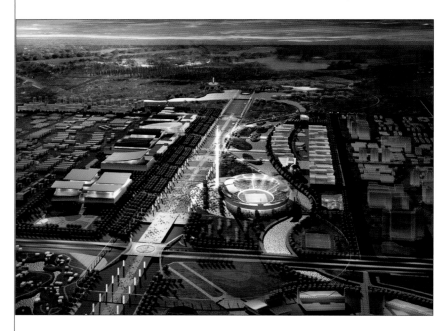

Left: *Axial esplanade running north to park, with 80,000-seat stadium, other Olympic venues, civic and mixed uses to either side.*
Below left: *Canal and stadium seen from north.*
Bottom: *Axis extending south from hill in park, foreground, toward Forbidden City, near horizon.*

Opposite right: *Plan features northward extension of city's axis between Olympic facilities to new Forest Park.*

Opposite far right: *Olympic Green as integral part of city.*

The Concept Master Plan for the Olympic Green seeks to achieve balance and integration in a manner that is both poetic and pragmatic. The Plan seeks to balance East with West, the ancient with the contemporary, development with nature, adjacent context with the Olympic Green. The Plan has 3 fundamental elements: the Forest Park, and its extension

southward; the Cultural Axis that is the northward extension and conclusion of the great central axis of the city; and the Olympic Axis, a new axis that links the Asian Games site to the south with the new National Olympic Stadium towards the north. The Forest Park is conceived as an ideal paradise from which Chinese civilization emerged many millennia

ago. The Park is designed as a beautiful, sculpted landform of hills, forests and meadows created by excavating a lake within the Park. In a gesture that seeks to balance the great parks of central Beijing with an idea of equal scope and grandeur in North Beijing, the water from the Forest Park flows southward within a canal adjacent to a tree-lined esplanade.

The canal and esplanade are arranged to symbolically link the Forest Park, Central Area and Asian Games site through nature. The Concept Master Plan is most respectful of the significance of the central axis to the city, and is deliberate in choosing to place new buildings at its edge rather than on-axis. The enduring power, boldness and simplicity of the

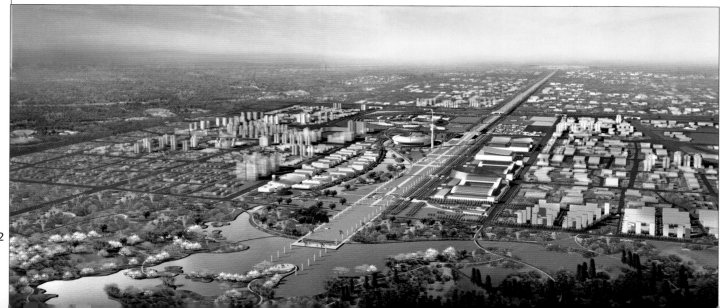

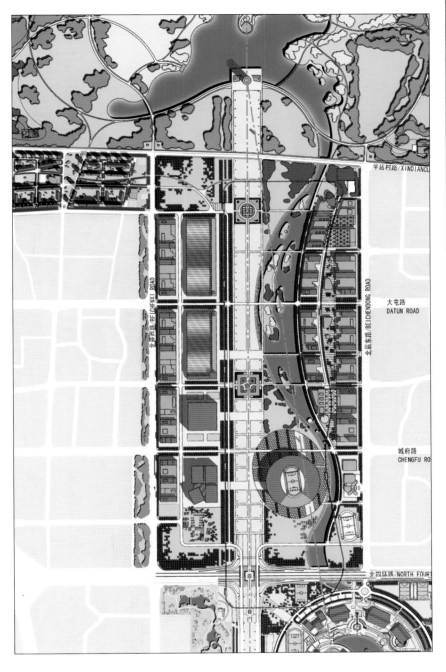

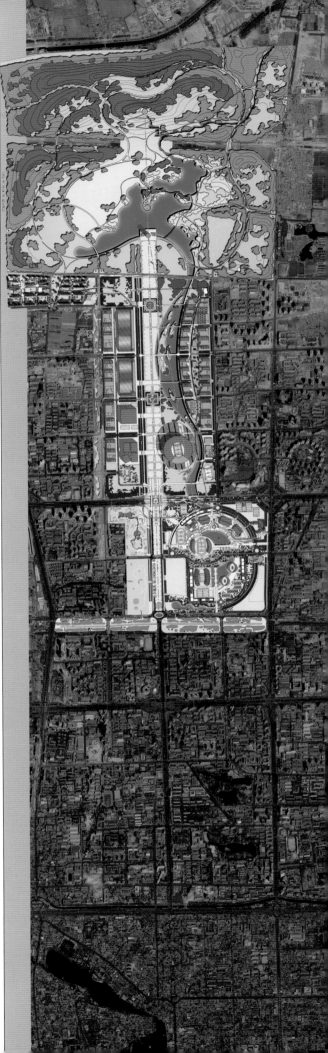

Cultural Axis extend beyond the relatively temporal nature of buildings. Along the axis, the plan seeks to commemorate the achievements and contributions of the great Chinese dynasties. The scale of the axis is monumental, to emphasize its significance. The axis concludes with a powerful simplicity, in the hills of the Forest Park, signifying the beginning of Chinese culture and civilization in nature. The Olympic Axis begins within the existing Asian Games stadium, extending northwest through the proposed National Stadium, continuing onward to a Sports Heroes Garden, intersecting with the Cultural Axis. Thus, the Olympic ideals of Sports, Culture and Environment are equally represented within the Olympic Green plan. The combination of the Forest Park, Cultural and Olympic Axes provide a framework within which the building development program is arranged, providing extraordinary flexibility in the ultimate siting and design of each Olympic venue.

Sasaki Associates, Inc.

Jian Guo Dong Lu Project
Shanghai, China

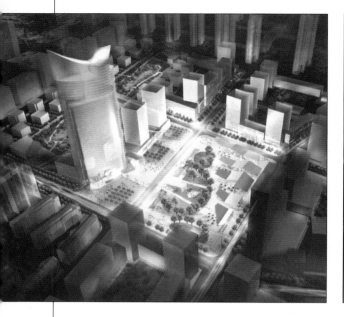

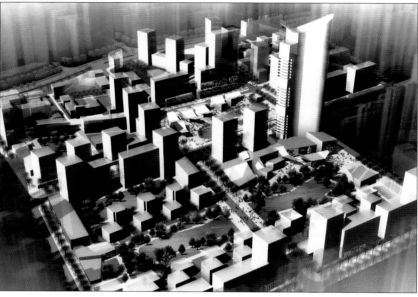

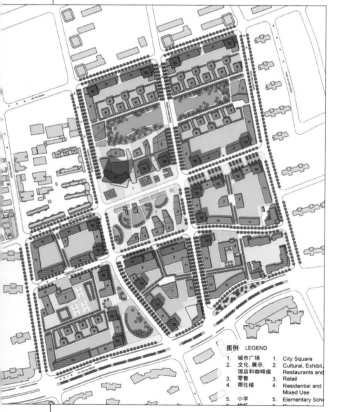

图例 LEGEND
1. 城市广场 — 1. City Square
2. 文化,展示, — 2. Cultural, Exhibit,
 饭店和咖啡座 — Restaurants and
3. 零售 — 3. Retail
4. 商住楼 — 4. Residential and
 — Mixed Use
5. 小学 — 5. Elementary Sch
6. 幼托 — 6. Kindergarten

As Shanghai's status among world cities rises, the perceived need for public spaces has produced examples such as the People's Square and Century Park in Pudong. The plan for the Jian Guo Dong development adds City Square, a dynamic new civic space conceived as another destination place in the metropolis. The streets of the development extend the pattern of the old French Concession, with the square at their nexus. The lower levels of buildings surrounding this central space include commercial uses, with dining, entertainment, and cultural venues occupying pavilions in the square itself, which will also offer an outdoor performance space. Underground parking is provided below the square. To the north of City Square, the quiet Neighborhood Park is the focus of a range of residential types. The pivotal block between the two urban spaces will include an apartment tower that is the tallest building proposed. The area's two new schools will be identified by small plazas along the street.

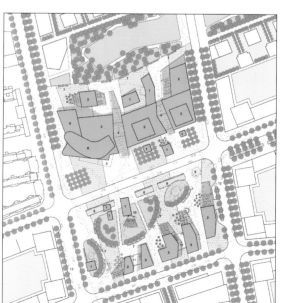

Top left: *Aerial view of project, with City Square at center.*
Top right: *View with Neighborhood Park in foreground.*
Far left: *Plan of whole project.*
Left: *Center of area, with square in lower portion, part of park at top.*

Sasaki Associates, Inc.

New London Waterfront Park
New London, Connecticut

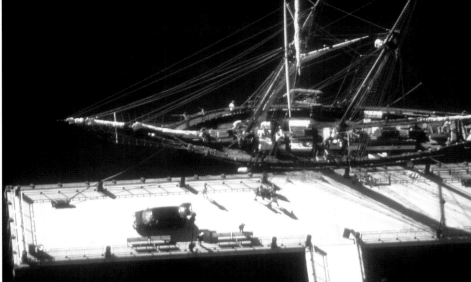

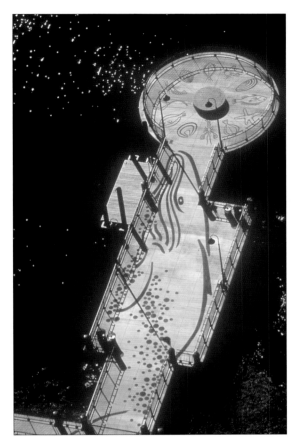

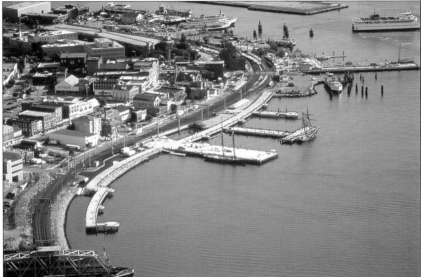

Designed to increase activity along the Thames River, the waterfront park had to deal with an Amtrak railroad line, which separates the waterfront from the city. Sasaki designed a half-mile-long promenade curving along the river, linking several piers and activity areas with different themes. At the Children's Discovery Pier, interactive signage teaches about the river and the ocean. The Amistad Landing Pier commemorates the slave ship that once landed there. Shaw's Cove is a fishing pier, and the Coast Guard Pier accommodates an outdoor market and festive events. City Pier Plaza, which terminates the main pedestrian link from the city, can accommodate several large boats. It includes a pergola and a performing stage with glass block illuminated from below.

Above left: Marine related designs on fishing pier.
Top: Sailing vessel at one of several piers.
Above: View of city with railroad along waterfront.
Right: Plan of City Pier Plaza, with historic railroad station and queuing area for island ferries.
Photography:
Landslides, 2001.

Sasaki Associates, Inc.

Schuylkill Gateway
Philadelphia, Pennsylvania

The area of the Schuylkill Gateway urban design plan occupies a uniquely central riverfront position, surrounding the newly refurbished main railroad station and within walking distance of the downtown and two major universities. But the site also presents unique challenges, with a confluence of roadways and rail lines, elevated and on the surface, which have discouraged development and form obstacles to pedestrian movement. Movement and development will be facilitated by new local streets, to be lined with mid-rise, mixed-use buildings, that will connect existing east-west arteries. Public spaces will include a linear park beneath a 60-foot-high rail line. Another riverfront park will extend the main axis of the University of Pennsylvania to the river, where a new footbridge would link the two banks.

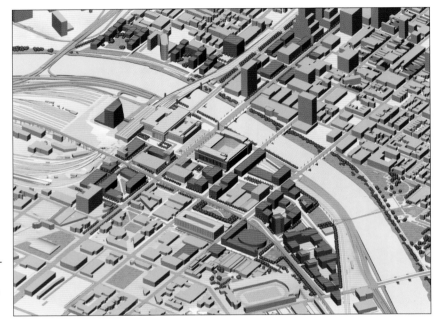

Left: *Aerial from southwest, with Penn campus in foreground, downtown at top.*
Below left: *One of proposed local streets, with mixed-use development.*
Bottom, left to right: *Core of project, with existing station at right and equally grand post office, with almost 1 million sq ft to be available for new uses; High Line park under tracks; Locust Park, with new footbridge.*

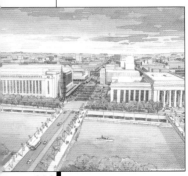

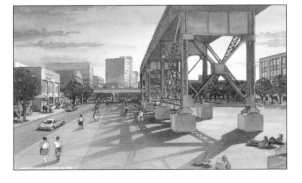

SWA Group

2200 Bridgeway

PO Box 5904

Sausalito

California 94966

415.332.5100

415.332.0719 (Fax)

www.swagroup.com

Sausalito

Laguna Beach

Houston

Dallas

San Francisco

SWA Group

World Wide Center Plaza
New York, New York

SWA was retained by architects Skidmore, Owings & Merrill to design this one-acre mid-block plaza in a redevelopment complex on the West Side of Midtown Manhattan. The full-city-block project includes 1.5 million square feet of office space in a 49-story tower and 300 residential units in a 38-story tower with low-rise wings. The massing of the buildings makes an effective transition between a high-rise commercial district to the east and a low-rise neighborhood to the west. The ground floors of both towers, which flank the plaza on the east and west, are occupied by retail. The plaza is at street level, broadly open to the streets on the north and south. Massing of the buildings assures ample midday sun. Under the plaza is a six-theater cinema complex and a complete fitness center. In order for the developer to receive a bonus of allowable

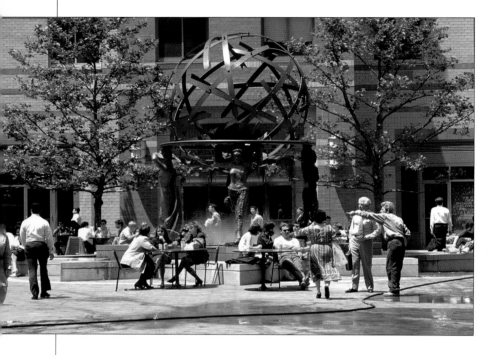

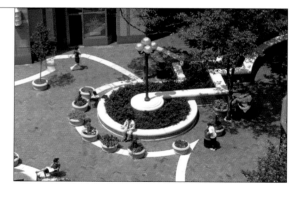

Above: Activity at center of plaza.
Right: Generous planters and seating walls.
Below right: Part of plaza's broad exposure to adjoining streets.
Photography: Gerry Campbell, Tom Fox, and Tom Lamb, all SWA Group.

floor area, the plaza design had to meet stringent criteria set by the city for public open space, and it underwent a complex public review process. The entire World Wide Center complex was the subject of a Public Broadcasting System television series entitled "Skyscraper," which documented the process of development from financing, design, and approvals through construction and leasing.

Right: Midtown Manhattan, World Wide Center in foreground.
Below: Planters, fountains, and paving forming bold patterns when seen from towers.

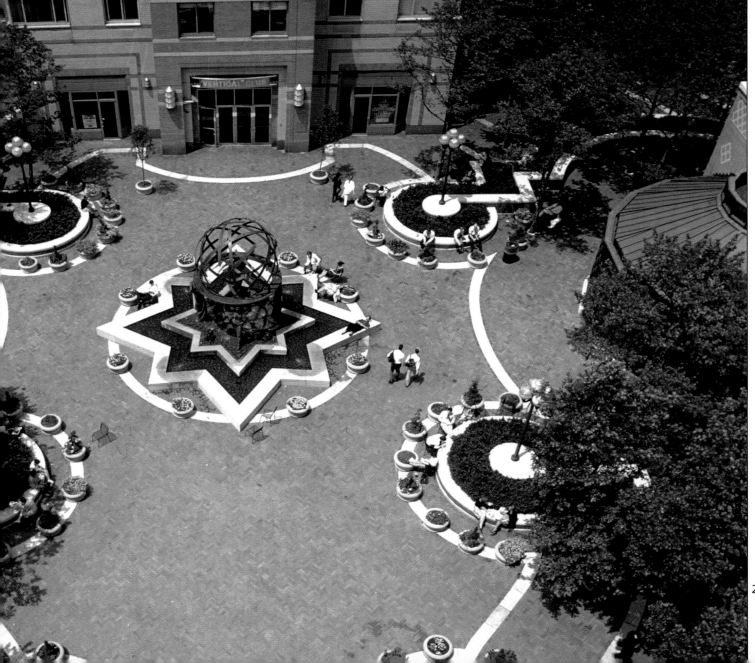

299

SWA Group

International Center
Dallas, Texas

An urban roof garden over a parking garage provided an opportunity to create a welcome retreat from the urban environment. Developed for the Harwood Pacific Corporation, the project was carried out in phases over a four-year period. The 1.5 acres of water and greenery have been planned and landscaped to offer a variety of outdoor environments suited to large events, small groups, and individual reflection. The project's layout and details take their cues from the European formal gardens admired by the client. The formal geometries are striking in views from surrounding buildings, and rows of trees and flagpoles along the street frontage make the regularity of the layout apparent even from pass-

ing cars. Located at the edge of downtown Dallas, the project has helped spark the revitalization of the adjacent Oakwood district.

Right: Aerial view displaying garden's bold geometries.
Left: Shaded walkway.
Photography: Tom Fox, SWA Group.

Left: People gather for events on the terrace.
Below left: Meeting on gridded terrace.
Right: Chess game setting.
Far right: Central pond and downtown towers.

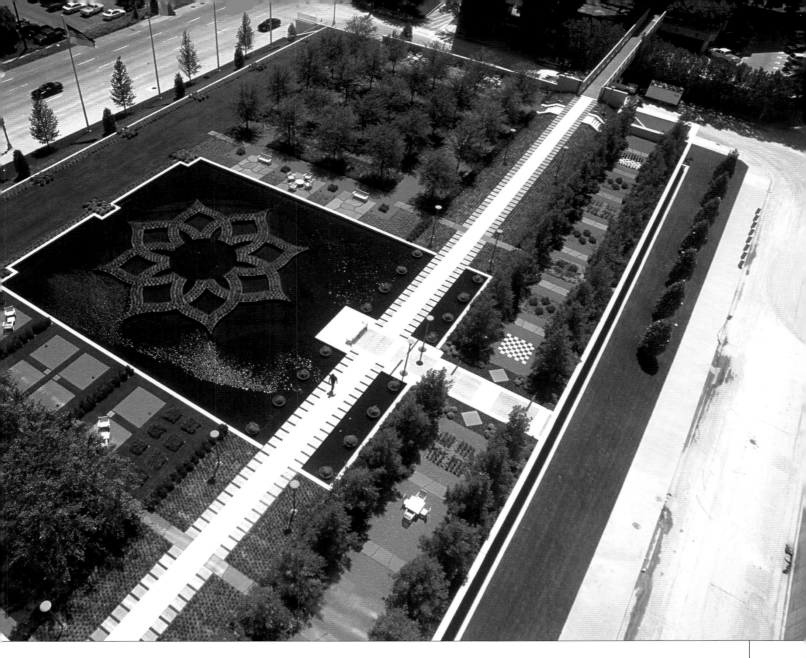

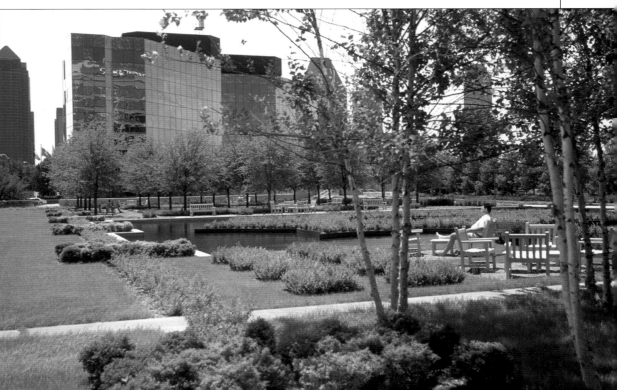

SWA Group

McCormick Place
Chicago, Illinois

Below: Fountains and planting at a main entrance.
Right: Geometric play in landscape.
Opposite page: Two views of large-scale landscape with lighting pylons.
Photography: Tom Fox, SWA Group.

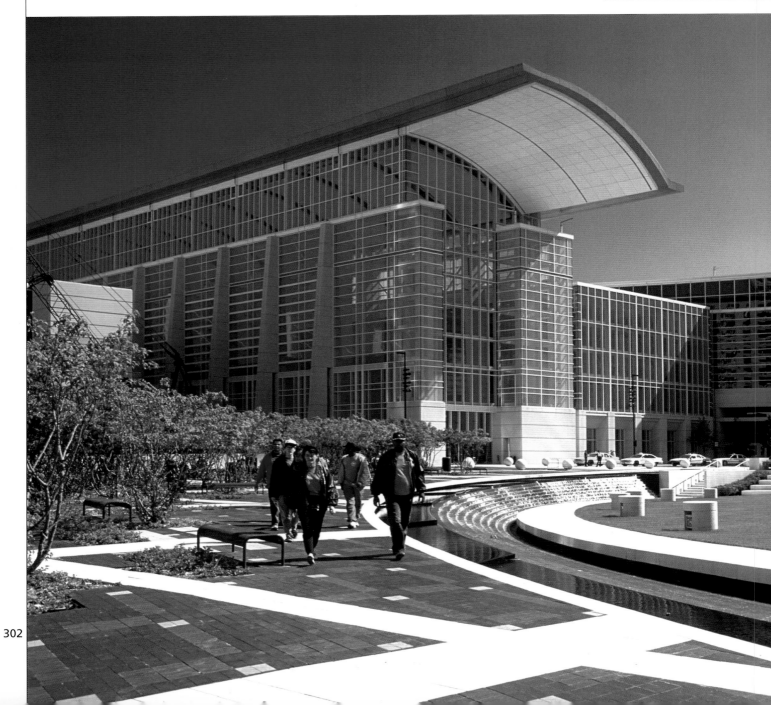

The SWA Group was one member of a team selected through a competition to design the $800-million expansion of the McCormick Place convention center. The program called for 1,000,000 square feet of additional exhibition/meeting facilities, 230,000 square feet of galleria, and a master plan that included a 74,000-seat multipurpose stadium. The project has increased Chicago's exhibition and convention space to 3,000,000 contiguous square feet. The public plaza and landscape improvements accounted for $3.5 million of the cost. Besides the proposed stadium, the project also makes provision for potential new near-town mixed-use development. The open spaces are scaled to both present and future developments on the site.

SWA Group

Williams Square
Las Colinas/Irving, Texas

Right: *Entire plaza.*
Below: *Horses appearing to splash water.*
Photography: *Tom Fox.*

Landscaping for an office complex in the center of the planned community of Las Colinas has become a regional icon not only for the Dallas area but for all of Texas. SWA's design abstracts the West Texas landscape as the setting for bronze sculptures of mustangs – wild horses – galloping through an arroyo. Small water jets representing the splash of water as the horses cross a stream create a striking illusion of actual movement. The project uses moving water to create the kind of sculptural dynamism long associated with the Trevi Fountain in Rome. The vivid interpretation of the moving horses is by sculptor Robert Glen.

Torti Gallas and Partners

1300 Spring Street

4th Floor

Silver Spring

Maryland 20910

301.588.4800

301.650.2255 (Fax)

www.tortigallas.com

Torti Gallas and Partners

Infill in the Capital City

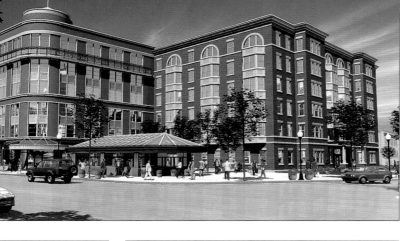

Above: *The Ellington.*
Left: *One parcel of Columbia Heights.*
Renderings: *Interface Multimedia.*

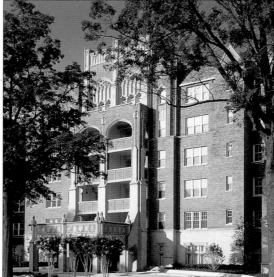

Cities are built building by building and are usually rebuilt in similar fashion. It is this process that makes the fabric of our historic urban centers so rich. The series of infill projects in Washington, DC, presented here includes adaptive reuse of existing structures as well as new construction that draws from surrounding architectural languages.

The Ellington
Washington, DC

This building responds to the demand a new Metro station has created for luxury apartments and street-level retail. The building is E-shaped in plan, defining two semi-public courtyards along U Street. The design of the structure includes a red brick corner pavilion with large windowed loft apartments and a buff brick structure which evokes the landmark building of the neighborhood.

Columbia Heights
Revitalization
Washington, DC

Metro stations on the new Green Line are catalyzing revitalization of formerly prosperous neighborhoods. Parcels adjoining the two station entries at 14th and Irving Streets are being redeveloped with retail at street level and apartments above, in buildings massed to "embrace" the spaces around the transit entrances, creating lively plazas.

Alban Towers and
The Residences at
Alban Row
Washington, DC

A forgotten half block in a luxury neighborhood has been revived through a combination of efforts. The facade and the interior public spaces of the 1920s Towers have been faithfully restored. A 250-car underground garage has been added with a landscaped deck and air rights sites for 15 semi-detached houses. The new homes are built facing the street to the rear, making a sensitive transition from the mid-rise structure to the single-family neighborhood beyond.

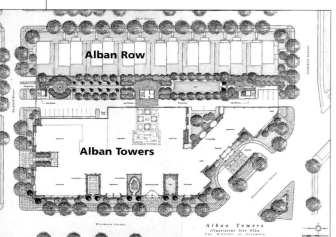

Alban Row

Alban Towers

*Alban Towers
Illustrative Site Plan
The District of Columbia*

Above left: *The Residences at Alban Row.*
Above: *Alban Towers.*
Left: *Plan of entire block.*
Photography: *°Larry Olsen (above right).*

Torti Gallas and Partners

Inner City Revitalization

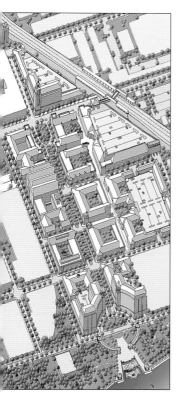

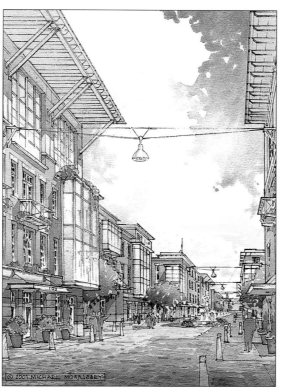

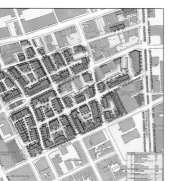

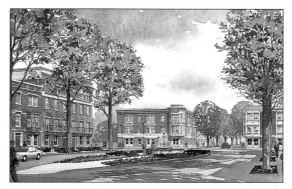

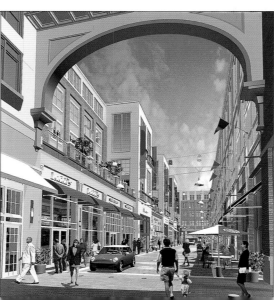

Far left: Harrison Commons aerial perspective.
Left: Harrison Commons street scene.

Renderings: ©2001 Michael B. Morrissey MRAIC.

The rebuilding of our cities happens at neighborhood, as well as individual building, scale. The projects shown here create vibrant new communities, drawing their architectural and urban patterns from surrounding contexts.

Harrison Commons Harrison, New Jersey

This 41-acre brownfields site adjoins a PATH station with a 10-minute commute to Manhattan. It also fronts on the Passaic River directly across from downtown Newark. One key strategy of the traditionally gridded plan is to wrap four-story loft apartments around a 2,500-car commuter garage at the station. This 3,000 unit Transit Oriented Development (TOD) will begin construction in 2004.

Arlington East Bethesda, Maryland

This will be the last piece of the Bethesda Row ensemble, a mixed-use office and retail area developed over the past ten years, which has become the new 100-percent corner of the downtown. The new increment will add 180 residential units and 50,000 square feet of retail to the mix. It features a through-block "festival street" open to the public, which increases valuable retail and apartment frontage by 80 percent.

Flag House Courts Revitalization Baltimore, Maryland

A short walk from downtown, the development will integrate an existing public housing site and an adjacent neighborhood in a mixed-use, mixed-income community. Owned, rented, and live/work units will be undifferentiated in aesthetic treatment that eliminates the stereotypes typically associated with public housing. A historic retail street known as Corned Beef Row will be re-created.

Above: Flag House Courts site plan.
Above right: Flag House Courts community green.
Right: Through-block passage in Arlington East.
Renderings: Richard Chenoweth (above right); Interface Multimedia (right).

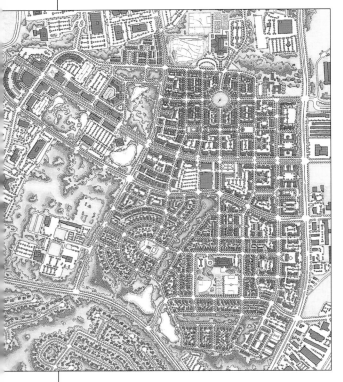

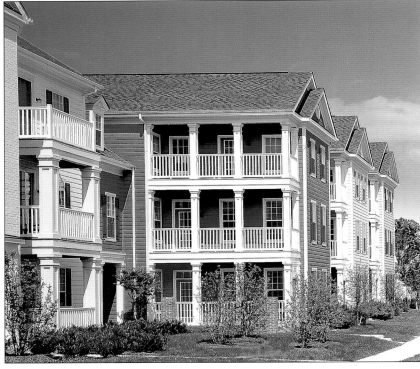

Above: Site plan.
Above right:
Multifamily housing.
Below: Aerial view of community node.
Below right:
Multifamily residential street.
Photography: Kenneth M. Wyner.
Rendering: Dariush.

The paradigm of the bucolic American street, with its majestic elm trees and single-family houses, is a powerful tradition, providing the inspiration for infill developments and greenfield neighborhoods. Important to this model is the establishment of the street as the primary element of the public realm. Equally important is the use of traditional house types with architectural and cultural associations along with new types that respond to the current market.

**King Farm
Rockville, Maryland**
For this 440-acre development, a set of design principles were drawn from traditional communities to inform not only the urban design but the architecture of individual buildings. To reduce dependence on the automobile, the plan facilitates pedestrian, bicycle, bus, and light rail travel, as well. The design emphasizes the harmonious relationship of buildings to streets and open spaces.

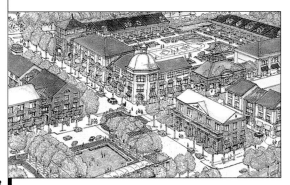

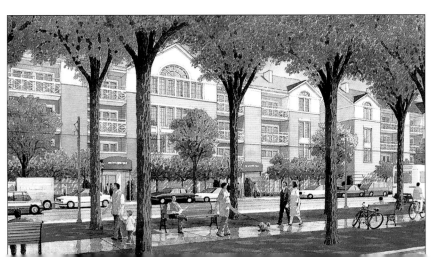

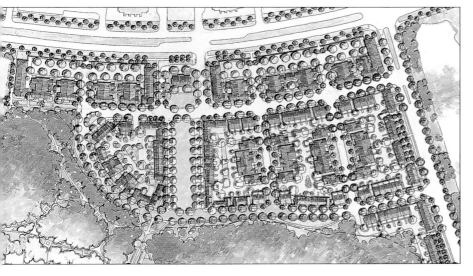

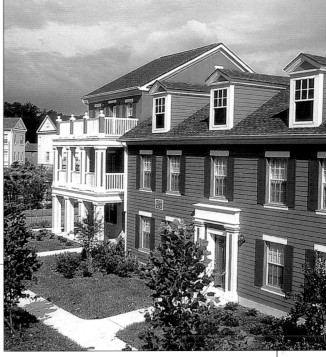

Above: Site plan.
Above right and right:
Various residential types.

Centergate Celebration
Celebration, Florida

Traditional house types, in diverse styles as required by the Celebration design code, give this apartment community an idiosyncratic, pedestrian-scaled atmosphere. The 50-acre site accommodates traditional streets, neighborhood squares, small gardens, and courtyards, reconciling the needs of cars and pedestrians. Parking is provided in either parking courts or rear-loaded garages.

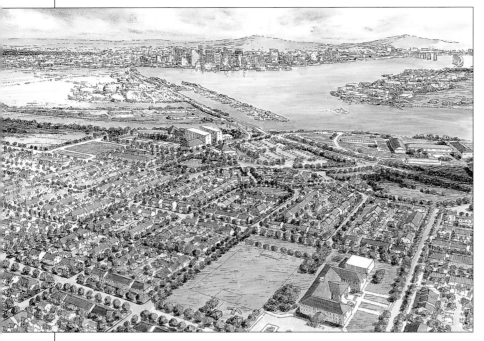

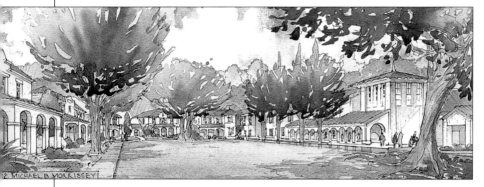

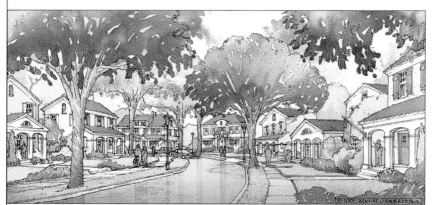

Above: View toward community center.
Left: Aerial view.
Renderings: ©2001 Michael B. Morrissey MRAIC (above); Howard Associates (left).

Left: Housing around a green.
Below left: Street of single-family houses.
Renderings: ©2002 Michael B. Morrissey MRAIC.

The Village at NTC
San Diego, California

An innovative public/private venture will transform military base housing into a traditional neighborhood. Redesigned streets will resemble – and connect with – those of adjoining private-sector neighborhoods.

Monterey Family Housing
Monterey, California

The revitalization of two military family housing areas will create well-defined neighborhoods designed to take advantage of exceptional landscape and views. Each neighborhood will have central greens and community buildings.

Belmont Bay Town Center
Occoquan, Virginia

A New Urbanist town center in a rural context, this townhouse-density development takes lessons from many maritime communities. Its 600 residential units will be within walking distance of the marina and the golf course.

Far left: Site plan.
Left: Marina and mixed-use town center.
Rendering: ©2002 Michael B. Morrissey MRAIC.

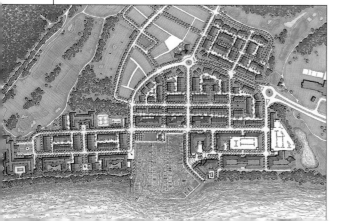

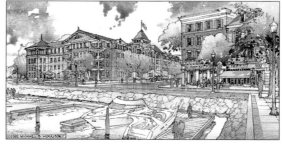

**College Park
Memphis, Tennessee**
An existing public housing project has been radically transformed, with 319 units in small-scaled buildings patterned after local house types. It includes a senior building and a community building shared with a nearby college.

**Strathmore Park at Grosvenor Metro
Rockville, Maryland**
This 60-unit adult complex offers an alternative to the isolated senior community. Located a half-block from a Metro station, it offers rapid connections to urban centers. Purchasers have a choice of spacious house-like units.

**Baldwin Park Village Center
Orlando, Florida**
This new 60 acre village center is part of the larger 1,000 acre community which will replace the former Orlando Naval Training Center. The mixed-use center will offer 1,120 residences, including lofts and live/work units. The plan features a "main street" leading to a waterfront park.

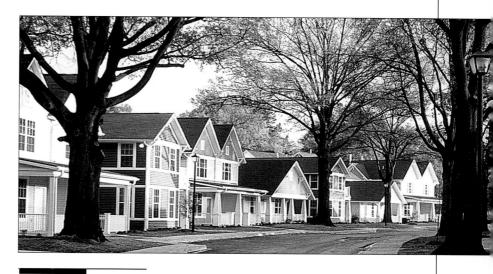

Above: College Park's modest scaled and mature trees, recalling nearby single-family neighborhoods.

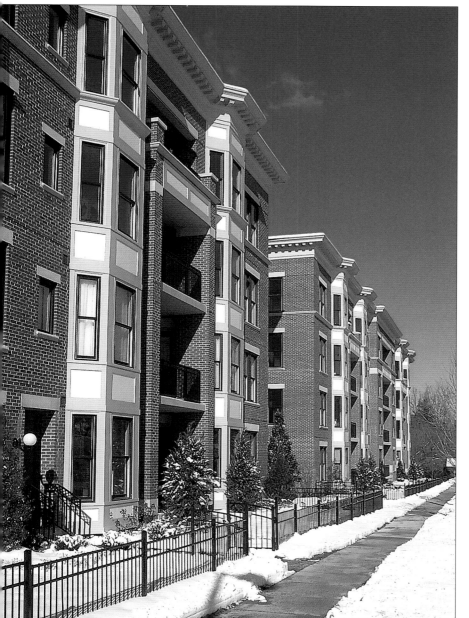

Left: Strathmore's urban adult residences.

Above: Views of Baldwin Park Village Center waterfront and "main street."
Renderings: ©2001 Michael B. Morrissey MRAIC.

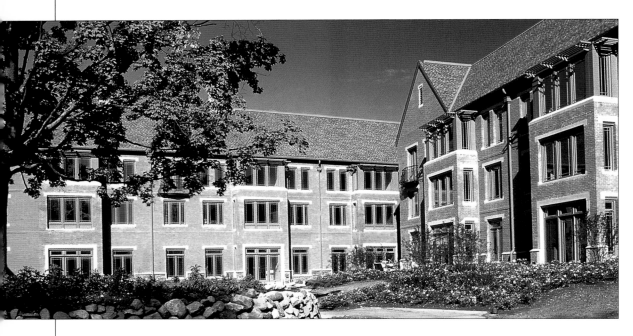

*Left: Gardened court-yard at The Garlands.
Below left: Residence meets landscape.
Below: Stream and semidetached villa.*

The single-use district has a long history in the city, reaching back to European monasteries and finding its most dominant American tradition in the educational campus. This urban design tradition provides a model for a senior living district that is an extension of a Midwestern town.

**The Garlands at Barrington
Barrington, Illinois**
This senior living neighborhood will provide a much needed complement to the established community of Barrington Village. In a parklike setting, it will offer 26 semidetached villas, 258 apartments, 60 assisted-living units, and 60

skilled nursing beds. A 60-room country inn with banquet facilities will serve both residents and the nearby village. Below-grade parking will offer residents convenience and security, while making way for a landscape of trees, ponds, and gardens.

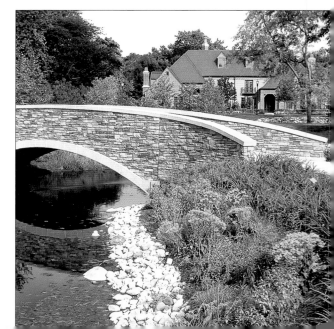

PROJECT CREDITS

Exceptional care has been taken to gather information from firms represented in this book and transcribe it accurately. The publisher assumes no liability for errors or omissions in the credits listed below.

ANNEX/5

Beijing Dazhalan Area Renewal Master Plan
Client: City of Beijing
Principal consultants:
annex/5 Architects, architecture, urban design
A.Epstein and Sons, civil and structural engineers

Mangrove Bay
Client: joint venture, City of Shenzhen and private developer
Principal consultants:
annex/5 Architects, architecture, urban design
A.Epstein and Sons, civil and structural engineers
Model Options, model maker

NTTA Prototype Toll Plaza
Client: North Texas Tollway Authority
Principal consultants:
annex/5 Architects, architecture, urban design, landscape design
Walter P. Moore, structural engineering
A.Epstein and Sons, structural engineering
Kimley-Horn, traffic/equipment
Gerard Associates, electrical engineering
Mas-Tek Engineering, civil engineering
Caye Cook & Associates, landscape design
Cost Resource Group, estimating
Mary Peyton, lighting

Beibo Mixed-Use Development
Client: joint venture, City of Beijing and private developer
Principal consultants:
annex/5 Architects, architecture, urban design
A.Epstein and Sons, civil and structural engineers

AYERS SAINT GROSS

Lexington College Town Study
Client: University of Kentucky and Lexington Fayette Urban County Government
Principal consultants:
Ayers Saint Gross, master planning
Martin/Alexiou/Bryson, traffic engineers
Zimmerman/Volk Associates, residential market analysis
ZHA, retail market analysis
Jay Kabriel, illustrator

J.J. Pickle Research Campus
Client: University of Texas
Principal consultants:
Ayers Saint Gross, campus plan, concept and design
Carter & Burgess, associated architects and planners, transportation consultant
Datacom Design Group, LLC, communications
Janke Design, wayfinding
McQueen and Southerland, Inc., research park consultant
Jay Kabriel, illustrator

Beall's Hill Master Plan
Client: Beall's Hill Development Corporation, City of Macon, CORE Neighborhood Revitalization, Inc., Macon Housing Authority, Mercer University
Principal consultants:
Ayers Saint Gross: neighborhood master plan
Jay Kabriel, illustrator

Notre Dame Avenue
Client: Notre Dame University
Principal consultants:
Ayers Saint Gross, master plan, design guidelines, schematic design for residential buildings
Jay Kabriel, illustrator

University of Maryland
Client: University of Maryland at College Park
Principal consultants:
Ayers Saint Gross, master plan
Jay Kabriel, illustrator

BAR Architects

Santana Row
Client: Federal Realty Investment Trust
Principal consultants:
BAR Architects, architectural design, construction documents, construction administration (4 blocks of 8 blocks in phase 1)
Paradigm, structural engineer
RJS Associates, structural engineer
Design Engineering Services, mechanical engineer
Flack & Kurtz, electrical engineer
Michael Painter & Associates, landscape

Avalon Towers on the Peninsula
Client: Avalon Bay Communities
Principal consultants:
BAR Architects, architectural design, construction documents, construction administration
Skilling Ward Magnusson Barkshire, structural engineer
Design Engineering Services, hvac/mechanical engineer
Belden Consulting Engineers, hvac/mechanical engineer
Toft Wolff Farrow, electrical engineer
Rex Moore, electrical engineer
Sandis Huber Jones, survey
Lowney & Associates, geotechnical engineer
Therma, plumbing
Edward L. Pack Associates, acoustical
The Guzzardo Partnership, landscape
BVC Architects, interiors
Ultimate Interiors, interiors
Watry Design, parking

Paseo Plaza
Client: San Jose Redevelopment Agency; Goldrich Kest & Stern; Kimball Small
Principal consultants:
BAR Architects, site design, architectural design
Andrew Vidikan & Associates, structural engineer
Design Engineering Services, hvac/mechanical engineer
Toft Wolff Farrow, electrical engineer
Amelect, electrical engineer
BKF Engineers, civil engineer
Nolte & Associates, civil engineer
Danalex, hvac
Edward L. Pack Associates, acoustical
Johannes Van Tilburg & Partners, executive architect
Stephen Wheeler, landcape
The Office of Cheryl Barton, landscape
Watry Design, parking

Sun City Tower, Kobe Senior Living Complex
Client: Half Century More
Principal consultants:
BAR Architects, site planning, space planning, architectural design, review of local architect's construction documents, construction oversight
M.D.A. Associates, consultant
Babey Moulton Jue Booth, interiors
SWA Group, landscape

BEELER GUEST OWENS ARCHITECTS

Austin Ranch
Client: The Billingsley Company
Principal consultants:
Beeler Guest Owens Architects, architectural design
Brockette Davis & Drake, civil engineering
Jerald Kunkel & Associates, structural engineering
Perry Hescock & Associates, mechanical, electrical, plumbing
Mesa Design Group, landscape design
Kenner-Moore Design Group, interior design

Eastridge
Client: Phoenix Property Company
Principal consultants:
Beeler Guest Owens Architects, concept development, site planning, architectural design
Ferguson Deere, Inc., civil engineer
Falkofske Engineering, Inc., structural engineering
Perry Hescock & Associates, mechanical, electrical, plumbing
Enviro Design, landscape design

2400 McCue
Client: Hepfer, Smith, Airhart and Day
Principal consultants:
Beeler Guest Owens Architects, site planning, architectural design
Enviro Design, landscape design
Freedom Furniture & Design, interior design
Scott Peck Illustration & Design, marketing consultant

The Highlands of Lombard
Client: Lincoln Property Company
Principal consultants:
Beeler Guest Owens Architects, site planning, architectural design
Virgilio & Associates, Ltd., structural engineer
Lehman Design Consultants, mechanical, electrical, plumbing
V3Companies, civil engineering
Enviro Design, landscape design

BROOKWOOD GROUP

Peachtree Corridor Project
Client: Buckhead Community Improvement District
Principal consultant:
Brookwood Group, master planner and design director
HGOR, landscape architect
Parsons, transportation consultant
Communication Arts, environmental graphics
Costing Services, Inc., cost consultant

Morehouse College Master Plan
Client: Morehouse College
Principal consultant:
Brookwood Group in joint venture with R.K. Brown, master plan, design guidelines
Costing Services, Inc., cost consultant

Turner Techwood Campus Master Plan
Client: Turner Broadcasting System
Principal consultants:
Brookwood Group, strategic real estate planner, master planner, design consultant
Syska & Hennessy, m/e/p
W.L. Jorden, civil engineer
Moreland Altobelli, traffic consultants
KPS Group Architects, architect of record
Costing Services, Inc., cost consultant

Georgia Institute of Technology, Savannah
Client: The University Financing Foundation on behalf of Savannah Economic Development Authority and Georgia Institute of Technology
Principal consultants:
Brookwood Group, development management and design architect
Arquitectonica, master plan for university business park
Hardin Construction Company, general contractor
Smallwood, Reynolds, Stewart & Stewart, architect-of-record with Hardin
Thomas & Hutton Engineering, civil engineer
Stanley D. Lindsey, structural engineer
EDI, information technology
HESMA, m/e/p and lighting design

The Wakefield
Client: The Wakefield Development Company
Principal consultants:
Brookwood Group, developer and design architect
Skanska (formerly Beers), general contractor
Smallwood, Reynolds, Stewart & Stewart, associate architect-of-record with Skanska
B&A Consulting Engineers, contractor's m/e/p
Advanced Engineering Structures, contractor's structural engineer

Engineering & Inspection Systems Inc., contractor's civil engineer
Newcomb & Boyd, design m/e/p
Spencer Tunnell, landscape architect
Costing Services, Inc., cost consultant

Lakeside Commons II
Client: Lendlease (developer); Boss Properties and ERE/Yarmouth Group (owner)
Principal consultants:
Brookwood Group, design architect
Kendall-Heaton Associates, Inc., architect-of-record
HESMA, m/e/p and lighting design
Roy Ashley, landscape architect

CENTERBROOK

Phelps Science Center
Client: Phillips Exeter Academy
Principal consultants:
Centerbrook, complete architectural services, interior designer
Harley Ellis, laboratory/classroom planners
Gibble Norden Champion Brown, structural/geotechnical engineers
Bard Rao + Athanas Consulting, mechanical/electrical engineers
Rist-Frost-Shumway Engineering, PC, civil engineers
Michael Van Valkenburgh Associates, Inc., landscape architect
P.R. Sherman, Inc., code consultant
Robert Schwartz and Associates, construction specifications
Hanscomb Associates, cost management
George B.H. Macomber Company, construction advisor during design phase
Acentech Incorporated, audiovisual/acoustical consultant
Rumney Associates, graphic designer
Pizzagalli Construction Company, contractor

Church House for United Church of Christ World Headquarters
Client: United Church of Christ
Principal consultants:
Centerbrook, complete architectural services
Valentine J. Shute, AIA, Robert N. Wandel, AIA, Ann Vivian, AIA, consulting architects for chapel
Planned Environmental Design Corporation, architect of record for chapel
Gibble Norden Champion, structural and geotechnical engineers (hotel)
van Zelm Heywood & Shadford, Inc., mechanical and electrical engineers (hotel)
The C.W. Courtney Company, civil engineers (hotel)
Rolf Jensen & Associates, code consultant (hotel)
Robert Schwartz and Associates, specifications (hotel)
Architectural Glass Art, glass designer for chapel
The Albert M. Higley Co., contractor (hotel)
Building Improvements, Inc., contractor (chapel)

Yale Child Study Center
Client: Yale University
Principal consultants:
Centerbrook, complete architectural services
Gibble Norden Champion, structural and geotechnical engineers
R.G. Vanderweil Engineers, mechanical/electrical engineers
Rolland/Towers, P.C., landscape architects
Purcell Associates, civil engineers
P.R. Sherman, Inc., code consultant
Andrew Chartwell & Company, cost consultant
Robert Schwartz and Associates, specifications
Fusco Corporation, construction manager, contractor

Pfizer, Incorporated
Client: Pfizer, Incorporated
Principal consultants:
Centerbrook, complete architectural services
Diversified Technologies Corporation, engineers and landscape architects
Kenneth Champlin Associates, model
Colin Brash, Architectural Resources, CAD modeling consultant

Headquarters, National Outdoor Leadership School
Client: National Outdoor Leadership School
Principal consultants:
Centerbrook, complete architectural services
Gibble Norden Champion Brown, structural engineers
The Ballard Group, mechanical engineers
Innovative Electrical Systems, Inc., electrical engineers
Inberg-Miller Engineers, civil engineers
P.R. Sherman, Inc., code consultant
Robert Schwartz and Associates, specifications
SE Group, landscape architect
Rider Hunt Chartwell, LLC, cost consultant
Kloefkorn-Ballard Construction/Development, Inc., contractor

CHARLAN BROOK & ASSOCIATES, INC.

North Lake Park Apartments
Client: Van Metre Residential; Roy Barnett, project developer
Principal consultants:
Charlan Brook & Associates, Inc., design development, contract
 documents, construction administration
Donald W. McIntosh, civil engineer
Roger Kennedy Construction, builder
N. H. Joshi & Associates, structural engineer
KTD Consulting Engineers, m/e/p
Glatten Jackson Kircher England Lopez Rinehard, land planner,
 landscape
 architect
Beasley and Henley, clubhouse interior designers

Garden Apartments, Main Street at Hampton Lakes
Client: Hampton Lakes Main Street, LLC; Geoffrey C. Weber, lead
developer
Principal consultants:
Charlan Brook & Associates, Inc., and Duany Plater-Zyberk, conceptual
 land planning
Charlan Brook & Associates, Inc., preliminary design, design
development
 and working drawings for first phase
Tew Barnes & Atkinson, LLP, legal counsel, land planning consultant
N. H. Joshi & Associates, structural engineer
King Engineering & Associates, zoning and land use permit processor
URS Corporation Southern, landscape architecture

Martinique
Client: Aronov Realty
Principal consultants:
Charlan Brook & Associates, Inc., master planning, architectural design
 and construction documents of all housing, sales and amenity product
Landscape Dynamics, landscape architect
N. H. Joshi & Associates, structural engineer
Volkert & Associates, civil engineer, environmental engineer

North Bridge on Millennium Lake
Client: Sandspur Housing Partners
Principal consultants:
Charlan Brook & Associates, Inc., and Dix Nance, land planners
Charlan Brook & Associates, Inc., preliminary design, design
 development, working drawings and construction administration
Madden Engineering, civil engineer
SGM Engineering, m/e/p engineer
N. H. Joshi & Associates, structural engineer

Colonial Grand Town Park Reserve
Client: Colonial Properties Trust
Principal consultants:
Charlan Brook & Associates, Inc., preliminary design, design
 development, construction documents
Bowyer Singleton & Associates, Inc., civil engineer
Dix Nance Landscape, landscape architect
N. H. Joshi & Associates, structural engineer
C.M.H. Architect, Inc., town center architect
Street Works Development, Inc., and Consulting Group, master plan
 design consultant

Winter Park Village Lofts
Client: W.P.V. APCO, Inc.
Principal consultants:
Charlan Brook & Associates, Inc., full architectural services
N. H. Joshi & Associates, structural engineer
Dix Nance Landscape, landscape architect
Kristine N. Gregonis, Interior Design, interior design
Cheese Cake Factory, architectural staff, elevations and restaurant
 interiors

CMH ARCHITECTS

Vanderbilt Collection
Client: David Hocker & Associates and Pelican Bay Development
Principal consultants:
CMH Architects, feasibility studies, architectural design, hardscape
 planning, master/site planning, tenant reviews
Structural Design Group, structural engineer
McWilliams Associates, PC, mechanical engineer
Hyde Engineering, electrical engineer
Wilson Miller, civil engineer
Design Studio BOCA, landscaping

The Avenue East Cobb
Client: Cousins Properties Incorporated
Principal consultants:
CMH Architects, feasibility studies, architectural design, hardscape
 planning, master/site planning, tenant reviews
Hardin Construction Group, Inc., general contractor
Structural Design Group, structural engineer
Atlanta Testing & Engineering, geotechnical engineer
Southern Civil Engineering, civil engineer
McWilliams Associates, PC, mechanical engineer
Ray Engineering Group, electrical engineer
Post Landscape Group, Inc., landscape architect
LRE Engineering, Inc., traffic engineering
Ramon Luminance Design, lighting design
Dougherty & Associates Architects, Inc., design consultant
CMH Graphics, Inc., graphics

The Avenue Peachtree City
Client: Cousins Properties Incorporated
Principal consultants:
CMH Architects, feasibility studies, architectural design, hardscape
 planning, master/site planning, tenant reviews
Bovis Lend Lease, general contractor
Structural Design Group, structural engineer
Atlanta Testing & Engineering, geotechnical engineer
Southern Civil Engineering, civil engineer
McWilliams Associates, PC, mechanical engineer
Hyde Engineering Group, electrical engineer
Post Landscape Group, Inc., landscape architect
LRE Engineering, Inc., traffic engineering
Ramon Luminance Design, lighting design
CMH Graphics, Inc., graphics

The Summit (Phases I – III)
Client: Bayer Properties, Inc.
Principal consultants:
CMH Architects, feasibility studies, architectural design, hardscape
 planning, master/site planning, tenant reviews
Brice Building Company, general contractor
LBYD, Inc., structural engineer
Bhate Engineering Corp., geotechnical engineer
McWilliams Associates, PC, mechanical engineer
Jackson/Renfro & Associates, electrical engineer
Nimrod Long Associates, Inc., landscape architect
CMH Graphics, Inc., graphics

The Summit Louisville
Client: Bayer Properties, Inc.
Principal consultants:
CMH Architects, feasibility studies, architectural design, hardscape
 planning, master/site planning, tenant reviews
Brice Building Company, general contractor
LBYD, Inc., structural engineer
Bhate Engineering Corp., geotechnical engineer
McWilliams Associates, PC, mechanical engineer
Sajjadieh Engineering Group, electrical engineer
Nimrod Long Associates, Inc., landscape architect
CMH Graphics, Inc., graphics

CMSS ARCHITECTS PC

City Center at Oyster Point
Client: Newport News Town Center LLC, City of Newport News (project
infrastructure), City of Newport News Economic Development Authority
(parking garage) , HL Development LLC (project manager)
Principal consultant:
CMSS Architects PC, site selection; feasibility studies; public participation
 and involvement; mediating collaboration between public and private
 shareholders; master planning; architectural design of numerous
 buildings; streetscape, landscape, and public plaza and parks design;
 urban standards guidelines manual
(all other consultants involved only in particular components of project)

Shockoe Plaza
Client: Highwoods Properties Inc.
Principal consultants:
CMSS Architects PC, site selection; feasibility studies; design
 development of building, streetscape, public plaza and existing
 parking garage; interior programming; promoting public participation
 and involvement
Colonial Engineering/Simmons Rockecharlie & Prince, Inc., m/p engineers
Arc Electric, electrical engineers
Stroud Pence & Associates, Ltd., structural engineers
Clancy & Theys Construction Company, contractor

Downtown Norfolk
Client: for individual projects
Collins Enterprises LLC, Heritage Apartments at Freemason Harbour, PierPointe Condominiums, Boush Street Apartments
Rising Tide Productions LLC, The NorVa Theater
Robinson Development Group, 150 West Main office building, Freemason Market at Tazewell Place
City of Norfolk, 150 West Main parking garage
Marathon Development Corporation, 411 Granby Street
Principal consultants:
CMSS Architects PC, site and feasibility studies; public participation and involvement; mediating collaboration between public and private shareholders; master planning; architectural design of numerous buildings; streetscape, landscape, and public plaza design
Abiouness Cross & Bradshaw, Inc., structural engineer (Pierpointe, 150 West Main), civil engineer (411 Granby)
McPherson, Broyles and Associates, PC, structural engineer (NorVa Theater)
C. Allan Bamforth, Jr., PE, civil engineer (Pierpointe)
Kimley Horn & Associates, civil engineer (150 West Main)
ESG (Environmental Specialties Group), environmental engineer (Pierpointe)
GHT Limited, m/e/p engineer (150 West Main)
Hickman-Ambrose, Inc., m/e/p engineer (411 Granby)
GER (Geo Environmental Resources, Inc.), geotechnical engineer (Pierpointe, NorVa Theater)
Hoy Construction, contractor (Heritage Apartments)
JD & W, Inc., commercial general contractor (NorVa Theater)
W.M. Jordan, Inc., civil engineer

The Village of Rocketts Landing
Client: Rocketts Landing LLC
Principal consultant:
CMSS Architects PC, site selection; feasibility studies; public participation and involvement; mediating collaboration of public and private shareholders; initiation of zoning changes; master planning; architectural design of numerous buildings; streetscape, landscape, and public plaza design; marketing brochure for potential investors
Wiley & Wilson, Inc., civil engineer

COTTLE GRAYBEAL YAW ARCHITECTS

Silver Mill, Black Bear Lodge, Jackpine Lodge
Client: Keystone Real Estate Developments
Principal consultants:
Cottle Graybeal Yaw Architects, architectural design
Weitz-Cohen Construction Company, contractor
Eldon Beck & Associates, site planning/landscape design (Silver Mill)

Zephyr Mountain Lodge
Client: Hines Interests Limited Partnership
Principal consultants:
Cottle Graybeal Yaw Architects, village planning, architectural design
Design Workshop, landscape architect
Monroe & Newell, structural engineer
M-E Engineers, Inc., mechanical engineer
CTL/Thompson, Inc., Consulting Engineers, geotechnical consultants
Martin/Martin, civil engineer
J. Kattman Associates, interior designer
Mortensen, contractor

Falling Leaf Lodge
Client: Randy and Jeanie Banks
Principal consultants:
Cottle Graybeal Yaw Architects, envisioning, architectural design
Scott Melrose & Associates, landscape architect
The Ranch House, interior designer
Masters Gentry Architects, consulting architects
DCF Engineering, structural engineer
United Engineering Group, MEP engineer
Patrick Quigley Associates, Village Green lighting
Miller Building Corporation, contractor

The Little Nell
Client: Aspen Skiing Company
Principal consultants:
Cottle Graybeal Yaw Architects, architectural design
Design Workshop, planners, landscape architect
Anderson & Hastings, structural engineers
MKK Consulting Engineers, mechanical engineers
Contractor: Shaw Construction

Architects' Studio
Client: Toree Associates, LLC
Principal consultants:
Cottle Graybeal Yaw Architects, architectural design
SK Peightal Engineers, Ltd., structural engineer
Beaudin/Ganze Consulting Engineers, mechanical engineer
High Country Engineering, civil engineer
Mt. Daly Enterprises, landscape architect
B & H General Contractors, contractor

CRANDALL ARAMBULA, PC

Racine Downtown Development Plan
Client: Downtown Racine Corporation
Principal consultant:
Crandall Arambula, PC, urban design and public involvement – downtown revitalization plan and implementation strategy

Interstate MAX Station Area Revitalization Strategy
Client: Portland Development Commission, Portland Office of Transportation, Oregon Department of Transportation, Oregon Department of Land Conservation and Development
Principal consultant:
Crandall Arambula, PC, urban design and public involvement – station area plans and implementation strategy
Bay Area Economics, market analysis
Architectural Cost Consultants, cost estimating

Knoxville Downtown Civic Vision
Client: Nine Counties, One Vision
Principal consultant:
Crandall Arambula, PC, urban design and public involvement – downtown development plan and implementation strategy
Economics Research Associates, economic and market analysis
Benefield Richters, local liaison
Hall Communications, Inc., public outreach

DAHLIN GROUP

Alameda Point
Client: Alameda Point Community Partners
Principal consultants:
Dahlin Group Architects and Planners, land planning, urban design, architecture
Carlson Barbee Gibson, civil engineer

Sun City Grand
Client: Del Webb Corporation
Principal consultants:
Dahlin Group Architects and Planners, master plan, landscape and hardscape concepts, architectural design and documents

Rivermark
Client: Rivermark Partners, LLC
Principal consultants:
Dahlin Group Architects and Planners, land planning, entitlement, design guidelines, residential design
Nuvis, landscape
HMH, civil engineer

St. Vincent's
Client: Shapell Industries
Principal consultants:
Dahlin Group Architects and Planners, land planning, urban design, architecture
CSW/Stuber-Stroeh, civil engineers
SWA, landscape

DAVID OWEN TRYBA ARCHITECTS

Wellington E. Webb Municipal Office Building
Client: Civic Center Office Building, Inc., owner (Mile High Development); City and County of Denver, tenant
Principal consultants:
David Owen Tryba Architects and RNL Design, in joint venture, full architectural services, interior design
Martin/Martin, structural/civil engineer
Rous-Synsinskie Engineering, electrical engineer
Intermountain Electric, electrical engineer (design-build)
BCER Engineering, mechanical engineer
Southland Mechanical, mechanical engineer (design-build)
Hensel Phelps Construction Co., construction manager, general contractor

16th Street Center
Client: Carlyle 17th Street, LLC
Principal consultants:
David Owen Tryba Architects, full architectural services
Martin/Martin, structural engineer
Swanson Rink, Inc., electrical and mechanical engineer
The Weitz Company, Inc., general contractor

RTD Transit Facility
Client: City of Englewood (Englewood Environmental Foundation)
Principal consultants:
David Owen Tryba Architects, master plan, full architectural services for
 bridge, plaza, and civic center
Martin/Martin, structural engineer
Swanson Rink, Inc., electrical engineer
Trautman-Shrieve, mechanical engineer (design-build)
Saunders Construction, general contractor

DE STEFANO AND PARTNERS

Fountain for the Chicago Board of Trade
Client: Public Building Commission of Chicago
Principal consultants:
DeStefano and Partners, architectural design, construction documents
Rubinos & Mesia Engineers, Inc., structural engineer

North Halstead Streetscape
Client: City of Chicago Department of Transportation
Principal consultants:
DeStefano and Partners, planning and architectural design
McDonough & Associates, consulting engineer

Division Street Gateways
Client: City of Chicago Department of Transportation
Principal consultants:
DeStefano and Partners, architectural design, construction documents
McClier Corporation, associate architect
LeMessurier Consultants, structural engineer
Chicago Ornamental Iron, fabricator

Hammond Streetscape
Client: City of Hammond, Indiana
Principal consultants:
DeStefano and Partners, planning and architectural design
Rubinos & Mesia Engineers, Inc., structural engineer

Diversey Driving Range
Client: Chicago Park District
Principal consultants:
DeStefano and Partners, architectural design
Matrix Engineering Corporation, structural engineer
Building Systems Chicago, electrical engineer
Peter Lindsay Schaudt Landscape Architecture, Ltd., landscape architect

Hayes Park New Natatorium
Client: Public Building Commission of Chicago
Principal consultants:
DeStefano and Partners, architectural design
W.A.T.E.R., Inc., natatorium consultant
Rubinos & Mesia Engineers, Inc., structural engineer
Primera Engineers, Ltd., MEP engineer
Hayden Bulin Larson Design Group, Ltd., landscape

Fernwood Park Natatorium
Client: Chicago Park District
Principal consultants:
DeStefano and Partners, architectural design
Primera Engineers, Ltd., MEP engineer
W.A.T.E.R., Inc., natatorium consultant
Chris Stefanos & Associates, Inc., structural engineer

North Park Village Gymnastics Center
Client: City of Chicago, Department of General Services
Principal consultants:
DeStefano and Partners, architectural design
Rubinos & Mesia Engineers, Inc., structural engineer
Environmental Systems Design (ESD), MEP engineer
Cotter Consulting, Inc., project management

Korean International Exhibition Center
Client: The Samsung Consortium, comprising Samsung Corporation,
 Hyundai Corporation, and Daewoo Corporation
Principal consultants:
Junglim Consortium – comprising DeStefano and Partners, Junglim
 Architecture, Space Group, Kunwon Architecture, and Wonyang A&E –
 master plan, architectural and landscape design

The Residences at RiverBend
Client: BEJCO Development Corporation
Principal consultants:
DeStefano and Partners, architectural design
Halvorson Kaye Structural Engineers, structural engineer
WMA Consulting Engineers, MEP engineer
Daniel Weinbach & Partners, Ltd., landscape design

DOVER KOHL & PARTNERS

The Jupiter Waterfront Quarter
Client: Sheehan Realty, Inc.
Principal consultants:
Dover Kohl & Partners, urban design, architectural design
Chael, Cooper & Associates, architecture
Gentile, Hollaway, O'Mahoney & Associates, landscape architecture
James Dougherty, Pedro Pablo Godoy, & Marice Chael, illustrations

A New Neighborhood in Old Davidson
Client: Boone Communities, Inc.
Principal consultants:
Dover Kohl & Partners, public input process, master planning,
renderings,
 design guidelines
Turnbull Sigman Design, landscape, civil engineering
James Dougherty, Chris Ritter, renderings

Hammond's Ferry
Client: Civitas and Leyland Development
Principal consultants:
Dover Kohl & Partners, public input process, master planning, renderings
Daws & Floyd, civil engineers
James Dougherty, Andrew Giorgiadis, renderings

Downtown Kendall
Client: Chamber South and Miami-Dade County
Urban Advantage, marketing and imaging
Richard Hall, traffic engineering
Thomas Gustafson, transit greenways
James Dougherty, David Rodriguez, Debbie Ahmari, Steve Price,
 illustrations

South Miami Hometown Plan
(credits for two individual buildings below)
Client: Hometown, Inc.
Principal consultants:
Dover Kohl & Partners, public input process, master planning, new land
 development code, design and construction documents for several infill
 buildings (see below), renderings
Barton Ashman, traffic planners
Holland & Knight, code legal consultants

South Miami Hometown Plan – Amster Building
Client: Harvey Amster
Principal consultants:
Dover Kohl & Partners, town planning
Chael, Cooper & Associates, architects

South Miami Hometown Plan – Sunset Courtyard Building
Client: Gay Cinque
Principal consultants:
Dover Kohl & Partners, town planning
Chael, Cooper & Associates, architects
Eric Colville, structural engineer
Tom Armstrong, electrical engineer
Juan Lagomasino, mechanical engineer

DUANY PLATER-ZYBERK & COMPANY

Kemer Village
Client: Kemer Yapi Ve Turizm, A.S.
Principal consultant:
Anthony Philipson, Mark Butler, Mehmet Atakan, Cemal Mullu, Tahla
 Gencer, architects

Dos Rios
Client: Terelay Investment & Development Company
Principal consultant:
Palafox Associates

Putrajaya Diplomatic Enclave
Client: Peradanan Putrajaya
Principal consultant:
Teo Ah Khing & Associates

Wustrow
Client: ECW Entwicklungs-Compagnie Wustrow GmbH & Co. KG
Principal consultant:
Duane Phillips, Architektur und Stadtebau, planning

Heulebrug
Client: WVI (West-Vlaamse Intercommunale voor Economische Expansie,
Huisvestingbeleid en Technische Biijstand cvba)
Principal consultant:
Leon Krier, planning

Quartier am Tacheles
Client: Johannishof Projektentwicklung, GmbH & Co. KG
Principal consultants:
Duane Phillips, Architektur und Stadtebau, planning and coordination
Cenicacelaya & Salona, architects
Piotr Choynowski, Architect, architect
Hammond Beeby Rupert Ainge Architects, Inc., architects
Robert A.M. Stern Architects, architects
Gabriele Tagliaventi + Associati, architects
Tsao & McKown, architects

EARL SWENSSON ASSOCIATES, INC.

One Century Place
Client: Willis Corroon Group, changed in 1995 to Shorenstein Group
Principal consultants:
Earl Swensson Associates, Inc., architecture, interior design
Hardaway Construction Corporation of Tennessee, general contractor
Stanley D. Lindsey & Associates, Ltd., structural engineer
Phoenix Design Group, m/e/p engineer
C.M. Kling & Associates, lighting designer

BellSouth Tennessee Headquarters
Client: BellSouth Telecommunications, Inc.
Principal consultants:
Earl Swensson Associates, Inc., architecture, interior design
Carter/ONCOR International, development consultant
Stanley D. Lindsey & Associates, Ltd., structural engineer
I.C. Thomasson Associates, Inc., m/e/p engineer
Barge Waggoner Sumner & Cannon, civil engineer
Bell/Brasfield & Gorrie (joint venture of Ray Bell Construction Co., Inc., and Brasfield & Gorrie, Inc.), general contractor
JPJ Architects, high-rise consultant
Hawkins Partners and Hodgson & Douglas (joint venture), landscape architect
Metropolitan Historical Commission and Historic Nashville, historical consultants (unpaid)
AVDI, audio/video
Inman Associates, Inc., food service
C.M. Kling & Associates, lighting designer
Walker Parking Consultants, parking
Dickerson Group and Art Network Inc., art
Lin Swensson, sculptor (plaza and winter garden art)

The Commerce Center/Pinnacle National Bank
(clients and credits listed by parts of project)

The Commerce Bank
Client: The Matthews Company
Principal consultants:
Earl Swensson Associates, Inc., architect
Stanley D. Lindsey & Associates, Ltd., structural engineer
Barge Waggoner Sumner & Cannon, m/e/p engineer
R.C. Matthews, general contractor
Hawkins Partners, landscape architect

Pinnacle National Bank
Client: Pinnacle Financial Partners, Inc.
Principal consultants:
Earl Swensson Associates, Inc., inteior architect, interior designer
John Hughes/Waterscapes by Design waterscape design
The Arts Company, art

Smith Travel Research Headquarters
Client: Randy and Carolyn Smith
Principal consultants:
Earl Swensson Associates, Inc., architecture, interior design
TRC International, structural engineer
Volunteer Electric, electrical engineer
Lee Company, mechanical engineer
Barge Cauthen & Associates, Inc., civil engineer, landscape architect
The Hannah Company, LLC, general contractor

ERIC R. KUHNE & ASSOCIATES

Bluewater
Client: Lend Lease Europe
Principal consultants: Eric R. Kuhne, research, concept, master planning, architecture, landscape design, civic art, interiors, furniture design, graphics
Lend Lease Projects BCMT & Bovis, construction
Benoy Ltd., executive architects
BDG McColl Architects, architects: South Village
Brooker Flynn Architects, architects: West Village, John Lewis Partnership
RTKL UK Ltd., architects: Marks and Spencer
Waterman Group plc, civil and structural engineers
Ove Arup & Partners, mechanical and electrical engineers
Townshend Landscape Architects, landscape
Speirs and Major, lighting

JPRA Architects, interior design
The Design Solution, finishes
GMH Rock Townsend, cinemas
David J. Peek Associates, market research
Coverpoint Catering Consultants, catering
Crystal Fountains, water features
Wet Design, water features
Cyril Sweett & Partners, quantity surveyors
W.A. Fairhurst & Partners, highway engineers
WSP Consulting Engineers, consulting engineers
Battle McCarthy, consulting engineers
Henrion Ludlow & Schmidt, sign graphics
Sandy Brown Acoustics, acoustics
Jeremy Gardner, fire strategy
Stefan Barcikowski, model makers
Andrew Putler, photography
Chorley Handford Ltd., photography
Michael Chittenden Photography, photography

Darling Park
Client: Lend Lease Development
Principal consultants: Eric R. Kuhne, research, concept, master planning, architecture, landscape design, civic art, interiors, finishes, furniture design
Civil & Civic Pty. Ltd., construction
Lend Lease Design Group, executive architects, civil, structural, mechanical and electrical engineers
Belt Collins & Associates, landscape, water features
Site Image, landscape (phase II)
Royal Botanic Garden, landscape
Theo Kondos & Associates, lighting
Stan Sarris, catering consultant
Ove Arup & Partners, bridge engineers
Norman Disney & Young, consulting engineers, fire strategy
Minale Tattersfield, Bryce & Partners, sign graphics
Robert Fitzell Acoustics Pty. Ltd., acoustics
Arup Façade Engineering, façade consultants
Kone Elevators Pty Ltd., vertical transportation
Bob Brown, model makers
Michael Chittenden Photography, photography

Cockle Bay Wharf
Client: Lend Lease Development
Principal consultants: Eric R. Kuhne, research, concept, master planning, architecture, landscape design, civic art, interiors, finishes
Civil & Civic Pty. Ltd., construction
Lend Lease Design Group, executive architects, civil, structural, mechanical and electrical engineers
Belt Collins & Associates, landscape, water features
Theo Kondos & Associates, lighting
Norman Disney & Young, consulting engineers
Minale Tattersfield, Bryce & Partners, sign graphics
Michael Chittenden Photography, photography

Touchwood
Client: Lend Lease Europe
Principal consultants: Eric R. Kuhne, research, concept, master planning, architecture, landscape design, civic art, interiors
Bovis Lend Lease, construction
Brooker Flynn Architects, architects, John Lewis Partnership
Waterman Group plc, civil and structural engineers
WSP Consulting Engineers, mechanical and electrical engineers
Barry Chinn Associates, landscape, water features
Speirs and Major, lighting
Unick Architects, cinemas
Coverpoint Catering Consultants, catering
Gardner & Theobald, quantity surveyors
Kandor Modelmakers, model makers

Island Gardens
Client: Flagstone Properties
Principal consultants: Eric R. Kuhne, research, concept, master planning, architecture, landscape design, civic art
Spillis Candela DMJM, executive architects, civil and structural engineers
EDSA, landcape
Fairchild Tropical Gardens, landscape
Shopping Center Solutions, market research
Alkas Retail Solutions, market research
David Plummer Associates, highway engineers
Camper & Nicholsons, marina consultants

Mid Valley Gardens
Client: Mid Valley City
Principal consultants: Eric R. Kuhne, research, concept, master planning, architecture, landscape design, civic art, interiors
KYTA/SA Architects, executive architects
Battle McCarthy, consulting engineers, mechanical and electrical
Symonds, highway engineers

Van Deusen and Associates, vertical transportation
Kandor Modelmakers, model makers

GARCIA BRENNER STROMBERG

Abacoa Town Center
Client: DeGuardiola Development
Principal consultants: Garcia Brenner Stromberg, architectural and structural engineering
D'Agostino Izzo Quirk, design architects
Gentile, Holloway, O'Mahoney & Associates, Inc., landscape architecture
GD Klieger, Inc., structural engineer
Steven Feller & Associates, m/e/p engineering

Costa del Este
Client: Roseberry Investments
Principal consultants: Garcia Brenner Stromberg, architecture and landscape architecture
Victor Cano, structural engineer

Monterey Medical Center
Client: Monterey Medical Center LLC
Principal consultants: Garcia Brenner Stromberg, architecture, site design; structural, mechanical, electrical, and plumbing engineering; lighting, graphics
Lucido & Associates, landscape architect
OCI Associates, m/e/p engineering
Victor Gerly, structural engineer

GARY EDWARD HANDEL + ASSOCIATES

Millennium Place
Client: Millennium Partners (developer); MDA Associates (developer); The Ritz Carlton Company (hotel)
Principal consultants:
Gary Edward Handel + Associates Architects, design architect
CBT/Childs Bertman Tseckares Architects, executive architect
Bovis Lend Lease, Inc., construction manager
Culpepper, McAuliffe & Meaders, hotel architect
Cannon, sports club architect
Rockwell Group, theater design
DeSimone Consulting Engineers, structural engineers
Cosentini Associates, mep engineering
Haley & Aldrich, civil/geotech engineer
Shen Milsom & Wilke, acoustical engineer
Ava Shypula Consulting, curtain wall consultant
Kugler Tillotson Associates, lighting consultant
Landworks Studio, landscape design

High Line
Client: Friends of the High Line
Principal consultants:
Gary Edward Handel + Associates Architects and Beyer Blinder Belle, feasibility, impact study
Department of City Planning, consultant
Rails-to-Trails Conservancy, consultant
Friedman & Gotbaum, consultant

Four Seasons Hotel + Tower
Client: Millennium Partners (developer)
Principal consultants:
Gary Edward Handel + Associates Architects, design architect
Del Campu & Maru, associate architects
Bovis Lend Lease, Inc., construction manager
Frank Nicholson Inc., hotel architect
Gensler, sports club architect
The Office of Cheryl Barton, landscape architect
Hood Design, landscape architect
DeSimone Consulting Engineers, structural engineers
SJ Engineers, mechanical engineer
O'Mahony & Myer, electrical engineer
MDL & Associates, civil engineer
Treadwell & Rollo, geotech engineer
Shen Milsom & Wilke, acoustical engineer
Ava Shypula Consulting, curtain wall consultant
ARS & Associates, code

Ritz Carlton
Client: Millennium Partners (developer); EastBanc (developer)
Principal consultants:
Gary Edward Handel + Associates Architects, full architectural design services, interior design for hotel and residential building
Shalom Baranes Associates, associate architect
DeSimone Consulting Engineers, structural engineers
Hargreaves Associates, landscape architects
Wiles Mensch Corp., civil engineer
Engineering Design Group, mechanical engineer
Shen Milsom & Wilke, acoustical engineer
Lerch Bates North America, Inc., vertical transportation
Bovis Lend Lease, Inc., construction manager

HNTB Corporation

Invesco Field at Mile High Stadium
Client: Metropolitan Football Stadium District
Principal consultants:
HNTB Corporation, lead architect, architectural design
Fentress Bradburn Architects, Ltd., associate architects
Bertram A. Bruton and Associates, associate architects
Walter P. Moore & Associates, structural engineering
The Sheflin Group, structural engineering
Kumar & Associates, Inc., geotechnical engineering
J.F. Soto and Associates, civil engineering
M.E. Engineers, Inc., m/e/p
Civitas, landscape
Compositions, local interior design support
Monigle Associates, Inc., stadium graphics
William Caruso & Associates, food servce consultant
The Lund Partnership, surveying
Lockwood Greene Technologies, security system design
Lerch Bates North America, Inc., vertical transportation
Cermak Peterka Peterson, Inc., wind consultants
Millennium Sports Technologies, turf/irrigation systems
Peton, Marsh, Kinsella, audiovisual/sound systems
ERO Resources, endangered species analysis
Martin & Wood Water Engineering, hydrologists: building
Gruen Associates, architectural peer review
McLaughlin Water Engineering, hydrologists: bridges
FP & C, code consultants
Keesen Water Management, irrigation
Evan Terry Associates, disabled access consultant
Clanton Engineering, site lighting & electrical design
Trio Display, Inc., retail planning & design
Washington Infrastructure Group, ITS system
Irrigation Design & Consulting, irrigation design
Smith Environmental, Inc., environmental impact analysis
Wiss, Janney, Elstner Associates, Inc., specialty engineering
Turner Construction Company: general contractor
Alvarado Construction, general contractor partner
Empire Construction, general contractor partner

Fifth Third Field
Client: Lucas County, Ohio
Principal consultant:
HNTB Corporation, architectural and engineering services

Downtown Joliet
Client: Joliet/Will County Center for Economic Development
Principal consultant:
HNTB Corporation, master planning

Manchester Regional Centre
Client: English Tourist Board Manchester-Salford and Trafford Development Group
Principal consultant:
HNTB Corporation: urban design and site planning

Belfast City Centre
Client: Department of the Environment, Northern Ireland
Principal consultants:
HNTB Corporation: design and planning services

HELLER • MANUS ARCHITECTS

San Francisco City Hall
Client: City and County of San Francisco, Bureau of Architecture
Principal consultants:
Heller • Manus Architects, architectural design
General contractor: Huber Hunt & Nichols
Castelero Design and Project Management, architectural consultant
Levy Design Partners, architectural consultant
Rachael Hagner Architect, architectural consultant
Marie Fisher Interior Design, architectural consultant
Peters & Associates, architectural consultant
Cervantes Design Associates, architectural consultant
Gayner Engineers, mechanical/plumbing-infrastructure engineers
SJ Engineers, mechanical/plumbing engineers – tenant spaces
FW Associates, electrical engineers
Forell/Elsesser, structural engineers
Luster Construction Management, cost estimating
Melina Renee Specifications Consultant, specifications
Keilani Tom Design Associates, graphics (original consultant)
Kate Keating & Associates, graphics (signage)
Hesselberg Keesee & Associates, Inc., elevator consultant
Elevator Interior & Design, elevator design
Patricia O'Brien Landscape Architecture, landscape architecture
Carey & Co., historical consultant
Turner Construction, construction management
Horton-Lees, lighting design
Risk International, security risk analysis

9-1-1 Emergency Communication Center
Client: City & County of San Francisco, Bureau of Architecture
Principal consultants:
Heller • Manus Architects, architectural design
SJ Amoroso, general contractor
DPW Bureau of Engineering, engineering consultant
Finger & Moy Architects, interior architect
Levy Design Partners, associated architect
Arcost/CPM Group, cost estimating
Forrell Elsesser Engineers, Inc., base isolation
Structural Design Engineers, structure/frame
SJ Engineers, mechanical/fire protection
Raymond Brooks Engineering, plumbing engineer

275 Sacramento Street
Client: Patson Development Co.
Principal consultants:
Heller • Manus Architects, site study options, architectural design
 through construction
Plant Construction, pre-construction services, general contractor
Dames & Moore, original civil engineers
Acres Inc., current civil engineers
KCA Engineers Inc., civil engineers
SOHA Engineers, sheeting and shoring
ESA, EIR consultant
Rider Hunt Levitt & Carey, cost estimator
Ralph Jensen Associates, code consultants
Huntsman Architectural Group, space planning consultant
Simpson Gumpertz Heger Inc., waterproofing
HKA, elevator consultant
TopFlight Specs, specifications
Patricia O'Brien Landscape Architects, landscape architects
Robert Frank, renderer

55 Second Street
Client: Myers Development
Principal consultants:
Heller • Manus Architects, feasibility, architectural design, planning
 approval, materials selection, design development
HKS Architects Inc., production architects
Horton-Lees, lighting design
Charles Salter, acoustical consultant
KCA Engineers, civil engineer
Hesselberg, Keesee & Associates, elevator consultants
Simpson Gumpertz Heger Inc., waterproofing
On Line Electric, security
Patricia O'Brien Landscape Architects, landscape architects

Hayward City Hall
Client: City of Hayward, Bureau of Architecture
Principal consultants:
Heller • Manus Architects, architectural design
DPR Construction Inc., contractor
Seidel/Holzman, housing architect
Guzzardo and Associates, Inc., landscape architects
KPFF Consulting Engineers, structural consultant
EQE International, structural peer review consultant
RK Associates, structural peer review consultant

EmeryStation
Client: Wareham Development Group
Principal consultants:
Heller • Manus Architects, architectural design (schematic design to
 construction administration)
Webcor Builders, general contractor
HKA, structural engineers
Kier & Wright, civil engineers (EmeryStation North), survey information
 (EmeryStation Plaza, Terraces at EmeryStation)
Ajmani & Pamidi, Inc., m/e/p engineers (EmeryStation North, Terraces at
 EmeryStation)
Design Engineering Services, mechanical plumbing, fire protection
 (EmeryStation Plaza)
Toft, Wolff Farrow Associates, electrical engineer (EmeryStation Plaza)
Fitschen & Associates, lobby consultant (EmeryStation North)
Gieklhorn Lazzarotto Partners, space planning consultant (Terraces at
 EmeryStation)
Carducci & Associates, Inc., landscape architect
Treadwell & Rollo, soils consultant
TopFlight Specs, specifications (EmeryStation North, Terraces at
 EmeryStation)
Marx/Okubo, construction consultant (EmeryStation North)
Simpson Gumpertz Heger Inc., waterproofing (EmeryStation North)

ThunderSpring
Client: ThunderSpring-Wareham, LLC
Principal consultants:
Heller • Manus Architects, architectural design
Morgan and Partners, graphics consultants

Richard Berridge Landscape Architect, Inc., landscape architect
TopFlight Specs, specifications
Simpson Gumpertz Heger Inc., waterproofing
IMA, snow country consultant
Calthorpe Associates, planners
Paden Prichard/Design Inc., design associate

300 Spear Street
Client: Union Property Capital, Inc.; Collier International
Principal consultants:
Heller • Manus Architects, architectural design (schematic design, design
 development)
Skilling Ward Magnusson Barkshire, structural engineer
Hesselberg Keesee & Associates, elevator consultant
C & B Consulting Engineers, mechanical engineer

HUGHES GOOD O'LEARY & RYAN

Coolidge Park
Client: RiverCity Company
Principal consultants:
Hughes Good O'Leary & Ryan, site planning, landscape architecture,
 lighting
Franklin Associates Architects, project lead consultant
T.U. Parks Construction Co., general contractor
Georgia Fountains, Inc., water feature consultant
Merritt Brothers Landscape, landscape contractor
SC Lighting Design, security and night visibility
Cherry Lion Studios, artist, animals with exterior water feature

Piazza at Paces
Client: Ben Carter Properties
Principal consultant:
Hughes Good O'Leary & Ryan, landscape architectural planning

Carillon
Client: Hesta Properties
Principal consultants:
Hughes Good O'Leary & Ryan, landscape architecture and urban design
Thompson, Ventulett, Stainback & Associates, building architects

Columbus Streetscape
Client: City of Columbus
Principal consultants:
Hughes Good O'Leary & Ryan, site analysis, site design, civic leadership,
 construction documents and observation/management
Earthscapes, Inc., general contractor: hardscape and landscape
Columbus Water Works, water feature
Hans Muir, artist, water feature

Liberty Landing
Client: Liberty Landing
Principal consultants:
Hughes Good O'Leary & Ryan, Inc., and Burt Hill Kosar Rittleman
 Associates, master plan team, urban design

JOSEPH WONG DESIGN ASSOCIATES

Xiamen International Bank Tower & SK Development Company
Client: Xiamen International Bank
Principal consultants:
Joseph Wong Design Associates in association with Kai Chan Architects +
 Planners, full architectural services
Chris Huang of SK Development Company, developer
Tino Kwan Associates, lighting consultant
Beijing Design Institute, Xiamen Branch, local architectural &
 engineering consultant

Industrial and Commercial Bank of China, Bund Branch
Client: Industrial and Commercial Bank of China
Principal consultants:
Joseph Wong Design Associates, construction documents, design
 coordination, construction administration
Shanghai Design Institute, consultant
Studios Architecture, consultant
Team 7 International, consultant
Shanghai Architectural Decoration Group, main contractor
Shanghai Design Institute, m/e, structural, and civil engineer
Shanghai No. 3 Construction Co, Ltd., hvac/mvac & electrical
Wen Hang & Phillips, light fixture & fittings

Industrial and Commercial Bank of China – Data Center
Client: Industrial and Commercial Bank of China
Principal consultants:
Joseph Wong Design Associates, architectural design, interior design,
 portion of landscape architecture
Tong Ji University Design Institute, structure and mep
Famous Garden, landscape architecture
Syska Hennessy Group, m/e consultant

Shanghai Telephone Building
Client: Shanghai Telephone Company
Principal consultants:
Joseph Wong Design Associates, architectural design
Shanghai Design Institute, structural and mep engineer

Shanghai International Tennis Center and Regal Hotel
Client: Shanghai East Asia Development Group
Principal consultants:
Joseph Wong Design Associates, complete architectural services
Shanghai Institute of Architectural Design & Research, local
 architectural/engineering services
Ye Zheng, interior design consultant
The Nakamaki Group, landscape architect

Marriott Del Mar
Client: JMI Realty
Principal consultants:
Joseph Wong Design Associates, complete architectural services
Studio L, interior design
Wallace Roberts Todd Inc., landscape design
Kaplan Partners, lighting design
Nabih Youssef & Associates, structural engineer
Southland Industries, mechanical and plumbing engineer
Ila Zammit Engineering Group, electrical engineer
Swinerton & Walberg, general contractor
Douglas Eilar & Associates, acoustical consultant

JPRA ARCHITECTS

The Mall at Robinson
Client: Forest City Commercial Group
Principal consultants:
JPRA Architects, site feasibility studies, architectural design, documents,
 field administration, graphic design
Hillman DiBernado & Associates, Inc., lighting designer
The Law Company, Inc., general contractor

The Shops at Willow Bend
Client: The Taubman Company, Inc.
Principal consultants:
JPRA Architects, complete master planning, design, construction
 documents and field administration for architectural, structural, m/e/p,
 lighting design, graphics and signage, landscaping, and interior
 furnishings for mall, food court, and project facilities
Sordoni Skanska Construction, general contractor

The Mall at Millenia
Client: The Forbes Company/Taubman Centers, Inc.
Principal consultants:
JPRA Architects, land planning, building planning, architecture, graphics,
 and all documentation; bid, construction administration, interior
 design, lighting design, graphics and signage, selection of purchasing
 of interior furnishings
Ehlert/Bryan, Inc., structural engineer
Tilden Lobnitz Cooper, electrical
Focus Lighting, lighting

LOONEY RICKS KISS

Memphis Ballpark District
Principal consultant:
Looney Ricks Kiss, master planning, urban design
(clients and additional credits listed by project)

AutoZone Park
Client: Memphis Redbirds
Principal consultants:
Looney Ricks Kiss in association with HOK Sport + Venue + Event,
 architects
Looney Ricks Kiss, interior designer
Stanley D. Lindsey Associates, structural engineer
Office of Griffith C. Burr, mechanical engineer
Metz//DePouw, electrical engineer
PDR Engineers, Inc., and Jackson Person & Associates, civil/landscape
 architect
SWA Group, landscape architect
Beers/Inman Construction, general contractor
Fisher & Associates, food service
Wrightson, Johnson, Haddon & Williams, Inc., a/v
Douglas Gallagher, graphics
Oxford Lighting Consultants, lighting designer
Don Merkt, artist, plaza paving and baseball hat gazebo
Jim Green, artist, sounds art for entry plaza
Gary Sweeney, artist, baseball figures in plaza and whirlygigs

Toyota Center
Client: Parkway Properties (developer), Moore Building Associates,
owner
Principal consultants:
Looney Ricks Kiss, architects, interior designer
Stanley D. Lindsey Associates, structural engineer
Office of Griffith C. Burr, mechanical engineer
Metz//DePouw, electrical engineer
Beers/Inman Construction, general contractor
Fisher & Associates, food service
Oxford Lighting Consultants, lighting designer
Wies, Janney, Elstner Associates, Inc., building conditions consultant
Walker Parking Consultants, parking consultant

Echelon at the Ballpark
Client: Echelon Residential LLC
Principal consultants:
Looney Ricks Kiss, architect, interior designer
Southern Civil Engineers, civil engineer
Cates Engineering, Ltd., structural engineer
KTD Consulting Engineers, m/e/p engineer
U.S. Fire, fire protection
Warren McCormick & Associates, landscape architect
CF Jordan Residential, general contractor
Flintco, Inc., general contractor for garage
Natural Graphics, graphics

YMCA Lofts
Client: Echelon Residential LLC
Principal consultants:
Looney Ricks Kiss, architect, interior designer
Southern Civil Engineers, civil engineer
Stanley D. Lindsey Associates, structural engineer
U.S. Fire, fire protection
CF Jordan Residential, general contractor

Downtown Elementary School
Client: Memphis City Schools
Principal consultants:
Looney Ricks Kiss, architect, interior designer
Jameson-Gibson Construction Co., Inc., general contractor
Toles & Associates, civil engineer
Tahiliani & Associates, structural engineer
V.T. Gala & Associates, mechanical and plumbing engineer
Metz/DePouw, electrical engineer
Ritchie Smith & Associates, landscape architect

The National Pastime Museum
Client: The National Pastime
Principal consultants:
Looney Ricks Kiss, architect
ESI Design, museum design

Harbor Town
Client: Henry Turley, Jr./Island Properties Associates
Principal consultants:
Looney Ricks Kiss, modified original land plan, subsequent planning
 phases, design guidelines, administered design review of projects,
 served as town architect, development/marketing consulting, designed
 majority of buildings/projects
RTKL, original land plan
J. Carson Looney, FAIA, of Looney Ricks Kiss, town architect
Reaves & Sweeney, landscape architect

Cherry Hill Village
Client: Biltmore Properties Corporation
Principal consultants:
Looney Ricks Kiss, research, planning, architectural guidelines, design
 review, architectural design
Canton Township, MI, public agency
Warner, Cantrell & Padmos, Inc., engineers
McNamee, Porter & Seeley, Inc., engineers
Gibbs Planning Group, landscape architect
Dominick Tringali Associates, additional architect

Main Street, Baldwin Park Village
Client: Baldwin Park Development Company
Principal consultants:
Looney Ricks Kiss, town architect and architect for mixed-use Main
 Street and single-family residential
Avid Engineering, Inc., civil engineer (owner's consultant)
Jenkins and Charland, structural
Forney Engineering, Inc., m/e/p
TLC, fire protection (owner's consultant)
Glatting Jackson, landscape architect

LUCIEN LAGRANGE ARCHITECTS

Park Tower
Client: Hyatt Development Corporation
Principal consultants:
Lucien Lagrange Architects, architecture, construction administration
HKS, Inc., associate architects
Chris P. Stefanos Associates, structural engineer
Environmental Systems Design, Inc., mechanical engineer, electrical
 engineer
James McHugh Construction Company, contractor

175 West Jackson
Client: 175 West Jackson, LLC (owner);
Intell Management & Investment Co. (developer)
Principal consultants:
Lucien Lagrange Architects, architecture, construction administration
Halvorsen and Kaye Structural Engineers, structural engineer
Environmental Systems Design, Inc., m/e/p engineer
Walsh Construction Company, general contractor
Charter Sills & Associates, lighting design

Erie on the Park
Client: Smithfield Properties
Principal consultants:
Lucien Lagrange Architects, architecture
Thornton Tomasetti Engineers, structural engineer
Advance Mechanical Systems, Inc., mechanical engineer
Innovative Building Concepts, electrical engineer
Wooton Construction Company, general contractor

65 East Goethe
Client: The Fordham Company
Principal consultants:
Lucien Lagrange Architects, architecture, construction administration
Alfred Benesch & Company, civil engineer
Daniel Weinbach & Partners, landscape architect
Halvorsen and Kaye Structural Engineers, structural engineer
WMA Consulting Engineers, Ltd., m/e/p engineer
Innovative Building Concepts, electrical engineer

MBH ARCHITECTS

North Beach Malt House
Client: Chestnut Street Partners, c/o Emerald Fund; (Wharf & Associates,
owner)
Principal consultants:
MBH Architects, feasibility studies, architecture, interior design
Nibbi Brothers, contractor
Structural Design Engineers, structural engineer
Ajmani & Pamidi Inc., m/e/p design/build engineer
Cliff Lowe Associates, landscape
Luk & Associates, civil engineer
Charles M. Salter Associates, acoustics
Rolf Jensen & Associates, code consultant
John Raeber, specifications
Jaidin Consulting Group, permit consulting
SGH Simpson Gumpertz & Heger Inc., waterproofing consultant
SPEC Systems: waterproofing consultant

San Francisco Fire Credit Union
Client: San Francisco Fire Credit Union
Principal consultants:
MBH Architects, site feasibility studies, interior architecture and design
MBH Architects in collaboration with Gary Gee, Architects: exterior
 architecture
Dinwiddie Construction Company, general contractor
Nishkian & Associates, structural engineer
Taylor Engineering, mechanical engineer
KCA Engineers, Inc., civil engineer
The Engineering Enterprise, electrical engineer
Charles M. Salter Associates, acoustical engineer
Keller Mitchell & Co., landscape

Embarcadero Lofts
Client: Embarcadero Pacific
Principal consultants:
MBH Architects, feasibility studies, architectural and interior design
Oliver & Company, contractor
Smith & Smith, landscape engineers
Thorburn Associates, acoustics
Steven Tipping & Associates, structural engineers
Ihsan Ali & Associates, mechanical engineers
POLA (Pete O. Lapid Associates), electrical engineers
Luk Milani & Associates, civil engineers
Subsurface Consultants, Inc., geotechnical engineers
Engineering Construction Services, construction management

Harbor Lofts
Client: The Emerald Fund/Lalanne Volckmann
Principal consultants:
MBH Architects, architectural and interior design, seismic upgrading
Webcor Builders, Inc., contractor
Treadwell & Rollo, soils
Martin M. Ron & Associates, survey
Nishkian & Associates, structural engineers
Ihsan Ali & Associates, mechanical engineers
POLA (Pete O. Lapid Associates), electrical engineers
Smith & Smith, landscape engineers
Charles M. Salter Associates, acoustics
Luk Milani & Associates, civil engineers

MOORE IACOFANO GOLTSMAN, INC.

Chase Palm Park
Client: City of Santa Barbara
Principal consultants:
Moore Iacofano Goltsman, Inc., design for play area from concept
 through construction review
Scott Peterson, artist (whales, lighthouse, wave walls)
Susan Jordan, artist (sound wall mural)

Ibach Park
Client: City of Tualatin Parks and Recreation Department
Principal consultants:
Moore Iacofano Goltsman, Inc., public involvement, concept design,
 construction documents, construction review
Tim Richards, architect
Kurahasi Associates, engineers
Tom Aire-Donch, artist (mastodon rib cage, redwood boat)

Stafford Park Renovation
Client: Redwood City Parks, Recreation, Community Services
Principal consultants:
Moore Iacofano Goltsman, Inc., site inventory, use analysis, community
 outreach and public workshops, master plan, concept plan, landscape
 design, construction documents

Cisco Systems Childcare Center
Client: Cisco System, Inc.
Principal consultants:
Moore Iacofano Goltsman, Inc., concept plan, landscape design,
 construction documents, construction review
Tom Aire-Donch, artist (daisy water play faucet)

Spokane Riverfront Park Master Plan
Client: City of Spokane, Parks and Recreation Department
Principal consultants:
Moore Iacofano Goltsman, Inc., master plan, development plan, design
 guidelines
David Evans & Associates, infrastructure analysis
Fehr & Peers Associates, transportation planning
Integrus Architecture, design
Jim Kolva Associates, environmental and regulatory analysis
Keyser Marston Associates, economic analysis
RAMM Associates, landscape

University of California, Davis
Client: University of California, Davis
Principal consultants:
Moore Iacofano Goltsman, Inc., master planning, design guidelines, site
 selection
William McDonough + Partners, eco-effective design strategies
Fehr & Peers Associates, transportation circulation studies
Ove Arup, site environmental engineering

OTAK INC.

King Street Station Redevelopment
Client: Washington State Department of Transportation
Principal consultants:
Otak Inc. in association with Hardy Holzman Pfeiffer Associates,
 architecture, historical research, urban design, landscape architecture,
 project management
Swenson Say Faget, structural engineers
Interface Engineering, Inc., electrical engineers
Dames and Moore, Inc., geotechnical consultants
Sound Transit, signage and graphics
J. Miller & Associates, lighting design
Ned Kahn, artist, commuter rail station

Obermeyer Place
Client: Klaus Obermeyer
Principal consultants:
Otak Inc., land use planning, including pubic involvement, urban design,
 landscape architecture
Cottle Graybeal Yaw Architects, overall design, architecture
Szymanski/Ray, real estate development and financing
R.A. Nelson, contractor

Portland Streetcar
Client: Portland Streetcar Incorporated for the City of Portland
Principal consultants:
Otak Inc. civil engineering, survey, overall engineering coordination
Shields Obletz and Johnson, project management
LTK Engineering, electrification, signals, vehicle selection, engineering, and inspection
BRW, civil engineering, trackwork design
Zimmer Gunsul Frasca Partnership, architectural and station design
David Evans and Associates, field surveying
VLMK Engineering, Otak Inc., BRW, and LTK Engineering, maintenance facility design
Tacy and Witbeck Inc., general contractor
Inekon-Skoda, streetcar manufacturer

Center Commons
Client: Lennar Affordable Communities; American Pacific Properties, Inc.
Principal consultants:
Otak Inc./Vallaster & Corl, architects
Otak Inc., engineers
Otak Landscape Architects, landscape architect
R&H Construction Company, general contractor

The Yards at Union Station
Client: GSL Properties, Inc.
Principal consultants:
Otak Inc., approvals process, architecture, civil engineering, landscape architecture
Walsh Construction Company, contractor

OWP/P

The Shops at North Bridge
Client: The John Buck Company
Principal consultant:
OWP/P Belluschi, architecture, interiors
Kellermeyer Godfryt Hart, exterior restoration consultant
Thornton-Tomasetti Engineers, consulting engineers, structural
Environmental Systems Design, Inc., consulting engineer (m/e/p)
Bowman, Barret & Associates, Inc., general contractor

Tabor Center Renovation
Client: Urban Retail Properties
Principal consultant:
OWP/P Belluschi, architecture, interiors
KL&A of California, structural engineer
ABS Consultants, m/e/p, fp engineer
Heitmann & Associates, window wall consultant
Randy Burkett Lighting Design, lighting consultant
John J. Urbikas & Associates, elevator consultant
Ambrosini Design, graphics/signage
Rolf Jensen & Associates, code consultant
Valerian Landscape Architects, landscaping

Aspen Grove
Client: Poag & McEwen Lifestyle Centers, Inc.
Principal consultant:
OWP/P Belluschi, architecture, planning
Eskenazi, Farrell & Fodor, structural engineer
OWP/P Engineers, m/e/p, fp engineer, lighting consultant
Greg Youngstrom Design, Inc., graphics/signage
Daniel Weinbach & Partners, landscape architect
David Evans Associates, civil engineer

550 West Jackson Boulevard
Client: Mark Goodman & Associates, Inc.
Principal consultant:
OWP/P Belluschi, architecture, interiors
Shuler & Shook, lighting consultants
Thornton Tomasetti Engineers, structural engineer
Cosentini, m/e/p engineer

909 Davis Street
Client: Mesirow Stein Real Estate
Principal consultant:
OWP/P, architecture, interiors/public areas, engineering, planning
ESD, m/e/p
Power Construction, contractor

PERKOWITZ + RUTH ARCHITECTS

Long Beach Towne Center
Client: Vestar Development
Principal consultant:
Perkowitz + Ruth Architects, conceptual design, design development, construction documentation, construction administration
PSI (Professional Services International), structural engineers
ANF & Associates, structural engineers
Huitt-Zollars, civil engineer

Lino Palmieri & Associates, electrical engineer
Westland Heating and AC, hvac
Mechanical Building Systems, plumbing
Eriksson Peters Thoms, landscape architect
Western laboratories, soils engineer

Buena Park Downtown
Client: The Festival Companies, Pritzker Realty Group, Krikorian Premiere Theatres
Principal consultant:
Perkowitz + Ruth Architects, conceptual design, design development, construction documentation, construction administration
Tildin Engineering, structural
Davar & Associates, mechanical plumbing
Lino Palmieri & Associates, electrical
GLP Karjalla Associates, Inc., electrical (theatre only)
Lighting Design Alliance, lighting design
EDAW, landscape design architect
John Weineke & Associates, landscape production architect
Psomas, civil
Mercer Construction, general contractor

Gresham Station
Client: Center Oak Properties
Principal consultant:
Perkowitz + Ruth Architects, design concept, design guidelines, construction documentation, construction administration
W&H Pacific, civil engineer and landscape
Geodesign, Inc., site/soils engineer
Torabian and Associates, hvac
VLMK Consulting Engineers, structural engineer
Bayley Construction, general contractor

Pacific's The Grove Theatres
Client: Caruso Affiliated Holdings
Principal consultant:
Perkowitz + Ruth Architects, design concept and design development (in collaboration with client), construction documentation, construction administration
Tildin Engineering, structural
GLP Karjalla Associates, Inc., electrical
Davar & Associates, mechanical plumbing
Kleinfelder, Inc., soils engineer
Whiting-Turner Contracting Company, contractor

RETZSCH LANAO CAYCEDO ARCHITECTS

First Union Plaza
Client: Songy Partners, Ltd.
Principal consultants:
Retzsch Lanao Caycedo Architects, architect of record, design development, construction documents, construction administration
Philip Johnson and Alan Ritchie, design architect, schematic design
Martinez Kreh & Associates, Inc., structural engineer
Kamm Consulting, m/e/p engineer
Caulfield & Wheeler, Inc., civil engineer
A. Grant Thornbrough & Associates, landscape architect
Bluewater Builders, Inc., general contractor

IBM at Beacon Square
Client: St. Joe Commercial (owner); Codina Development Corp. (developer)
Principal consultants:
Retzsch Lanao Caycedo Architects, site studies, architectural design
Sun-Tech Engineering, Inc., civil engineering
Donnell Duquesne & Albasia structural engineer
R.A. Kamm & Associates, Inc., m/e/p engineer
A. Grant Thornbrough & Associates, landscape architect

The Ellington
Client: Victoria Place, LLC
Principal consultants:
Retzsch Lanao Caycedo Architects, feasibility, architectural design, construction documents, construction administration
Flynn Engineering Services, P.A., civil engineer
Johnson Structural Group, structural engineer
Puga and Associates, m/e/p engineer
Landscape Architects Collaborative, landscape

Hillsboro Commons
Client: Zenith Realty Investments
Principal consultants:
Retzsch Lanao Caycedo Architects, feasibility, architectural design, construction documents, construction administration
Johnson Structural Group, structural engineer
Thompson Engineering Consultants, m/e/p engineer
Beasley & Peck Landscape Architects, landscape

ROMA DESIGN GROUP

Dr. Martin Luther King, Jr., National Memorial
Client: Washington DC Dr. Martin Luther King, Jr., National Memorial Foundation, Inc.
Principal consultants:
ROMA Design Group, memorial design, winner of international design competition
Dr. Clayborne Carson, content advisor
Christopher Grubbs, illustrator

Suisun City Master Plan and Open Space
Client: City of Suisun City
Principal consultants:
ROMA Design Group, master planning and urban design, including design of downtown plaza and waterfront promenades
Moffat & Nichol, civil and coastal engineering

Downtown Santa Monica
Client: City of Santa Monica
Principal consultants:
ROMA Design Group, urban design and planning of downtown and Civic Center area, design of Third Street Promenade

North Park
Client: Irvine Apartment Communities
Principal consultants:
ROMA Design Group, master plan architect, park and streetscape design
Carlson, Barbee & Gibson, civil engineers
Backen Arrigoni & Ross, building architects
Fisher-Friedman Associates, building architects
McLarand, Vasquez, Emsiek & Partners, building architects

RTKL

North Bund District Master Plan
Client: Shanghai North Bund Development Group/Shanghai Hongkou Urban Planning Bureau
Principal consultant:
RTKL: master planning

Salamanca Train Station
Client: Grupo Riofisa
Principal consultants:
Antonio Fernandez Alba, architect
RTKL, designer
Theo Kondos, lighting design

Mockingbird Station
Client: Ken Hughes and Simpson Housing Group
Principal consultants:
RTKL, master planning and architectural design
Selzer Associates, architect of record
Veselka Mycoskie Associates, Inc., landscape
Lighting Design Alliance, lighting
Taub Associates, m/e/p
Turner Engineering, Inc., structural and m/e/p
Stenstrom Schneider, structural and m/e/p
Brockette Davis Drake Inc., civil engineer
CD Henderson Inc., contractor

835 Market Street
Client: Forest City Enterprises (developer) in partnership with Westfield Corporation (leasing and management of retail center)
Principal consultants:
RTKL, strategic planning, architecture, interior architecture, environmental graphics, new media
Kohn Pedersen Fox Associates, design architect for Bloomingdale's
KA Inc., Architecture, executive architect
Carey & Company, Inc., preservation architect
Flack & Kurtz Consulting Engineers, LLP, m/e/p
Nabih Youssef & Associates, structural engineer

Veso Mare
Client: REDS S.A.
Principal consultants:
RTKL, design architect, environmental graphic design
Archicon Ltd., production architect, landscape architect
Lightmatters, lighting design
Elliniki Technodomiki S.A., general contractor

SASAKI ASSOCIATES

Central Indianapolis Riverfront – Upper Canal
Client: City of Indianapolis Division of Planning in participation with the U.S. Army Corps of Engineers
Principal consultants:
Sasaki Associates, urban design, planning, landscape architecture, construction administration
CSO Architects and Engineers, mechanical and electrical engineers
FRP, structural and cost estimates
Wilhelm, contractor
The Design Consortium, landscape architecture
Ann Beha Associates, historic preservation
ATEC Associates, Inc., hydrology/wetlands and geotechnical engineers
Dann/Pecar/Newman, attorneys
Pflum, Klausmeier & Gehrum, transportation
RUST Environment & Infrastructure, environmental
Wallace Roberts & Todd, construction documents
RATIO Architects, landscape architecture and irrigation
MSE Engineering, survey
Paul I. Cripe, construction phase services
RQAW Engineering, construction phase services
Fink Roberts & Petrie, Inc., civil engineers

Beijing Olympic Green
Client: Beijing Municipal Planning Commission
Principal consultant:
Sasaki Associates, urban design, planning, landscape architecture, transportation and traffic planning, utility planning

Jian Guo Dong Lu Project
Client: COB Development (Shanghai) Company, Ltd.
Principal consultant:
Sasaki Associates, urban planning, planning, landscape architecture

New London Waterfront Park
Client: City of New London, Connecticut
Principal consultant:
Sasaki Associates, urban planning, master planning, landscape architecture, civil engineering, architecture
The Maguire Group, structural and electrical engineering

Schuylkill Gateway
Client: Legg Mason Real Estate Services, University of Pennsylvania, PIDC, Center City District
Principal consultants:
Sasaki Associates, urban planning, planning, landscape architecture
Legg Mason Real Estate Services, real estate economics
Urban Engineers, civil and transportation engineering
Chance Management Advisors, parking study

SWA GROUP

World Wide Center Plaza
Client: ZCW Associates
Principal consultant:
SWA Group, full design and landscape architectural services for mid-block plaza
Skidmore Owings & Merrill, architect

International Center
Client: Harwood International
Principal consultant:
SWA Group, full landscape architectural services, coordinating services of civil, structural, and mechanical engineers; for phases II and III, site design for on-structure gardens, collaboration with structural engineer on tree planting locations.
Gromatzky Dupree and Associates, architect of record
DMJM/Keating, architect of design phase III and IV
Brockette-Davis-Drake Inc., civil engineers

McCormick Place
Client: Chicago Metropolitan Pier and Expansion Authority; Stein Company (owner)
Principal consultant:
SWA Group, full landscape design services
A. Epstein International, engineers, developer
Thompson, Ventulett, Stainback & Associates, convention center/galleria architects
Ellerbe Becket, stadium architects

Williams Square
Client: Southland Investment Company
Principal consultant:
SWA Group, site planning, landscape services, and sculpture siting for office plaza
Skidmore Owings & Merrill, LLP, architects
Robert Glen, sculptor

TORTI GALLAS AND PARTNERS

The Ellington
Client: Donatelli & Klein
Principal consultants:
Torti Gallas and Partners, architectural design, feasibility analysis, HPRB
 presentation, zoning, construction administration
Tadjer Cohen Edelson Associates, structural engineer
Schwartz Engineering, mechanical/electrical engineer
Bowman Consulting Group, civil engineer
Schnabel Engineering Associates, geotechnical engineer
Design Works, Interiors, interior design
Land Design, Inc., landscape architect

Columbia Heights Revitalization
Client: Donatelli & Klein/Gragg & Associates
Principal consultants:
Torti Gallas and Partners, rfp response preparation, architectural design,
 construction administration
Bowman Consulting Group, civil engineer
Holland & Knight, land use counsel
Delta Associates, market research

Alban Towers Renovation
Client: Charles E. Smith Residential
Principal consultants:
Torti Gallas and Partners, condition assessment surveys, architectural
 design, construction administration
Martinez & Johnson Architecture, preservation architects
EHT Traceries, architectural historian
Smislova Kehnemui & Associates, structural engineer
Hartman Design Group, interior design
Lee & Liu Associates, landscape design

The Residences at Alban Row
Client: Encore Development
Principal consultants:
Torti Gallas and Partners, feasibility analysis, urban design code analysis,
 architectural design, construction administration
Alliance Structural, structural engineer
AD Engineering, m/e/p engineer
VIKA, Inc., civil engineer
Parker Rodriguez, landscape architect

Harrison Commons
Client: Harrison Commons, LLC
Principal consultants:
Torti Gallas and Partners, site planning, feasibility analysis, master
 planning, urban design, neighborhood planning
Lynch Giuliano and Associates, civil engineer

Arlington East
Client: Federal Realty Investment Trust
Principal consultants:
Torti Gallas and Partners, rezoning, site plan approval, feasibility, urban
 design, architectural design
Macris Hendricks and Glascock, civil engineer
Structural Design Group, structural engineer
KTD Consulting Engineers, m/e/p engineer
Engineering Consulting Services, geotechnical engineer

Flag House Courts Revitalization
Client: Midcity Urban/The Integral Group
Principal consultants:
Torti Gallas and Partners, feasibility, master planning, community
 coordination, architectural design, urban design
KCI Civil Engineers with STV, Inc., civil engineer

King Farm
Client: King Farm Associates, LLC (for master plan); Pritzker Residential
(for Charleston housing units)
Principal consultants:
Torti Gallas and Partners, master planning, site planning, architectural
 design, urban design, construction administration
Linowes & Blocher, attorney
Loiederman Associates, civil engineer
Land Design, landscape architect
The Traffic Group, traffic engineer
McCarthy & Associates, environmental consultant

Centergate Celebration
Client: Pritzker Residential
Principal consultants:
Torti Gallas and Partners, programming, site plan approval, feasibility,
 design charrette, master planning, urban design, architectural design
Danny Powell Landscape Architecture, landscape architect
KTD Engineering, m/e/p engineer
Plowfield Engineering, structural engineer
Margaret McCurry, clubhouse architect

The Village at NTC
Client: Clark Realty Capital
Principal consultants:
Torti Gallas and Partners, site plan approval, design charrettes, design
 guidelines, architectural design, master planning, neighborhood
 planning
Edmond Babayon & Associates, structural engineer
FARD Engineers, Inc., m/e/p engineer
Leppert Engineering Corporation, civil engineer
Christian Wheeler Engineering, geotechnical engineer
RECON, acoustical engineer
Gillespie Design Group, Inc., landscape architect
Chameleon Design, interior design

Monterey Family Housing
Client: Clark Pinnacle Family Communities LLC
Principal consultants:
Torti Gallas and Partners, design charrettes, community meetings,
design
 guidelines, architectural design, master planning, neighborhood
 planning
Greenhorne & O'Mara, civil engineer
Delorenzo, Inc., landscape architect

Belmont Bay Town Center
Client: EFO Capital Management, Inc.
Principal consultants:
Torti Gallas and Partners, comprehensive planning, feasibility, master
 planning, urban design, community meetings, urban design,
 architectural design

College Park
Client: Lemoyne Gardens, LLP (private joint venture between Mid-City
Urban and the Integral Group for the Memphis Housing Authority)
Principal consultants:
Torti Gallas and Partners, programming, master planning, architectural
 design, materials selection, construction administration
Pickering, Inc., civil engineer, landscape architect
Beazer Metro – Homebuilder, general contractor

Strathmore Park at Grosvenor Metro
Client: Eakin Youngentob Associates
Principal consultants:
Torti Gallas and Partners, site planning, architectural design
Cates Engineering, structural engineer
Schwartz Engineering, m/e/p engineer
Loiederman Soltesz Associates, civil engineer
Parker Rodriguez, landscape architect
Carlyn & Co., interior design

Baldwin Park Village Center
Client: Baldwin Park Development Company
Principal consultants:
Torti Gallas and Partners, site plan approval, master planning, urban
 design, design charrette, architectural design
Skidmore, Owings & Merrill, associate architects

The Garlands at Barrington
Client: Barrington Venture, LLC
Principal consultants:
Torti Gallas and Partners, feasibility studies, code analysis, master
 planning, architectural design, design guidelines, construction phase
 services
Gewalt Hamilton Associates, civil engineer
Smislova Kehnemui & Associates, m/e/p engineer
Joe Karr & Associates, landscape architect
STS Consultants, geotechnical engineer

Index by Projects

Acknowledgments

Publishing the third edition of *Urban Spaces* was a most rewarding experience that would have not been possible if not for the contributions of many great people and organizations.

The ULI once again cooperated with VRP to cosponsor the publication of the book. Thanks especially to Rick Rosan, Rachelle Levitt, Gayle Berens, Lori Hatcher, Lloyd Bookout and Karrie Underwood for their help and advice on the production and distribution of the book. And an especial thanks to the ULI organization for their support in initiating and continuing this series.

John Dixon's editorial expertise and boundless knowledge of all aspects of the architectural world made his insightful commentary interesting and informative. And most importantly, his ability to connect with our participating firms and present the salient facts and features of over 190 varied projects expedited the exchange of copy and proofs.

The dedication and talent of the design and production professionals working on *Urban Spaces* was essential to the creation of this handsome book. Thanks to Harish Patel, John Hogan, Adam Yip and Alex Lam.

My associates at VRP, Larry Fuersich and Lester Dundes were there as usual to provide advice and guidance.

The architects and marketing and graphic directors at all the participating firms we worked with were fabulous. Their cooperation and enthusiasm made my task of coordinating the many components of the publishing process so much easier. Yes, we took advantage of all the new high tech methods of printing and communicating—using email, high resolution scans, electronic proofing, etc., but you don't make friends as I did during the process without conversation. And even with the frustrations of "voice mail," I thoroughly enjoyed chatting with all of the representatives of the 38 firms in *Urban Spaces No. 3*, many of whom were participants in our previous editions.

Again, thanks to all of you whose interest and input enabled us to establish *Urban Spaces* as a continuing series of visual editions presenting the very best in worldwide urban design, architecture and planning.

Henry Burr,
Publisher